longslowburn

longslowburn
sexuality and social science

kath weston

Routledge

New York London

Published in 1998 by

Routledge
29 West 35th Street
New York, NY 10001

Published in Great Britain by
Routledge
11 New Fetter Lane
London EC4P 4EE

Printed in the United States of America on acid-free paper.
Text Design by Debora Hilu

Library of Congress Cataloging-in-Publication Data

Weston, Kath, 1958–
 Long slow burn : sexuality and social science / Kath Weston.
 p. cm.
 Includes bibliographical references (p.) and index.
 ISBN 0-415-92043-4 (alk. paper). — ISBN 0-415-92044-2 (pbk. :
alk, paper)
 1. Homosexuality. 2. Lesbianism. 3. Sex role — Philosophy.
4. Gay and lesbian studies. 5. Ethnology — Research. 6. Sociology
— Research. I. Title.
HQ76.25.W475 1998
306.76'6 — dc21 97-48675
 CIP

contents

the bubble, the burn, and the simmer **1**
introduction: locating sexuality in social science

1. get thee to a big city **29**
sexual imaginary and the great gay migration

2. forever is a long time **57**
romancing the real in gay kinship ideologies

3. made to order **83**
family formation and the rhetoric of choice

4. production as means, production as metaphor **95**
women's struggle to enter the trades

5. sexuality, class, and conflict
in a lesbian workplace **115**
coauthored with lisa b. rofel

6. theory, theory, who's got the theory? **143**
or, why i'm tired of that tired debate

7. lesbian/gay studies
 in the house of anthropology 147

8. requiem for a street fighter 177

9. the virtual anthropologist 189

 notes 213
 references 229
 permissions 257
 index 259

the bubble,
the burn,
and the simmer

introduction: locating sexuality in social science

Shortly before *The Lesbian and Gay Studies Reader* appeared on bookstore shelves in 1993, *Glamour* magazine produced a photo essay about two girls who accompanied one another as dates to their high school prom. *Redbook* published without fanfare a story about lesbian parenthood entitled, "My Two Moms." As the decade rolled on, television sitcoms began tossing bit parts to gay characters. A job ad appeared in the newsletter of the American Anthropological Association with "lesbian/gay issues" tucked away into a long list of potentially desirable specializations. Something called "queer theory" found its way into English departments and the pages of the *New York Times*. Publishers signed five-figure, even six-figure, book deals with researchers in the emerging field of lesbian/gay studies. Critics as well as supporters of the lesbian/gay/bisexual/transgender (LGBT) movement asserted that the movement had encouraged the study of sexuality in general and homosexuality in particular. Professors began to lament that the social sciences had lagged behind the humanities in taking advantage of these new opportunities (Stein and Plummer 1994). Sexuality had suddenly become a "hot," if not quite respectable, topic for investigation.[1]

Suddenly? In this popular truncated version of the history of scholarship on sexuality, an increasingly "open" social climate allows

queer theory to "liberate" sexuality for study, with the humanities leading the way (cf. Seidman 1994). A narrative of progress if ever there was one. But in order to portray research on sexuality as a late-breaking development, the raconteurs of this tale have to pass quickly over widely publicized empirical studies of sexual behavior from mid-century by investigators such as Alfred Kinsey, William Masters, and Virginia Johnson. In order to portray social science as a latecomer to the party, they also have to minimize the contributions of an array of investigators who matched Kinsey in commitment, if not acclaim. During her lifetime the psychologist Evelyn Hooker (1965, 1967) received little more than a nod for bringing the study of homosexuality out from under the rubric of deviance. Over in sociology, William Gagnon and John Simon (1973) were developing their concept of "sexual scripts" while the parents of some of today's queer theorists were debating the merits of cloth versus disposable diapers. When W. H. R. Rivers embarked on a multidisciplinary expedition to the Torres Straits at the turn of the century, he wasn't just interested in mythology or gardening techniques. He also posed questions about marriage, erotic dreams, and conception (see Kuklick 1991).

A few of the earliest researchers, such as the anthropologist Bronislaw Malinowski, are remembered as pioneers in their fields, but rarely because they studied sexuality. Most are barely remembered at all. Yet the impact of their findings has extended beyond their respective disciplines to shape debates about sexuality and intimacy that still grip the popular imagination. Thus the long, slow character of the burn, or at least the simmer.

This forgotten legacy of sexuality within the social sciences intimates that the present resurgence of interest in the topic represents something more than an abrupt enlightenment or a newfound "openness" toward controversial issues. Nor can the latest burst of scholarship on sexuality be explained by allegations that multicultural politics have conspired with a "gay agenda" to foment sexual revolution in ivory tower offices and high school locker rooms (see "The Virtual Anthropologist" in this volume). Within the social sciences, too much research predates the late-twentieth-century movements for social justice to legitimate such a contention, and even

research conducted in conjunction with those movements has encountered formidable opposition. While activists have worked hard, against great odds, to clear a space for study, the latest round of graduate student papers on transgender identity, international gay organizing, and abstinence is just one installment in a much longer story. Queer studies, as an outgrowth of the LGBT movement, may have insisted upon stirring up the pot. But queer studies hasn't been the first to assemble the ingredients or turn up the fire.

Long Slow Burn builds upon this legacy by repositioning sexuality at the heart of the social sciences. If sexuality is already deeply embedded in the topics and debates that constitute social science's stock-in-trade, then more explicit attention to those aspects of social life marginalized as "just sex" has the potential to reconfigure conventional analysis along more productive lines. Each chapter grapples, at some level, with the problem of how to resist the segregation of eroticism from both the intellectual history of social science disciplines and ostensibly "larger" themes of social science inquiry. Which is another way of saying that this book stands against those who, in relegating scholarly treatments of sexuality to a passing fad, would wish to make it so.

What does the most recent surge of research on sexuality mean for business-as-usual in the social sciences? What does queer scholarship have to say to taken-for-granted ways of understanding bodies, relationships, and lives? What kind of scholarship can truly come to grips with the inequalities of our time? What will it take to bring research on sexuality out of the universities and into the streets or onto the airwaves? Are there contiguities between the new research and the old? The answers to these questions depend upon making a distinction between investigating sexuality *per se* and investigating the ways in which sexuality can become embedded in any and every topic constituted as an object for research. It's one thing to study sexuality as an entity unto itself; it's quite another to study the infusion of sexuality into the very pursuit of knowledge.

The essays in this volume refuse to draw an artificial line around sexuality in order to make it out to be a discrete object for study, lying there supine, waiting for its researcher to come. A person

cannot "just" study sexuality, because sexuality is never separate from history, "class," "race," or a host of other social relations. Accordingly, the book explores sexuality through the lens of what amount to standardized topics in the social sciences: work, family, inequality, migration, even method. Collectively its chapters argue that a scholar cannot do any of these topics justice without taking sexuality into account. Once s/he begins paying attention to sexuality, social issues never appear in quite the same light again.

If sexuality is already integral to many of the topics examined by social scientists, it is equally integral to the history of social science disciplines. I mean this not just in the obvious sense that researchers have devoted long hours to analyzing the timing of orgasms, the social construction of impotence, the sexual metaphors in descriptions of trade wars or military maneuvers that hope to "penetrate," and the contrasting ways in which societies handle "adultery." I also mean that the classic debates which molded social science into a distinctive set of disciplines relied, often as not, on illustrative examples drawn from the "realm" of sexuality.

Go back to foundational studies of cognition and you will find "marriage classes" used to explain "primitive classification." Scratch the surface of the concept of social organization and you will lay bare speculative debates in which some scholars hypothesized sexual jealousy where others imagined an evolutionary stage of promiscuity. Look a few steps past the figures customarily associated with sex, and you will find Durkheim, Mauss, and Weber consorting with the likes of Darwin and Doctor Freud. Nor are such instances confined to the past. Consider, for one, that eminently contemporary and highly contentious debate on reflexivity in social science. As researchers ponder whether or not to use "I" in their work, they are, in effect, grappling with aspects of cultural categories (narcissism, confession, self-indulgence, kiss-and-tell) that have become parceled off, boxed up, and increasingly marketed under the rubric of sex.

Put this way, the study of sexuality starts to look like the bread and butter of the social sciences, rather than the sure-fire prescription for academic suicide as it was described to me during my student days. Yet it is important to understand precisely how sexuality came

to be construed as a compact and isolated subtopic, a matter of specialized study for the few renegade scholars foolish enough to pay it any mind. Only once sexuality becomes cordoned off in the professional imagination from the examination of religion, diaspora, voting behavior, interpersonal dynamics, community organization, and a million other facets of social life does the study of sexuality become a professional bridge-jump. Only then can it be said that a move to position sexuality at the heart of the disciplines does not describe social science as usual, or at least social science as most people have been trained to know it.

For all the attention recently garnered by queer theory, institutions of higher learning continue to ghettoize the study of sexuality. Best to pack it safely away, isolate it in the corner of a discipline, give it very limited standing as a subfield, maybe organize a lesbian/gay studies department, but preferably just revise the curriculum to offer a token course or two. Best not to let sexuality wander too much farther afield, lest it come into contact with subjects near and dear to the hearts of "mainstream" scholars, not to mention a wider public.

It wasn't always this way. What processes have obscured the links between the efflorescence of work associated with queer studies and earlier scholarship? What is the price of that forgetting? What allows researchers to sound credible when they insist that sexuality has little bearing on the rest of social science inquiry? How did sexuality come to be formulated as a fringe topic that can get any scholar's license to presumed heterosexuality revoked? One place to look for clues is on the hallowed ground where empiricism meets ethnography.

What Do They Do?
Hunting the (Homo)Sexual in Early Ethnography

In some parts of Western Australia, wrote R. H. Mathews in 1900, a circumcised man would be allotted an uncircumcised brother of the woman he would later marry. "The boy is used for purposes of masturbation and sodomy, and constantly accompanies the man" (125). Mathews described the arrangement in matter-of-fact

terms and followed his comments with an account of the uses of
heated sand to keep warm during winter months in the desert.
Thirty years later, in "Women and Their Life in Central Australia,"
G. Róheim progressed directly from a list of the foodstuffs gath-
ered by women (tubers, fruit, lizards, birds' eggs, mice) to a
description of a dance in which men sounded a musical instru-
ment called an *ulpura*. "The woman who hears it follows [the play-
er] when he goes hunting, and finally she elopes with him." On
the same occasion, "the first lover of a woman will go up to the
husband and ask him to give her back for one night, and he is
expected to grant this wish" (1933: 208–209).

Like the chronicles from the voyages of exploration on which
they were modeled, many early ethnographies adopted a flora-
and-fauna approach to the study of sexuality (cf. Kuklick 1997).
Details of social life that European and North American observers
considered "sexual" provided nothing more and nothing less
than additional data. In many accounts that took the form of a
report back from the field, "sexual acts" did not seem to call for
specialized examination, much less a disciplinary subfield. They
merely constituted phenomena to be documented and integrated
into monographs that compiled information on everything from
edible plants to myths, from body painting to funerary practices.
Kava drinking, circumcision, "a special form of *nambas* or penis
wrapper," hereditary chieftainship, and "a remarkable organiza-
tion of male homosexuality" share a paragraph in A. Bernard
Deacon's 1934 monograph, *Malekula* (14). Mutual masturbation
and the removal of one or two upper front teeth (for aesthetic
reasons) share a page in Melville Herskovits's *Dahomey* (1938:
289). In Papua New Guinea, young men were said to eat limes to
prevent pregnancy from male-male intercourse during initiation
ceremonies (F. E. Williams 1936: 200–201). And in the lowlands of
northern Colombia, according to Julian Steward and Louis Faron,
both rich men and chiefs practiced polygyny. After the authors
duly noted the presence of female prostitutes and "a special class
of male inverts who went from village to village selling their sexu-
al services" among the Calamari, they moved on with the same
deliberation to examine war patterns, cannibalism, and some-

thing called a "priest-temple-idol complex" (1959: 223).

Some observers offered thicker descriptions. Instead of cata-
loging "inverts" and acts, they explained how adults negotiated
rights to children in cases of "adultery" or how children ignored
adults when they wanted to engage in "sex play" (e.g., Evans-
Pritchard 1951: 91; Berndt and Berndt 1951: 86–87). John Shortt
(1873: 402) devoted an entire article to "the true Kojahs, or
Eunuchs" left in charge of the women's quarters of "Mussulman
nobles" in southern India. His essay contributed less to the estab-
lishment of sexuality as a subfield than to the ethnographic pro-
ject that called upon social science to verify the existence of
diverse "peoples" in order to place them firmly within the annals
of discovery.

Nor was this documentary imperative some antiquated
holdover from the turn of the century. In her study of Nyakyusa
age-villages in Africa, Monica Wilson took the time to point out
that the word for sex play between girls, *ubugalagala,* doubled as a
word for the "wicked cleverness" of witches (1963: 94). Her reason
for including the information in this context? The linguistic reso-
nance had significance for other topics of interest to Wilson,
including witchcraft and "mystical interdependence." Raymond
Kelly followed a similar logic in his study of witchcraft by alluding
to the Etoro belief that "heterosexual intercourse in a garden will
cause the crops to wither and die" (1976: 45). When June Nash
wrote up her research on tin miners in Bolivia, she included a
description of Carnival that encompassed not only music, cos-
tume, and cosmology, but also the "perverse dance combinations
where whites play blacks, men play women, and all the contradic-
tions of their lot in life are transformed into the opposite and
transcended" (1979: 318). Whatever one might think of the
appeal to transcendence, crossdressing features in the account in
such a way that it is simultaneously noted and brought to bear on
a more extensive discussion of racial categories and oppression.

Of course, what these researchers busied themselves docu-
menting (in a manner integral to the reports on kava drinking
and taro cultivation) were phenomena they *perceived* to be sexual.
The categories that framed their descriptions—perversion, inver-

sion, adultery, norm, marriage, homosexuality, transvestism—
came straight out of Euroamerica. Social scientists imported clas-
sificatory schemes that marked some things as erotic (and others
as not) along with their rucksacks, typewriters, and steamer
trunks. No wonder that ethnographies often made non-sense to
the very people they were supposed to describe.

And a complex sort of nonsense it was, given the colonial situ-
ation that prevailed in most of the locations under study.
Nationalist movements frequently stressed the "normality" of local
practices in response to European characterizations of colonial
subjects as sexually uncontrollable and perverse. In the context of
domination, people could not always afford to undo the sexualiz-
ing logic of the colonial powers.

Anticolonialist movements ended up building certain argu-
ments for home rule on the backs of European categories and,
some would say, local women. Dress modestly. Clothe yourself to
swim. No "obscene" dances. No drums. No daring backless blous-
es. Hands off the colonial equation of nudity with immorality and
lust. Scrutinize your wives' and daughters' every gesture for
"unbecoming" implications in order to demonstrate yourself fit to
govern. This was a rhetorical strategy that adopted the language
of sexuality to speak propriety and decorum to power. Its conse-
quences and its ironies are still in the process of being unraveled.[2]

So it is not quite correct to say that the notetakers and the
about-to-be-annotated subscribed to independent, much less
mutually incomprehensible, modes of "thinking sex" and think-
ing relationship.[3] Rather, they participated in the *inter*dependent
exchanges of groups locked in struggle, in which sexualization
offered both a rhetorical chip and a weapon. There is plenty that
Samoans of Margaret Mead's time could have said (and did)
about a book index in which *"Fa'atama* (tomboy)" succeeded
"Elopement"; *"Lavalava* (loincloth)" found itself sandwiched
between "Love affairs" and "Incest"; while an entry for "Sex" sub-
divided into "Sex (erogenous zones)," "Sex (experimentation),"
"Sex (friendship)," "Sex (techniques)," "Sex (adventure)," and
"Sex (American girl)."[4] But not without a political cost.

In the earliest days of ethnography, social scientists tended to

conceive of sexuality as a self-evident, perhaps intriguing, perhaps disgusting, possibly trivial, but nevertheless unified object for inquiry.[5] This was no category with meanings shaped by class warfare and colonial struggle, but a force both primal and given. That Thing Called Sex might be forever molded and sculpted by social forces, leading to tremendous variety in the ways that people around the world "do it." But there "it" was, awaiting report or observation, firmly grounded in a biological substrate of hormones and drives. Only with the newer scholarship that followed in the wake of publications such as Erving Goffman's *Stigma* would researchers begin to see needs, identities, desires, and repulsions as themselves socially constructed, their power explicable only with reference to something larger than the individual and biology. After that, the mind became a contender for the most erogenous zone (Ross and Rapp 1983).

Meanwhile, cultural relativism had gained ground. In the absence of any serious analysis of history or colonialism, the tremendous variety in erotic practices appeared to be the product of localized preferences and localized "traditions." If Ojibwa etiquette demanded cross-cousin joking that could edge over into flirtation (Landes 1937) and young men undergoing initiation in parts of New Guinea had to "practise sodomy in order to become tall and strong" (Landtman 1927: 237), well, that seemed to represent no more and no less a range than could be found in matters of religion or diet.

Although many ethnographies professed not to judge what they described, a certain amount of evaluation was inevitably conveyed in the description. "Adultery" is hardly a nonjudgmental term and "invert" sounds like something your kid would hate to be called on the playground. "Homosexual" implied a life-long identification, yet researchers applied the word to rituals that lasted only months, years, or days. But even those like Malinowski who approached the topic of sexuality with a certain distaste argued strongly for its place within social science: "Man is an animal, and, as such, at times unclean, and the honest anthropologist has to face this fact" (1927: 6).

Of course, not all researchers approached the phenomena they dubbed "sexual" with equal aplomb. In some instances, sex

appears as a "present absence" in ethnography. An investigator notes the "sexual" character of something observed and then either affirms his or her reluctance to discuss it, or simply moves on without comment. In his classic essay, "Religion as a Cultural System," for example, Clifford Geertz described a Rangda-Barong performance in Bali, in which the "witch" Rangda (taken by some as an incarnation of the Hindu goddess Durga) "evokes fear (as well as hatred, disgust, cruelty, horror, and, though I have not been able to treat the sexual aspects of the performance here, lust)" (1973: 118). At a later date, perhaps?

Over the years, entire articles on sexuality and even the occasional book did emerge within the ethnographic literature. Malinowski's *Sex and Repression in Savage Society* is among the best known, but there were also articles by Edward Westermarck on "Homosexual Love" (1906), Ruth Benedict on "Sex in Primitive Society" (1939), Ruth Landes on "A Cult Matriarchate and Male Homosexuality" (1940), Ian Hogbin on "The Sexual Life of the Natives of Wogeo, New Guinea" (1946), Ronald Berndt and Catherine Berndt on "Sexual Behavior in Western Arnhem Land" (1951), Robert Suggs on "Marquesan Sexual Behavior" (1966), Alice Kehoe on "The Function of Ceremonial Sexual Intercourse Among the Northern Plains Indians" (1970), and Evans-Pritchard on "Sexual Inversion Among the Azande" (1970), to name only a few. A veritable cottage industry arose on Two-Spirits (formerly called by the pejorative *berdache*), a category applied across American Indian groups to describe people considered at once sacred, cross-gendered or multiply gendered, and therefore inadequately described by terms such as "homosexual" or "bisexual" (see Lang 1996: 92).

This deliberately eclectic collection of sources suggests that, when it comes to establishing a lineage for the study of sexuality, social scientists are not dealing with the odd article out. There are plenty more ethnographies where these came from, without even extending the search to anthropology's sister-disciplines of psychology and sociology. Yet the references to sexuality in early ethnographies are important for more than their ability to dispute the joanna-come-lately charges aimed at queer studies. The

colonial "adventure" that informed these ethnographies has had a lasting impact on the way that researchers (and the public) approach the study of sexuality (Stoler 1995). So has the on-again, off-again alliance of social science with "hard" science. In the popular imagination, the social sciences have become associated with a reductive sort of empiricism that contemporary research on sexuality has yet to shake. Nowhere is this more evident than in the question that runs from the latest sex survey right back through early ethnographic accounts: What *do* they do?

"What *do* they do?" There is only so much to be gleaned from the information that Marquesan children live in fear of being reprimanded for masturbation, but that "the error appears to lie in being so inept as to be caught at any of these activities . . . rather than in the activity itself" (Suggs 1966: 46). First of all, this isolated observation offers no context. Are we talking pre- or post-missionary? Who asks and who answers, under what sorts of conditions? Whose category, this "masturbation"? How is the presentation of this decontextualized observation linked to a larger intellectual/ political project? Yes, it's data, but never simply data. Data is selected and collected, used and abused by researchers who are always in some sense a product of their times.

Such a litany may approach methodological truism at this late date, but like good sex, it bears repeating. The point is not just that social science has more to contribute to the study of sexuality than forays into social life that bring back data in bits and relatively undigested pieces. The point is also that the long history of flora-and-fauna accounts of sexuality—a history coextensive with ethnography itself—has fostered a mistaken impression of social science research on sexuality as an overwhelmingly empirical project. Empirical it has been and must be, but not without an edge that is simultaneously moral, theoretical, political, and analytical.

To the extent that early ethnography has helped sustain a "just the facts, ma'am" approach to social science research on sexuality, ethnography's relevance exceeds the anthropological. Caricatures of social science as a data-spewing science were only reinforced when attention shifted from "Them" to "Us," from exotics abroad to misfits at home, from analyses that focused on

difference to analyses that heralded deviance.[6] From the moment that "deviance" emerged as a topic for scholarship and a foil for "the norm," the topic was sexualized. College courses on deviance were much more likely to cover crossdressing than political rebellion or the odd girl out who hated apple pie, refused to salute the flag, and resisted the postwar marketing imperative to consume. In the interim, Kinsey had arrived on the scene to tabulate interviews on sexuality into percentages: 37 (not 35, not 38) percent of American men had experienced homosexual sex to orgasm. Masters and Johnson showed up with electric leads to hook up volunteers to machines that monitored, measured, and ultimately condensed a host of bodily functions (heart rate, sweat) into a "human sexual response cycle" (J. Jones 1997; Robinson 1989).

Sexology's mid-century aspiration to scientific precision gelled well enough with the approach of turn-of-the-century expeditions that had taken the world as their lab. But a renewed emphasis on data entailed a diminished recognition for the importance of the analytic frameworks that give form to data itself. Cultural relativism, to take just one such framework, has had a tremendous impact on how people think about "nature," "sexuality," and human possibility.

For all their utility and appeal, then, flora-and-fauna approaches contributed mightily to the fantasy of the social scientist as documentarian, a purveyor of distilled data ready to be taken up into other people's theories and analyses. What is at stake when so much attention accrues to social science as a source of "facts," and so little to data's uses, derivation, or production? Why, when it comes to social science's *theoretical* contributions to the study of sexuality, do so many still feel compelled to avert their eyes?

Before I move to examine that question in greater depth, I want to consider another way in which social scientists have been writing about sexuality all along. The grab bag of erotic practices integrated into flora-and-fauna accounts is the least of what's lost when contemporary research on sexuality proceeds without an understanding of its heritage. In the early years of social science, researchers staked out a territory for fledgling disciplines based upon case studies, illustrations, and debates that prominently fea-

tured matters of sexuality. So it is not merely that there is a theoretical component to research on sexuality in the social sciences. There is also a sexual component to the most basic social science theory. Without it, there wouldn't be a social science. Or more precisely, there wouldn't be *this* social science.

How the Social Scientist Got Her Spots

Think about some of the founding concepts and debates in social science, the kind any aspiring researcher spends hours committing to memory in graduate school. Social organization. Families and kinship. Norms and roles. The incest taboo. Nature versus culture. Diffusion versus independent invention. Interpretations of myth. Reciprocity and the gift. Work. Ritual. Solidarity. Cognitive competence. Inheritance and resource transfers. Primitive promiscuity. Evolution. The division of labor. Gender differences. Social stratification. International relations. The Protestant ethic. Characteristics that distinguish homo sapiens from the rest of the animals. Society. Instinct. Culture. Change. Some (the incest taboo, primitive promiscuity) appear more explicitly sexual than others (the exchange of gifts). But each and every one of these pivotal concepts in the history of social science drafted sexuality into the service of some "larger" debate.

The move usually happened in one of two ways. In the more pedestrian instance, an aspect of the erotic occupied center stage not as an isolated datum point, but as evidence advanced to make an argument. To take just one example, in that founding document of social science, *The Protestant Ethic and the Spirit of Capitalism*, Max Weber groups "temptations of the flesh" with "idleness" in a discussion of Puritan reservations about the pursuit of wealth (1958: 157). Here the material related to sexuality is offered almost as an aside, a small matter duly noted, but one that buttresses the author's point. Something similar occurs when E. E. Evans-Pritchard includes "virility medicine" in a more extensive catalog of Azande medicines, or explains the resort to "good magic" by describing how a man might employ magic to determine who was

sleeping with his wife. Readers learn that good magic can be used not only to find out "who has committed adultery," but also who has "stolen his spears or killed his kinsman" (1976: 183, 189). Evans-Pritchard does not require adultery to explain the concept of good magic, but adultery will serve his purpose just as well. The activity marked as sexual appears alongside nonsexual activities, but Evans-Pritchard offers it up as more than description or detail, because he uses the observation about "adultery" to support a particular analysis of witchcraft.

Sometimes eroticism dwells in the analysis by implication. One way Franz Boas explained the concept of diffusion was through a discussion of the spread of people and myths across large geographic areas. As groups spread out, they inevitably produced what Boas called "race-mixture." Well, we all know what folks have to do to get miscegenation. So when Boas recounts the story of the Dog-Rib Indians of the Great Slave Lake—in which a woman marries a dog, has six pups, loses her affiliation with her tribe, figures out how to remove the pups' dog-skins, and turns the pups back into children—he is telling that story to a purpose, and he ends up conveying a multilayered narrative about inequality and "sexuality" in the telling (1940: 438). People travel, myths travel, and both work to renegotiate social ties, sometimes in ways that happen to be mediated by sex. Evidence marshaled, argument made.

The second type of liaison between sex and analysis in social science was by far the more spectacular, and of more lasting consequence. In this case, authors treated sexual relations as a paradigmatic instance that offered either the best illustration of a concept or the best means of adjudicating an argument. "Puberty" (initiation) rites, with their implicit reference to sexual maturation, almost came to define the general category of ritual in both the popular and scholarly imagination.[7] Researchers interested in cognition did not just ask people to narrate inkblots, explain their reasoning, and fit odd shapes into boxes. They also gravitated toward a highly sexualized form of the $64,000 (cf. p. 158) question: Was it possible that Those Savages understood the mechanics of human conception? (Show that you can give a biological accounting for

fatherhood and you too can be granted mental acuity, accompanied by a fair-to-middling post on the evolutionary ladder.)[8] Likewise, when social scientists began to develop the concept of a norm, it was heavily indebted to contrasts drawn with the practices of "Others" imagined to fall outside the norm's parameters. These Others, pictured as deviant or exotic or both, were supposed to be recognizable in part by sexual excess (cf. Bleys 1995).

In each case, the analytic turn toward sexuality sought out material that would prove exemplary rather than interesting of its own accord. When Marcel Mauss developed his analysis of gift-giving as a device that created social solidarities, he took from Malinowski's work on the Trobriand Islands the notion that relations between husband and wife constituted the "pure" gift. "One of the most important acts noted by the author," declared Mauss, "and one which throws a strong light on sexual relationships, is the *mapula*, the sequence of payments by a husband to his wife as a kind of salary for sexual services" (1967: 71).[9] When Mauss teamed up with Emile Durkheim (1963) to study so-called primitive classification, "marriage classes" (moieties) provided a key component of their analysis. They contended that the division of some societies into two camps (the eligible and the off-limits) had provided researchers with a way of understanding different kinds of logic and basic modalities of human thought. In most of the societies they examined, what they referred to as "marriage" had its erotic dimensions, although sex did not necessarily feature as the centerpiece that it is often assumed to be in a society that claims "a good sex life" as a birthright.

Shadowing these discussions are philosophical treatises about human nature and fantasies about human beings in a primeval state. When it came to inquiry into what, if anything, humans universally share, the linchpin of debate often as not turned out to involve sexuality. One still hotly contested concept, the incest taboo, became a stepping-stone to the theorization of social relations. Does *everyone* (at least officially) find it repugnant to sleep with their children and their parents? What about siblings? Half-siblings? What to make of the coexistence of groups that forbid cousin marriage and groups that enjoin it (see Wolf 1995)? At

stake for many writers was not an understanding of eroticism *per se*. More to the point were questions about the degree to which biology dictates the ordering of human relationships. The move to push back the claims for biology in turn created room for new analytic concepts such as "society" and "culture."

The culture concept has accrued a range of meanings over the years, including "high" art, custom, collective invention, the constructedness of practically everything, and the possibility of multiple cultures. In a global economy where very little seems discretely bounded, the notion of culture has undergone sustained critique, but at the time that it first circulated widely within the social sciences, scholars explained culture in part by opposing it to "instinct." Seemingly inevitably, the path to instinct led through sex. Instinct paired birds with birds, bees with bees, and humans with other humans, but only humans went a step beyond instinct to give rules, regulations, and irate relatives a say in how they mated. Or so said the wisdom of the day.[10]

The work of Sigmund Freud, who wrote extensively on the topic of instinct, was also tremendously influential in moving sexuality to a position of prominence within social science. Before literary critics struck up their latter-day flirtation with psychoanalysis, psychologists and anthropologists tried their hand at the game. But Freud was not some Ur-source who accomplished this feat single-handedly. He himself was in the habit of citing ethnography to make his points, not only in the celebrated *Totem and Taboo* (1918), but also in essays such as "The Sexual Aberrations" (1975). And writing well before Freud were authors who pitched their arguments on the terrain of sexuality without becoming known as scholars of sex. Among them were Lewis Henry Morgan, Frederick Engels, Henry Maine, John McLennan, Emile Durkheim, and Charles Darwin.

Back in the emphatically pre-Freudian days of the nineteenth century, scholars endlessly debated the theory that societies progress through a number of developmental stages, the first being "primitive promiscuity." In his 1865 study, *Primitive Marriage*, McLennan speculated that men in the earliest societies had originally mated indiscriminately with women of the group.

Under such conditions, no one could trace biological fatherhood with any hope of certainty. Darwin vociferously disagreed, contending that "sexual jealousy was a fundamental emotion, and that it must have contributed to the early establishment of orderly mating arrangements amongst men" (Kuper 1988: 40). Engels picked up where McLennan left off, arguing that primitive promiscuity was obviously unsuitable for a system of private property. How would men know who stood to inherit? Something must have succeeded "the horde" once large-scale agriculture made the accumulation of surpluses possible. Engels, who drew heavily upon Lewis Henry Morgan's research on Iroquois Indians, proposed that this something was "the family." The family as Engels envisioned it restricted access to women in a way that allowed for the institutionalization of private property and control over its now regularized transmission.

What was at issue in the debate about primitive promiscuity? Not so much the "mating practices" of a bygone era, but an understanding of power relations: who owns, who inherits, who controls. The same debate provided an opportunity to elaborate theories of development and social evolution. Few, if any, of the authors who participated in the debate on primitive promiscuity set out to write about sexuality. Typically they came at sexuality from another angle, beginning with ostensibly asexual topics for investigation. How do you explain the logic for property transfers? The division of labor? Social organization? Changing modes of production? The rise of the state? They ended up writing page after page about marriage alliances, sexual jealousy, promiscuity, and the like.

In these speculative accounts, the way that a group handles eroticism becomes a marker of social (dis)organization and evolutionary advance. Joseph Marie Degérando, writing during the French Enlightenment, reflected on the state of "savage" society by asking, among other things, if "savages" focused love on one person alone and whether "such a degree of brutalization" existed among them that "the women . . . go [naked] in front of men without blushing" (Stocking 1968: 25). How different were his concerns from those raised by Darwin, Engels, Maine, and

McLennan more than half a century later? Given that many turn-of-the-century writers on evolution attributed darker skin to "savages" and "barbarians" as a matter of course (Stocking 1968: 132), the hypersexualization that was integral to the invention of the primitive would reappear in some of the most patently offensive stereotypes associated with the emerging concept of "race."

Out-and-out racism characterized the decades-long search for a "missing link." And where did social scientists go to seek this putative bridge between human and ape? To sexual relations generally and Africa specifically. In the many spurious accounts of African women who mated with orangutans or chimpanzees, heterosexual intercourse symbolized a continuity between humans and animals, in sharp contrast to tool use and the acquisition of language, which figured as tropes for a reassuring division of "man" from beast. When Europeans caged and exhibited a Khoi woman as "The Hottentot Venus," her lasciviousness was assumed, while the size of her genitalia became a matter for public comment and censure (Comaroff and Comaroff 1991: 104, 123; Gilman 1985).[11]

The eroticization of the search for a missing link cannot be understood apart from the concomitant search for a rationale for domination. As many have pointed out, social science lends itself admirably to the uses of intervention.[12] Terms such as "primitive promiscuity" may have been speculative, but they were not without worldly effect. Maine's *Ancient Society*, which followed Darwin's position on "sexual jealousy" in the primitive promiscuity debates, can also be read as a pseudo-historical polemic against Indian independence (cf. Kuper 1988: 18–20). So long as colonial subjects lived lives of sexual immorality, the product of a rudimentary ("patriarchal") stage of social evolution, who were they to take up agitation in the name of Home Rule?

After Captain Cook returned from his first voyages, European romantics tethered dreams of free love to the South Sea islands (Stocking 1992: 307). Their less romantic peers gazed into the same mirror and walked away aghast at the image of a sexuality so "out of control" it seemed to beg for European "civilization" to set it to rights. Of course, bare skin that intimated lust to colonial

eyes could signify very differently to people who thought the colonizers fools for fainting away in the monsoon heat in their button-downs.

These fevered fantasies of the colonial imagination came down hard on people under even nominal European or American control. Clothes, music, art, and anything else judged "obscene" by imported standards frequently became hybridized, displaced, or forced underground. Rampant eroticization also had a boomerang effect, both upon social science and upon the societies that proposed to rule. International relations emerged as a subfield from a shuffle of papers that attributed impotence, effeminacy, and enervation to countries, if not entire climates. Sociological studies of immigrant communities in the United States helped establish government standards for housing. When the state stepped in to assume custody of children in cases of neglect, judgments about "overcrowding" (based upon whose standard, what manner of living?) reflected fears that kids might see adults "doing it," not just safety issues regarding tenements in disrepair.

Social science also had a hand in producing the relief that some readers feel when they learn that neither a proclivity for nipples nor an 8.5-centimeter penis falls outside the (social-science-produced) "norm" (see Masters and Johnson 1966: 191). Some bad psychology and even worse incarceration programs have been developed in search of "cures" for departures from that norm. And it's a sure bet that adolescents who tease their friends about a sexual repertoire limited to "the missionary position" seldom have in mind the centuries of violence and religious/political repression interred in that phrase. Nor need they be conscious of the debt that the aspiration to master an elaborate array of sexual techniques owes to colonialist escapades.[13]

Even methodological debates could turn on issues of sexuality. In anthropology, the Mead/Freeman controversy was fought out (in part) over the issue of forcible rape. Freeman attacked Mead's reputation with the claim that forcible rape had, indeed, taken place on Samoa during the years when Mead heralded its virtual absence (see Stocking 1992: 332). Did forcible rape occur on

Samoa or not? Was it common? (And, by implication, was Mead a researcher worth her salt, or was she seduced away from rigorous scholarship by celebrity and the opportunity to popularize her work?) In this case, sex offered a site for testing out the reliability of a method and the limits of professional credibility.

Researchers who presumed "sexual acts" to be abstractable and so in principle available for scholarly inspection ran into problems when they tried to employ the methodological staples of the social science arsenal. If they used surveys, they found that sexuality again offered a paradigmatic case, this time regarding a methodological issue called the problem of self-report. How could social scientists gauge the veracity of retrospective testimony about something like sex without subjecting it to first-hand investigation (Lewontin 1995)? That left the methodological techniques of observation and, yes, participation.[14] What means were justified to gain knowledge of sexuality? What ethics should prevail? The turn to examine sexuality as a discrete object for inquiry threatened to lay bare the voyeurism (not to mention the romanticism) embedded more generally in the documentary project.

I have risked the oversimplification entailed in offering down-and-dirty summaries of what were, in their time, intricately argued and nuanced debates in order to drive home the point that, from the very beginning, assumptions about sexuality infused social science concepts such as normality, evolution, progress, organization, development, and change. Likewise, judgments about sexuality remain deeply embedded in the history of scholarly explanations for who acquires power, who deserves it, and who gets to keep it. The same can be said for a multitude of theories about cognition, reciprocity, gender, race, and many other stock concepts in social science. These are not just abstractions; they are abstractions with a past. Over years of application, they have proven as concrete in their effects as they have proven convenient in the hands of those who seek to justify domination. That's something to think about the next time you stop to read an essay on developmental stages of coming out, normative trajectories for building families, or public policy initiatives that frame population as a problem with "sexuality" and a matter for "control."

There are many ways to tell a tale, and the social scientist is not the only animal in the forest. I have chosen for the moment to make the social scientist central to an intellectual narrative that highlights sexuality. In this telling, researchers engaged in the study of everything from ritual to social change have cut their eye-teeth on documents that locate eroticism at the heart of the darkness that becomes a discipline. Many a researcher has gone on to save her professional hide by penning a manuscript dotted with arguments that appeal to "sexuality" to make a case. And that, best beloved colleagues, is how the social scientist got his spots.

Data on the Half-Shell

Social science researchers who come into this inheritance find themselves in a real quandary. On the one hand, they know they bring concerns and convictions to their projects, which means that their data is always produced, usually analyzed, and frequently theorized, just-so. Even the concepts they use to frame questions can carry an erotic charge. On the other hand, they go to work in a world that treats social scientists as the bringers of data. In this view, data figures as pure content, waiting for collection like cans on the street or driftwood on the beach. Forget the theory and analytics. With researchers cast as data-bearers, the contribution of social science to an understanding of sexuality diminishes in the mind's eye to the documentation of "acts" and "beliefs," little more.

Malinowski, a leading exponent of getting it "right" when it comes to the fauna, can be thought of as a data collector, or he can be remembered as someone who made sexuality into the terrain of an early foray into interdisciplinarity. In *Sex and Repression in Savage Society*, Malinowski held up Freudian models for cross-cultural inspection, pausing along the way to reflect about the implications of his analysis for class relations in Europe. (How does the mother's brother, ever-important in the Trobriand Islands, fit into the Oedipal triangle? The answer: He doesn't, because psychoanalytic theory can't do justice to his relationship

with his sister's son. The conclusion? Time for psychoanalysis to moderate some of its universalist pretensions.) Malinowski's book does much more than report back on research findings. The point is to read Malinowski for *how* he studies as well as *what* he studies. But that sort of reading would be incompatible with the marginalization of the study of sexuality taking place within the social sciences today, a marginalization that casts "sexuality studies" as a subfield and a "strictly empirical" project, with little bearing on theory or other aspects of social life.

Under these conditions, when something becomes marked as sexual, it looms large. So large, in effect, that it can overpower the rest of a writer's points. Margaret Mead "was amazed that the students of a professor at a Tennessee teachers' college should have thought that her book *Coming of Age in Samoa* was 'mainly about sex education and sex freedom,' when 'out of 297 pages there are exactly sixty-eight which deal with sex'" (Stocking 1992: 318). Even in passages that directly addressed sexuality, Mead analyzed and theorized, oftentimes in the description. Having noted that Tchambuli women engaged in sex play with the female masks worn by male dancers, she remarked upon "the double entendre of the situation, the spectacle of women courting males disguised as females" (Mead 1963: 256). In this instance Mead's comments have a contemporary, almost cultural studies, ring. Passing, reversals, and mimesis are obvious components of the story, but they can scarcely be discerned in the erotic haze that descended upon her work.

To say that *Coming of Age in Samoa* is a book about sexuality is like saying that Evans-Pritchard's *The Nuer* is a book about cattle. Both statements have a certain logic, but evaluation can't stop there. *The Nuer* may be a book about cattle, but it sets up the feeding and decoration and exchange of cattle as a device for understanding lineage and alliance. Likewise with Mead. Her observations about sexuality provide a point of entree to other issues about which she cared deeply, such as childhood development and the limits of human malleability. To imagine otherwise is to employ a familiar combination of seeing and refusing to recognize, like parents who know that their son has a boyfriend but somehow refuse to find out.[15]

A cursory review of the ways that literary critics, historians, and cultural studies scholars have taken up social science research into their own accounts reveals the latter principle in action. Passages on initiation ceremonies and seconds-to-orgasm tend to be cited uncritically, presented as truths bereft of politics or theory, in a way that literary theory strongly counsels against. Nor are social scientists themselves immune to the ironies and seductions of "discovery." "You'll never guess how they do it in New Guinea!" "You'll never believe what this survey tells us about the difference between what Americans say they do and what they actually do when they close the bedroom door!" Got the facts, ma'am. Just the facts.[16]

Flora-and-fauna accounts remain a useful but limited form of investigation, dangerous to the degree that they brook no accounting. When social science goes under to the uses of documentation, it never has to acknowledge the desire for mastery bound up in the written word. It never has to call attention to the selection or interpretation of what it "finds." It can overlook the multiple ways in which "data-bearers" carry with them the histories of disciplines. It can indulge in the convenience of forgetting that the notion of (pure) data works behind the scenes to make someone's perceptions, someone else's pet theory, more palatable. The utopian fantasy of ordering your data raw depends upon the illusion that the world is your oyster.

To the degree that social science lags behind the humanities in contemporary research on sexuality, something more must be involved than mere prudishness or a recalcitrance that inexplicably afflicts social scientists more frequently than their counterparts in literature and history. Within academic divisions of labor, the notion of the social scientist as a collector of other people's data has demoted social science to a kind of unskilled labor in the fields of sexuality studies. (Honestly, Paulo, how much skill can it take to go out and observe?) Yet the history of social science disciplines testifies not so much that sexuality is good to collect, but that sexuality is good to think. For centuries scholars have used what passes for "the erotic" to work their way out of intellectual dead-ends and back into vigorous debate. To highlight the empirical here, at

the expense of the analytic, places social scientists in an untenable position, because in their research the two are already one. In the food for thought served up by any scholar, data is already cooked, and in the hands of some, about to become highly spiced.

How did it happen that, by the late twentieth century, sexuality had become associated with a flora-and-fauna style of analysis, then isolated and disparaged as a fringe topic? What gives staying power to the mistaken belief that social science research on sexuality speaks for itself without offering theory or interpretation? The issues here are complex. Certainly the erasure of the intellectual history described in these pages, along with the assimilation of that history into ostensibly "asexual" topics for study, has not helped. Responsibility might also be laid at the door of an impoverished conception of the science in social science, in which knowledge appears as certitude, as fact. The kind of science most often (mis)attributed to research on gay friendship networks or fidelity in marriage is one in which the world stops turning for the observer-explorer. This is hardly the science of black holes, bubble universes, and mutable genes. But even these explanations beg the question of why an outdated conception of social science should regulate discussions of sexuality more than other areas of investigation.

There may be another culprit: an unholy alliance between the deskilling of social scientists in the popular imagination and the packaging of eroticism into a separate and distinct sphere. Following Foucault, Steven Seidman (1991) has argued that the imaginative segregation of sexuality from other aspects of social life is a relatively recent historical development that preceded the emergence of the LGBT movement. But the erotic sphere, once established, came to signify a domain of pleasure, frivolity, and fluff, a domain ostensibly peripheral to social life and therefore hardly a matter for serious investigation. No easy route to tenure here!

These historical developments are critical to understanding how sexuality, once ensconced in debate at the disciplinary center, became sidelined with respect to the simmering controversies and burning issues of the present day. Under such conditions,

"sexuality studies" and "lesbian/gay studies"—like the ethnic stud-
ies programs that these would-be fields took as their model—
tended to assume the shape of a bounded area of scholarship.
Coincidentally (or not), the emergence of lesbian/gay studies as
a discrete field of study corresponded with a move away from dis-
crete, canonical academic subfields such as political sociology or
economic anthropology. Once bounded, the study of sexuality was
bound to resemble an intellectual backwater in a society increas-
ingly preoccupied with themes of displacement, border-crossing,
and change.

While many social scientists today are busy talking diaspora,
race, territoriality, civil society, secularism, transnationalism, capi-
talist restructuring, and global relations, when it comes to sexual-
ity people want to know what "the X" *really* do in the privacy of the
shack, the hut, or the boudoir. This is the language of ethnonos-
talgia, a language of false certitude and mystified connection.[17] It
is part of the mechanism by which flora-and-fauna studies pretend
to be the whole of what social science can contribute to an under-
standing of sexuality, as well as the mechanism by which the sexu-
ality embedded in workaday social science concepts is minimized or
disappeared. Easy then to ghettoize the study of sexuality, making it
fit for queers or for no study at all. How far is this scholarly mar-
keting practice, really, from the retailing of a video such as *Sacred
Sex*, which promises to instruct the buyer, in return for her contri-
bution to public television, in "Tantric techniques" that will "pro-
long lovemaking pleasure"?[18] Both are exoticizing, orientalizing,
portable, importable, eminently collectible, and oh so convenient
on the replay.

In the pages that follow I work to widen the space for the dis-
cussion of sexuality within social science by asking, implicitly or
explicitly, how a researcher can operate from such a paradoxical
position. Most of the chapters in this book were written over the
course of a decade in which lesbian/gay studies came into its own.
Yet they are supremely old-fashioned in one vital respect: Each
takes its inspiration from the long history in the social sciences of
using material on sexuality to explore central theoretical ques-
tions and to jump-start debates. Although these essays rely upon

the ethnographic study of lesbians and gay men in the United States to make their case, they are in effect reflections on migration, labor, kinship, nationalism, reflexivity, theory, and a host of what social scientists are fond of calling "broader" topics.

"Get Thee to a Big City" examines accounts of the Great Gay Migration to San Francisco during the 1970s in order to explore some of the tensions associated with nationalism, the creation of an imaginary homeland, and identity politics. "Forever Is a Long Time" and "Made to Order" ask what an analysis of temporality and ideologies of consumer choice, respectively, can mean for kinship theory. "Production as Means, Production as Metaphor" and "Sexuality, Class, and Conflict in a Lesbian Workplace" present case studies in labor conflict and the anthropology of work. But they also make it their business to theorize the part played by ideology in structuring hiring decisions, the division of labor, and relations on the shop floor.

"Theory, Theory, Who's Got the Theory?" addresses the proletarianization of social science within queer studies and argues for a more creative, less class-biased understanding of what counts as theory. "Lesbian/Gay Studies in the House of Anthropology" works along with this introduction to establish an intellectual lineage within the social sciences for the analysis of "sexual" practices and beliefs. "Requiem for a Street Fighter" brings home methodological questions about fieldwork, reflexivity, and writing, with the story of a friend's suicide and a book's dedication. "The Virtual Anthropologist" uses the concept of virtuality to retheorize (and re-embody) hybridity. In the process, it explores the opportunities and the damage associated with studying "sexuality" in a time and a place called social science.

Ultimately, the different chapters resist the very notion of sexuality as a disciplinary subfield by dissolving "sexuality" back into social life. My goal is to bring research on sexuality into dialogue with writing on labor, race, colonialism, and the like, as a way of confronting the social forces that would confine eroticism to its own sphere, mine to study or yours to enact. Each chapter links assumptions about eroticism to conditions at once political, economic, and historical. None adopts an anti-empirical stance. In

most, theory melds with ethnography, which is, after all, the point.

It's not easy to acknowledge the ways in which sexuality remains the proclaimed lack and continuous obsession of social science. It's not easy to resist the utopian fantasy that the researcher's job is to collect "pure" data, albeit redeemable for little more than the going rate for aluminum cans. But there's a cost when scholarship refuses to acknowledge its intellectual debts, or to recognize its hand in the production of what it finds.

To the researcher worried that the social sciences offer an inhospitable climate for the study of sexuality, this book says: Claim your heritage. Don't fall for the seductions of the academic market in exotica by subscribing to a theory/data split. To the foolscap warriors still attempting to turn back the new wave of research on sexuality, this book says: It's too late to mount a defense. You don't need to know anything about queer studies to realize that sexuality is inscribed in your history, your concepts, your most disciplinary desires.

Some will reconcile with this intellectual legacy. Others will try to walk out the door. Whether or not they look back, they cannot escape the legacy's hold. Like unrequited love, that most romantic of attractions, the history of sexuality within the social sciences has proven impossible to live with, yet equally impossible to live without.

get thee
to a big city

sexual imaginary and
the great gay migration

On a temporary stage erected in San Francisco's Castro District, Meg Christian leaned toward the microphone. Whether the occasion was a rally or a street fair I can't recall, for I was all of 19 and had yet to become a sociocultural anthropologist or take my first field note. I had never particularly liked Christian's genre of "women's music." Yet there I was, new in town, and here she was, a recognizable face and a star. I stopped to listen. Following a spirited rendition of "Ode to a Gym Teacher," a comedic ballad about a young girl's crush on her physical education instructor, the singer paused to comment on the difficulties of "growing up gay" in a rural area. Her advice to onlookers who had friends or relatives still struggling to "come out" in the countryside: Tell them to take the next bus or train to a big city. Whistles, cheers, and nodding heads greeted this clarion call.

In the late 1970s, unknown to myself at the time, I was riding a wave of lesbian and gay male migrants to the Bay Area. After finishing college in the Midwest, my girlfriend and I piled all our worldly possessions into a drive-away car to head for the gay metropolis on the coast.[1] The incongruities of age and class in this scenario were apparent to the first patrolman who chanced to observe my raggedy T-shirt-clad self at the wheel of a brand-new

Cadillac with 12 miles on it. He pulled us over and demanded to
see registration papers within a mile of the agency that had
assigned us the car. Time in the streets had left me wary of police,
so it took me a while to relax after that initial altercation. But
once we hit the highway, I remember taking pleasure in climbing
out of that Caddy to walk into cafés in small towns across the
United States where a white woman in jeans and boots was not
nearly enough to turn a head.

During my years of work and graduate school in California, the
occasional cross-country trip with its truck-stop cafés was the closest
I got to "rural life." When I chose the San Francisco Bay Area as the
site for a research project on lesbians, gay men, coming out, and
(as the project evolved) kinship, homosexuality in rural areas was
far from my mind. Tired of reading studies of "gay people" top-
heavy with white, male college students, I hoped that my seven
years' residence in the city would provide the contacts necessary to
create a study that attended to racial, ethnic, and class relations. I
selected San Francisco not as a field site that could represent all
"gay people," but rather for its internationally unique reputation as
a gay city. Armed with anecdotal evidence about gay migration pat-
terns to the Bay Area, I expected to encounter lesbians and gay
men who had begun their lives in many parts of the country. At the
time I felt such a geographical distribution might compensate for
the widespread tendency to interpret every "community study" as
a study of "gay people in the United States."

In 1992 I was invited to participate in a small working confer-
ence on Rural Women and Feminist Issues. "I didn't know you
worked on rural women," a colleague commented after she heard
the conference title. "I think I'm attending in theorist's garb," I
replied, explaining the structure of the conference. Initially I
thought my conference paper would focus on absences, the ways
in which my work failed to take account of gay-identified (or sim-
ply homosexually active) people in rural areas. Clearly their expe-
riences had never been the direct focus of my research.

Often as not my work entails disrupting the taken-for-granted
meanings associated with categories such as "identity" and "com-
munity," a potentially discomforting procedure for scholars ori-

ented primarily to documenting the heretofore undocumented. Loathe to replace the search for the Vanishing Native with the quest for the Invisible Native, I have always intended to do more than "give voice" to sexualized subjects whose stories remain unheard. I want to know more about the historical and material processes by which "gay people" have constructed themselves *as* a people, and what implications those processes have for theories of ideology and identity.

The more I thought about the conference, the more I realized that I had, in a sense, studied rural women (and men) all along, despite the urban location of the ethnographic fieldwork I incorporate into most of my writing. Integral to the oral histories gathered for my work on kinship are travelogues of the journeys—both bodily and imaginative—that brought the lesbian- and gay-identified people I met to the city of San Francisco. To study the rural in this way is a different sort of project from the study of "rural lesbians and gay men" as a group defined by spatial positioning and rooted to place.

While it is true that many of the oral histories I recorded back in 1985–1986 include accounts of childhood years spent outside metropolitan areas, those same accounts render problematic the very concepts of city dwellers and country dwellers. After going back over the interviews, I asked myself whether I would necessarily know a rural woman if I saw her. Did Carolyn Fisher, who had left behind her home in the California countryside three years earlier, count as a rural or an urban lesbian?[2] Did Andy Wentworth, arrived from small-town Pennsylvania only ten months before, qualify as an urban or a rural gay man? What about Danny Carlson, who planned eventually to return to the reservation on which he had grown up after completing his "white man's education" in the city? How to categorize Vic Kochifos, whose stories of coming out in Chicago seemed inextricable from references to his youth in a small New Mexican town? How useful was the rural/urban opposition for understanding the experiences of Atsuko Ito, who had moved from her birthplace in Tokyo to a women's commune in the Japanese Alps, followed by a disillusioning sojourn on "women's land" in Oregon and then a renewed hunt for "women's community" in the Bay Area?

Just as I began to question the validity of the rural/urban opposition as an analytic tool for classifying persons, I noticed that this symbolic contrast was central to the organization of many coming-out stories. The passages in these narratives that link sexuality to the opposition between city and country encouraged me to pursue the possibility of studying the rural *through* the urban. It quickly became evident that more was at stake than "discovering" a rural past among migrants who had traveled to the city to embrace an urban present.

In what follows I show how the symbolics of urban/rural relations figure in the peculiarly "Western" construction of homosexuality as a sexual identity capable of providing a basis for community. The part played by urbanization in the creation of a homosexual sub-culture is already well established. The part played by urban/rural contrasts in *constituting* lesbian and gay subjects is not. I begin by revisiting coming-out narratives that I originally solicited with nary a nod to the rural, this time seeking the sexual imaginary that drew lesbians and gay men to the city.[3]

The Sexual Imaginarium

What I call the Great Gay Migration of the 1970s and early 1980s witnessed an influx of tens of thousands of lesbians and gay men (as well as individuals bent upon "exploring" their sexuality) into major urban areas across the United States. San Francisco was the premier destination for those who desired and could afford to live in "gay space" (D'Emilio 1989). The city continues to be the object of pilgrimages by others satisfied with the occasional visit to a lesbian club or a walk down the streets of symbolically gay neighborhoods such as the Castro. By informal accounts this migratory trend continues, though not at the furious pace of earlier decades. When I spoke at a bookstore in Tucson recently, for example, a woman approached me to discuss her concerns about the "brain drain" of Southwestern lesbians with leadership potential who had decided to relocate to the Bay Area.

At its height the Great Gay Migration coincided with a gay

movement that ushered in the so-called minority model of gay identity (Epstein 1987). In the minority model homosexuality becomes an entity supposed to be discernible without respect to culture or context. To write unreflectively about "gay people" is to treat homosexuality as a presocial given. To say "I am a lesbian" or "I am gay" usually presumes a consistency of attraction to the same sex that makes an individual a different kind of person. When the minority model grants gay people ontological status as a finite, bounded group, it universalizes a "Western" classification in which sexual behaviors and desires are understood thoroughly to infuse a self.

Taking apart "the" gay subject in this manner does not necessarily diminish its force as an operative category in people's lives. One thing this type of analysis can do, however, is provide an indication of the imaginative processes associated with gay migration from rural and suburban areas to cities such as San Francisco. How did a significant proportion of migrants to the Bay Area end up consolidating a varied range of sexual practices and fantasies into a lesbian or gay identity? How did "we" come to believe that others like ourselves existed? Even more puzzling, what led us to conjecture that those "like" others were to be found in urban centers?

A standard feature of coming-out narratives, in which people recount the events that led them to claim a label such as "lesbian," is a statement about originally believing oneself to be "the only one in the world." Sometimes a narrator credited a sexual or romantic encounter with dispelling this initial impression of uniqueness. Routes to finding a partner could vary with class, race, gender, region, and the historical period during which the narrator came out. In some cases the setting for that first encounter was summer camp; in others, basic training, a college dormitory, a public restroom, or a park. For Terri Burnett, an African-American woman who enlisted in the Navy during the 1950s, the military promised not only upward mobility but also an opportunity to look for other lesbians. Before the McCarthy purges sent twenty women in her company home with dishonorable discharges for homosexuality, Terri remembered the relief of receiving "acknowledgment, *finally,* that there really were people

like me." For Danny Carlson, finding a gay man on the reservation where he spent his adolescence was an important event. "When you're out on a reservation—a reservation being isolated from the urban population—and [having] the feeling of you're the only one in the world, to know another gay Indian, it was a good feeling. That I wasn't all alone."

Of course, not everyone experienced this original sense of being "the only one in the world." Yet most considered isolation the customary starting point in the process of claiming a lesbian or gay identity. One of the few lesbians who told me she had never had to search for other lesbians because she had always known them described her experience as "weird." Significantly, she attributed her early familiarity with lesbian- and gay-identified people to growing up in a large city.

These descriptions of college crushes, military escapades, and summer camp adventures chronicle the beginnings of participation in a gay *imaginary*, rather than some empirical "discovery" of pregiven desires within the self or intrinsically "like" others. Finding a partner for homosexual activity was no guarantee of feeling part of a larger group; conversely, lesbian or gay identity could be claimed in the absence of sexual activity. A woman could always interpret a homosexual encounter as an isolated circumstance, or a crush as love for someone who just happened to be another woman. A man who believed that no potential lovers existed for miles around might still begin to see himself as part of a larger category called gay people. In this way the designation of lesbians and gay men as "a people" becomes bound up with the search for sexual partners and the construction of a lesbian or gay identity.

During the Great Gay Migration, countless individuals launched themselves upon a quest for community in Benedict Anderson's (1983) sense of the term. As "members" of an imagined community, people feel an attachment to a necessarily fictional group, be it nation, race, gender, class, or sexuality. In the process they interpret themselves *through* that attachment, so that their subjectivity becomes inseparable from constructions of "we-ness." The popular depiction of "gay people" as a constant 10 per-

cent of humanity naturalizes the imagined gay community by rendering "it" susceptible to identification, quantification, and spatial location. To the degree that membership in the imagined community is interpretively constructed, the matter of who "is" lesbian, gay, or queer becomes no less indeterminate than the question of who qualifies as a rural woman. More than an illusion, the imagined community threads its way through social structures and everyday experience, even as it depends upon conditions "on the ground" for its social purchase.

Specific historical and material circumstances have facilitated the emergence of various forms of sexual imaginary. In the case of homosexuality, one key was the availability of print and other forms of media that alluded to the "existence" of people called homosexuals.[4] In many coming-out narratives a stock episode depicts the protagonist going to the dictionary or the library to look up "homosexuality." References gleaned from news reports, radio shows, and the occasional appearance of a gay character in feature films figure more prominently in accounts from the 1970s, when the gay movement began to come into its own. In the stories of people who came out in the late 1980s and 1990s, allusions to media coverage of AIDS, as well as materials produced by and for gay people, become common.

Vince Mancino was born in 1955 into a working-class, Italian-American family in suburban Chicago. His story exemplifies the genre that features descriptions of tracking a gay imaginary through media representations.

> When I was about eleven or twelve or thirteen, we were watching a program on prison reform, and they kept talking about homosexuality. I asked my mother what it was. She said to go look it up. I went to the dictionary and I looked up the word. I immediately closed the dictionary, and I took the book and brought it into my room, and I *hid* the dictionary. Because there was actually something that described what I felt. Which I *vowed* to myself I would always keep secret. Nobody would ever know these feelings that I had. That there was something that actually said exactly what I felt was mind-boggling. It was as if I had always known the definition; now I knew the term. And it was as if I had been found out. I thought I had invented something new. I really had no conception that anybody ever felt the same thing.

After that point, I read everything I could get my hands on. I first started by going to the public library in Bellwood, Illinois, and there I would find everything I could. I would find a few references, but not much. By the time I was about fifteen or sixteen I did find more books, but they all told me that it was a phase and it would pass. I thought, "Oh, good. I'm going to be okay." But by sixteen or seventeen, when the "phase" did not pass, I knew it wouldn't, and that this is what I felt

From there I found the book called *The Lord Is My Shepherd and God Knows I'm Gay* [sic] by Troy Perry. That helped me a great deal. . . . I saw Troy Perry on a talk show, a late-night talk show in Chicago, and I just couldn't believe my ears. I thought it was a joke. I thought it was absurd. But I finally read his book. . . . Looking back, I don't know how I ever got up the nerve to buy it, but it was just one of those things where you can't not do it. I just could not resist buying it, no matter how embarrassing and painful that would be. Because there was something inside me that was desperate to find out what I felt.

Because this episode is related in the context of a coming-out narrative, listeners already know the dénouement. The passage in which Vince hides the dictionary is a recognition scene that presupposes "the homosexual" as a kind of person. When he presents his tale as a movement out of pain, uncertainty, and isolation, he implicitly contrasts his early circumstances with the sense of belonging and group membership that is to come.

Interviewing Vince Mancino brought back memories of my own adolescent belief that I could find other lesbians if only I could find the money to travel to Paris. Perhaps I had read something about Alice B. Toklas and Gertrude Stein somewhere along the way. In my raid on a local college library, one of the few books on homosexuality I uncovered was Violette Leduc's boarding school romance, *Thérèse et Isabelle*. Though the book was untranslated and I knew no French, the cognates were enough to make the case that this was the book for me. Hands shaking, I walked up to the circulation desk with a borrowed library card and checked it out.

This common mode of "discovering" the gay imaginary depends upon access to print, television, and other media. Getting beyond the family dictionary or the television set that projects directly into the privatized realm of the home requires access

to facilities such as libraries, bookstores, and movie theaters that disseminate gay-related materials. Equally essential is proximity to a site—usually an urban area—where these resources are available.

Rose Ellis grew up in rural Virginia, far from libraries and card catalogues. In her case, the route to the gay imaginary lay between the covers of a book given to her by a high school physical education instructor (Meg Christian take note).

> It wasn't a whole book on homosexuality. It had a part in it telling, explaining, what homosexuality was. . . . But then, at that time, I figured there was nothing I could do about it. There's nobody else there gay. So I just . . . went out with my friends with the boys. Just looked at the women, and that's it. Just started in my head, that's it. That's all I could do about it, until I got away from the clutches of my mother!

Rose grew up poor in an African-American family in which the children had to work in the fields to make ends meet. Literacy gave her the means to be able to "start in her head" with women during the years that she dated men and dreamed about moving to a city. Yet literacy in and of itself was not sufficient. For Deborah Gauss, who entered a Roman Catholic convent in 1959, the decision to lead a cloistered life precluded reading secular books or newspapers. Her first memory of the word "homosexual" came well into adult life, after regaining access to printed material.

Before the gay movement, and to some degree still today, the books a person encountered were likely to be shaped by a psychological perspective that could hardly be described as gay-friendly. Kurt Halle first thought he might be gay about age twelve or fourteen "when I read Dr. David Reuben's book *[Everything You Always Wanted to Know About Sex But Were Afraid to Ask]*." Kurt's narrative described growing up German-American in a medium-sized city in Mississippi during the 1960s.

> I think I'm part of the age that read that [book], and I was horrified by that chapter [on homosexuality]. It was something that I could identify with, but I could not accept how he defined the gay world at the time: A dark room. There would be no windows, and you see couples that seem like men and women sitting at a

table with the jukebox playing. And maybe on the dance floor a couple would be dancing, and then you'd realize that the women weren't really women but were the men dressed up as women. That's how he defines what a gay bar is like. And *that* just completely turned me off. . . . I think that because of his book, I felt *doomed*. Which probably is why, at that time in my life, I never thought I would reach thirty. I thought that I would be alone, because he painted a very, very desperate and lonely picture. Which I'm glad is not true!

Given that the gay subject was also a stigmatized subject, books offered a way to seek out "information" without letting other people know of the reader's interest. Movies provided another venue. "There are plenty of people growing up right now in teeny tiny towns in the middle of nowhere," said Vic Kochifos, "who are digesting really weird ideas about sexuality and what gays are like."

Movies that are put out now about gay people, if they're not specifically about gay people—which no one in a small town is going to go see anyway—they have gay people shown peripherally as . . . being a silly, flighty person. . . . The stereotypes are still being pumped out. And it's, I'm sure, hurting someone else who is as eager to absorb that sort of thing as I was.

Of course, movies screen in major urban areas as well as "teeny tiny towns." Vic's concern with the impact of media representations on gay viewers *outside* the city hints at urban/rural contrasts embedded in the gay imaginary.

In addition to portrayals in print and electronic media, indirect modes of alerting bystanders to the "existence" of the gay subject developed. Taunts of "faggot" or "dyke" on the playground fall into this category, although the search for the meaning of these terms often led the listener back to books. Regardless of medium, however, the gay subject seldom appears as a person who socializes with other "gay people." It matters little whether the character is a gay man coming out to his parents in a sympathetic television portrayal or a lesbian wielding an ice pick on the big screen. In either case, the gay subject is most commonly presented as a subject bereft of community.

How did individuals exposed to *this* sort of sexual imaginary get

from the vision of a lonely and isolated life to belief in a gay col-
lectivity? Andy Wentworth described himself coming out in rural
Pennsylvania at age fourteen:

> I recognized myself as being homosexual, and being what *seemed*
> to be one of a very few. I had what I've discovered since then is
> a very common syndrome. I *very* much had that feeling of "I'm
> the only one". . . . I've heard a lot of people say that since then.
> Especially people who were not in a city where they could see
> other gay people around. They were out in the suburbs or the
> sticks or the boonies or something. It's like, "Gee, there's no
> other gay people around me. I've never *seen* another gay person.
> I've got to be the only one on the face of the earth!"
>
> The thing is, logic overrides. In effect, you recognize that
> there's enough people on this earth. There's bound to be a few
> others. You can't possibly be the only one. Otherwise, nobody
> else would have ever heard of the term "homosexual." And since
> all the kids at school have bad things to say about being that way,
> there must be more of them around. It's just a matter of look-
> ing for a needle in a haystack.
>
> I started formulating the idea of moving to San Francisco,
> which was the gay city. And I figured that was *very* far away from
> family, so I could do what I wanted without having them find out
> about it.

Notice how, in Andy's story, "the only one in the world" scenario
is replaced by the conviction that there must be not only some*one*
like me, but also someone out there some*where*. "Like" others
become spatially located at the very point a person enters the gay
imaginary. But where to look? Andy's narrative explicitly links
claiming a gay identity to setting his sights on a new life in the city.
Terri Burnett and Vince Mancino were others who hit the
California Trail. Vic Kochifos landed temporarily in Chicago,
while Danny Carlson tried his luck in Reno. For Rose Ellis and
Kurt Halle, the first stop was New York.

Why did these seven, and so many like them, become convinced
that gay people were to be found by leaving the area in which they
had grown up and heading for a city? Why not try a neighboring
town, or remain in place and look harder for potential partners?
(Some did.) When first coming out, a few recalled receiving advice
from relatives or acquaintances versed in the sexual imaginary who

urged them to migrate. In their study of lesbians and gay men in rural areas, Anthony D'Augelli and Mary Hart (1987: 87) found that when people asked for help, friends and family sometimes responded by "lamenting the 'obvious' need of the gay person to move to an urban area." The accompanying message? "Rural life is not for gays, and . . . life in the 'big city' holds the hope of a new life."

After graduating from high school in rural Orange County, L. J. Ewing moved from Los Angeles to Santa Barbara and finally on to the Bay Area. "I always had the sense that things would be better if I moved further north," she explained. "Just a sort of vague sense that things would be better." Where did migrants like L. J. get that sense? Here again, books, television, movies, and personal contacts supplied some of the means that anchored the imagined community in space. Every friend who sends a letter back from San Francisco filled with tales of city streets covered with queers builds the city's reputation as a safe harbor for "gay people." Every reporter who files a story on gays from Greenwich Village or Castro Street locates the gay subject in space, and that space is almost invariably an urban one. Her report simultaneously conveys a vision and a directive to people in pursuit of the gay imaginary: "Come to the big city. This is the place where surely you can find others who occupy the categories 'lesbian' and 'gay.'" From pride parades to persons with AIDS, representations of the gay subject are almost always situated in an urban setting.

From the start, then, the gay imaginary is spatialized, just as the nation is territorialized. The result is a sexual geography in which the city represents a beacon of tolerance and gay community, the country a locus of persecution and gay absence. At present there are undeniable concentrations of lesbian, gay, bisexual, and queer-identified people in major urban areas of the United States. Here, however, I am concerned with how people employ a semiotics that constructs sexuality through spatial contrasts. For not only did the rural-born claim that they needed to make the journey to the city to "be gay": the urban-born voiced relief at having avoided the fate of coming out in rural areas where they believed homophobia to be rampant and "like" others impossible to find.

In story after story, a symbolics of urban/rural relations locates gay subjects in the city while putting their presence in the country-side under erasure. One way to read narratives that depict rural gays as exceptions or impossibilities is as cautionary tales about what happens to preconstituted gay people who fail to find "community" (i.e., their proper place). But that reading ignores the extent to which urban/rural contrasts have structured the very subjectivity that allows people to think of themselves or others as gay.

City Cousins, Country Cousins, Kissing Cousins

Rural-urban migration has been an ongoing feature of life on earth for some time now, affecting many "groups" in many contexts. In the years since the Industrial Revolution, a symbolic contrast between rural and urban has developed that castigates the city for its artificiality, anonymity, and sexual license. By relative definition, the country becomes a reservoir for nature, face-to-face relations, and "tradition."

In their stories, gay people who had migrated to the city often recapitulated this contrast, but they were also quick to revalue its terms. As they began to reposition themselves as lesbian, gay, bisexual, or queer, the city as a locus of iniquity became something that appeared to work *for* rather than *against* them. Its reputation for sexual license promised room for experimentation, its anonymity a refuge from the discipline of small-town surveillance.[5] Any nostalgia for a rural pastoral seemed outweighed by a longing for a future in an urban area that would open up a space of sexual possibilities. For people exploring same-sex sexuality in the years following World War II, the city became the place to be, not the place to flee.

Most symbolic contrasts between city and country depend upon an idealized portrait of the two as separate, self-contained spaces. Yet the factories, mines, and country markets in rural areas could not exist without being integrated into larger economic and polit-

ical relations. People are constantly moving between rural roads
and city streets, passing through without relocating. The restruc-
turing of agriculture has forced country dwellers to seek employ-
ment in nearby cities to supplement earnings from family farms.
Meanwhile, the tourist industry funnels a steady flow of city folks
into the countryside for vacation sojourns.

Different histories also disrupt facile oppositions between city
and country. Movements of global capital, with associated shifts in
gender- and race-segregated labor markets, have moved people in
and out of urban areas in complex rotations. Since the 1940s
wartime dislocation, employment opportunities and a more gen-
eral commercialization of sexuality have played a part in drawing
"gay people" to North American cities (Bérubé 1990; D'Emilio
1983a). African-American migration from the rural south to
northern cities, forced relocations of American Indians onto and
off reservations, circular migration between California towns and
Mexican villages or the mountains of Puerto Rico and New York
City, all combine in complex ways with the pull of any sexual imag-
inary.

Not everyone I interviewed considered sexuality a factor in
their individual decisions to migrate. Some had followed friends
and relatives to the Bay Area, or arrived looking for economic
opportunities.[6] During the 1970s and early 1980s the city's
expanding service sector beckoned people from around the globe
as the economies in rural regions of the United States stagnated.
In hindsight, the move to a city might also appear as one in a
series of circumstances. Mark Arnold explained what happened
after he dropped out of college because he could no longer
afford the tuition.

> I looked around for a job. There was nothing available, inviting.
> And the area [where I grew up], upstate New York, it's kind of
> dying, economically. It seemed kind of depressing to be there. I
> guess I thought I wanted to go away. . . . I really hadn't discov-
> ered that there were other gay people, so there wasn't that kind
> of feeling that I wanted to be in a city or anything like that. I just
> once again wanted to get away and figured that a change was
> better than nothing.

After meeting gay men in the military and eventually receiving an honorable discharge, Mark made his way to San Francisco. Notice, however, that he generically links the "discovery" of gay people to the feeling of wanting to be in a city, despite his contention that this association had not applied in his own life.

A continent away from Mark's birthplace, Carolyn Fisher grew up "sixteen miles in the country" in rural California, "so there wasn't nobody around." She did not define herself as a lesbian at the time she arrived in the Bay Area.

> When I first came to San Francisco, women were looking at me and smiling and hitting on me and stuff, and I was like, "Ugh, get away from me!" Because I'd come straight from the country. Never seen a gay person in my life. Real naive to city life. And everybody said, "Oh, you're a dyke. You just don't know it." I'd get so defensive. I'd be like, "Get out of here! I don't want to hear that!" When it started happening, I *knew* inside. It was like, "I *am* gay. But I'm afraid to tell people. Because I'm afraid they won't accept me, won't like me."

Although neither Mark nor Carolyn came to the Bay Area in search of a gay center, both recognized the centrality of the city in the standardized tale of gay migration. Even those who were initially unaware of San Francisco's reputation as a gay destination made a point of highlighting their ignorance of the subject, implying that almost everyone else *did* know.

Migrants' depictions of their arrival in the city are replete with characterizations of the country bumpkin, naive and uninformed about big city life. Yoli Torres, who moved to New York City after spending her first six years in Puerto Rico, remembered being puzzled by the phenomenon of "moving stairs" (escalators) and blowing on ice cream to cool it off because she took the frosty steam as a sign of a hot food. Jeanne Riley told of traveling the same route every day from the University of California campus to her Berkeley apartment lest she lose her way. But there is also something gay-specific in many of these accounts. Vic Kochifos explained why he did not act on feelings of sexual attraction to men until moving to Chicago:

I didn't see that there was really much . . . to be done about it. Especially not in Aztec, New Mexico. Teeny tiny town in the middle of nowhere. Even when I go back there, homosexuality is just not seen, not seen. It must be practiced somewhere, somehow, but I don't know where, I don't know how. I don't know who, I don't know when. And being terribly, terribly conscious of rejection, I'm not going to be the first person to make overtures and find out.

In a small town, you get the impression that everyone knows you. Knows what's going on for you. So unless you're real careful, all sorts of terrible things get out. And you know that not everything's going to be accepted. I couldn't let gay feelings out and know that I would be okay. . . .

If I had had to stick around in small towns in the middle of nowhere, I may have lucked out and found someone. But that's not likely. I'm sure that scenario is being played right now all across the country. People who cannot come out. I'm sure it's a very important factor in a lot of lives right now, a lot of unhappy lives out there. Marriages that were gotten into for the wrong reasons, that are not going to last. There's a lot of bad things going on out there that are the results of not being able to come out.

Vic's is a classic tale of the escape from surveillance into freedom, in which the anonymity of city life becomes a precondition for coming out and "being gay," or at least expressing "gay feelings." Kurt Halle related a similar liberation story that credited the search for gay community with opening up economic as well as sexual and romantic opportunities:

> I go back home [to Mississippi] very rarely now. When I was back there last time, I said, "You know, Mom, I'm *so* glad I escaped." I got out of there. I saw so many friends of mine who are straight who are living *horrible* lives. Pumping gas at the Dixie Quick, and selling eggs. It's such an impoverished life. I see the fact that I was gay as a way of freeing myself from what fate would have decreed.

In most stories of the Great Gay Migration, the rural is not only the space of dead-end lives, oppression, and surveillance. It is also a landscape emptied of gay people. Rose Ellis characterized her birthplace this way:

> Virginia is not a place where gay people are, not that I know of.
> . . . Where I was born, there was no lesbians. I don't even think
> there's one there. There was no such thing of being gay where I
> was. It was never brought up. And just looking around, I would
> never be curious of anybody, even. They were all so much into
> the boys. Having babies. So I'm pretty much sure that there's
> none there.

Significantly, the same narratives that use urban/rural con-
trasts to set up the gay imaginary may also contain elements that
disrupt the characterization of rural-urban migration as a move
from surveillance into freedom and isolation into community.
The bulldagger in the next town over or the "one effeminate
man" on the reservation can loom as large in stories of a child's
awareness of homosexuality as the lesbians working at the local
car wash in an urban area. In retrospect, the people most visible
as gay were often those whose presentation welded sexuality onto
gendered stereotype.[7] "A girl that I knew had a mother who was a
lesbian," Kenny Nash remembered.

> I mean, now that I know what a lesbian is, I know that. She grew
> up, I think, with her relatives [in that small Eastern town], but it
> was always whispered about her mother being a bulldagger. I
> didn't know what that was. She was dressed like a man. Now that
> I look back on it, she was very, very butch. She would come by.
> You'd see her sometime while you were out playing, and that was
> her mother. I didn't know what that meant, but it was something
> different. Something to whisper about.

Despite her doubts about finding gay people in Virginia, Rose
Ellis's first tentative experiments with lesbian sexuality occurred
in that very setting when she kissed her high school gym teacher.
L. J. Ewing remembered clearly her crush on the town's most
respected female figure, "the veterinarian's wife." In rural
Michigan, Bob Hampton managed to have sex with a distant
cousin on leave from the Navy.

> I wasn't in love with him. At all. I liked him a lot, but . . . I think
> I was looking for my people. And this, this was one of my peo-
> ple. So I started talking about some things. He just said, "Turn
> over. Go to sleep!" Shut me right off. And I was really hurt. I felt

> very betrayed by him. Well, here I was, sixteen years old, and
> here he is twenty-two, and he just committed a crime. I didn't
> know any of this. All I knew is that I'd been betrayed. I felt lost
> again. Where do you find these gay people? What do they look
> like?

For Bob, the problem was not finding a partner in a small town.
Ironically, it is at the very moment of sharing his bed with anoth-
er man that he articulates his frustration with the search for an
imagined community ("my people") capable of being located in
space and identified by as-yet-unspecified markers of sexual iden-
tity. In the story his cousin appears as a gatekeeper to the gay
imaginary who refuses to turn over the keys.

Nicole Johnson reversed the directionality of the journey to
sexual discovery by traveling to rural Maine to live with a woman
she met in a New Jersey city. As challenging as coming to terms
with her sexuality was figuring out how to live as an African-
American in a predominantly white region of the countryside.
Mark Arnold, who originally despaired of finding gay men in
upstate New York, later wondered why he had been so quick to
dismiss the possibility.

> It never occurred to me. Slow kid. Or see what you want to see.
> . . . There certainly must have been other gay people there.
> There's a military base there; there's an Air Force base there. So
> there must have been other gay people around. Since I've been
> back, I've checked a bar guide, and there's this one particular
> restaurant that has a bar listed. . . . I just wanted to be so
> removed from that situation I never even bothered to check any-
> thing out. . . . It wasn't a particularly pleasant time. All the
> things associated with growing up just in general, and then real-
> izing that all this time . . . I was gay inside and couldn't be gay
> outside.

If homosexual contacts and desire could occur in the country-
side, isolation could also characterize life in the city. In a study of
gay men in Toronto, John Grube (1991: 126) found evidence that
connections with "like" others were not necessarily easy to make.
Some of the migrants to Toronto from rural areas took months
before knowingly meeting another gay man. As a student at
UCLA, Bob Hampton discovered the gay character of West

Hollywood purely by accident after he and a lover moved to a new apartment. Toni Williams, who had grown up in the Los Angeles metropolitan area, insisted that she "certainly did not think that there was a community of lesbians and gays. I just felt like there was that one person out there that would understand and accept me, and want my love just as much as I'd want theirs. It was just a trial and error sort of thing."

Upon arrival, it sometimes became difficult to sustain the vision of the city as a space of liberation from sexual restrictions and surveillance. When Kurt Halle left Mississippi after seeing a male peer abused at his high school for "running around in lamé," he never stopped to consider the antigay violence that has flourished in tandem with gay visibility in urban areas (cf. Comstock 1991; Vázquez 1992). When young gay American Indians arrived in San Francisco, Danny Carlson had observed that their visions of sexual freedom sometimes became tempered by lack of housing and employment. When Tyrone Douglas marched in his first gay pride parade in New York City, he never expected to see people looking on wistfully from the sidelines: "The closet there, it was as much in force as the parade was, coming down the street." The anonymity of big cities that is supposed to open up a space of sexual freedom often appeared spurious to those who had grown up in cities, and even to immigrants themselves after a few years. As they began to meet partners, make families, and build friendship networks, migrants spoke about the "incestuous" and "small-town" character of San Francisco.

Even lesbians and gay men who had grown up in urban areas were not immune from the impulse to move to a big city. Relocation, especially of the sort that put miles between relatives and the person coming out, could itself be the prerequisite for acquiring that desired sense of anonymity (Weston 1991). For Paul Jaramillo, leaving Los Angeles for San Francisco had offered an opportunity to "experience real life for a change, because I could never be myself as long as I lived at home with my parents." Getting away from the "people who know me" in order to explore a stigmatized sexuality might entail moving from Boston to Philly or Birmingham to Atlanta as often as making one's way to Castro

Street from County Road B. Urban-urban migrants still found themselves moving through space, but in this case the face-to-face relations associated with the surveillance they hoped to escape were city born and bred.

Perhaps the most striking aspect of gay migration as it enlists the gay imaginary is that it could be accomplished by traveling *within* a metropolitan area. When Marvin Morrissey, who had spent most of his youth in the Bay Area, set out on a search for gay men during the late 1960s, he found himself surrounded by

> kids who were just coming out, who had just moved here, heard about how easy San Francisco was to live in if you were gay. *If they came from the East Bay, it was just as long a trip for them psychologically as if they were coming from the Midwest* [my emphasis]. They were trying to get that first little clerk job or waitress job or waiter job or whatever they were doing. They were trying to figure out where they stood in the community. What was expected of them. I'm sure some of the more ambitious ones taste-tested everybody they could get their hands on.

City dwellers' descriptions of learning how to get downtown on the bus in order to find a lesbian bar or a gay male cruising area incorporate all the standard elements of risk, dislocation, and naïveté found in chronicles of rural-urban migration.

Many of these examples seem counterintuitive when viewed in light of the sexual imaginary that led so many migrants to the city. What does it mean that the search for the imagined community can be undertaken inside or outside city limits? What are the consequences when narratives concerned with surveillance and sexual freedom fail to preserve a distinction between rural and urban space? What happens when city life collides with a sexual imaginary that has been transported from the countryside as surely as the clothes, photographs, and addresses that accompany the migrant?

In their very departures from the conventional narrative of gay migration, these counterexamples illustrate the ways that rural/urban contrasts are bound up with the creation of an imagined community peopled by gay subjects. Even at their most dispirited, migration tales tend to be framed by an account of

what the narrator originally expected to find. Whether introduced by words of surprise, satisfaction, disillusionment, or disappointment, the stories confirm the power of participation in sexual imaginary at the very moments they dispute its existence.

Here, There, Everywhere

Lesbians and gay men who participated in the Great Gay Migration began their journey at a time of widespread geographic mobility. Across the globe the movements of refugees, migrants, wanderers, and work-seekers have contributed to what Edward Said has described as a "generalized condition of homelessness" (quoted in Malkki 1992: 25). Sexuality as well as ethnicity or nationality can be harnessed to a search for "roots" and shaped through a symbolics of place. In its guise as the gay capital of the United States (or, in a phrase that treats Islam rather cavalierly, as "gay mecca"), San Francisco became the focal point of an imagined rather than a spatially determinate community. For many lesbians and gay men in the 1970s San Francisco—or, in its stead, the nearest big city—represented a homeland that could enlist the nostalgia of people who had never seen the Golden Gate. In relationship to an urban homeland (and, by inference, rural areas left behind), individuals constructed themselves as "gay people": sexual subjects in search of others like themselves.

Yet most tales from the Great Gay Migration do not end in the discovery of a bounded community ("my people") after the arduous trek to the urban Promised Land. Instead they culminate in a kind of anti-identification, recounting the experiences of people who arrived in the big city only to conclude, as Scott McFarland did, that "gay people weren't like me much at all." To the extent that individuals were differently positioned within relations of gender, race, age, and class, they entered the urban space of the gay imaginary from very different trajectories. In this respect tales of the Great Gay Migration highlight paradoxes of identity politics with which queer theorists, like the rest of the marginalized, still wrestle.

Because the search for a gay imaginary involves the pursuit of like persons gathered together in space, it incorporates increasingly problematic categories of identity and community.[8] What happens when a person who is lesbian-identified finally reaches the big city? In imagination she has become convinced that there must be other lesbians "out there." She may already feel uncomfortable with stereotypes of gay people encountered through reading, peers, television, or the movies. She probably has noticed that the sexual imaginary pictures lesbians and gay men in particular ways in the course of dreaming them into existence. Depending upon the historical period, the representations of gay people she brings with her to the city may include crossdressers, AIDS "victims," sexual omnivores, people without family, or women who really want to be men. These are representations she may take pains to distinguish herself from, though she is likely to carry them into her first encounters with "real live lesbians." In the months following her arrival, the city will almost inevitably present her with situations that force a reevaluation of whether she is indeed part of a collectivity called "gay people."

When Kurt Halle went away to the city to attend college in the early 1970s, his initial impressions of "gay life" confirmed some of his worst fears. Notice how he links those fears to a 1960s version of a homosexual imaginary mediated by the printed material he described earlier.

> There was *a* bar in Jackson at the time called Mae's Cabaret on, I think, Roach Street or something disgusting like that (laughs). It *fit* Dr. David Reuben's book! I remember you had to go [into] this nondescript building, up these dark stairs and around a corner, then down, and then over. It was back into this warehouse. I think I saw my first drag show there.

Before the gay movement, bars that catered to a homosexual clientele were likely to occupy the Tenderloin areas of cities, fostering the association of homosexuality with crime and other forms of stigmatized sexuality such as prostitution. In the coastal cities where gay liberation first emerged, the decade of the 1970s saw the introduction of gay bars that opened onto the street. There, the most likely point of comparison from self to ostensibly

like others was no longer a dimly lit bar, but a neighborhood spreading out from a commercial strip of gay-owned businesses.[9]

From its inception, the imagined community incarnated in gay neighborhoods has been gendered, racialized, and classed. Much as the imagery associated with the terms "inner city" and "barrio" types African Americans and Latina/os as drug dealers, welfare mothers, and gangbangers, so the "gay neighborhoods" of the Castro, the Village, and West Hollywood fix the gay subject as wealthy, white, and male. Even at its most visible, the vision of gay community represented by gay neighborhoods of the 1970s offered an exceedingly limited guide to what had become, within the terms of identity politics, an extraordinarily varied constituency. For people on the bottom of hierarchies of class, gender, age, and race relations, knowledge of where to find a gay neighborhood did not guarantee identification with "other gay people."

Marvin Morrissey blamed the domination of "gay communities" by businesses and a wealthy few for making "being gay . . . something that you can be more comfortably only if you can afford it." From the vantage point of a professional job, Deborah Gauss claimed she had little relationship to lesbians in tattered clothes or gay men "into" motorcycles and leather. Cheryl Arthur said she was tired of attending gay events with high entrance fees and programs that reflected "what the boys think is important." And Carolyn Fisher, who had come out in her teens, found the condescension from older lesbians who treated her as a "baby dyke" so intense that it made her "think twice [about] my sexuality."

After reading literature steeped in stereotypes of gay male effeminacy, Barry Isaacs spent hours in front of a mirror scrutinizing his appearance to ensure a masculine presentation. When Scott McFarland was unexpectedly introduced to the masculinized fashions of "gay clones" in the San Francisco of the 1970s, he had the opposite reaction. True to narrative conventions of the country bumpkin at a loss in an urban environment, Scott opened his story with a scene in which he loses his way even after receiving directions.

> I had read in an *Advocate* [a national gay magazine] once about Castro Street, which I remembered being: "Oh, in San Francisco,

someday I must remember to go over to *Cuba* Street" (laughs)....
I called up my friend Nancy and asked for instructions on how to
get to her house, and I got on the wrong bus. I got on the 8-Market,
which took me to Castro Street. I looked up and down Castro
Street, and I realized what was going on in short order. And that's
how I arrived in San Francisco.

It devastated me. It just devastated me. This is it! This is the
dream of all these people like me moving to somewhere. I had
read in this issue of the *Advocate,* that somebody had this great
idea to put out the call to all gay people across the nation to
move to some pretty liveable town. I know it was in California,
but I don't know who or what. The hue and cry from the peo-
ple in that town was immense. But I thought, that's a great idea.
That's a really good idea. We can start to really build the city of
ideals. When I got off on the Market, the "8" bus, and looked
and realized where I was, and that this *is* in fact what the town
looked like, I just wanted to die.

Everybody was dressed in these incredibly macho fashions. I
mean, I've gotten used to it, but they are. But they are. These
weigh-a-ton shoes. Jeans. The first five years I lived in San
Francisco, I refused to wear blue jeans. It was just like this big
cruise scene. Everybody was looking at everybody. It seemed to
me in those days that it was all just bodies and leering and all
these weird shops.... It took me years to recover from finding
out that gay people weren't like me much at all!

Eventually Scott heard about the group Radical Faeries, which he
said he joined to celebrate "the feminine" in himself. His arrival
story describes a classic confrontation of self-perception (itself
mediated by sexual imaginary) with an imagined community
anchored in the urban space of a gay neighborhood.

Like gender, age, and class, race could also constitute bound-
aries that separated self from the gay imaginary. Although Simon
Suh knew where to find gay people in Honolulu, for years he
experienced them as "not-me," white people completely "outside"
his Korean-American community. When Tyrone Douglas, an
African American, accompanied two white gay friends to what was
going to be his first gay bar, "They walked right in. I got hit for
three pieces of ID."

I couldn't figure out why *I* got hit and they didn't.... I asked a
black gay man who was also standing outside. He said, "That's
the way it is. This is Philadelphia. That's the way it is." So that

was pretty disillusioning. . . . It's not like once you're out and you're gay, that everything in the gay community is cool. It's the same stuff that's happening in the straight community. Racism still continues. Having that shared sexual identity is all you have. People don't regard it as any more than that.

Leroy Campbell made an interpretive link between his family's move to a new neighborhood in pursuit of upward mobility and his later migration in search of gay community. One day, he said, the racism and homophobia he had experienced came together when he remembered "an incident that happened to me in elementary school, when my family had first moved to this white neighborhood, and I was enrolled in this predominantly white elementary school."

Something like the second day of being in the school and being out on the playground, these white boys were taunting me. They said, "Don't play with him," referring to me. "He's a chocolate mess." I realized that it really hurt me deeply, because I was in this situation that I didn't feel a part of the people there. They were really intent on letting me know that I wasn't a part of them.

That incident hit me a couple of years ago, while going through therapy, as the basis of the feelings that I got when I walked into a gay bar. Most gay bars, like in Portland or Chicago, were predominantly white. And I wasn't a part of it. Men would look at me and then look away like I wasn't even there. I would get this feeling of rejection, and never understood it. . . . It's constantly being added to whenever I walk into a gay bar. . . . I think being in the gay community and not being accepted as a black person has set such a precedent that I don't think that the black community could hurt me as much as the gay community has.

A common response to this sort of treatment was for the person at the receiving end to disaffiliate from the imagined community. This was Tyrone Douglas's first reaction when he encountered representations that depicted gay men as white and effeminate. "I was trying to separate . . . my feeling towards being gay from the idea of what someone who was gay- or fag-identified was," he explained. "They were like completely different worlds. . . . [I wanted to be] nothing like them. Redefined the species." At its

most extreme, this response marked a loss of faith in the very con-
cept of gay community.

Another way in which individuals coped with the lack of fit
between self and allegedly like others was to revise monolithic
representations of the gay subject that were symbolically
anchored by Castro Street. Although this approach produced a
more variegated picture of the imagined community, it did little
to address the inequalities responsible for disrupting the sense of
belonging to a larger entity called gay people. For as much as
Leroy Campbell initially pictured himself belonging to a racially
inclusive "people," his dream still shattered against the avoidance
that greeted him whenever he ventured into a "gay" bar.

A third approach to resolving dilemmas of identity and repre-
sentation involved organizing to carve out a niche "within" gay
community, as Scott McFarland did when he joined Radical
Faeries. Groups for gay Asians, working-class lesbians, or gay men
over 40 attempted to meld sexuality with aspects of gender, race,
age, and class that were missing from the generic gay subject. The
result was a more specialized identity politics that no longer
demanded urban residence as a precondition for "being gay" in
the fullest sense of the term. When Danny Carlson described his
efforts on behalf of an organization for Native American lesbians
and gay men, he pictured himself and his peers taking the sexual
imaginary back to "Indian space."[10]

> Hopefully what we started here [in San Francisco] ten, eleven
> years ago with our gay Indian club [will help make it] okay to be
> homosexual on the reservation. . . . What we started ten years
> ago as an organization [was] in the hopes that we can relax and
> go back home and say, hey, you done your homework in the big
> city. Go back home and live in peace.

This import/export model of the sexual imaginary participates in
a broader cultural tendency to map time onto space by character-
izing inland locations as "ten years behind" cities on the coasts.
Danny's solution still required a sojourn in the city to gather
knowledge of what it means to be gay, albeit for modification in
relation to other "roots traditions" (e.g., Native American Two-
Spirits). Yet it also implicitly exposed the racialized character of

the gay subject as constituted through the opposition of the urban space of the gay neighborhood to a rural space of gay absence.

Each of these reactions marked a decline in the conception of an imagined community that could sustain "a deep, horizontal comradeship" (Anderson 1983: 16). Moving to a city only to find power exercised "within" the gay community at one's own expense bore the potential to dissolve or diffuse gay identity at its geographic locus. By the 1980s people like Leroy Campbell began to organize to demand their own place at the table. Based upon their participation in the sexual imaginary, they rejected the tacit equation of gays with all that is wealthy, white, male, masculine, or even exclusively homosexual in choice of partners. But the very movement to relocate these "others" inside the imagined community broke apart the unitary gay subject, and with it the spatial metaphor of a community capable of inclusion or exclusion.

This paradox of the disruption of gay identity at its semiotic heart suggests that there is far more to community than the reshaping of urban space to accommodate gay neighborhoods or a localization of persons who call themselves gay. The gay imaginary is not just a dream of a freedom to "be gay" that requires an urban location, but a symbolic space that configures gayness itself by elaborating an opposition between rural and urban life. It is also the odyssey of escape from the isolation of the countryside and the surveillance of small-town life into the freedom and anonymity of the urban landscape. Its call has enticed those who grew up in cities and suburbs as well as small towns and rural areas. Symbolic contrasts between rural and urban did more than encourage the concentration of gay-identified people in major cities of the United States. From the start, they were embedded in the gay subject.

If the Great Gay Migration participated in the construction of the imagined gay community, it simultaneously undermined this sexual imaginary. Rural-urban migration meant moving from imaginary in the generic (I know there are others like me) to an imaginary that embraced the particulars of geography and desire (I want to go where they are and live among them). In the process, individuals often found themselves asking, "Am I them?"

and "Who are we?" (cf. Cohen 1991). Especially for those who did not fit the profile of the Castro clone, the journey to a big city that initially signified "coming home" could end up raising more questions than it answered. Their experience is not without relevance for a world in which old analytic categories are giving way before diasporas and social struggles that evoke a nostalgia for place (cf. Malkki 1992).

For all the conflicts and contradictions associated with identity politics, scholars have been premature in heralding its demise. Across the United States, lesbians and gay men continue to be constituted *as* gay subjects. A semiotics of rural/urban relations remains integral to the construction of gays as a collectivity rather than scattered specimens of deviance or diversity. Yet something is stirring in the birthplace of gay identity. Lately some of "the natives" have been regrouping under rubrics like "different" and "queer." Not all migrants who traveled to the big city during the 1970s came upon the sort of gay community that allowed them to feel part of a people, but they did discover one thing. Homelands can be easier to desire from a distance than once you arrive on their figurative shores.

forever is
a long time

2

romancing the real
in gay kinship ideologies

"If it's real, it's got to last!" The place was a small café in San Francisco's Mission District; the topic, kinship. Tony Paige was attempting to explain his reluctance to recognize lesbian and gay families as a legitimate form of relatedness.[1] In the beleaguered tones occasionally adopted by heterosexual residents of this "gay city," Tony protested, "When the gays talk about their chosen families, they're telling me that *anybody* can be a relative. How will we know who's family and who's not? Where will it all end, I ask you? Besides, gay relationships are notorious for their instability. If people come and go, how can you call them kin?" In response, I noted that the jury was still out on the question of the relative length of gay versus heterosexual relationships.[2] In the eyes of many gay men and lesbians, I continued, "biological" relationships were no less subject to termination than relationships with the friends, lovers, and children that gay people incorporate into their chosen families. As Tony listened to me recount portions of coming-out narratives in which "biological" kin severed family ties after learning that relatives were gay, his look changed to one of perplexity and concern. "I just can't understand that," he responded. "Parents are parents and blood is blood. What kind of person could cut off a child that way?"

For years, anthropologists constructed genealogies and gener-
ated accounts of kinship that incorporated a set of cultural pre-
suppositions remarkably congruent with the ones that framed
Tony's views on gay families. Kinship ties were, by definition, ties
that endured. Unalterable biogenetic connections accounted for
the permanence of this very special sort of social relation. In the
United States, cultural expectations associated with bonds of kin-
ship incorporated a belief in what David Schneider (1968) called
"diffuse, enduring solidarity." Diffuse, because relatives were pre-
sumed to interact in a variety of circumstances for a multitude of
purposes. A cousin could show up to fix the family car but, unlike
a professional auto mechanic hired specifically for the task, the
cousin might well stay for dinner and return the following week to
celebrate someone's birthday. Enduring, because bonds of kin-
ship should not be broken or substantively transformed in
response to life's vicissitudes. Relatives were not supposed to keep
a strict accounting of services rendered or make loyalties contin-
gent upon a person's conduct. At the time of my fieldwork in the
Bay Area during the mid-1980s, a broad spectrum of people con-
tinued to describe relatives as "the ones who are always there for
you," a select group upon whom an individual could rely, regard-
less of context or crisis.

Those who accepted this analysis of a kinship constituted
through biological connection and "code for conduct" acknowl-
edged that non-familial ties might also be marked by the sort of
diffuse, enduring solidarity called "love." Friends, coworkers, old
army buddies could be—indeed, were often expected to be—
"there" for a person. What social scientists believed distinguished
these "other" sorts of relations from kinship ties was their volun-
tary, and therefore "fragile," character (Allan 1989; Norman
1989).[3] "You can pick your friends, but not your relatives" went an
old saying that made its way into monographs on kinship during
the 1950s and 1960s. Friends might be loved "just like" family, but
they remained "fictive," "pseudo," or "artificial" kin. Whereas
friendships and other "non-familial" relationships marked by
enduring solidarity could be terminated at will, a person was sad-
dled with relatives for life, whether she despised them or eagerly

anticipated the next family gathering.[4] Implicit in the distinction between friendship and family—like the distinction between "fictive" and "real" kinship—was a contrast between ties supposed to be freely chosen and ties understood to be given, usually at birth. Procreation determined "true" kinship, and what was "genuine" was not subject to change.

When Schneider (1968, 1984) developed a critique of the reduction of kinship to genealogy, that critique focused less on the permanence attributed to kinship ties than on the notion of the biological infrastructure alleged to support the cultural edifice of an array of kinship terms and practices that varied widely from one society to another.[5] To Schneider and his colleagues, biogenetic connection appeared as nothing more (and nothing less) than a peculiarly Western mode of demarcating a certain set of social ties, a culturally specific way to signify belonging. In the long shadow cast by the critique of kinship, *all* kinship ties (indeed, all social ties) could be characterized as fictive. No justification remained for privileging biogenetic connection as a presocial "fact of life" that ordained certain relationships to be of central importance to social organization.

As is the case whenever an insurgent critique casts doubt upon a field's most cherished paradigms, not everyone accepted this novel view of kinship. Scholars on either side of the constructionist debate fortified their positions by drawing upon already well-entrenched relativist versus universalist lines of argument. While some ethnographers resolved to define family as "the natives" defined family and refused to assume that all societies "had" kinship, others continued to perceive a (usually nuclear) family in any assemblage of genitor, genetrix, and progeny.

In the course of deconstructing genealogy, the critique of kinship simultaneously deconstructed kinship as a domain. Without a biological referent, kinship studies seemed in danger of losing its object (Schneider 1984; Yanagisako and Collier 1987). As proponents laid siege to the genealogical nexus that defined the discipline, participants on both sides of the constructionist debate began to echo Tony Paige's lament: "Where will it all end?" Having dismantled the subfield's procreative underpinnings, what more

was there for kinship specialists to do but document how kinship was meaningfully constituted for those who employed the concept? After years of being treated as an ethnographic staple, kinship virtually disappeared as a category in advertisements for teaching positions in anthropology.

Ironically—but perhaps not coincidentally—this stagnation in the field of kinship studies occurred at the very historical moment when controversies over so-called "new family forms" were heating up in the United States. By the late 1980s and early 1990s, even the *New York Times* had begun to run stories about gay relationships under headlines such as "How to Define a Family" and "What Makes a Family?" (Gutis 1989; T. Lewin 1990). The disputes chronicled in such media coverage announced the coming-of-age of kinship ideologies that contested the narrow interpretations of "the family" that had previously dominated public discourse. Cases were not limited to gay people seeking recognition for their partnerships. In one instance, a woman fought to overturn prison policies so that she could see the child she had raised to adulthood but never formally adopted; in another, a surrogate mother asked for custody of the child she had borne but contracted away. Unmarried heterosexual couples sued to get the family discount rate at the local health club, while friends who considered themselves "part of the family" demanded hospital visitation rights.

Illuminating as the critique of kinship has been in exposing the ethnocentrism built into kinship studies, thus far it has contributed little to an understanding of the conflicting interpretations of kinship that had gained currency in the United States by the late twentieth century. As a critical and textual endeavor, it has not developed ways to account for the appearance of kinship ideologies that challenge received wisdom about what constitutes a family. Without detailed reference to historical and material context, kinship studies cannot assess what has made procreative ideologies of kinship seemingly resilient in the face of such challenges. Neither can it evaluate the relative efficacy of the various strategies employed to gain recognition for chosen families and other reconfigurations of kinship ties.

This is not the place to explore in depth the limitations of what might now be considered a deconstructivist project. Suffice it to say that in targeting "biology" and the procreative nexus for deconstruction, anthropologists who subscribed to the critique of kinship approach allowed other key constituents of kinship ideologies in Western societies to maintain their taken-for-granted status.[6] Left largely untheorized are questions about how kinship ideologies arise, how people bring them into play in everyday arenas of dispute, the effect of specific lines of argumentation on power relations between dominant and subordinate groups, what possibilities emergent ideologies open or foreclose, how contests of meaning are themselves socially structured, and how social struggles to legitimate particular forms of kinship end up reshaping the very ideologies they deploy. Addressing these questions requires something more than a straightforward investigation of what different people mean when they invoke categories such as "blood," "love," "choice," or "forever."

To move beyond oversimplified arguments that "alternative" families either totally mirror or completely counter "hegemonic" forms of kinship requires a less dichotomized understanding of the dynamics of ideological change. To move toward an approach that encompasses the interplay of history, meaning, and practice involves reconstructing as well as deconstructing kinship. Rather than marginalizing the study of kinship after exposing the latter as "a special custom distinctive of European culture" (Schneider 1984: 201), this focus on contests of meaning reframes the study of families in Western societies in ways that break through the narrow conceptualization of kinship studies as a discrete domain of inquiry.

Competing interpretations of "the family" in Western societies draw upon broader themes of voluntarism, permanence, genuineness, and imitation that historically have mediated the conception of kinship-as-genealogy. It is no accident that the same country that successfully marketed a soda pop as "the real thing" has conducted a national debate on what makes a family in terms that require participants to come up with arguments as to why their preferred forms of family should be considered "the genuine

article." The notion of kinship as a biogenetic connection that brings with it diffuse enduring solidarity represents only one among a number of what Arjun Appadurai (1988) has called "ideologies of authenticity." In the United States, a cultural preoccupation with authenticity is evident across domains that range from "the family" to gender, ethnicity, and cultural politics. Chromosome tests to determine the "true" sex of athletes, advertisements that tout the "authentic" cuisine of ethnic restaurants, museums that scrutinize their collections for forgeries, global tours that pull in customers with promises of a look at "how the natives really live," all speak of a society that continuously reinvents and romanticizes "the real."[7]

Within Tony Paige's objection to the concept of chosen families—"How will we know who's family and who's not?"—dwells a desire to seek and to separate the genuine from the imitative by linking authenticity not only to biology but also to duration. Why should scholars and "subjects" alike be so preoccupied with the adjudication (or dissolution) of authenticity? Why the temptation to elide history through the deep-seated conviction that what is "real" cannot, should not, be subject to change? What, in terms of power, is at stake? It is, after all, rather peculiar (at least to the ethnographic eye) that permanence—mediated by particular conceptions of time and biology—should be integral to both scholarly and popular discussions of kinship. To pose and then investigate such questions offers an opportunity to reinvigorate kinship studies by linking the subfield to important and theoretically vibrant research on history, time, class relations, colonialism, gender studies, and the construction of "the Other."

The concept of gay families is the product of a population whose lesbian, gay, bisexual, and queer subjectivities have been shaped, in part, by the fear of having kinship ties sundered in response to disclosure of a stigmatized sexual identity. Like the anthropological critique of kinship, the gay kinship ideologies that emerged in the United States during the 1980s refused to naturalize familial ties by equating biogenetic connection with kinship *per se*. At the same time, these ideologies problematized the attribution of permanence to "blood" ties and impermanence

to "nonbiological" relationships such as friendship. The same gay kinship ideologies that warn of the fragility of "blood" ties celebrate friendship as an enduring bond that can assume the status of kinship. Within discourse on gay families, friendship turns on its head the cultural association of biogenetic connection with permanence by presenting friendship as the *most* reliable and enduring of kinship relations.

For Once and For Always
Gay Kinship Ideologies of the 1980s–1990s

> *Light from the restaurant spilled over into the bus stop on the corner. Inside diners were too preoccupied with their mussels marinière to notice the small reunion. Since Debra Lee and Gloria Salcido last met, the better part of a summer had passed. Now they gazed at one another fondly, anxiously, across a suddenly endless expanse of table. Over the years, first as friends, then as partners, and now as "ex-lovers," they had shared the goal of making their connection last. Although each had had time since the breakup to adjust to the changes in their relationship, neither was eager to put feelings about those changes into words. Only after the waitress ended her shift, leaving behind two cups of coffee and the check, did the conversation turn to the matter both knew had brought them here. "You'll always be family to me," Debra said with conviction. Gloria reached out for Debra's arm, then seemed to think better of it. With an ear to the ground and an eye to the future, they began to speak in low tones about the prospects for "working" on their friendship.*

The concept of gay or chosen families first began to achieve wide circulation among lesbians and gay men on the West Coast while I was conducting fieldwork in the San Francisco Bay Area during the mid-1980s. At that time, few went so far as to disallow a rather vaguely defined category called "blood" or "biology" as the basis for some type of family tie.[8] Instead they began to speak of "blood" ties as socially negotiated rather than biologically mandated, one among many possible forms of familial relationship.

Before exploring the linkage between friendship and enduring solidarity in gay kinship ideologies, I want to stress that not every-

one who identified as lesbian or gay subscribed to these ideolo-
gies or articulated them in the same fashion. A small number
believed that "blood" relations could never be terminated or
resisted the notion that friends could count as family. When I
speak of "gay kinship ideologies," then, I do so with some sense of
irony, since this rhetorical tactic resurrects an ethnographic vision
of timelessly enduring, discretely bounded cultures (see Thomas
1991: 309). Gay "communities" are hardly homogeneous, and they
have no neatly demarcated borders. Yet the rhetorical tactic of
writing about "gay kinship ideologies" is useful to the extent that
it allows me to focus on recurrent *formal* features, such as refer-
ences to relationships that last, which tended to cross lines of
class, race, and ethnicity in discussions of kinship.

In *Families We Choose* (Weston 1991) I explored some of the ways
in which differences of identity and interpretation have inflected
kinship among lesbians and gay men in the United States.[9] This
essay develops a line of inquiry opened in the concluding chapter
of that volume: How useful are the terms "same" and "different" for
describing the complexities of social change? Can similarities
encode difference, and differences similarities? What does it mean
that people of different colors, classes, and sexualities consistently
alluded to the length of friendships and partnerships in discussions
of kinship? Does it make a difference that lesbians and gay men
often voiced these remarks in the context of seeking legitimation
for their closest relationships? An anniversary celebration for a gay
male couple may appear related to a party that commemorates
twenty years of heterosexual marriage, but what about the mention
of a "longtime friend" in the death notice of a middle-aged lesbian?

For my present and limited purpose, I have posited a (far from)
unified gay population as the source of "gay kinship ideologies"
in order to throw everyday notions of the permanence that is sup-
posed to be embedded within kinship into strange and startling
relief. That move enables me to consider how ostensibly similar
formal features of kinship can carry conflicting meanings and
embed subtle ideological shifts, allowing "new" family forms to be
read simultaneously as radically innovative and thoroughly assim-
ilationist. In the end, they are intrinsically neither.[10]

As constituted during the late 1980s and early 1990s, gay families could encompass gay and heterosexual friends as well as lovers, ex-lovers, and children who might or might not be bio-genetically connected to the gay person doing the parenting. Although Gloria Salcido's and Debra Lee's relationship had shifted from one of friends to lovers and then ex-lovers, the two women considered one another "family" throughout the difficult months of their separation and breakup. The size and composition of gay families varied tremendously. Because chosen families generally took the form of a network of kin radiating out from the particular lesbian or gay man who had done the choosing, members frequently spanned several households. Like many others who spoke of having lesbian or gay families, Gloria and Debra described a limited number of friends they considered kin.

Among gay men and lesbians in the Bay Area, a utopian outlook tended to shape discussions of "alternative" family forms. "[Building gay families] is very complicated, I think," explained Paulette Ducharme, "because there's not necessarily a model. So people try a lot of different things. What[ever] works." In practice, however, this sense of creating kinship in the absence of precedent gave way to social arrangements that were meaningfully structured and choices that were inevitably constrained. The formal criteria used to differentiate chosen kin from nonkin incorporated signs of diffuse, enduring solidarity that did not differ substantially from those featured in dominant discourse on kinship. Ideally, gay families incorporated relationships forged and tempered over the course of years. Chosen kin were expected to "be there" for one another through ongoing, reciprocal exchanges of material and emotional resources.

Sometimes gay families formed in the context of a life crisis, such as a chronic illness that required exceptional levels of social support (see Dorrell 1991; Hays, Chauncey, and Tobey 1990).[11] During the 1980s AIDS provided one catalyst for the movement to incorporate chosen kin into prevailing definitions of family (Levine 1990: 39). For gay men, a diagnosis of HIV+ often forced the issue of coming out to heterosexual relatives, which generally brought changes to "blood" relationships that could take the form

of outright abandonment or unexpected levels of support. Members of a person's gay and straight families might find themselves interacting—in cooperation or in conflict—for the first time. In many cases friends and other peers became the primary caregivers, although in high-incidence areas a person's friendship network might prove too decimated by illness to offer effective assistance (Lovejoy 1990). Incredible efforts of formal and informal organization yielded the essentials of daily life: housecleaning and shopping services, transportation to medical appointments, pet care, cooking rotations, conversation. Families of friends, backed up by a range of new community-based organizations, occupied a central position in these activities.

Long before gay kinship ideologies referred to friends as family, anthropologists and sociologists had approached friendship as one of kinship's liminal categories. Along with institutions such as *compadrazgo* in Latin America and "going for sisters" in urban Black communities of the United States, friendship became a focus of research on what social scientists once called fictive kinship.[12] In North America, researchers documented numerous instances of people who claimed that they considered certain friends to be family or "like family." Unlike bonds of marriage or descent, however, these friendship ties were not systematically organized through a sexual relationship or a procreative nexus. Also unlike bonds of marriage or descent, friendships remained systematically peripheralized in studies of belonging (Jerome 1984; Paine 1969). Even today, many researchers continue to relegate friendships to the status of "fictive kinship" when they do not minimize the importance of these ties or ignore them altogether.

In scholarly treatments of friendship, it is not at all unusual to find analysts placing a lighter value on friendships than those relationships carry for the people subjected to scholarly scrutiny. An early study of relationships between gay men and heterosexual women, for instance, referred to friendships that "achieve high levels of understanding that enable [their participants] to relate in imaginative, creative ways" (Nahas and Turley 1979: 121). Having characterized these ties in glowing terms, the authors hastened in the next sentence to christen these bonds "marginal rela-

tionships." Friendship generally fares no better in popular treatments. As gay kinship has become a topic of controversy and debate in society at large, the friends incorporated into chosen families have received little attention, despite the respect historically accorded to friendship by many lesbians and gay men.[13] For every newspaper article devoted to lesbian mothers or an attempt by a gay couple to acquire a marriage license, another that could have covered a family of friends remains unwritten.

The scholarly literature portrays friendship as the most unpredictable of social ties precisely *because* most people in the United States construct friendship as a chosen, or voluntary, relationship (Allan 1989; Gouldner and Strong 1987; L. Rubin 1985; Wiseman 1986). What can be freely entered should be just as readily subject to termination, or so the cultural reasoning goes.[14] Through an implicit contrast with biogenetic connections, which are taken to be irrevocable, friendship becomes assimilated to a contractual model of relationships. Even accounts that treat friendship as a form of "fictive kinship" cast friendship as a less reliable and less enduring tie than relationships calculated through "biological" connections. In *All Our Kin*, for example, Carol Stack recognizes the significance of the participation of friends in the "personal kindreds" of poor African Americans in urban communities, yet describes friends as people who "drop in and out of one another's [kinship] networks" (1974: 54). Similarly, Christopher Ellison's (1990) tendency to view friendships in African-American communities through the lens of voluntarism and fragility leads him to characterize friendships as likely to be "less supportive and reliable" than "family ties" (299–300), despite his claim that "blacks are more likely to receive support from friends than from family members" (306).

Given this combination of a cultural legacy that subordinates friendship to kinship and a scholarly legacy that tends to depict such "fictive kin" as fair-weather friends, why should friendship appear as a signifier of stability in gay kinship ideologies? An African American from The Flats (the neighborhood where Stack [1974] recorded beliefs regarding the relative unreliability of friends as kin) would likely have encountered conflicting attitudes

toward the stability of friendship relations if she later came out as a lesbian, moved to the Bay Area, and became active in "the gay community." The same gay kinship ideologies that highlight friendship as an important, even distinctive, aspect of social relations among lesbians and gay men have also portrayed friendship as a bond more likely to endure than ties of "biology," marriage, or partnership. As one man put it, "Your straight family may reject you because you're gay. Your lovers may or may not stick around. But good, solid friendships can last you a lifetime." In most cases people elaborated this emphasis on the reliability of friendship through comparisons that drew attention to the uncertainties attendant upon relationships with lovers and "blood" or adoptive kin.[15]

When gay kinship ideologies depict friendship as an enduring relationship, more is involved than a logical inversion of the cultural categories of belonging linked to permanence (fragile friendships and enduring biogenetic ties in the dominant ideology, lasting friendships and terminable biogenetic ties in discourse on gay families). Understanding why gay kinship ideologies associate friendship with permanence and other forms of belonging with impermanence requires an understanding of the specific historical circumstances in which these ideologies have emerged. This inversion of the dominant ideology has been structured through the lived experiences of individuals who make their relationships not as they please but rather within the context of a society where heterosexuality remains normative.

Like the fragility often attributed to friendship, the permanence customarily attributed to "blood" ties (and sometimes marriage) became problematized for people who claimed a lesbian or gay identity in the wake of the gay movement. Elsewhere I have argued that the gay movement of the 1970s contributed to the emergence of a discourse on lesbian/gay families in the 1980s by encouraging people to "come out" to "biological" and adoptive kin (Weston 1991).[16] In previous decades, individuals sometimes disclosed their homosexuality to relatives, but not in any systematic fashion. By the 1980s coming out had become a possibility to be contemplated, if not always a plan of action to be implemented. At the time of my fieldwork, I did not meet a single lesbian-,

bisexual-, or gay-identified person who claimed never to have considered coming out to parents and other "close" relatives.

The prospect of being disowned by "blood" or adoptive relatives was the greatest threat recognized by people preparing to disclose their lesbian or gay identity to "straight family." Coming-out stories consistently focused on the prospect of "losing" kin and highlighted the devastating emotional impact when rejection ensues. Although outright rejection did not occur with great frequency, neither was it uncommon. Perhaps more important than the incidence of rejection was the generalized *fear* of being "cut off" that pervaded these narratives. A lesbian need not actually come out in order to realize that heterosexual relatives might not "be there" for her, precisely because she is gay.

Many anthropologists have argued that "biological" connection must incorporate social connection to make kinship. Whether biological, adoptive, or chosen, all kinship ties are optative, in a sense. Even for those who restrict themselves to a biogenetic paradigm for calculating kinship, selectivity is built into the classification of certain relatives as "closer" than others and the editing of "family trees" (Schneider 1968). For gay people contemplating disclosure to "blood" relatives, the contradiction between prescriptions for enduring solidarity and the selectivity built into this ostensibly most durable of ties often became evident. At issue was not so much the outcome of disclosure—"rejection" or "acceptance"—but rather a growing recognition of the potential for the termination of "indissoluble" ties.

Even coming-out stories that featured a happy ending tended to reaffirm, rather than assume, kinship. In many cases, the narrator resolved the suspense leading up to disclosure through a phrase that evoked the specter of the terminability of kinship ties in the very act of affirming a solidarity that endures: "You're still my son! You're still my daughter! I still love you!" Family trees dropped branches or sprouted new foliage as relatives embarked upon the complex process of coming to terms with a stigmatized sexuality. Coming out set in motion a personal politics that reconfigured, when it did not sever, now apparently mutable "blood" ties.

If "biological" and adoptive ties no longer seemed fixed, people

coming out into gay "communities" during the late twentieth cen-
tury also encountered conflicting views on the stability of relation-
ships between lovers. Most were already well acquainted with stereo-
types of gay relationships that circulated in the larger society.
Among lesbians and gay men in the Bay Area, opinions differed as
to whether (or to what extent) gay relationships could be consid-
ered more transient than heterosexual relationships. Those who
questioned the longevity of gay relationships tended to attribute
the instability they perceived to a lack of social legitimation and
institutional support.

"It's funny," said Frank Maldonado. "With my straight, married
friends, there's that awareness: 'Well, they're gonna be around a
long time.' Whereas sometimes, with some of my [gay male]
friends, they might have a boyfriend for a couple of months or a
year or whatever. There isn't that stability." Lourdes Alcantara
complained about gay friends who thought that she and her lover
of five years were eventually going to break up. "People don't trust
gay relationships. They think it's just for a while, that we are too
inconstante, that we're going to find somebody else. . . . [Yet] I'm
monogamous, we are monogamous, and I believe in forever."
Diane Kunin was careful to qualify her remarks on the challenges
facing lesbian couples with a reference to the historical rise in
heterosexual divorce rates: "[It's] not that marriages really last,
straight marriages. Not that the divorce rate isn't astronomical,
but I've watched some of my friends who are lesbian mothers
deal with lovers moving in and out of their lives, and it's a hard
thing."

In contrast, Roberta Osabe saw lesbian relationships as more
stable than heterosexual *or* gay male relationships: "I always saw a
lesbian relationship as being pretty constant. . . . My experience
has been that women tend to stay together pretty much longer
than men do. Straight relationships—the kind of people I see or
friends that I have who are together—a lot of them don't stay
together for that long, just because things are so different
[between women and men]." And cynicism about what had hap-
pened to his friends' relationships did not prevent Frank
Maldonado from planning to remain with his partner "forever":

> If you're going to make a commitment, you have to make a commitment and stand behind it. So when Bobby and I got together . . . we told each other that, hey, we're going to look at this as a lifelong endeavor until death do us part, better or worse, sickness or in health. It's not like a dance partner—if you step on my foot, I'm getting another partner. It's the real world and we're going to go all the way with it.

There were those who expected a relationship with a lover to last "only as long as it's good," and those who wanted their partnerships to endure "for always." Like Frank Maldonado, many mentioned the ideological stability accorded heterosexual marriage, despite ample evidence in an era of no-fault divorce that a large number of marriages do not begin to approach "forever."

Significantly, categories of transience and permanence organized the entire discussion of gay relationships. "I'm not saying this instability, or whatever, is a bad thing," insisted Paulette Ducharme. "I'm not putting any judgment on that." Using years spent together as an index of commitment had little to do with whether a particular person wanted a life partner or valued long-term relationships in the abstract. A "strong" relationship meant, among other things, a relationship that had endured the test of time.

Whether or not people expressed interest in building a lasting relationship with a lover, almost all sought commitment from the friends they considered family. Some of the same people who wanted their partnerships to endure also cited a variation of the old gay adage: "Lovers may be passing through, but friends stay." Knowledge of the importance placed on friendship within gay "communities" often came in the form of advice given by an older lesbian or gay man who had "been around," someone who had seen people disowned by "blood" relatives, someone who remembered all too well the pain that people go through when relationships end that once aspired to "forever." Drawing upon over sixty years of experience, Harold Sanders was but one of many who had concluded: "That's the way one builds a good life: a set of friends."

If friendships are the relationships believed most likely to endure, one way to create long-lasting kinship ties is to transform ex-lovers into friends who are also kin. In theory, if not always in

practice, former lovers could be recuperated as friends (Barrett 1989; Becker 1988). According to Diane Kunin, "After you break up, a lot of people become as if they were parents and sisters, and relate to your new lover as if [the new lover] were the in-law." While lesbians seemed more likely than gay men to attempt to transform ex-lovers into friends, this distinction was by no means absolute.[17] One man, for example, met another man in the military who introduced him to "the beauties of sex and how it could make you feel. It was a wonderful thing. Then, shortly after Roger and I met, we both received orders for overseas. I went to Guam, and he went to Germany. So we were separated, but we always remained friends." It was as friends, not simply "ex-lovers," that former sexual partners became reincorporated into gay families.

When the Time Comes
"Fictive Kin," Reconsidered

After considerable thought and several sessions with a calculator, Bruce Edelman decided to install new wall-to-wall carpeting in his modest Sunset home. With the money from his second job, he figured he could just afford to rip out the coffee-stained shag rug that had come with the house and send it the way of other relics of decades gone by. Because he could not miss any days from work, Bruce estimated that it would take him two months to finish the task alone. Depressed by that thought, he placed a ten-minute phone call which initiated a chain of communications that crisscrossed the city. The following weekend, seven of his closest relatives converged on his home with hammers in hand. Bruce contributed pizza, beer, soft drinks, and all the necessary materials. To the accompaniment of music from the boom box that followed Bruce wherever he went, this improvised work crew installed the entire carpet in a day.

Although Bruce Edelman made it quite clear to me that he included in his chosen family each of the people who helped him lay the carpet, none were related to him by "blood" or marriage. In earlier decades, an ethnographer might well have described the relatives in Bruce's narrative as "pseudo-kin." At a minimum, the ethnographer would have placed quotation marks around the

term "relatives" to mark it off from "real" kinship ties, still the point of implicit (if not explicit) contrast where friendships are concerned.[18]

This dichotomy between real and imitative, authentic and inauthentic, continues to inform much of the research conducted under the rubric of kinship studies. To categorize some forms of friendship as fictive kinship is to presume that "blood" relations, organized through procreative heterosexuality, not only constitute "true" kinship but also provide a model for all possible derivative forms of family. When viewed through the lens of an ideology that refuses to recognize biology and marriage as the foundation for all conceivable types of kinship, however, gay families no longer appear as "alternative," "fictive," or "substitute" formations.[19] Once "the" (nuclear) family, organized through heterosexual procreation, is dislodged from its position of preeminence, to what would gay families (or single-parent families, or postmodern families) pose an alternative?

Rather than rejecting the quest for authenticity, gay kinship ideologies have tended to portray gay families as "just as real" as other forms of kinship. Attempts to authenticate gay families have occurred not in an ideological vacuum but in a context of social struggle. As gay people have confronted dominant constructions of kinship that deny chosen families legal or social recognition, they have framed litigation and legislative strategies over issues that range from hospital visitation privileges to joint adoption and property rights. The consequence of the success or failure of such bids for legitimacy can be very concrete: It can mean the difference between being able to take time off for a partner's funeral or holding back unexplained tears for weeks at work.

To comprehend the relation between ideological transformations and social change in contemporary debates over what makes a family requires an understanding of not only the claims advanced, but also the *manner* in which advocates of chosen families have made their case. Having rejected the equation of biological connection with the sort of "genuine" kinship supposed to lead to enduring solidarity, many gay men and lesbians looked to enduring solidarity alone as sufficient basis for laying claim to

familial status for their relationships. By stressing the lasting char-
acter of certain "nonbiological" ties, they cast as kin friendships
and partnerships that were not organized through a procreative
nexus.

Intentionally or unintentionally, advocates began to highlight
the length of time two people had remained "in a relationship" in
cases that argued for gay people's rights to bereavement leave, rent-
controlled apartments, child custody, and benefits packages offered
by employers. Lesbian/gay organizations helped frame domestic-
partnership legislation that stipulated coresidence for a specified
waiting period (anywhere from three months to a year) before an
unmarried couple could register to attain the legal standing that
entitled them to benefits available to married couples.[20]

With very few exceptions, media coverage of court cases relat-
ing to gay families also emphasized markers of enduring solidari-
ty.[21] A *New York Times* article on Sandra Rovira, who sued AT&T for
death benefits, portrayed Rovira as having "formalized" her rela-
tionship to her deceased partner "in a 1977 ceremony for relatives
and friends" (T. Lewin 1990). *Gay Community News* characterized
Rovira as the partner in "a 12-year committed relationship with
Marjorie Forlini, who for 10 years had also served as co-parent to
Rovira's two children from [a] previous marriage" (Graham
1990). In a report on *Alison D. v. Virginia M.*, a suit before the New
York Court of Appeals that sought visitation rights for a "nonbio-
logical" lesbian parent, a couple was described as having separat-
ed "after a seven-year relationship" (Nealon 1990). Similarly, the
lead sentence of a *New York Times* story on custody battles between
lesbian coparents described Michele G. and Nancy S. as having
"lived together for 11 years" before their decision to raise children
(Margolick 1990).

Because friendship has minimal legal standing in the United
States, families of friends have not become a focus of court cases
and the accompanying media coverage. Yet it has not been at all
uncommon in nonlegal arenas for gay men and lesbians to
emphasize the length of time a friendship had endured as a way
to establish its importance and kinship character. "The closest
people in my life are not my blood family," Frank Maldonado

explained. "The people I surround myself with now are mostly gay. And lesbian. I have a number of straight friends that I see day to day, or week to week, whatever. And they're my family. They take care of me, I take care of them. . . . Some of my friends I've known for fifteen years. You get attached." Others, like Bruce Edelman, distinguished people who were "just friends" from friends who were also family by referring to events that he and other members of his chosen family had experienced together. A few spoke of encouragement—even pressure—from gay peers to remain in "close" friendships and partnerships once those relationships had passed a high-water mark of five or ten years. In such cases, longevity could offer a reason to "work" to extend those relationships and justification for naming them kin.

As authenticating narratives—narratives that say "these are real families"—gay kinship ideologies invert the assertion that "what's real is not subject to change" in order to argue that "whatever endures is real." This transformation of Tony Paige's deep-seated conviction—"If it's real, it's got to last!"—sets aside syllogistic reasoning in favor of a cultural logic that plays upon the widespread interpretation of kinship ties as ties that bind.

Like their heterosexual counterparts, most lesbians and gay men in the United States during the 1980s and 1990s were looking to the future when they constructed kinship ties and argued for their authenticity. They spoke of their gay families as a source of "security," expecting chosen kin to "be there" for them at some unspecified time of need in days to come. Unlike most of their heterosexual peers, however, they were also looking to the past when they contended that gay families were every bit as legitimate as other forms of kinship *because* those relationships had lasted. In this discourse, "stability," "strength," and "commitment" were measured by the months and years that a person had remained in an erotic or nonerotic relationship.

Forever can, indeed, be a long time. At certain points in arguments for the legitimation of gay families—especially (but not exclusively) families made up of friends—enduring solidarity recasts itself as a temporal rather than a timeless concept. It matters little whether the time span cited is five or fifteen or fifty

years, whether the figure given reflects the finality of death or the unexpected dissolution of a friendship. The result is a different kind of "forever" than the one envisioned by those lesbian, gay, bisexual, and heterosexual couples, who, like Frank Maldonado, took as their own the marriage vow "till death do us part." "Forever," in this alternate reading, represents neither a will to eternity nor an immutable biogenetic connection, but rather the outcome of the day-to-day interactions that organize a relationship. Only in retrospect can a set number of years be attached to a relationship in order to assert its legitimacy as a form of kinship. Only with hindsight and the passage of time can such a bond be termed "lasting." In this transformation of the dominant biogenetic paradigm for kinship, permanence in a relationship is no longer ascribed ("blood is blood"), but produced.

When all is said and done, are these "new family forms" simply old-fashioned institutions in queer clothing? To the extent that questions of transience and permanence organize discussions about chosen families, gay kinship ideologies do appear to stake their claims on the terrain of a dominant discourse on kinship. After all, one can imagine other possible constructions: an open-minded curiosity regarding what will come to pass rather than a value placed on accumulating years, or discussions of relationships in which a time orientation hardly figures. Gay kinship ideologies recreate an authenticating vision of social ties each time they bring forward evidence to demonstrate enduring solidarity or argue that what perseveres is "real" (if not everlasting) kinship.

Yet gay kinship ideologies represent neither a simple case of assimilation into the dominant discourse nor an "alternative" ideology that breaks completely with the terms of a biogenetic paradigm for kinship. Shifts in the *concept* of time embedded in gay kinship ideologies emerged from developments in *historical* time that associated sexual identity with a particular mode of organizing a family and labeled the latter "gay."[22] The very process of contending for the legitimacy of chosen kin tended to introduce subtle changes into the notion of enduring solidarity. Even as gay kinship ideologies built upon prevailing beliefs about what makes a family, they transformed those beliefs by putting duration into forever and persistence into permanence.

Authority, Authenticity, and the Reconstruction of Kinship

A woman lies dying. In a small apartment on 18th Street, the friends Helen Reynolds names family gather around the handmade quilt that covers Helen in her hospital bed. Over the last six months, these have been the ones who carried Helen to the doctors and carried daily sustenance back to Helen. Now, amidst the tubes and medicine jars they hover, speaking softly or not at all, reaching out to grasp Helen's hand or sparing her the effort. Someone risks a joke. Everyone laughs; no one feels like laughing. Sometimes her chosen kin look over at Helen, watching her grow ever smaller in the bed, but increasingly they exchange glances with one another. In and out of the tiny rooms they wander, staring at the walls or the floors, serenading Helen with a haphazard choreography of movement and sound. There is nothing left to do but wander, and hover, and wait.

For all its apparent material substantiality, "biology" has operated within procreative kinship ideologies as a floating signifier of both permanence and authenticity. As Johannes Fabian astutely notes:

> *Kinship*, on the surface one of the most innocent descriptive terms one could imagine, is fraught with temporal connotations. From the early debates on "classificatory" kinship systems to current studies of its *continued* importance in Western society, *kinship* connoted "primordial" ties and origins, hence the special strength, persistence, and meaning attributed to this type of social relation. (1983: 75)

Through the biogenetic paradigm that has constituted kinship and dominated kinship studies, the social relations known as "family ties" have been turned into the "stuff of nature and primitivized" as a procreative, rather than political, arrangement (A. Levy 1989, 1991).[23] Like gender and sexuality, nationality and ethnicity have also been constructed through ideologies of authenticity, first naturalized in the course of attribution by birth, then immobilized to the extent that biological ties continue to be conceived as immutable.

If anthropology has credited "other" societies with timeless traditions, it has simultaneously ascribed to Western societies a cate-

gory of belonging called kinship that places social ties outside time's reach. Yet it is not enough to expose "biological" connection as a culturally contingent mode of reckoning relationships. In Pierre Bourdieu's terms, "Genealogies kill the properly strategic dimension of practices which is related to the existence, at every moment, of uncertainties, indeterminations, if only subjective ones" (1990: 385). After a lifetime of independence, Helen Reynolds initially resisted the efforts of her gay family of friends to supply her with food, medicine, and daily companionship. Bruce Edelman could not have known for certain whether his chosen kin would respond to his call for assistance. Gloria Salcido and Debra Lee saw one another four times before each felt confident that they would find a way to preserve their friendship. Examination of the link between timelessness and authenticity offers one way to place such strategic moves by individual actors in the larger context of the historical and material conditions in which kinship ideologies emerge, challenge the status quo, and change.

In and of itself, nothing about "biological" connection implies permanence, much less ongoing relationship or enduring solidarity. When people in the United States speak of "blood" ties, they do not have in mind the ever-shifting biology of Darwinian evolution or a neurology that has documented the degeneration of nerve cells in the absence of use or a body in which cells are continuously sloughed off and replaced. More commonly, they picture biology as an unchanging "natural" bedrock believed to support superstructures of "culture" and "society." This particular reading of "blood ties" transforms two of life's most evanescent events—death and birth—into foundational episodes that establish kinship. Genealogies forge links between people at the point of procreation, making birth the focal point of alliance and "blood." Only a biological process (death), as opposed to a social process (rejection, neglect), is supposed to be capable of sundering "blood" ties. In this reading, death becomes the terminus that marks attainment of "forever" in a relationship. From mortality and procreation to the perpetual renewal of tissue at the cellular level, biological processes might just as easily constitute a signifi-

er of change and flux rather than continuity and control. Instead, Anglo-European societies historically have pressed birth and death into the service of a permanence supposed to establish authenticity in social relations.

When people enumerate the years a relationship has lasted in order to support a custody claim or explain the classification of friends as kin, they appear to assimilate terms such as "enduring solidarity" directly into their arguments. In this sense the gay kinship ideologies that have emerged during the late twentieth century seemed to stake their claims to legitimacy on the same ground of authenticity occupied by the biogenetic paradigm they seek to displace. But by inverting the cultural logic that links genuineness to endurance (moving from "what's real must last" to "what lasts is real"), these emergent ideologies have produced some unforeseen effects.

Ideologies of authenticity are "about" much more than belonging. In context, authenticity can establish authority to speak, to order, to act, to control. Attributions of permanence obscure power relations by locating relationships outside of time and therefore beyond social intervention. What exists in perpetuity, like what occurs "in nature," appears impossible to contest. Arguing for the enduring character of a relationship can then become a way to assert authority, making kinship a political project in both its scholarly and strategic guises. In contrast, narratives of authenticity that cite persistent (but not timeless) solidarity in relationships reconfigure authority "not as border-patrolling, boundary-engendering, but as meaning-giving" (K. Jones 1991: 123).[24] Rather than attempting to fix the meaning of kinship from the perspective of a lesbian or gay identity, the claim that chosen families are "real" families effectively highlights the indeterminate and ultimately contextually defined meaning of "family" as a category.

Gay kinship ideologies undermine the authority ceded to authenticity even as they utilize its terms precisely *because* they build duration into "forever." Pictured as a steady state, "forever" veils the manufacture of stability in both "biological" and "nonbiological" relationships. In contrast, when "forever" surfaces in discussions of chosen families, it tends to represent not so much

irrevocability as an *intention* to forever that shapes practice and perception. Diane Kunin described herself as gradually "realizing . . . how hard it is to find people that you're really willing to make that kind of commitment to, and who are willing to make it back. And then how hard it is to set it up." Attempting to build a lasting friendship or emphasizing the years that a sexual relationship has endured become part of a process of creating kinship.

Recasting "forever" as a temporal concept is but one possible outcome of claiming a lesbian or gay identity under historically specific conditions. In a situation in which partnerships may appear unstable and "blood" ties can be sundered in response to disclosure of a gay identity, no relationship—not even friend-ship—is taken for granted. Yet in the absence of any axiomatic association of a particular type of social tie with permanence, any-one can "work" to turn a relationship into kinship. Paradoxically, at the very moment gay kinship ideologies conceal the historical context of their own emergence by speaking in timeless fashion of the authenticity of gay families, they democratize the prospects for laying claim to kinship ties.

At stake in the arenas where gay people seek legitimacy for cho-sen families is something more than conflicting values or beliefs or definitions of family. Determinations of who shall count as kin have material as well as social and ideological consequences. When those who contest the authenticity of chosen families ask in fear or exasperation, "Where will it all end?", theirs is not the scholar's concern with the fuzzy boundaries that demarcate social categories, but more often an implicit acknowledgment of a cul-tural link between authenticity and control over valued resources. For the person seeking access to a partner's health insurance plan or input into the treatment of a friend who lies in a coma, how family ties will be determined and what specific reconstructions of kinship will gain legitimacy remain compelling questions. With issues such as these hanging in the balance, it would certainly be premature to raze the forest of kinship studies or condemn ethno-graphers to wander about identifying the "family trees" that con-stitute culturally specific constructions of relatedness.

Although I have focused here on contests of meaning, my

intent is not to move "American kinship" from the study of symbols in the clouds to the study of symbols in the storm. When Tony Paige and I discussed the legitimacy of gay families in a Mission Street café, we unwittingly linked bodies and biology to permanence and authenticity in a way that opened up new possibilities for reconstructing kinship studies as an undertaking that is not only symbolically but also politically, economically, and historically engaged. Ideological conflicts are nothing without the historical and material conditions that give them life. Only after the gay movement encouraged people to risk rejection by coming out to relatives did gay families emerge as a cultural category that highlighted choice and recast "close" friendships as kinship. As the concept of chosen kin undercut the reification of time in procreative constructions of kinship, arguments for the legitimation of gay families drew attention to the everyday activities involved in producing and maintaining relationships. Nowhere was the politics of the definition of kinship more apparent than in the United States of the 1980s, where drastic cuts in government funding of social services resulted in the increasing mediation of subsistence and assistance through categories of "blood" or "marriage."

If contemporary controversies about what makes a family are evaluated within the minoritizing framework of a civil rights model, attempts to authenticate gay families may appear as a bid for inclusion by "a people" historically denied the most basic claims to kinship. Particularly for those who have something to lose if power relations are renegotiated to give lesbians and gay men access to entitlements allocated through families, it is tempting to take refuge in an overly neat and ultimately much too reassuring dichotomy between hegemonic ideologies belonging to "us" under attack by counterhegemonic ideologies assigned to "them." But it is misleading to speak of "gay kinship"—or, for that matter, "biogenetic kinship"—as a freestanding paradigm. This sort of polarization into dominant and subordinate, straight and gay, seriously underestimates the potential of contests of meaning to span sexual identities and other cultural domains. In doing so, it misses all the complexity of social struggle.

Lesbian and gay families cannot be dismissed as a fiction pred-

icated upon a heterosexual model for constituting kinship. Yet they have incorporated prevalent symbols and appeals to authenticity in ways that make it difficult to separate dominant from "alternative" constructions of family. Through paradox and inversion—blood relations are chosen, ties that last create real families—gay kinship ideologies have used common categories to generate uncommon meanings. Sometimes, with ideologies as with relationships that endure, *plus c'est la même chose, plus ça change.* The more things stay the same, the more things change.

made to order

3

family formation and the rhetoric of choice

Hammer meets Sheetrock. Shards of plaster fall to the floor, a domesticated rain. "I need some light and air," is the explanation Evelyn Couch tosses over her shoulder toward her husband Ed's gaping mouth in the movie *Fried Green Tomatoes*. Her next swing carries the sledgehammer through the wall, landing it squarely in the metaphoric space of family relations. Crumbling under the blows is the ossification of yet another marriage. Contact! The everyday sounds of destruction, or is it construction?

Several scenes later, the camera follows Evelyn as she pounds nails into a two-by-four. "Why you putting up this wall where you just tore one down?" asks her now thoroughly perplexed mate. "Ed, you remember how you used to tell me you always wanted two women in your house?" "Yeah," Ed laughs sheepishly. "Well, what if I was the younger of the two?" With this preamble, Evelyn launches into her plan to bring Ninny Threadgoode, a woman Evelyn has befriended at a local nursing home, to live with them. Not exactly thrilled with this disruption of the representational perfection of their little nuclear household, her husband demurs. Ed: "She's an old woman. What if she got sick or something? Who will take care of her?" Evelyn: "I will. I can't leave her in that place." "She's not a stray cat," Ed protests. "Hell, she isn't even family."

Evelyn's unwavering reply: "She's family to me."

During the 1980s and 1990s, the concept of chosen families began to gain currency in the United States. Unlikely political alliances emerged as lesbian/gay/bisexual advocacy groups joined forces with unmarried heterosexuals and senior citizens to back domestic partnership legislation. People went to court to gain custody of children they had raised in the absence of biogenetic connection or legal adoption. These are the decades that whipped up "blended families" from the ingredients of divorce and remarriage, the same years that witnessed a proliferation of nonnuclear forms of residential arrangements and dubbed them postmodern. "Choice" lent an unaccustomed ideological flexibility to so-called new family forms, allowing them to encompass living alone, same-sex partnerships, a combination of "blood" relationships and friendships, even (in the case of one of my students) a cat named Einstein.

In their capacity to accommodate the wants and whimsy of the chooser, chosen families seem made *to order*. They are customized creations that permit tremendous variation in composition and rationale. Their organization appears accountable only to the reflexive question, "Who is family *to me*?"

At the same time, these families are *made* to order, tailored and constrained by culture, economic developments, the historical moment, the state. The ego-centered networks that have characterized gay families are as patterned and predictable in their ego-centeredness as they are individualistic. Likewise, when asked to explain why they consider So-and-So family, people tend to fall back upon culturally standardized (though admittedly polyvalent) categories such as shared experience, love, and closeness. There are reasons other than caprice to explain why, when it comes time to enumerate family relationships, Einstein the cat is in but Angela the goldfish is out. It is also noteworthy that the rise of chosen families has coincided with the decades in which government policies and a restructured economy have shifted the burden of child care, health care, and elder care away from public institutions, back into the privatized space of households and social networks.

In the first sense of order—"your order's up"—reside the extremes of agency; in the second—"come to order"—the extremes of structure. "Social forces" (structure) do not solely determine the shape of these families. Neither do individuals have the power (agency) to dictate the precise form that chosen families will take. In queer families, structure and agency are intertwined.[1] This well-worn point now approaches truism, like the products of many a debate in which polarities have foundered on the rocks of mutual implication.

It is not my purpose here to beat a dead, or at least whimpering, horse by reviving discussions that oppose agency to structure. Instead, I want to investigate a persistent (mis)reading of chosen families as "freely chosen," a reading that tips the scales to the side of agency by collapsing choice into the radical individualism of free will.[2] Interestingly and significantly, this (mis)reading is shared both by advocates of chosen families, who tend to view the idiosyncratic qualities of these family forms as a strength, and by detractors of chosen families, who paint an alarming picture of a society in which the dissolution of "the-family-as-we-know-it" means that "anything goes."

I could begin by arguing the ethnographically obvious: that choices are always constrained, as much socially informed as individually willed. This much said, it remains to examine choice itself as a key category that has circulated in debates about "new family forms." What are its cultural resonances? The circumstances of its deployment? As the transformation of families in the United States has garnered headlines and made its way into the programs of scholarly conferences, three subtle valences attached to choice have come to haunt these discussions. Public debate on the fate of "the family" has cast choice as potentially (1) infinite, (2) random, and (3) bound up with social responsibility. It matters little whether commentators highlight the elements of selectivity in family formation in order to incite fear or to inspire hope. Each valence permeates both negative and positive evaluations of "new family forms," and each has worked to equate the "choice" in chosen families with the unhampered exercise of free will.

For advocates of social change, chosen families seem to offer

infinite, even utopian, possibilities. No longer must kinship sub-
ordinate itself to a single dominant form or remain confined to
"traditional" meanings. Chosen families are supposed to liberate
participants from the bonds of the nuclear family, bringing them
one step closer to a paradise of social relations that, in images
drawn from Christian progressivism, lies just over the next ridge.
In this pluralist vision, a panoply of family forms leaves plenty of
room for differences organized through categories of race, eth-
nicity, class, culture, religion, sexual identity . . . what have you.

Meanwhile, detractors of chosen families look around and cry,
"What next?" They view with alarm changes in the organization of
a kin-ship that, though dragging the anchor of the nuclear fami-
ly, seems to be drifting off into a wider sea of human relations.
What will kinship mean after throwing the question of what makes
a family up for grabs? The downside of the apparently infinite
possibilities that accompany choice is not their only concern. An
individualized conception of choice threatens to introduce a rad-
ical disorganizing principle into social life. Now that "anyone can
be family," critics conjure up the specter of families composed of
attenuated relationships that are randomly or at least eccentrical-
ly chosen. Advocates respond that the lack of prescription
attached to choice offers an opportunity to create flexible family
structures that are responsive to changes in individual needs,
desires, and circumstances.

But doesn't the voluntaristic character of chosen families imply
that whatever relations those families encompass can be easily sev-
ered? Critics are quick to warn that tinkering with "the family" will
affect loyalties and responsibilities customarily organized through
kinship. Advocates mount a defense without questioning the basic
model of chosen families as a collection of freely contracted rela-
tionships. They argue that people in chosen families undertake
only the responsibilities they are prepared to fulfill, out of desire
rather than obligation. Gone is the mandate to extend family ties
that have become "all burdens and restrictions." Gone is the infu-
sion of day-to-day life with the kind of guilt that leads partners to
protest, "Don't 'should' on me." In its place is validation for
already existing relations of reciprocity and obligation that people

have maintained without benefit of social or legal recognition.

Of course, social transformation is never so simple. In practice, chosen families do not disrupt one unified type of family, because diversity in family forms predates the current debates on changes in kinship. Something is changing, but it is not anything so monolithic as "the" family. In practice, too, chosen families have not been characterized by principles of random selection or infinite reconfiguration. Despite the association of choice with consumerism in the United States, people who say they have chosen families do not present researchers with shopping lists of family membership that change daily as they restock the shelves. No one-to-one correspondence links chosen families with extremes of responsibility *or* irresponsibility. And the living arrangements associated with chosen families can be far from utopian. People in chosen families are quite capable of moaning about the electric bill, complaining about friends who don't live up to their expectations of familial behavior, and feeling pressured to extend relationships past the point of ambivalence.

Even when chosen families walk the experimental edge, they do not begin with a blank slate, much less a blank check. Historical developments, material conditions, and complex social negotiations inform apparently individuated choices. What separates "free will" from power and circumstance in the case of the man who acquired a family of caregivers and friends because he lived in an area that lacked publicly funded services for people with AIDS? What does choice mean for the mother who longs to be reunited with her child after serving time in prison, only to learn that the child will not be released from foster care because the one-bedroom apartment the mother can afford does not meet state standards that require children to sleep in a separate room?[3]

There are no neutral juridical subjects in family court.[4] Individuals who choose their families are raced, classed, gendered, and sexualized in specific ways that make a difference for the relationships that result. Even the characterization of chosen families as a "new" family form takes white as its implicit standard by obscuring continuities between, say, friends-as-family among gay people of many colors and the historic practice of recasting

friendship as kinship in poor African-American communities (see Stack 1974). Chosen families look "alternative" only when viewed against the backdrop of that mythic monolith, the nuclear family, in all its Anglo-European, middle-class, and increasingly faded glory (Rapp 1987).

So both proponents and opponents of chosen families evoke a (mis)reading of choice as an unconstrained, individuated, color- and class-blind affair. But there is a paradox here. If choice is nei- ther a guarantor of absolute freedom nor an isolated decision- point emanating from an exercise of pure will, the way the term saturates this debate still testifies to its efficacy as a rhetorical strategy. And once the choice in chosen families is understood *as* a rhetorical strategy, attention shifts to the circumstances that have situated selectivity at the center of discussions of family in the United States. The same category of "choice" that carries meanings of randomness and infinity is itself neither infinitely malleable nor randomly positioned in national debates about latchkey children and family values. Rather than stop short at the observation that choices are always limited, it becomes imperative to trace out the ways in which relations of power operate (ironi- cally enough) to incarcerate people within a rhetoric of choice.

Consider the close bonds that lesbians and gay men often forge as adults, "chosen" relationships they have increasingly cast in familial terms. These ties would not look particularly elective had popular sentiment, the legal system, and a series of historical developments not long ago assigned gay people a social location as exiles from kinship (Weston 1991). In heterosexist representa- tions at their most blatant, queers face the prospect of ending life childless and alone, if AIDS does not get them first. Stereotype pictures them drifting in a socially imposed isolation, caught between the hostility of "blood" relatives who reject their sexuali- ty, and homoerotic relations portrayed as unreliable and fleeting. In the legislatures and the courts, they have fought an uphill bat- tle to retain custody of their children; to gain the most basic visi- tation rights for family members who are ill or imprisoned; and to secure access to entitlements channeled through kinship, such as tax breaks, rent control, and insurance coverage. More informal-

ly, they have struggled to participate in family gatherings on the same basis as their heterosexual siblings.

Despite the contested location of chosen families outside legitimate ways of constructing belonging, the relationships they incorporate are no more or less selective than heterosexual marriage, government-sponsored family planning campaigns, or the carefully pruned family trees that dot the cultural landscape in the United States. This point has not been lost on gay men and lesbians themselves. Many have seized upon the concept of chosen families in their attempts to relocate their relationships within the fold of social respectability. Only after the 1980s brought gay families to national attention would organizers have publicized a demonstration against the homophobic rationale for funding cuts in Cobb County, Georgia, as a "Queer Family Picnic." The same decade lent a twist to the story of the heterosexual woman who phoned to inquire about the health of her granddaughter. "What granddaughter?" came the bemused reply from the woman's 40-something lesbian daughter and her partner. "You know, Ayesha!" the doting grandmother replied, referring to the poodle the lovers had picked out at a local pet store.

Don't let the humor in these examples fool you. Camp has a long legacy among gay men and lesbians as a voice in storytelling and a form of resistance with its deadly serious side (Newton 1979, 1993a). To joke about "my granddaughter the dog" is also to lend legitimacy to the coupled status of Ayesha's proud owners.

Yet the rhetoric of choice is double-edged in its application to lesbian, gay, and bisexual relationships. To the degree that listeners understand choice to be an asocial and ahistoric affair, chosen families resonate uncomfortably with phrases such as "homosexual narcissism" and "your chosen lifestyle" that conservatives have wielded as political weapons. To the degree that listeners reduce agency to a sum of individual whims and wants, they can hear in chosen families echoes of infantilization and lack of accountability, a disconcerting medley of "I Won't Grow Up" and "Don't Fence Me In." In this dichotomous vision, heterosexuals remain the people with "real" family responsibilities and ties that bind. With their chosen families, homosexuals appear free to come and go as they

please. Even the joke about the poodle has overtones of frivolity that can be dangerous in this context.

The bitter irony, of course, is that, far from operating in isolation, many of the people who claim chosen families identify as lesbian, queer, bisexual, or gay in terms that are always and already collectivized. They have not been exiled from kinship for their idiosyncrasies, but for their (thoroughly cultural) identities. Their commitments lose validity (or disappear altogether) only after being refracted through culturally standardized representations of what it means to be gay *and* to choose. The narcissism of "your chosen lifestyle" cannot be reconciled with the altruism of terms such as "unconditional love" that dominate discussions of family life in the United States.

By shielding my choices, my business, from public scrutiny, the rhetoric of choice also constructs a private space. After all, this is America, where people—pardon me, individuals—are supposed to have the freedom to choose, and the freedom to bear the consequences of those choices. But like choice, privacy is a double-edged concept for lesbians and gay men. Criminal prosecution, deportations, and less formal (but no less effective) methods of policing have subjected queers to the double move of enforced privatization and a withholding of the most basic protections of the privacy doctrine. "Why can't you keep it in the bedroom?" is a formulaic question in the country where the *Bowers v. Hardwick* decision handed down by the Supreme Court denied Michael Hardwick the right to have sex in the privacy of his own home. When it comes to custody and immigration cases, families we choose can become families we lose. In a society where coworkers routinely flash pictures of spouses and children, "don't flaunt it" is a strategy of containment, with the state reserving the power to come crashing through the bedroom door.

When lesbian and gay groups fight for recognition of chosen families, they often do so with the sense of making visible something that has heretofore remained hidden from public view. But to cast this struggle as the emergence of privatized, chosen families into the light of day is to frame yet another collective coming-out story: Out of the Shadows II, the Sequel. It is a moment of threat or promise, depending upon one's perspective.

The private space that choice structures requires a public reve-
lation for recognition to ensue at all. What has emerged from
beyond the pale is neither the anarchy and decadence feared by
critics, nor the thoroughly customized configuration of family
relations heralded by supporters. In fact, what has found its way
into the public eye is nothing so coherent as a pre-existing entity
called a gay family. Instead, chosen families have been reconsti-
tuted through the very process of their emergence into public dis-
course.

In the national debate on family values, some commentators
mourned the vanishing family. Like the citified "native," chosen
families had a hard time bearing the burden of nostalgia. The cul-
prit, again, was their apparently infinite variety, their potentially
random composition. In response, some advocates of chosen fam-
ilies sought to render them predictable, even pedestrian. A gay
rights organization funded a billboard near City Hall in San
Francisco that depicted an interracial lesbian couple, one of the
women obviously pregnant, over the caption, "Another tradition-
al family." Look at the two of them, arms around each other, baby
on the way: They appear but a hop, skip, and jump away from the
Nelsons or the Cleavers. "Only" sex and race have changed in this
brave new family portrait.[5]

From media accounts and court cases, a person would think
that gay families are made up exclusively of partners, coresidence,
kids, and commitment ceremonies. One effect of the delicate
negotiation between advocacy groups and the state has been a
narrowing of the possibilities for representation where chosen
families are concerned. Friendships, ties that cross household
lines, multiple coparents—also a part of gay families—rarely
appear in public view. Gay families can end up looking surpris-
ingly like straight families, not necessarily because there is little
difference, but because researchers have taken little account of
how the freedom implicit in the rhetoric of choice solicits reas-
surance that "we" are not all that different from "you."[6]

Likewise with the celebration of family diversity. What image
does an avowedly progressive organization choose—and I use the
word advisedly—to stand in for the diversity of family forms on a

global scale (assuming all the while the transcultural applicability of a term like family)? Take the ad on the back of the Body Shop catalogue that marketed something called "The Year of the Family Soap," designed to commemorate the United Nations declaration of 1994 as the year of the family. What does the politically conscientious consumer receive when her order arrives in the mail? A miniature nuclear grouping, appropriately whited out ("choose" from an amazing range of one color), with gender and age tacitly indicated by the size and positioning of the figures. Mama, Papa, plus two kids. Sound familiar?

Both the billboard and the catalogue advertisement represent as fixed what is actually quite fluid. Both achieve their effects by drawing attention to families that are understood to have been present and fully formed in privatized space all along. In so doing, the advertisements veil their own participation in the process of fixing what can be seen within a rhetoric of choice and legitimation. Girl-girl and guy-guy couples make headlines in right-wing newsletters, legal briefs, and queer publications alike. Friends who consider themselves kin do not. As particular forms, such as families of friends, fail to find a place in these representations, they may begin to lose their appeal—perhaps even their substance—for the lesbians, bisexuals, and gay men who have created them.

By obscuring the processes that privatize and personalize so-called new family forms, the rhetoric of choice has had mixed effects. Here, a wall is torn down; there, another erected in its place. It is the "same" wall, assuredly, but it is more likely to mark a return of the same as different. When Evelyn cordons off a room for Ninny in *Fried Green Tomatoes*, she simultaneously opens up a space for a relationship between the two women within a household where companionate heterosexual marriage has been the only available yardstick to measure frustration and desire. Yet Evelyn's apparently free and independent decision to invite Ninny into her home depends upon factors well beyond Evelyn's control: the economic relations that consign Ninny's house to the wrecking ball, the bleakness of the only other housing alternative available (a nursing home), and the stories in which Ninny shows

Evelyn a way to stand up for herself and start acting like an agent.

It is possible, as Sut Jhally has written, for people to learn too well the lessons that teach them to "live their own domination as freedom" (1989: 67). But it is also possible to arrive at a less individualized, more nuanced understanding of agency in which creativity operates to order as well as disorder, even in the act of appearing to take down the walls. Trowel or sledgehammer, your choice.

production as means,
production as metaphor

<div style="text-align: right;">

4

</div>

women's struggle
to enter the trades

We sat in an open circle on orange plastic chairs, the kind that leaves you eight hours later with a spinal column molded to the seat's contours, rather than the other way around. Our mission? To make book-sense out of the ways that community-based organizations (CBOs) had managed to recruit unprecedented numbers of women into the trades. This 1980 gathering included two women of color from the CBO with the best track record for job placement; an African-American representative from the state, which would fund the publication; and one white woman, a Freedom Rider turned consultant. Two white women if you counted me, the writer hired by the Department of Vocational Education for the project. We had the afternoon to begin to figure out just how these organizations did what they obviously did so well. My job would be to write it all up so that folks from Omaha to San Luis Obispo could build community programs of their own.

Everyone in the room agreed that good money was not enough of a draw to get most women into the trades. What obstacles separated women from the paycheck that skilled blue-collar work could provide? Try, for starters, employment discrimination, union resistance, and the intimidation factor associated with anything unaccustomed or out-of-bounds.

I spent a good part of that first session listening to participants swap tips and stories. Like the one about the woman on a construction site who broke her arm when the male coworker below her on a ladder pulled down her pants. (Was she justified in slamming him with her hammer? Would they file charges? How widespread was the harassment?) Or the guy from

*the business council who was bound to be falling-down drunk by the
time he got to his speech at the upcoming conference on women in the
trades. (What could anyone do about him?) How to translate the dex-
terity required to knit a sweater into the skills needed to wire a switch.
(Check out this skills translation form!) The best employers to contact.
The best places to recruit.*

*The best places to recruit? Someone from the CBO asked whether I
would include lesbian bars on my list of places to hold meetings and dis-
tribute literature. "We get a lot of women that way," she insisted. Heads
nodded. Time for the woman from the state to speak her piece. "I don't
think the Department of Voc Ed is ready for gay liberation," she said,
catching the eyes of the other women with her smile. And that was the end
of that.*

*I never mentioned sexual identity in the book that came out of those
meetings (Weston 1982). Neither did I include direct references to sexu-
ality in "Production as Means, Production as Metaphor," the essay
reprinted below, in which I began to theorize the resistance that women
encountered when they went out looking for blue-collar work. Yet sexu-
ality was critical to efforts to get women into the trades, and everyone sit-
ting in that circle knew it.*

*When I say that sexuality was critical to this endeavor, I mean it not
just in the simplistic sense that many gay-identified women have operat-
ed a cutting torch or turned a wrench for cash. No doubt substantial
numbers—perhaps disproportionate numbers—of lesbians have pursued
blue-collar work over the years, although there are no statistics on the
subject. During the 1970s lesbian-feminism struck up a definite
romance with cabinet-building and carpentry. A running joke of the
period even advised women to take up a trade as a good way to get a
date. Then, as now, there were also lesbians who were interested in the
trades less for the romance, more for the skills or the income. But not only
lesbians. My classes at San Francisco trade schools in the mid-1980s
were filled with women who went home to boyfriends, husbands, or
Harlequins. And for every gay woman in the trades, there were scores of
lesbians who typed or taught or dispensed medicine for a living.
Whatever linked sexuality to employment markets, it was more than a
body count.*

*As important as bodies to the hiring-and-firing process were ideas
about bodies. What made someone appear fit for such-and-such a job?
Which qualities (hardness, steadiness, toughness) was the job in ques-
tion supposed to require? Some employers held onto the idea that compe-
tence means muscles. But what if the muscles on display indexed gym-
built upper-body strength, whereas the task at hand demanded lifting
power in back and calves and thighs? What if a preconceived focus on
muscles eclipsed concern for the blueprint-reading skills that would
ensure the correct routing of ductwork through a building? What if the
ingrained belief that girls don't have muscles meant that the foreman*

couldn't be bothered to look? In the firing and the hiring, ideas about bodies cannot be separated from the materiality of bodies-in-action, bodies-at-rest, workmanship, craftsmanship, unemployment lines and paychecks banked. Reenter sexuality, intertwined with representations of race, age, ability, and class.

So what, besides anecdote and experience, informs the belief that lesbian institutions such as bars offer excellent places to recruit women into the trades? (A belief which, ironically, echoes the sentiments of employers who object to hiring women on the grounds that they're all dykes, and what contractor in his right mind would want one of those on the crew?) Coming into play here is a complex mix of stereotype, opportunity, history, and desire. The negotiation may start with ostensibly color-blind representations: the diesel dyke (who by definition should be able to get that eighteen-wheeler down the road), the motorcycle mama (if she can handle a bike, maybe she can handle a backhoe). Before long, representations slide into color-coded stereotyping of the capacities assigned to bodies: bulldaggers (read: strong, African-American, street, butch), truck drivers (conjure: loud-mouthed, working-class, white), Latina lesbians (wonder: is it my imagination, or did the guy assembling that crew regard darker bodies as more capable, more manly?), Asian-American lesbians (impute: femininity, an inability to do the job). With the significant exception of the latter, many of these stereotyped abstractions collapse lesbian into mannish, masculine, butch.

At issue is a centuries-old, culturally specific association of homosexuality with gender inversion. Needless to say, the search for a manly woman to do a man's job tends to overlook those ladies, gay or straight, who've ditched the fingernails yet kept the ponytails in their quest for blue-collar employment. It completely ignores cultural differences in what counts as "woman's work" or "man's work." It treats Chinese-American butches as an impossibility. Likewise for femmes with biceps, as well as the woman who couldn't get her coworkers to take her heterosexual marriage seriously because to them she was "butch as nails." This particular cultural equation focuses on the one-time tomboy, without a moment's notice for all those nail-pounding tykes who grew up to become secretaries. It encourages heterosexual tradeswomen to signal "femininity" when they tire of people assuming that they're queer. Above all, it cultivates rampant generalization: Surely all lesbians must be butches. Surely every woman with a butch identity feels comfortable and competent in the trades.

An analysis that really hopes to relate sexuality to labor and employment can't afford to stop at the stereotyping. Rumor has it that urban lesbian communities in the United States have offered women the leeway (sometimes the mandate) to experiment with certain forms of gender-bending. What effect might this have on the willingness of gay-identified women to pursue skilled blue-collar jobs? Has this willingness changed over time? Does it make a difference when there's no guy around (and no

money) to fix the washing machine or mow the lawn? What about the impact of historical legacies: the jobs that opened to a range of women during World War II, the positions for Native American women on road crews in rural areas (even if they often found themselves holding flags while the guys rode the big machines)? What about the presumptions embedded in institutional hiring structures, or the cultural/class backgrounds of the people in a position to make the hires?

Through it all, popular "wisdom" remains tremendously influential. Sexuality permeates conjecture about what people go best with what jobs, which qualities come with which girls, and which girls are girls. Think about it the next time you watch someone take out the want ads, make a career change, bring home an annual evaluation, or get steered away from a training program. Think about it when you look for the material on sexuality that has been pushed into the margins in the essay that follows. As you make your own connections, keep one thing in mind: The sexualization of the economy looks to be about as all-consuming in its mediocrity as your average clandestine affair.

The foreman and I had been talking for over twenty minutes. He had reviewed my résumé, noted the training classes in mechanics, verified my three years' experience working on cars, and shown me around the shop. "Just one question," said the man. "How do you check a U-joint?" Easy, I thought. "You put one hand on each side of the joint and twist. If you feel any play, the joint's bad." "Hey," he said, looking me in the eye for the first time, "you really *do* know your stuff!"

The foreman's surprise was genuine, and as he spoke I recalled similar stories told by other women who had applied for jobs in the trades. In the face of a weight of evidence indicating that a woman has the knowledge, skill, and experience to do a job, employers and coworkers still have difficulty believing that she will be *able* to produce. To me, the look on that foreman's face suggested that there was something about the situation which would be glossed rather than explained by concepts like discrimination or lack of gender parity. Gender parity, which describes the numerical ratio of men to women in a given occupational category, cannot explain the persistent references to productive capacity and gendered traits when managers allocate tasks or evaluate performance. Discrimination, for its part, cannot differentiate between blind resistance and shock or disbelief.

The potential for high earnings in the trades has been a major factor motivating women to seek access to so-called nontraditional occupations in a highly sex-segregated job market. But as women have attempted to enter skilled blue-collar jobs, they have come face to face with intertwined notions of gender and production that shape the opposition to their presence on the job site. Production is a cultural category infused with notions about gender, race, age, and class. To make a place for themselves in the trades, women have had to do more than fight for a well-paying job: They have struggled to reconfigure prevailing interpretations of productivity, capability, and competence.[1]

Many feminist scholars have argued that the sexual division of labor lies at the root of sexual inequality, expecting its amelioration to redress inequities and improve women's position in society (e.g., Barrett 1980; Chodorow 1978; Eisenstein 1979). But experience teaches that the sexual division of labor does not simply disappear in the face of exhortations for women to take up carpentry or men to assume their share of child care responsibilities. No more successful is the practice of simply juggling individual men and women from one job category to another, since occupations historically have tended to resegregate along gender lines.[2]

In industrial societies the persistence of a sexual division of labor has been variously attributed to technological innovation, historical circumstance, or self-serving calculation. While many theories of occupational sex segregation invoke culture to explain the form of the sexual division of labor—which particular jobs are allocated to women, which to men—they seldom implicate cultural factors in the perpetuation of that division as a whole. Segregated labor markets are held to be maintained by interests and economic variables predicated on the wider framework of capitalism and the profit motive,[3] or by patriarchy and men's desire to preserve male dominance.[4] Culture enters as a nebulous influence on employer and worker behavior, a residual factor that comes into play only after other motivations have been credited.

Some theories of occupational sex segregation cast gender typing of occupations as a "sexual idiom" that management and workers endorse in pursuit of their (presumably objective) inter-

ests. Others present gender typing as an example of static "beliefs" or "norms," seen as elements of a mythical tradition handed down through generations of male employers and employees. Although the tradition admittedly may change, it does so in an enigmatic manner, identifiable only in retrospect and hardly susceptible to intervention by women who wish to lay claim to "male jobs."

Ideology appears in these arguments as mere rationale or after-the-fact mystification, the icing on the cake of perceived interest.[5] But if this is all that ideology represents, why do male supervisors and workers alike so often invoke gendered traits *in particular* to explain women's historical exclusion from the trades?[6] Surely, it is significant that, when challenged about their resistance to hiring women, the answers male employers most often give to job developers and women applicants are variations of "women can't do the job" and "women don't have what it takes" (Weston 1982). This focus on gendered traits and productive potential suggests that there is far more to the creation of segmented labor markets than the straightforward pursuit of interests, or "divide and conquer" tactics devised by management to maintain control over the labor force.[7]

To treat ideology as a masking idiom or an amalgam of beliefs and norms offers a classic example of what I call "the Culture moves in mysterious ways" approach to social analysis. More challenging is to develop an analysis that grants insight into how the process works. How do individuals bring beliefs into play in social arenas like the workplace, and how do these understandings change? Building better theory will require accounts of workers and employers actively engaged in social give-and-take, rather than patriarchal versions of an ideal-typical "economic man," or a patchwork of explanatory variables whose whole seems to yield less than the sum of its parts (cf. Mason 1984).

Much has been made in anthropology in recent years of how ideology and symbolism are always and already integral to practice.[8] Within the Marxist tradition, Raymond Williams (1977) has formulated a similar critique of the analytic division between structure and superstructure—between economics and culture, if

you will. What has proved more elusive than mounting a theoretical critique has been the challenge of tracing this integration of ideology and action in the ethnographic material provided by everyday life. The "real-world" stakes are enormous: For women in the trades, it can mean the difference between being hired or being terminated, between a substantial or a poverty-level paycheck, between continuous harassment or the establishment of positive relationships with male coworkers.

"Doing your work is not enough," claimed Jessica, a construction worker.

> You do twice as much work. You do twice as well . . . Dealing with [men on the job] is dealing with their ego, and dealing with their ego is like trying to hold a raw egg in your hand without the shell, and still do your work at the same time. But I've got a way with words. I do it.

The tactics women have developed to gain entry to blue-collar occupations and the criteria men invoke to keep women out are part of a process in which actors contest, defend, and transform the cultural meanings that organize work. Understanding why some techniques intended to disrupt the sexual division of labor fall short while others prove effective demands a reexamination of the ways people link notions of gender to productive capacity and articulate gender through activity on the shop floor. What women who cross gender lines in their search for employment discover is nothing so simple as a sexual division of labor, in which men and women merely occupy discrete categories of jobs, but rather *gendered divisions* of labor, in which gender permeates not only the bodies and identities of workers, but production itself.

Background

In the 1970s and early 1980s, California witnessed the emergence of numerous training programs and advocacy groups intended to facilitate women's entry into skilled trades. Over the past decades, these programs have achieved a remarkable degree of success at

placing women from a broad range of racial and class back-
grounds in "traditionally" male blue-collar jobs and apprentice-
ships. In focusing here on community-based initiatives I do not
mean to detract from the importance of governmental and insti-
tutional support for implementing affirmative action during the
same period.[9] Even with federal rulings and regulations in place,
however, the overwhelming number of companies and unions
that dragged their feet on affirmative action encouraged activists
to develop tactics they could deploy effectively at the local level.
The challenge was to develop strategic responses that worked to
get women in the door and, once hired, to retain their hard-won
employment.

From 1978 to 1979 I helped to organize a series of conferences
that brought together Department of Labor personnel, high
school counselors, joint apprenticeship committee members, and
representatives of community organizations, to coordinate efforts
to bring women into the trades. As a writer/consultant for the
California State Department of Vocational Education in 1980, I
interviewed staff from community-based advocacy groups across
the state working to place women in apprenticeships. The infor-
mation collected became the basis for a procedures manual that
outlined paths of entry into skilled blue-collar jobs, offered sug-
gestions for networking with local agencies, and presented strate-
gies for overcoming particular obstacles that women entering the
trades can expect to face. Several years later I participated in a
vocational training program dedicated to placing women and
minorities in skilled blue-collar jobs, while simultaneously com-
pleting a community college course in auto mechanics where I
sometimes felt lost in a sea of male classmates. During this period
I went out on job interviews, talked at length with other students,
visited job sites, and listened to innumerable stories from women
already employed in "nontraditional" jobs. Although this essay
primarily draws on participant observation, I also have incorpo-
rated material from open-ended interviews conducted with job
developers, agency directors, clients of advocacy groups, and
women I met during my year in trade school.

Gender and Production

Managers are concerned with production in the broad sense of "getting the job done." Of course, related objectives like profit, efficiency, and control of the labor force also figure in managerial discourse, but in the context of blue-collar work, productivity remains the concept most frequently invoked when managers evaluate workers and assign them to jobs. In skilled trades, production can be measured in cars serviced, sprinklers installed, and buildings framed—or, alternatively, in the time taken to accomplish any one of these tasks. From this perspective, labor appears as just one of many material resources channeled into the production process. But hiring practices and job structures cannot be so easily quantified. Production is organized not only in terms of labor actually performed (concrete labor), but also in terms of the human qualities managers and coworkers *believe* will contribute to the accomplishment of job tasks.

According to Marx, it is *labor power* (the capacity to perform labor), not the activity of *concrete labor*, that a worker hires out for a period of time in return for a wage. From the worker's point of view, her labor power constitutes a commodity that must be exchanged in order to survive in a capitalist society. From the point of view of the employer, that labor power represents just another element in the means of production, one of many resources required to produce a particular product. Because the labor power purchased by the capitalist must be translated into concrete labor, or labor actually performed, management devises control strategies to extract labor from the worker. If an employer perceives—for whatever reason—that a worker lacks the productive capacity to accomplish certain tasks he will likely refuse to hire her, judging that she will prove of little use to him.[10] In setting up and periodically transforming the production process, what management creates is not a concrete division of labor but a division of labor power, in which jobs and the capacities believed necessary to perform them become reciprocally defined.

What Marx does not explore is the possibility that labor power, in the sense of capacity and capability, is not a neutral term. Our

society describes people in general and job applicants in particular as possessors of inherent "traits" of character and competence—traits that incorporate cultural notions of gender, race, class, age, and what it means to be "able-bodied." In popular discussions of working-class employment, women are often supposed to possess greater "manual dexterity" and "patience" than men, while men are favored with superior "physical strength," "mechanical aptitude," and "aggressiveness." Jobs, in turn, are described in terms of qualities considered necessary to perform them, "requirements" believed intrinsic to the work itself. The hiring process becomes a method of pairing jobs with applicants on the basis of traits "possessed" and traits "required." The gender-typed qualifications sought in job applicants then appear to be a direct outgrowth of occupational demands. All an employer has to do is perform the "impartial" task of matching one to the other.

Consider the cultural opposition between "heavy" and "light" work, terms that carry gendered meanings affecting perceptions of who will be the best candidate for a given job. In a phone conversation, a counselor affiliated with my automotive mechanics program advised me, as a woman, to choose "light-duty" work in a brakes class over a course that would involve handling "heavy" engines. Never having met me, he had no way to assess my physical capabilities; intent on characterizing engines as heavy objects, he ignored the fact that auto engines, which indeed weigh too much for a man or a woman working alone to lift, are removed and replaced with the aid of a hoist. In another case, a supervisor assigned women to do all the tungsten (TIG) welding aboard a ship, despite significant health hazards, because the thin sheets of metal being welded led him to view it as "delicate" work.

Most men who do the hiring in the trades seem convinced that traits do inhere in potential employees, traits they anticipate will translate into successful completion of job tasks. When male managers and workers object to women in skilled blue-collar work, they often appeal to traits grounded in cultural notions of biology and anatomy, along with mental attitudes like "toughness." Women are not as "strong" as men, the most common argument

goes, so they don't belong in the trades because they can't do the work.[11] Even for the occasional employer with some concealed motive for denying women jobs, the voiced objection that gender will limit a woman worker's productivity remains the opening gambit that women must counter to negotiate employment successfully. Such statements define the arena of discourse in which women engage with those who oppose their presence on the job site.

Women themselves are not immune from the cultural equation between male "strength" and "heavy" labor. Knowing this, a counselor for an advocacy group pointedly avoided describing a job as involving the operation of heavy equipment when she announced the opening of operating engineer apprenticeships. Instead, she depicted the work as learning to run "big yellow Tonka toys"— bulldozers, backhoes, and the like. During a similar session, a classified ad that called for "ability to lift fifty pounds" lost much of its power to intimidate after counselors reminded women to look to their own experience rather than to preconceived ideas of their abilities, observing for good measure that several women present had carried "heavy" children into the meeting that day.

Getting in the Door

Persons do not possess gender-typed qualities so much as they use symbols to fashion presentations of self that incorporate gender (Kessler and McKenna 1978). During the application and interviewing process, women work to convince managerial gatekeepers of their capacity to be productive workers. Since applicants rarely receive an opportunity to demonstrate abilities by actually executing tasks, they have learned to deal in indexical relations. Qualities such as courage, aggressiveness, or strength, which describe the type of labor power considered desirable for skilled blue-collar work, represent intangibles that cannot be observed directly. Using the cultural knowledge that traits can be displayed in appearance, women have found it advantageous to assemble "outward" indicators that point to the secrets of qualities pre-

sumed to be locked within the body's musculature and psyche, "in there" where most people in the United States believe the "true self" resides.

Realizing that many women are accustomed to applying for clerical and other "pink-collar" jobs, advocacy groups began to offer a sort of blue-collar dress for success program. When going on an interview, they recommend long-sleeved shirts and bulky sweaters to convey an impression of upper body strength. Women are told to wear work shoes or boots to job sites, intentionally scuffed, sandpapered, or spattered with paint if necessary. They are advised to take along a toolbox even if they don't expect to need it and to make tools look used and dirty, not like they just came off the shelf. Pre-interview roleplaying gives clients an opportunity to develop a firm handshake and a "no-nonsense" attitude. Because "let me see your hands" is not an uncommon request during an interview, some groups encourage women to plunge into manual labor of any sort, even if unrelated to their particular trades.

Each of these nonverbal indicators is intended to signify that the applicant is ready and *able* to work in a blue-collar environment. Implicit is the recognition that employers will base hiring decisions at least in part on their evaluation of productive potential. This evaluation weighs *signs* of ability to do the job, rather than observations of concrete achievements. The point of coaching women in such symbolic presentations is not to get candidates who lack appropriate technical skills or experience past employers. Advocacy groups assess women's work histories, train them in tool use, and may encourage regular workouts at a gym. But the counselors and job developers who staff the organizations understand that it is often a symbolically constituted impression of productive capacity that gets a person the job. Because competence in the trades is so closely identified with traits such as physical strength or mechanical aptitude that are commonly attributed to men, creating an impression of capability remains an uphill battle for women.

To shift attention away from questions of capacity, advocacy groups do everything possible to get women onto a job site where

they will have the opportunity to complete actual assignments. In their contact with foremen and managers, job developers from these groups counter objections by throwing the burden of proof back on the employer: "She can't do the work? How do you know? Have you ever tried hiring a woman? Give me the specifics of what you *think* she can't do. Give her a chance and let her show you!" In the course of challenging the congruence between gender and jobs, these women have effectively redrawn the lines of confrontation, shifting discourse away from metaphorical depictions of productive capacity or labor power, toward an emphasis on the concrete labor necessary to accomplish whatever task is at hand.

On the Job

Given the opportunity to work, women commonly find that managers and coworkers are reassured by demonstrated accomplishment of job tasks. Many men in the trades harbor a sincere concern that women really cannot do the work and will not be able to "pull their own weight." They fear that hiring women will only increase their own workload. Barbara Shaman, an outside machinist, tells the story of how her supervisor assigned one of the biggest guys on the job to help her move something. After her coworker failed to budge the object, Shaman successfully moved it, and he never again questioned her abilities (recounted in Schroedel 1985: 171). Some of the women I met made a point of reminding supervisors and coworkers that they were "just here to do a job," crediting this emphasis on production with stopping harassment in its tracks. Tabling questions of ability while giving center stage to demonstrated accomplishments or time taken to complete a task can resolve doubts about women's capacity to handle "nontraditional" occupations. This tactic attempts to disrupt preconceived links between work and gender by bringing observation and measurement into play. Concrete labor replaces labor power at the heart of discourse on job performance.

The appeal of this strategic separation of ability to work from work performed rests on the expectation that on-the-job achievements will

prove sufficient to refute stereotypes of women's incompetence. The gradual realization that the means of production carry their own metaphors proves disconcerting to women who enter the trades expecting "good work" to be self-evident.[12] Men may ignore success-fully completed job tasks, focusing instead on work yet undone or expectations that are less clearly defined. One woman at the auto school complained of a male tow truck driver on her night job who knew very little about cars. In the field, he repeatedly had to call on her for assistance through the dispatcher. When she arrived he would ask her to analyze the problem, and stand by while she got the industrial jack down from the truck—acknowledged among drivers as the "heaviest" part of the job. Rather than crediting her efforts, he maligned her driving ability, playing on the old saw that women make lousy drivers. Without a wider audience, she found it difficult to make her accomplishments count.

The conceptual links between gendered traits and job require-ments are so powerful that they can influence what men on the job see when they watch a woman work. In the context of an occu-pation like automotive repair, where deadlines are constant, the female-typed trait of patience is considered no virtue. Time and again women mechanics described the experience of having tools literally taken out of their hands by male coworkers who proceed-ed to try this and try that, when a more systematic approach would likely have saved time in the long run. What these women conceived as a calculated troubleshooting procedure could equal-ly well be interpreted as a failure to aggressively tackle the job, an absence of male style, or a patient ineffectiveness. In this way, ide-ologies about women's inability to do the work can become self-confirming.

Perception may defer to meanings that link gender and job per-formance. After several weeks in an auto electrical course, I noticed that the individual labeled the best student by teacher and students alike took longer than many of his classmates to get cars up and running. Little distinguished his results from those obtained by his peers: he traced the same kinds of shorts, using identical equip-ment and equal amounts of connectors and electrical tape. Why was he singled out as a better student? As far as I could ascertain,

this judgment rested on three factors. First, he proceeded without recourse to wiring diagrams, a method that took much longer but which gave him an air of independent initiative and "natural aptitude" for the job. He also shunned customary safety precautions, taking electrical shocks rather than disconnecting the negative battery cable or using the insulated tools available. Finally, he made great shows of physical strength by, for instance, supporting a component with one hand while examining wires located behind it with the other. I must give him credit for a certain ingenuity in this regard, since it is much more difficult to create opportunities for flexing the muscles when working with wires than, say, when removing a transmission.

Many workers in the trades present displays that reference gendered traits in order to affirm their work competence before peers or supervisors. Working without safety gear is supposed to demonstrate courage and toughness, just as exhibitions of force assert a worker's physical strength. Yet these displays are not universally taken as signs of proficiency. One morning the instructor in my auto mechanics class chased a male student out from under a car that was resting on a hydraulic floor jack without safety stands, yelling, "Do you want to die?" The student walked away muttering, "So what if it falls, I'm not afraid. I don't need those things." Similarly, the vocational training class I attended included a number of men who, whenever they encountered a particularly frustrating obstacle to finishing a job, would force bolts until the metal snapped, creating much more time-consuming problems than the ones they were originally attempting to fix. They tended to attribute such occurrences to bad luck or a stubborn fastener, rather than faulty technique and a misplaced emphasis on displays of physical strength. The derogatory term "hammer mechanic" was coined by some men to deride just such attempts to indicate possession of strength through unreflective recourse to force.

Despite occasional disparities in readings of gendered displays, however, the degree to which gendered traits and job descriptions are reflexively defined often leads workers to feel that they must conform stylistically to the notions of gender embedded in their

work. In the trades male workers do many things to look more productive on the floor. I have seen electrician apprentices working on live circuits when they could easily have thrown a circuit breaker, plumbers knowingly sawing through asbestos insulation without so much as a dust mask, tool crib attendants with back trouble lifting great weights when dollies or hand trucks were available.[13] In each case, the procedures followed did not significantly affect the time it took to complete the task. However, the women who witnessed these incidents (some of whom followed suit) believed that a certain disregard for safety and flexing of the muscles were linked to the men's reputation as "hard" workers.

Workers cannot always easily drop the gendered displays they take up at work when they put away their tools and head for home. Many women reported changes in behavior and self-perception after being placed in blue-collar jobs, from "rough" talk and transformed body posture to the newly acquired habit of making a mess and leaving it behind for someone else to clean. "I am a lot more shut down at work than I would even ever dream of wanting to be anywhere else in my life," said a woman doing metal fabrication. "I would never want to be that stone cold type of a person that I am at work." There is general agreement among women in the trades that a woman has to be "tough" to handle the work, not necessarily because job tasks are so demanding, but because they feel they must be able to present male-typed traits in order to satisfy management or head off criticism from coworkers.

After noticing such effects, many tradeswomen resist the pressure to conduct work as a gendered activity. They may question the assertion that the installation of sheet metal ductwork requires strength by arguing that an understanding of leverage will serve to get the job done. They may protest the symbolism of assigning women to small drill presses and men to larger versions of the same machines, though the operations performed on each are identical. They may stage small but creative rebellions, like the woman who riveted wheels to the bottom of her toolbox and pulled it along behind her on a rope, rather than lugging it from place to place in the shop like her male peers. "What's the matter, too much for you?" jeered coworkers when the rolling work station made its

debut. She considered it a personal triumph when wheels appeared under the toolboxes of several men in the months that followed.

Some women ridicule the gendered displays that are intended to show competence. Dolores was a mechanic who had learned her trade as one of the few women in a training program:

> When I took a brake maintenance class . . . years ago, the guys started lifting my tires for me and carrying them across the room. I had to go take them to the tire thing [tire buster], you know. And they came over and picked up the tires (laughs). I did not care. They *were* heavy. But you could have just rolled them over there. I didn't tell them that. They were real stupid. You just turn them on the edge and roll them across! You don't have to think about it. They'd pick them up and *carry* them over!

Pointing to the products of their labor rather than incorporating gendered displays into work routines also allows women to reject the backhanded compliment: "You're as good as/smart as/strong as/fast as a man."

> Oh, sure, you get customers who come in and treat you like you're doing this wonderful thing. And then I feel bad, because I'm doing exactly what I want to be doing in my life . . . and I'm not struggling to be a mechanic . . . So it's kind of embarrassing when people start giving you all these strokes for "doing a man's job," and, "Gee, it must be real hard for you."

As they encounter resistance to the dissociation of demonstrated accomplishment from gendered display, many women come to expect that the struggle will be ongoing.

Attempts to take the gender out of work will inevitably fall short of the utopian goal of establishing objective standards for job performance. It is a testimony to the beauty and the bother of human symbolic capacity that notions of work and ability remain subject to interpretation. Yet strategies that stress accomplishment over display have helped open the trades to women to the extent that such tactics disrupt the presumed correspondence between gendered traits and job requirements, the mesh of gendered meanings which does so much to perpetuate the feeling that women do not "belong" in the skilled blue-collar workplace.

Conclusion

Occupational settings, no less than households and families, are loci for the production and reproduction of gender in the United States. Not surprisingly, then, the dialectical relations linking style to accomplishment and ideology to practice become especially apparent to workers who cross gender lines in their search for employment. Women may struggle to change the workplace, but many have found that if they allow men to define the terms of that struggle by centering discourse on gendered attributes, the workplace will in turn shape them.

Of course, the reasons for women's historical exclusion from skilled trades in the United States are more complex than they may appear from this brief discussion. As individuals, women and men on the job site do not inevitably develop adversarial relationships. Not all women adopt the activist approach of contesting correspondences between gendered traits and job requirements. Some men believe that gendered displays do little to improve speed or productivity, and subscribe to the adage, "Work smart, not hard." The male instructor who chased the student from under the car did not promote hazardous risks to index bravery. Shifting alliances may form along lines of race or ethnicity in addition to gender. Age differences can also become a factor: Some older men, too weary or too wise to carry tires across the room, become as critical of gendered displays as their female coworkers.

Extremely significant in this context are nascent class differences that divide men from one another. To "work smart," to pause for a moment to don safety equipment, to think through a problem before running to the parts shelf or tool chest, all represent work styles that implicitly reconstitute a mental/manual division of labor. In my experience, these styles are more likely to be promoted by supervisors than male workers, suggesting that resistance of male workers to women in the trades may be different in kind from that of their male employers. "Just develop your skills and get your speed up," one foreman advised me. "We can always find an Arnold Schwarzenegger for $3.50 an hour to do

the grunt work." The particular types of gendered displays discussed here would therefore more accurately be described as an assertion of working-class male styles, rather than male style *per se*. It is possible that when working-class men incorporate gendered displays into work routines, they affirm a sort of class solidarity, which women unwittingly threaten to disrupt when they appear to take the side of management by enlisting brains rather than brawn in their approach to job tasks.

These caveats aside, women's efforts to break into the trades over the past twenty years have demonstrated that their power to strategize and to act can indeed have an impact on occupational sex segregation, especially when coordinated with the efforts of community-based advocacy groups. Ultimately, the preconceptions and preferences of men on the job cannot determine women's presence or absence in "nontraditional" occupations. No relationship and no struggle is that one-sided. It has always struck me as curious that men, of whatever class, do most of the acting in neoclassical and even socialist-feminist accounts of occupational sex segregation. Depending upon the theory, any shifts in a given pattern of segregation will be dictated by the preferences of male employers and/or employees, whether those preferences are considered a matter of "taste" or motivated by socioeconomic factors. Women must wait for male employees to search for greener pastures elsewhere, or for the introduction of new technologies like the typewriter, or for wartime to bring about the extenuating circumstances that will allow them to assume "traditionally" male roles (see Davies 1975; Milkman 1982, 1988; Strober 1984; Strober and Arnold 1987). This tendency to underplay women's power to act makes sense only to the extent that the structural explanations for job segregation developed by feminists and Marxists address human capital theories which attribute women's economic troubles to women's "voluntary" choices.

Nevertheless, by viewing actors in isolation and by focusing on male resistance to women's presence, most theories of job segregation have rendered invisible the struggle that has accompanied women's movement into skilled blue-collar occupations. After relying initially on skill and determination to make a place for themselves in

"nontraditional" employment, tradeswomen have gradually discovered that ability and achievement cannot speak for themselves. Over time they have developed strategies to disrupt the impression of superior competence and productivity fostered when workers "show" gendered traits that correspond to gendered job descriptions.

Fighting occupational sex segregation begins by disentangling gendered displays and notions of gendered capacity from labor performed. Far from representing some rhetorical flourish on the outskirts of culture, meaning and metaphor lie at the heart of hiring decisions and production processes (cf. Fernandez 1986). Rather than arguing that women too are strong, that women are tough, that women have been prepared by typing and macrame to be technically inclined, advocacy groups have done their best to get away from discussions of gendered traits. Work can then be redefined to encompass any mode, any style, of accomplishing a given task. Ignore the significance of gendered meanings in the rush to place women in "men's jobs," and shopfloor relations will continue to transform production into a metaphor for maleness.

sexuality, class, and conflict in a lesbian workplace

5

coauthored with lisa b. rofel

Lesbian-feminist discussions of class and conflict have defined class almost exclusively in liberal terms by reducing it to a matter of individual background.[1] "Liberal" in this sense describes not a position on the political spectrum from left to right but a conception of society as a collection of individual actors who make independent choices based on free will alone. These liberal assumptions are not unique to lesbian feminism; indeed, they underlie the dominant world view in American society, with intellectual antecedents far back in the Western tradition (see Eisenstein 1981). As lesbians concerned about recent conflicts in lesbian institutions, we have found that liberal interpretations leave too many questions unanswered about how class affects the way power and privilege are structured in those institutions. Socialist-feminist and Marxist analyses offer valuable criticisms of individualistic approaches to class theory, but are of limited use insofar as they ignore debates about sexuality and sexual identity or assume that sexuality and class constitute discrete levels of oppression (Riddiough 1981).

Our intention in this article is to move toward an integrated theory of class and sexuality that views class as the ongoing production of social relations structured through the division of labor, rather than simply as class background, and that also com-

prehends the significance of lesbian identity as a historical construct affecting social relations in lesbian institutions.

In order to examine these issues in a specific context, we undertook a case study of a recent strike at a lesbian auto repair shop in a metropolitan area with a sizable lesbian community. The study was based on in-depth interviews with eight of the ten women who worked in the shop at the time of the strike, including the two owners.[2] Although this is just one example of the conflicts that have emerged in lesbian institutions in recent years, its dynamics clarify cultural constructs and material relations that operate in larger social processes.

The women we interviewed constitute a fairly diverse group of self-identified lesbians. The different conceptions they have of their lesbian identity are reflected in the labels they choose to describe themselves—"queer," "gay," "dyke," or "lesbian." Some consider themselves feminists; others do not. Some are in long-term relationships with lovers; some are not. Two coparent children. They range in age from mid-twenties to late thirties. They locate their class backgrounds along a continuum from working class to upper-middle class, with both workers and owners at each end of the spectrum. Everyone is white; two of the women are Jewish. For reasons of space, we are unable in this analysis to explore the interconnections among race, ethnicity, class, and sexuality, a topic we believe is crucial for any comprehensive theory of conflict in lesbian institutions.

Although all the women interviewed were willing to be quoted by name, we have chosen to alter their names as well as the name of the business. This strike has generated a certain amount of controversy, and we want to be able to explore the theoretical issues it raises without reducing those issues to the sum of the personalities involved.

History of the Conflict

Amazon Auto Repair was founded in 1978 by two lesbian auto mechanics, Carol and Lauren, with $1,400 in capital from personal savings. Within the first two years, their financial success led

them to hire several more mechanics, who were paid on a commission basis of 50 percent. In the summer of 1981, the owners embarked on a major expansion, raising the total number of employees to eleven. When their clerical worker left in August of that year, both owners went into the office, discontinuing the practice of one owner supervising on the shop floor at all times.

The first overt incident in the conflict occurred about this time when Mary, the parts runner at the bottom of the job hierarchy, refused to stop working on a car in order to get lunch for everyone, as had been her custom. The owners not only insisted that this task was one of her job responsibilities but also added office filing to her duties, a change she resisted. In Mary's view, they also reneged on their earlier promise to make her an apprentice.

When the owners responded to new problems and pressures associated with expansion by tightening shop discipline, conflicts with other employees seemed to escalate as well. Tensions erupted at Christmas when the owners gave each employee a small gift that included a nail brush and chocolate-covered almonds. The workers, insulted by what they regarded as insignificant gifts in place of bonuses, presented the owners with a list of issues and demands calling for continued commissions with a guaranteed base pay of $200 per week, paid sick leave, a paid vacation, and a salaried shop manager. On February 2, 1982, the owners distributed statements rejecting the employees' demands, accompanied by nonnegotiable job descriptions that put everyone on an hourly wage effective the following week. That Friday, the workers asked the owners to postpone implementation of the descriptions and to meet with them in order to discuss salaries, the apprenticeship promised Mary, and other issues.

At this meeting the owners informed their employees they could no longer work at Amazon if they did not sign the job descriptions by 8 A.M. that day. Employees refused and, claiming they felt sick, left the shop. While the owners insist the employees walked out on their jobs, the workers say they were essentially locked out. The workers promptly filed charges of unfair labor practices with the National Labor Relations Board and set up a picket line, successfully turning away much of Amazon's business.

On February 24, the owners offered immediate and uncondi-
tional reinstatement under the old working conditions if the
workers would drop all charges. But contrary to their stated inten-
tions, the owners instituted speedups, set up procedures for sign-
ing in and out, and fired Mary for refusing to do filing. Two days
later the workers went on strike. After picketing for several weeks
with no sign of negotiations resuming, the workers reluctantly
decided to join the Machinists Union and sought other employ-
ment. The owners continue to operate the business with a
reduced staff of new employees. Technically the Amazon conflict
still has not been resolved, but a year after the strike workers have
given up hope of reaching a settlement.

Bridging the Public and Private

The establishment of Amazon as a lesbian workplace challenged
one of the deepest cultural divisions in American society: the split
between private and public life. The very categories "lesbian" and
"work" mirror this dichotomy, since lesbian identity has histori-
cally been defined in terms of the sexual and the personal, where-
as wage work in a capitalist context constitutes the public activity
par excellence.[3] In a homophobic society, any attempt to establish an
institution that links lesbian identity and productive activity
entails—not as a matter of ideological principle but by defini-
tion—a renegotiation of the culturally constructed boundary that
differentiates public and private spheres. To the degree that
Amazon integrated these spheres by hiring lesbians and bringing
them into an environment that encouraged them to be "out" on
the job, it not only provided a space sheltered from the hetero-
sexism of the wider society but also undermined the compart-
mentalization of lives and self that characterizes most workplaces.
Out of this radical potential to create a nonalienating work envi-
ronment emerged an atmosphere of involvement, excitement,
and commitment at Amazon during its early years. An analysis of
the reconciliation of private and public inherent in the project of
a lesbian workplace cannot explain Amazon's ultimate failure to

realize this radical potential. But because sexual and class politics meet at the boundary between personal and public life, such an analysis is crucial for understanding aspects of the Amazon case that resemble conflicts in other lesbian institutions and that distinguish it from more traditional labor disputes.[4]

The measure of what made Amazon a specifically lesbian workplace was not the sexuality of individual employees or the women's music played on the shop floor but the extent to which sexual identity received public affirmation in a place where being a lesbian was the rule rather than the exception.[5] Being out at Amazon was different from "coming out" at a straight workplace because, as one mechanic put it, workers "didn't *have* to talk about being dykes. It was pretty obvious!" Yet, as another woman said, "You could go in and when you're sitting around having lunch you could talk about your family, you could talk about your lover, you could talk about what you did last night. It's real nice to get that out and share that." Conversations at work led to friendships that carried over into the evenings and weekends. Women went to flea markets together, carpooled to work, cooked dinner for one another, and attended each other's sporting events. Lovers were treated as members of the extended Amazon "family" and welcomed into the shop during business hours. One woman's lover acknowledged: "There's nothing like walking into a women's business and being able to walk right up to my lover and kiss her and have lunch with her and have my kids behind me, our kids.[6] But you can't do that in the straight world, you know? It was a real valuable place to be." Friendship spanned all levels of the job hierarchy, weaving together employees' lives inside and outside work.

In a sense, Amazon resembled other small and alternative businesses that foster the development of multiplex ties among employees. Although such businesses often promote an integration of personal and work relationships, the size of an enterprise does not necessarily contribute to a breakdown of the private/public split within the self. The compartmentalization of life in Western industrial societies often leads individuals in public situations to withhold full expression of their feelings, sexuality, and other central aspects of identity regarded as private

(Hartsock 1981). One decisive difference between Amazon and the "straight" businesses that employees mentioned in contrast was the way public and private aspects of the self were united once lesbian identity became linked to productive activity. In attempting to elucidate how lesbian identity shaped social relations at Amazon, we are not asserting that the reconciliation of the cultural dichotomy between public and private is characteristic of lesbian institutions alone. A similar integration may occur in any organization of an oppressed group that explicitly invokes racial, ethnic, gender, or sexual identity to set the institution and its members apart from the dominant society. At the same time, we believe there are factors unique to lesbian institutions that affect the way conflicts are generated and negotiated but that cannot be explored here. These include the effect of same-sex romantic and sexual involvements on work relationships; the possibility that lesbian institutions foster what Audre Lorde (1978a) calls "the power of the erotic," which may contribute to the transformation of alienated labor; and the ways in which lesbian-feminist ideology, the organization of production, and systems of meaning originating in the wider lesbian community interact in the formation of lesbian workplace culture.

A principal effect of structuring Amazon so that lesbians could "be themselves" at work was the integration of emotions into workplace dynamics. "There was far more feeling than there ever is when it's just a cold business situation with men," remembered one owner. The reason was not simply, as she surmised, that women are socialized to express their feelings more freely than are men. Most former Amazon employees emphasized that their present work situations in straight businesses are not as emotional for them. But as a lesbian-identified workplace, Amazon encouraged the women who worked there to bring with them onto the shop floor the entire range of emotions and personal attributes associated with identity in American culture.[7]

Despite the lesbian-feminist principles of Amazon's owners, it is important to remember that this integration of public and private was not the product of a shared ideology. The commitment workers felt to Amazon was developed on the job, not brought to the

workplace from other contexts. Some started their jobs with a 9-to-5 attitude, only to find themselves becoming increasingly involved in what happened during business hours. It would therefore be a mistake to portray the Amazon conflict as a case in which women's unrealistically high expectations for an alternative institution led to disappointment when those expectations could not be met.

When she first came to Amazon from her job in a straight repair shop, one woman said, "I didn't *have* different expectations." But within a month, she was "like a kid in a candy store." It was precisely because working at Amazon had been such a positive, fulfilling experience, said another, that the rift between the owners and workers came as such a shock and a loss: "That's why [leaving Amazon] feels like death. It was part of my life—it was a part of our [family's] life—that would have gone on and on." By December 1981 the excitement of earlier years had given way to feelings of anger and betrayal, feelings so intense that the women involved in the dispute still dream about Amazon a year after the strike. "It hurts more with lesbians," concluded one mechanic, recalling that it had felt as though her whole being were under attack. The hurt was as much a product of the integration of private and public as the fulfillment that preceded it. In most work situations, the compartmentalization of life and self that accompanies alienation also protects individuals from the destructive effects of fixed power inequities (Hartsock 1981). Without that protection, the women at Amazon found themselves particularly vulnerable as tensions began to explode.

When Mary refused to get the mechanics' lunches, her intention was to defend herself against what she regarded as the owners' arbitrary exercise of power. Because she refused on the grounds that this task was a personal favor rather than a job duty, she tacitly reinvoked the private/public split. As the conflict deepened, attempts to reaffirm this distinction assumed a key position in the strategies of both parties. Workers called for a "businesslike" handling of affairs and tried to put their emotions aside. The owners took steps to distance themselves from workers by curtailing friendships and adopting written rules. By the time women were called back to work, the employee phone had been discon-

nected, giving symbolic emphasis to the new segregation of work from personal life.

Even as Amazon's radical potential to provide a nonalienating work environment was being undermined, its distinctive characteristics as a lesbian workplace continued to shape the course of the conflict by focusing the struggle on the division between the private and the public. But with the reaffirmation of the private/public split, many of the special qualities that distinguished Amazon from straight repair shops seemed to disappear. "I'm not in business to be a machine, to be a man, to be something I don't want to be," protested one owner. "This wasn't what we wanted to create," insisted the other. Both sides were left wondering how the conflict could have escalated so quickly, destroying relationships of trust and cooperation built up over three and one-half years.

The Politics of Trust

In the eyes of everyone who worked there, Amazon was built on trust. The owners trace this to their political commitment to lesbian feminism, which fostered a sense that a common lesbian identity would override other differences.[8] Before the February 8 walkout/lockout, neither owner seriously believed a strike could occur at Amazon. They displayed a similar degree of confidence in each other when they elected to go into business without a partnership agreement. For the workers, trust was not so much an outgrowth of ideology as a consequence of the multiplex ties that developed in the workplace. Not all employees identified strongly as feminists or saw themselves engaged in the project of creating a feminist business. But for workers and owners alike, trust was underpinned by friendships and the support Amazon provided for being openly and proudly lesbian.

From the beginning Lauren and Carol stressed that they were the owners, that Amazon was not a collective, and that they reserved the right to make all business decisions. Beyond these ground rules, however, they assumed a basic compatibility between their needs and those of their employees. In accordance

with a feminist ideology that valued being "nurturing" and "supportive," the owners installed a separate phone for employees' use and agreed to flexible scheduling around women's extrawork commitments. The lack of set policy and formalized rules, combined with the owners' efforts not to "act like bosses," made it easy to believe that everyone was equal at Amazon and that trust grounded in the integration of public and private life would constitute a sufficiently radical solution to the problems of oppression women face in other workplaces. But in the absence of a clearly defined business structure, this trust became politicized when owners and workers had to rely on interpersonal relationships to negotiate labor relations from day to day. The emergence of a politics of trust at Amazon points to a conclusion the owners never reached and the workers only gradually realized: The personal can be political, even among lesbians, whenever the personalization of work relations obscures power differentials structured through property relations and the division of labor.

As managers, the owners had the authority to define and evaluate others' needs, transforming what would otherwise have been examples of mutual agreement into instances of benevolence. Even if they had been able to satisfy every request or concede every point raised by employees, control of the business altered the meaning of their actions. What the owners perceived as gifts or favors the workers often saw as customs or rights. It is not surprising, then, that the owners began to get angry when workers stopped asking permission for routine procedures such as leaving early when work was finished for the day. Conversely, the workers' mistrust for the owners developed when Lauren and Carol chose to assert their covert power—for example, when they tried to force Mary to get lunches or do filing. For some workers the strike came to be seen as a fight to create a work environment in which the owners "would not have the power to say one thing and do another thing and change things around" when their decisions could have a major impact on employees' livelihoods.

It was not coincidental that the politics of trust fragmented along class lines, pitting owners/managers against workers. But because such a politics was grounded in interpersonal relation-

ships, it tended to personalize the issues for the women involved, leading them away from a relationally defined class analysis. The politics of trust, rooted in the liberal conception of autonomous selves interacting on a basis of equality, supported interpretations that reduced the conflict to a matter of individual actions, intentions, and capabilities.

The analysis of the conflict favored by the owners was built on a personality/provocateur theory, which held that the strike was instigated either by chronically dissatisfied workers or by someone in league with outside forces interested in destroying a "growing, thriving lesbian business." The owners alternately portrayed the workers as lazy, irresponsible, resentful because of unrequited love, or consciously determined to undermine their business. Power enters into this analysis only in the owners' focus on the individual psychology of certain employees who allegedly were not comfortable accepting authority and so created a strike situation in order to feel some measure of control.[9]

Explanations that ascribe the conflict to static personality traits fail to account for the workers' movement from enthusiasm to anger over time. The provocateur theory provides no better explanation, since it discounts the solidarity maintained by the workers throughout the struggle.[10] To speak of the "mob mentality" that held workers together, or the weakness of character that prevented individuals from standing apart from the group, implies that the workers followed one another like sheep, without legitimate grievances and a clear understanding of their own actions. The owners' preoccupation with the personality/provocateur theory also draws attention away from the possibility that they too might be implicated in the conflict.

The workers were less inclined to reduce the conflict to personalities, insisting instead that "nobody [at Amazon] was a good guy or a bad guy." They learned to distinguish between an individual's particular attitudes or competencies and her standing in the job hierarchy. Rather than defending Mary's actions, they identified broader problems with training and apprenticeship. Rather than attacking Carol's decision to side with Lauren about the lunches, they criticized the division of labor that induced the

owners to take the same position. However, this growing aware-
ness of structural factors underlying the conflict existed along-
side, and in contradiction with, a set of liberal presuppositions
evident in the workers' two most popular explanations for the dis-
pute: the miscommunication theory and the mismanagement
theory.

The miscommunication theory represents the women of
Amazon as equal, rational, independent individuals who came
into conflict only because they misunderstood one another.
Individual interviews clearly show, however, that both sides in the
dispute could accurately reproduce the other's point of view. In
addition, the premises of this theory are invalidated by the power
differential that allowed the owners to set the terms for commu-
nication and to refuse to negotiate with their employees.

The mismanagement theory depicts the owners as incompetent
managers; presumably, if Lauren and Carol had taken a few busi-
ness courses or had acquired more experience running a shop, the
conflict could have been avoided. Although this analysis recog-
nizes the power differential at Amazon, it does not call for a redis-
tribution or redefinition of power, because it shares the owners'
basic assumption that the needs of employers and employees can
always be reconciled. But if we consider needs as historical prod-
ucts tied to a changing division of labor, it becomes apparent that
merely substituting more competent actors or rectifying individual
"mistakes" would not have been sufficient to prevent these needs
from coming into conflict (Heller 1976).

We believe that a class analysis is essential for comprehending the
social, historical, and structural factors shaping the conflict that
these theories ignore. By class we mean the relations of property
and production mediated by the division of labor that separated
the women of Amazon into owners/managers and workers, adding
a dimension of power to personal relationships that politicized
bonds of mutual trust. In our view, material factors like ownership,
the division of labor, and the organization of production are
dynamically interrelated with the production of needs, culture, per-
ceptions, and feelings. Obviously, then, we disagree with those who
interpret class in a narrowly economistic or deterministic sense. The

way in which the public/private split is bridged by linking lesbian identity to productive activity demonstrates that class relations alone cannot explain events at Amazon. But without an understanding of class relations, lesbian feminism remains grounded in the same liberal, individualistic assumptions that originally led the women of Amazon to expect the bonds of trust to prevail over any dissension that could arise.

Class Relations and the Organization of Production

Class relations at Amazon, based on a hierarchical division of labor that enabled two individuals to own the business and maintain the power to define the conditions under which the others would work, shaped the tensions that eventually led to the strike. From the beginning, these tensions were inherent in the organization of production at Amazon, particularly in four key areas: the commission system, job allocations, apprenticeships, and informal job definitions.[11] They surfaced and became the focus of overt conflict only after the owners decided to expand the business and work in the office, creating a dichotomy between mental and manual labor that sharply distinguished owners from workers. In the face of these changes, Lauren and Carol found themselves struggling to defend their prerogatives as owners as their needs increasingly came into contradiction with the needs of their employees.

Carol and Lauren certainly never aspired to be bosses. In establishing Amazon they were motivated not by the desire for profit or the will to exercise power for power's sake but by the vision of working independently and determining the conditions of their own labor. Like many entrepreneurs who open small businesses, they initially hoped to escape the alienation they had experienced in other work situations[12]: "Do we want to work for those creepy lawyers and doctors for the rest of our lives? Or do we want to try to set up something that's ours? It may be a lot of things, but it will at least be ours." The connection Lauren and Carol drew between

ownership and self-determination lay behind their insistence on maintaining control as tensions heightened during the months prior to the strike.

When Carol and Lauren first began to hire mechanics to work under them, they decided to pay them by commission rather than by salary to ensure that the fledgling business would not go in the red. The commission system allowed mechanics a degree of control over their work, an arrangement that neither owner initially regarded as problematic but that later became a key issue in the struggle. Because mechanics were paid not by the hour but for jobs actually completed, they came to feel, as one mechanic phrased it, that "the time we worked there was our time." Some saw themselves more as subcontractors than employees, insisting, "All we were doing, really, was using [the owners'] space and giving them half the money we made." Workers felt not so much a time obligation to Amazon as an obligation to get the work done.

The commission system also tended to give employees a clearer picture of how Amazon made its profit and how much of that profit came from their labor: "We could see how much money they made off of our labor. . . . You doubled everybody's wages and they got it, plus the money they made on parts." This perception of the relation between their work and the business's prosperity fed the workers' sense of outrage when the owners refused to negotiate the terms of the February job descriptions.

The owners' control of job allocations constituted another potential source of conflict. A mechanic's commission-based income was contingent on the availability of work and on whether or not she received time-efficient jobs that matched her skill level. Several workers recalled being the "star" or the "fave" when they first arrived at Amazon only to become the recipients of time-consuming "shit jobs" as newer employees were given preferred assignments. Although not all the mechanics at Amazon experienced favoritism, concentration of the power to allocate jobs in the hands of the owners made the workers equally dependent on Carol's and Lauren's continued good will.

Training and apprenticeship were vital under commission, since specialization in only a few tasks left an apprentice-level

mechanic particularly vulnerable to job-allocation decisions. Without adequate supervision and opportunities to learn new skills, a novice assigned an unfamiliar task lost time and money, as did the more experienced mechanics she turned to for help. At Amazon, apprenticeship was not a formal program but a loosely structured arrangement in which employees were told an owner would be available to assist them when necessary. After the owners moved into the office, however, apprentices were largely left to fend for themselves in what became an increasingly untenable position.

Finally, the informality of job definitions under the politics of trust highlighted the inconsistencies between the owners' feminist ideals and Amazon's actual business structure. The owners promised their parts runner, Mary, that she could become an apprentice as part of their commitment to helping women enter the auto repair trade. At the same time, however, the owners expected her to continue to make herself generally available to meet their needs because she was the only salaried worker below them in the job hierarchy. Without reorganizing the division of labor, the owners never provided the conditions that would have made it possible for Mary to become a mechanic. Nor were the owners willing to relinquish their control over defining the content of workers' jobs, as Mary discovered when she confronted them on this issue.

Because capitalist culture values conceptual work over the "mere" execution of ideas, the mental/manual division between owners and employees that arose in the late summer of 1981 reinforced the owners' power to set the terms for the other women's labor.[13] In practice, this separation meant that the two owners' needs and perceptions became more congruent, and more opposed to those of their employees. One owner noted, "There's always been a kind of an 'us' and a 'them' between the office and the shop," a division that separated even the two owners when they worked in different spheres. "You're in the shop and you see everything from the mechanics' side. You're in the office and you see everything from the customers' side." For Carol, "the one thing that was a big pull for me about both of us being in [the

office] was that we were going to be on the same side."

The way the owners chose to expand the shop and the creation of a mental/manual split deepened class divisions at Amazon and brought underlying tensions to the fore. A heavier work load, tighter scheduling, and a greater number of mechanics meant an increase in work pressures and a decrease in the time available to resolve conflicts as they emerged. As the owners perceived a need to cut overhead and raise productivity, they began to contest accustomed areas of worker self-determination in a general move to tighten up the shop.

Control over mechanics' hours became a matter of controversy once the owners decided to adhere to a strict 8:30-to-5:30 rule. When workers resisted rigid scheduling by arguing that their time was their own under commission, the owners interpreted their defiance as laziness and a lack of commitment to Amazon's success. In the proposed job descriptions, the owners finally decided to replace the commission system with salaries "because that was the only way . . . we could know we were going to get eight hours of work from people." Many mechanics opposed the change because their new salaries were based on individual averages of their previous year's wages, which meant that they would receive the same amount of money annually for working longer hours.

Meanwhile, the owners' preoccupation with office work meant a decline in income for apprentice-level mechanics, who lacked regular supervision. Although the more experienced mechanics were willing to offer their assistance, they nonetheless resented these costly intrusions on their time. The owners rebuffed the workers' suggestion to pay a mechanic to be a lead worker or supervisor, even though the owners previously had compensated themselves for the same responsibility. Problems involving novice mechanics' limited training and narrow specialization were compounded when the owners allocated simple but money-making jobs to a new employee hired in the fall of 1981, who turned out to be on an apprentice level. The other less-experienced mechanic in the shop promptly witnessed a sharp drop in her weekly paycheck as she lost most of the jobs she knew how to do well. Such actions incensed many workers, ultimately leading to their demand for a steady base pay.

Carol and Lauren found themselves in the middle of yet another struggle when what they saw as a need for greater efficiency with expansion led them to oppose Mary's efforts to renegotiate the definition of her job to meet her need for an apprenticeship. By insisting that Mary get the lunches and do the filing, the owners invoked tasks especially symbolic of female subordination. The other workers, disturbed by the way the owners were "jerking Mary around," made her right to an apprenticeship a major issue as the strike developed.

With tensions mounting, workers saw their Christmas presents as the "last straw." The owners still find it incomprehensible that the workers organized over such a seemingly trivial issue, largely because the owners fail to recognize the symbolic meaning of those presents. Since Christmas bonuses traditionally serve as a statement of evaluation from employers, these token gifts were taken as a "slap in the face" of the workers' commitment to Amazon. The gifts had economic as well as ideological significance, since they were associated with the owners' decision to close the shop for a week, leaving the workers with no income, no Christmas bonus, and, according to employees, no respect. Because the owners were now so clearly treating the other women not as friends and equals but as employees, the Christmas presents symbolized the demise of the politics of trust by marking the class division that later would separate the two sides in the dispute.

Paradigm Shifting: From the Politics of Trust to the Politics of Contract

As the politics of trust began to disintegrate, the women of Amazon adopted an opposing symbolic paradigm, what we term the politics of contract. It represented an alternative mode of negotiating labor relations in which owners and workers ideally would bargain to agree on a business structure made explicit through written job descriptions and set policies. Although this formulation appears neutral from the standpoint of gender and

sexual identity, the women at Amazon came to favor it precisely because the two paradigms of contract and trust were relationally defined by incorporating popular—and opposed—notions of male and female.[14] Although the women at Amazon did not consciously define themselves in relation to men, their understanding of a lesbian business as an "all-giving, all-nurturing, endlessly supportive" institution carried an implicit contrast with the "cold, unfeeling" world of heterosexual male business, where decisions were held to be determined legalistically without regard for workers' needs.[15] Because the categories of "female" and "male" seem to exhaust the range of possible gender attributes in American society, the link between these categories and the two contrasting paradigms made those paradigms appear to be the only conceivable options for conducting labor relations. When the politics of trust proved inadequate, the politics of contract provided a readily available model sanctioned by the dominant society for attempting to settle the growing differences between workers and owners.

Both paradigms obscured class relations within Amazon. Under the politics of trust, the owners had asserted that Amazon was a non-oppressive environment by definition because it provided a haven from the "real world" where women have to "put up with crap from men." This belief allowed them to argue that any woman dissatisfied with working conditions should "go be with the boys," which had the double effect of augmenting their power and suppressing worker initiatives for change. At the same time, industry standards implicit in the contrast between Amazon and the straight male business world could be selectively invoked to justify practices such as paying the parts runner a minimal salary.

The owners' shift toward a politics of contract came in the wake of expansion. In light of their new concern with raising productivity and decreasing overhead, the owners began to perceive their employees as taking advantage of Amazon's loose structure. The institution of a written policy in October marked the owners' first attempt to establish a more structured work environment. To the owners, this deliberate decision to "act like bosses" meant abandoning the ideals of nurturance and sensitivity they associated with lesbian-feminist entrepreneurs to assume the straight male-

identified role of a "wrist-slapping disciplinarian." By the time
they handed out job descriptions in the form of ultimatums, they
had come to see themselves as "behaving maybe the way boys do
when . . . they say, 'This is it. Either you do it or you're not here.'"

The workers also came to accept the framework of the politics
of contract in their interactions with the owners, but for very dif-
ferent reasons. Workers began to press for job descriptions,
monthly shop meetings, and more specific policies in order to
protect themselves against what they regarded as arbitrary asser-
tions of managerial power. The formal presentation of a list of
issues and demands represented their attempt to "depersonalize
[the situation at Amazon] and make it a business thing."

Because the politics of contract was identified with a combina-
tion of formality and male gender attributes, the women of
Amazon began to belittle emotional reactions to the growing con-
flict as responses typical of women but inappropriate to busi-
nesslike conduct. In the process, they unknowingly rejected one
of the most positive aspects of lesbian workplace culture: the inte-
gration of public and private that encourages bringing the whole
self, including feelings, into work. Workers criticized the owners
for responding "on this real emotional level to our demands,
about how we were insulting their intelligence and honor."
Meanwhile, the owners dismissed the strike as lacking substantive
issues by referring to the emotional weight behind workers'
actions. Maintaining the bridge between the private and public
would have allowed both sides to acknowledge the intensity of
feeling surrounding the dispute without separating emotions
from more tangible bread-and-butter issues. Instead, the women
at Amazon redrew the private/public boundary by shifting to a
paradigm identified solely with the public sphere.

No one at Amazon was satisfied with the character of labor rela-
tions under the politics of contract, but the dualistic definition of
the two paradigms made contractual relations seem to be the only
possible substitute for relations based on friendship and trust.
Since both sides viewed the loose structure and informal manage-
rial style associated with the politics of trust as the source of the
conflicts at Amazon, both initially expected a shift to a more for-

malized business structure to resolve their differences. While some workers continued to hope for a consensual settlement, others began to understand the conflict as a power struggle rooted in the division of labor that would not be resolved by the establishment of a set policy. Implicit in the struggle over job descriptions was the recognition that measures intended to protect workers could also be used by the owners to maintain control. Workers who once had argued against the commission system opposed conversion to salary on the grounds that an hourly wage would "give [the owners] too much power" by allowing them to regulate employees' hours and subject workers to arbitrary requests.

Despite their growing awareness of the implications of the power differential at Amazon, workers believed the dispute could be resolved within the existing class structure. Yet the issues they raised posed a tacit challenge to relations of production that concentrated decision-making power in the owners' hands. This seeming paradox rests on the fact that, to the degree the workers' stand encompassed a claim to self-determination, their concerns could not have been adequately addressed while class relations at Amazon remained unaltered. Ownership never became an articulated issue, largely because the workers were tactically and philosophically committed to a politics of contract that limited their proposals to discrete, point-by-point demands.

Frustration with the restrictions of a bargaining procedure derived from male trade unionism led the workers to search for a "different way" to approach the owners, but their efforts to break through the paradigms that framed their struggle were unsuccessful. They failed in part because the shift from a politics of trust to a politics of contract focused discussions on questions of work discipline and managerial style. The deeper questions concerning ownership and the division of labor at Amazon, which were mediated by notions of gender and sexual identity, could not be addressed within the terms of either paradigm. The final irony was that the configuration of class relations at the heart of the Amazon conflict was never questioned as being incongruous in a lesbian institution but was instead uncritically adopted from the straight male world.

Lesbian Identity in the Formation
of a Workers' Alliance

The radical potential created with the bridging of the private and public was not completely destroyed by the elaboration of class relations and the emergence of open conflict at Amazon. The commitment that accompanied the integration of personal and work life had the radicalizing effect of motivating workers to struggle against what they perceived to be unfair labor practices. The unusually high degree of solidarity maintained by the workers throughout this struggle also had its roots in the kind of workplace Amazon was before the strike. Solidarity among workers was not a deterministic consequence of their being lesbians *per se*, but an outgrowth of a social context that allowed them to be out on the job in a lesbian-identified institution. Any analysis that reduced events at Amazon to a class conflict without taking these distinguishing features into consideration would miss the dynamics that turned a situation of contention and contradiction into a full-blown labor dispute.

The workers' radicalization was gradual. In the beginning, one mechanic commented, "We weren't a political force; we were just a bunch of women working." Concern about working conditions led them to meet as a group, but class and politics were not explicit topics at these initial meetings. At first women simply compared their reactions to incidents at work, breaking through the silence surrounding grievances that had kept individuals believing they were the only ones angered and confused by the owners' actions. As workers found their personal experiences confirmed by the experiences of others, they began to discuss the possibility of collective action.

Paradoxically, the same bonds of trust and friendship that made it difficult for many workers to break with the owners also stimulated their willingness to challenge the owners' position. Because the politics of trust masked power inequalities at Amazon, it had encouraged workers to consider all points negotiable and to believe they could ask for whatever seemed "fair" and "reasonable" according to their own needs. When the owners met their list of issues with a set of nonnegotiable job descrip-

tions, the workers' fundamental point of unity became an agreement not to accept the job descriptions in the form of ultimatums.

The workers' ability to achieve and maintain such solidarity is all the more remarkable given the diversity of the group and the differences in their politics. But the foundation for the collective structure that enabled them to mediate their disagreements had already been laid by the patterns of cooperation and strong emotional ties the women had developed by working together in the shop. Workers referred to this sense of camaraderie and closeness to explain what differentiated Amazon from a shop employing straight women, suggesting that these patterns were a product of lesbian workplace culture rather than a composite of individuated ties: "Everybody was a tight group at Amazon. . . . You've got all these dykes! [The owners] used to be a part of that when we were smaller, but then we started getting bigger and everybody had different needs, and so it was 'us' and 'them.' Unfortunately it had to come to that. But we were all pretty grouped emotionally before this stuff came up, so that we were all grouped in battle."

The workers' alliance was based on the synthesis of lesbian identity and a growing awareness of class divisions tied to the division of labor. On the one hand, the women clearly interpreted the conflict as a labor dispute and took a stand based on their needs as workers. On the other hand, they directed their appeals primarily to other lesbians and selected their tactics with the aim of keeping the struggle within the lesbian community.

Sensitivity to stereotypes about lesbians' pugnacity and women's alleged incompetence in business affairs made the workers deliberately protective of Amazon at the gay/straight boundary. Workers consistently refused to address the general public or what they considered the "straight media." They turned to the National Labor Relations Board as a last resort in order to keep the owners' job proposals from taking effect as contracts. Workers reluctantly agreed to bring in the "big boys" from the union only after they felt they had exhausted alternatives within the lesbian community and faced the possibility of having to abandon the strike effort altogether. Today, the union's failure to make progress toward a settlement seems to confirm the workers' original skepticism

about the union's commitment to the Amazon struggle and its ability to comprehend the concerns of a lesbian shop.

Stanley Aronowitz (1981) has argued that the most significant innovations in recent social theory have come from movements like feminism that have grown up outside the traditional boundaries of Marxist and trade unionist politics. Because strictly economic disputes appear to have lost their subversive potential under advanced capitalist conditions, Aronowitz predicts that questions raised by what he calls "cultural movements" will become the new focus of historical change. Events at Amazon seem to corroborate both hypotheses. However, Aronowitz's thesis is qualified by the fact that lesbian workplaces represent a historically unprecedented form of organizing productive relations that cannot be adequately comprehended by a notion of culture set apart from economic factors. The culture that has emerged in institutions like Amazon is not a simple reflection of lesbian-feminist principles but results in part from the bridge between the public and private spheres created by bringing together in practice the hitherto ideologically opposed categories of labor and sexuality. In the Amazon case, the development of a lesbian workplace culture united workers in a struggle that encompassed both economic and cultural concerns. In this sense, the Amazon conflict challenges socialist-feminist theory to grapple with issues of sexuality, and urges lesbian-feminist theory to move beyond its focus on sexuality and its legacy of liberal assumptions, in order to develop an analysis of class relations in lesbian contexts.

Conclusion: Class and Sexuality

Why has an ongoing dialogue about class comparable to the current discussion of race and racism failed to emerge within lesbian feminism? The Amazon case draws attention to several contributing factors: (1) the limited interpretation of class as class background favored by lesbian feminists; (2) liberal strains in lesbian-feminist theory that discourage a relational analysis of class focusing on social structure; (3) the institutional hegemony of an entrepreneurial and professional stratum within the lesbian

community; and (4) the heterosexual bias of socialist and social-ist-feminist approaches to class theory, which limits their applica-bility to lesbians.

Information on individuals' class backgrounds clearly cannot explain events at Amazon, for women from both middle-class and working-class backgrounds allied on opposite sides of the dispute. "It would be so much easier, in a way," observed the owner who grew up in a working-class household, "if Lauren and I were both upper class and my father gave me $50,000 and her father gave her $60,000, and we plunked it into the bank and started the busi-ness . . . but it's not that simple." To claim that class background does not determine present behavior does not mean it did not influence decisions made and strategies adopted during the con-flict. For example, the limited resources available to workers from certain class backgrounds made it more difficult for them to remain out on strike. In general, however, Amazon's employees had a clear sense that their current position in the relations of production outweighed their varied class backgrounds: "We all knew where we came from, but we all were working, and we knew how hard we worked, and we knew how we were getting treated. When you're a worker, you're a worker."

A background interpretation of class has led most lesbian femi-nists to define class according to individualized criteria like occupa-tion, income level, education, values, attitudes, and other indicators of socioeconomic status. While these attributes may be linked to class, they do not define class, unless one accepts the liberal view of society as an amalgam of autonomous actors fixed in absolute class positions. On the basis of occupation, all the women at Amazon could be labeled working class because of their blue-collar trade. If a combination of income and educational attainment were used as a gauge, some workers might be assigned a higher class position than the owners. Aside from the mutual inconsistency of these evalua-tions, neither offers any insight into the relations of class and power that actively shaped the Amazon conflict (see Giddens 1982). In contrast, placing the owners within the context of the job hierarchy at Amazon and the division of labor that structures ownership in society at large allowed us to explore the power differential that put

Lauren and Carol in a position of dominance over other women working in the shop.

A relational analysis of events at Amazon supports the conclusion that, since property relations and the division of labor continuously generate class divisions, tactics of consciousness raising and moral exhortations to eliminate classism will be insufficient to keep conflicts from emerging in lesbian and feminist institutions. The expectation that "feminist morality" or a principled politics can mitigate class differences rests on a notion of politics as an individualized, ideological stance adopted at will, independent of material circumstances and capable of transcending them. But at Amazon, differences in the values and political commitments of the owners did not prevent them from taking the same side in the dispute once lines were drawn. Lauren felt "morally justified" in presenting the workers with nonnegotiable job descriptions, never realizing the extent to which she defined morality and "responsible action" with regard to the needs of the business. Carol, on the other hand, found it "bizarre to be on the side of the owner. It's so much easier for me to think of it from the workers' standpoint." Yet she held to her position.

The owners both supported the principle of solving Amazon's problems through dialogue rather than by firing dissenting employees, yet in the end their power as owners and managers allowed them to abandon this ideal. In Carol's words, "Somebody reached the point where they put their foot down and said, 'That's it.' And you can only do that when you are in the powered position, which we were." Both owners admitted having discussed strategy about the possibility of an employee walkout in response to their job descriptions: "We did discuss it. We said, 'If that happens, the two of us built this from nothing. Now we have the books, we have the diagnostic equipment, we have the customers, we got the building, we're way ahead.'"

In the workers' eyes, control of the property associated with the business gave the owners a decisive advantage during the struggle. When economic necessity forced the workers to drop the picket line to look for other jobs, the prospect of negotiation receded as the owners continued production in the building all ten women

had shared before the strike. Since the owners established Amazon with minimal capital investment and took out few loans in the succeeding years, the property and equipment that helped them win the struggle actually came from surplus value created by the combined efforts of Amazon's employees and nonpartisan support from the women's community. The owners' exclusive claim to this property was based solely on a legal concept of ownership backed by a patriarchal state. The same principle of ownership underpinned the dominant class position that structured the owners' moral stance, neutralized their well-meaning intentions, and superseded their lesbian-feminist politics at the point of conflict.

It is true that Amazon is "not Bechtel" (a major multinational corporation), as the owners were quick to point out, but this fact obviously did not prevent class relations and a class-linked conflict from emerging in the shop. Although the lesbian community lies well outside the mainstream of American capitalism, it does include a stratum of entrepreneurs, professionals, and small capitalists like Carol and Lauren who own or control many of the institutions serving and symbolizing that community. We suggest that in practice such control allowed this group of women to maintain an institutional hegemony that mediates the relation of lesbian identity to community in ways that alternately support and oppress lesbians who stand in different relations to the social division of labor.[16]

The concern with self-reliance and independence that originally led Carol and Lauren to become entrepreneurs also informed their argument that dissatisfied workers should open their own enterprises rather than challenge the owners' right to make unilateral decisions in matters affecting employees.[17] Yet what might otherwise be dismissed as regressive, petty-bourgeois values in the tradition of nineteenth-century entrepreneurial capitalism has different meaning, origin, and political significance in this lesbian context. For Lauren and Carol, self-sufficiency represented a liberating ideology that signified autonomy from men in the area of skills, training, and the ability to earn an equitable income. The same ideology became oppressive only when, as owners and employers, they confused self-

determination with the need to control the labor of the women they hired.

The coincidence of entrepreneurial values with aspects of lesbian identity in the ideology of self-sufficiency is one more example of the recurrent theme in this study: There is no justification at the level of concrete analysis for abstracting class from sexuality or for treating heterosexism and class hegemony as two distinct types of oppression operating along separate axes. The strike at Amazon cannot be analyzed as a textbook labor conflict precisely because the male and heterosexist bias of most scholarly texts renders them incapable of grasping this integration. While a critique of the bias in class theory is beyond the scope of this paper, the Amazon case indicates why such an integration is necessary.

Lesbians are not simply exceptions to the rule who defy categorization as "nonattached" or "single" (but presumably self-supporting) women or as women residing in households without men.[18] Since most self-identified lesbians in American society expect to support themselves financially, the question of derived class becomes largely irrelevant in speaking of lesbian relationships (West 1978). None of the women in the Amazon study even suggested the possibility of defining her class position through her lover, though several were in relationships of long standing. Lesbians also fall outside the theoretical focus of most debates in socialist feminism, which tend to center on the sexual division of labor.[19] Although the sexual division of labor and job segregation by sex influence all women's experience, for most lesbians gender distinctions do not coincide with the split between home and work life or with the allocation of tasks within the home. When the split between personal and work life is linked to sexuality with the bridging of the private/public split in lesbian workplaces, socialist feminism proffers no theory capable of grasping the significance of what happens once lesbian identity is joined to productive activity.

At Amazon we saw how the reconciliation of the public and private created the potential for a nonalienating work environment where women were able to develop close ties with coworkers as well as to bring into the shop emotions and other ostensibly personal

aspects of the self. After the walkout/lockout, this integration shaped the dispute by placing emotions at the center of the struggle so that at various points the struggle itself involved drawing and redrawing the boundary between elements of public and private life. While the bridging of the private/public split could not defuse class relations at Amazon, it generated the conditions for overcoming class divisions by fostering a lesbian workplace culture that promoted solidarity among the workers and motivated them to defend their needs in a situation where the owners held the balance of power.

One of Amazon's owners ended her interview with a plea that lesbians learn to "put aside personal feelings and vested interests" or risk the destruction of community institutions. A careful analysis of the Amazon dispute points to the importance of taking personal feelings into account rather than putting them aside and remaining within the limitations of the contrasting paradigms of trust and contract. The effect of suppressing or ignoring the personal will be to reinvoke the division between the private and public, when the ability to bridge that gap constitutes one of the greatest strengths of lesbian institutions. In this sense, the experience of the women of Amazon Auto Repair challenges both lesbian feminism and socialist feminism to break through old paradigms, to recognize that separating sexuality and class in the theory merely replicates the segregation of the private from the public, and the personal from the political, in the realm of everyday life.

As for vested interests, they cannot simply be discarded at will, since they have material roots in socially constructed needs mediated by property relations and the division of labor. Yet there exist options for restructuring lesbian workplaces that reject ownership while providing leadership roles, job rotation, procedures for delegating responsibility, shared decision-making processes, and a division of labor that does not rest on a fixed power differential. The radical potential for nonalienated labor created in lesbian workplaces invites us to explore these alternatives as a means of redefining power as energy, skill, and capacity rather than as domination.[20] By drawing attention to the ongoing reproduction of class relations within the lesbian community, the struggle at

Amazon advances the possibility of self-determination inside and outside the labor process for all lesbians, not just for the few who formally or informally control lesbian institutions.

theory, theory,
who's got the theory?

<div style="text-align: right">6</div>

or, why i'm tired of that tired debate

Esther Newton's report about the rumor currently circulating that
"if you do too much queer theory you stop having sex" reminded
me of an interview I once did with an upper-class Anglo man who
had claimed a homosexual identity back in the 1930s.[1] At that
time, he maintained, many people still subscribed to the belief
that masturbation could make you go blind. The question that
incited passionate debate among his peers went something like
this: If masturbation causes blindness, how much can we get away
with before we need glasses?

But is theory something more than a form of intellectual mas-
turbation (perhaps not such a bad thing, when you think about
it)? If a person does queer theory—which may not, after all, turn
out to be such a solitary vice—what is she risking? Separation from
the communities of class and color in which some of us have
grown up? A fall from activism? Or a relatively harmless case of
eyestrain from poring over all those texts?

In his history of theory, David Simpson writes, "Theory has not
yet been blamed for the Gulf War or for the destruction of the
ozone layer, but it may be only a matter of time" (1993: 1). The right
attacks theory via a discourse of political correctness that seeks to
discredit intellectual work and defend hierarchies organized

through categories of sexuality, race, class, and gender. Meanwhile, the left attacks theory as elitist, white, male, part of an academic star system that creates a few of us as celebrities and sits us up here at a plenary to address you. Some social scientists are prepared to cede queer theory to cultural studies and literary criticism. Some queer studies scholars in the humanities charge the social sciences with a lack of theoretical sophistication. A growing contingent of social scientists responds, "Hey, over here! We have theory, too. What about our Hayden Whites, our Pierre Bourdieus? We'll see your Derrida and raise you one."

Then there is the issue of the linguistic accessibility of theoretical texts (jargon, to its detractors). Contrary to popular report, the use of seven-syllable terms whose comprehension requires a certain knowledge base and even translation skills is hardly confined to the humanities. I'm thinking of a colleague in sociology, Suzanne Vaughan, who claimed she never realized how many newly minted words existed in her discipline until she asked someone to sign for a deaf student in one of her courses. She was amazed to discover that the interpreter had to resort to phonetic spellings for every fourth or fifth word. ("Boys and girls, can you spell heteronormativity?")

Taking a pro- or anti-theory position does not automatically align you with the political right or left. Neither does it locate you squarely in the humanities or social sciences. In and of itself, theory is neither subversive nor elitist. It need not be confined to a certain discipline or set of disciplines. It is not by definition raced or classed or gendered in particular ways (although people can do theory in such a way as to make this so).

There is an old—and I believe convincing—argument that most of us theorize a fair amount of the time as we go about the business of living our lives, whether that living involves writing books or painting houses or changing bedpans. We ask how and why the world works as it works, why it does or doesn't change. So the useful question is not whether to do theory (we're already doing it) or who has a monopoly on theory (there's no corner on the market). We all spin our theories, and it can be dangerous to pretend otherwise. The question then becomes: What *kind* of theory do

"we" want to do? And who occupies themselves with which sort of theory?

At this point I'd like to give what I hope will be a productive twist to the debate over queer theory by distinguishing between two ways of doing theory. The first I call *straight theorizing*; the second, *street theorizing*. Straight theorizing is the one most folks recognize and name as theory. It comes complete with references to European philosophers, fancy footnotes, and words that haven't yet made it into my students' college dictionaries. It has the power to seduce and intrigue as well as intimidate. Most of you know it when you see it. Enough said.

Street theorizing is the activity that engages people as they go about their business. The old saying, "Butch on the streets, femme in the sheets," is an example of street theorizing. Postmodern before its time, the adage takes issue with the belief that individuals are gendered and sexualized in one-dimensional ways that they play out with perfect consistency. This bit of everyday wisdom is cognizant of power relations and well acquainted with the notion that turnabout is fair play. It is easy to remember and easy to mobilize, whether to tease, describe, disparage, or philosophize.

Over the past decade queer studies has, ironically enough, pursued a lot of straight theorizing at the expense of street theorizing. As we look to the future, scholars in queer studies need to do more work that bridges the two, regardless of whether they accomplish that research with the tools of the social sciences or the humanities. It should not be such a daunting task, for instance, to integrate materials from anecdotes and interviews and everyday life with theoretical encounters of the footnoted kind. The point is not to treat street theorizing as "raw data" that remains TBE—to be explained—but to approach street theorizing as a wellspring of explanatory devices and rhetorical strategies in its own right.

The other day in the Tucson airport I happened to come across a young boy, Latino, maybe 8 years old. Impatient with waiting, he began marching in circles around the rows of chairs, chanting, "HUP-two-three-four, HUP-two-three-four." After three times round, he would wheel on one foot, shoulder an imaginary gun, stand at attention, call out, "At ease! About face!" and collapse

into his seat, only to jump up and repeat the entire cycle. Nearby passengers flashed him an occasional smile, but after ten minutes of this, his mother ordered, "Sit down, *mijo!*" "But I have to practice so I can get into the army so I can get a college education," he protested, at which point he jumped up and proceeded—"HUP-two-three-four"—with no further interference from his mother.

Now here is a young man who has demonstrated a grasp not only of the class and race relations that make the army a likely avenue for upward mobility, but also of the uses of calling attention to those conditions as a rhetorical strategy that proved quite effective in allowing him to go on with his game. But what rhetorical strategies will queer theory place at his disposal should he grow up to come out, in some sense of the term, only to discover that he has come up in a society that still bans "homosexuals" from the military? How will theoretical moves in queer studies contribute to changing power relations in a society that offers "joining up" as one of the few paths available for him to pursue an education? I leave you with these questions because, as we work to reconfigure the field, it is important to keep in mind that while queers may not recruit, many powerful social institutions do.

lesbian/gay studies in the house of anthropology

As the Roaring Twenties drew to a close, Goldenweiser completed one of the few reviews then written of the sparse anthropological literature on sexuality. Homosexuality appeared midway through his account, in the guise of yet "another *sub rosa* aspect of sex" (1929: 61). *Sub rosa* means literally, under the rose; secret, clandestine, in a way that discourages disclosure. Throughout the first half of the century, most allusions by anthropologists to homosexual behavior remained as veiled in ambiguity and as couched in judgment as were references to homosexuality in the dominant discourse of the surrounding society.

Not until the late 1960s did the anthropological texts destined to become classics in lesbian/gay studies begin to be published. The same sociohistorical conditions that facilitated the development of a gay movement in the United States, combined with the efforts of a hardy few who risked not only censure but their careers, allowed homosexuality to move to the center of scholarly attention. Though the field of lesbian/gay studies in anthropology has been slower to develop than its counterparts in literary studies or history, by the 1990s ethnographic analyses of homosexual behavior and identity, "gender bending," lesbian and gay male communities, transgressive sexual practices, and homosociality were flourishing.

For a field that has been constituted through a set of stigmatized categories derived from Anglo-European societies, achieving legitimacy assumes an added significance. In this context, the inclusion of this essay in a publication such as the *Annual Review of Anthropology* represents an institutionalizing move. At present lesbian/gay studies in anthropology features the unevenness and border conflicts one would expect of any emergent domain of inquiry. Even the terms "field" and "domain" impute a coherence to the publications under review that may be as much an artifact of analysis as a contour of the intellectual terrain. What follows, therefore, is not a comprehensive survey. My purpose here is more focused: to chart presences and absences, critiques and controversies, which affect the potential of lesbian/gay studies to generate the kinds of questions that make people inside and outside anthropology think.

Within the last two decades the analysis of homosexualities and transgendering has become a "*supra rosa*" activity. To the extent that secrecy in the Foucauldian sense is productive rather than simply prohibitive, however, the legacy of silencing continues to shape the field (cf. Long and Borneman 1990). Despite a growing awareness of the limitations of "breaking the silence" as a scholarly project, lesbian/gay studies in anthropology has not been immune to the documentary impulse that brushes aside theory in the rush for "facts," or to a tendency to reify and idealize "traditional" forms of homosexuality in nonindustrial societies. During the field's early years, the rose, as a double signifier of secrecy and romance, set the tone for the efflorescence of scholarship that was to come.

The Data Gatherers

Almost without exception the review articles on same-sex relations, published over decades, lament the lack of ethnographic material on sexuality in general and homosexuality in particular (Carrier 1980; Davis and Whitten 1987; Fitzgerald 1977; Newton 1988; Sonenschein 1966). Westermarck's (1906) turn-of-the-century overview of "Homosexual Love," Cory's (1956) venture into cross-cultural material, and the Human Relations Area Files (HRAF) sur-

vey by Ford and Beach (1951) stand out among the very few broad treatments published before the gay movement. Even the increased production of ethnographic materials with the emergence of lesbian/gay studies in the 1980s can hardly be mistaken for the successful dénouement to a narrative of progressive enlightenment on previously unmentionable topics. Coverage of same-sex sexuality and transgendering remains uneven, for reasons that include willful ignorance, fear of professional repercussions, paucity of documents from earlier periods, and reticence on the part of ethnographers. Today, as in 1906, there remain plenty of "peoples" and places for which no one has asked the relevant questions.

Having identified such glaring lacunae in the anthropological record, the prescribed remedy initially consisted of calls for research and a concentrated effort to "get some data." Many of the scholars working within lesbian/gay studies in anthropology find themselves engaged in a form of *ethnocartography*, looking for evidence of same-sex sexuality and gendered ambiguity in "other" societies. Implicitly framing much of this literature is an old-fashioned empiricist project allied to a hard-won understanding of the sexual politics that continue to target lesbian and gay male relationships in Anglo-European societies. The effects of these voyages of discovery have been mixed, both for the field and its interlocutors.

Just as gay liberation had its roots in the homophile movement and bar culture of preceding decades, so lesbian/gay studies owes its emergence to a series of intellectual developments that prepared the ground for its current expansion. Before ethnographers could set out to remap the globe along the contours of transgendered practices and same-sex sexuality, homosexuality had to become a legitimate object of anthropological inquiry. One prerequisite was the redefinition of homosexuality from a matter of individual pathology (the medical model) to a cultural construct.

Credit for this move from psychological to cultural paradigms of homosexuality has customarily gone to the social constructivist school of the 1970s, represented most prominently by D'Emilio (1983b) in history and McIntosh (1981) and Weeks (1987) in sociology. Anthropologists used these writers and the work of Foucault (1978) to argue that specific cultural contexts shaped the forms, interpretations,

and occasions of homosexual behavior. Some went further, arguing that homosexuality and "sex drive" are social inventions without strict analogs outside Anglo-European societies. Only the occasional writer has taken issue with the findings of social constructivism, usually by marshalling data in support of biologistic explanations for homosexuality (Whitam 1987; Whitam and Dizon 1979; Whitam and Mathy 1986; Wieringa 1989). Vance's (1989, 1991) invaluable commentaries on the uses and misuses of social constructivist arguments are among the most cogent available in any discipline.

Before the social constructivists, the mid-1960s publications of Evelyn Hooker (1965, 1967), a psychologist who used ethnographic methods, were pivotal in directing researchers' attention away from an obsessive search for the "causes" of homosexuality. Hooker found psychological symptoms to be the product of the social stigmatization of homosexuality, rather than a source of "deviance." By looking beyond the individualistic approach embedded in most causal explanations, investigators formulated new questions about how different societies have structured and even "institutionalized" same-sex sexualities.

Within anthropology, another set of antecedents for the social constructivist turn can be found in the culture and personality school. Benedict (1939, 1959) and Mead (1949, 1963) did not dispute the conceptualization of homosexuality as a matter of individual drive or temperament, but they saw some societies as better prepared than others to accommodate this variance. During the 1930s and 1940s, a scattering of other ethnographers such as Landes (1940) and F. E. Williams (1936) added their observations to the small corpus of works that discussed homosexuality at any length. Yet it would be years before the deviance model of homosexuality gave way to a view of same-sex sexuality as patterned, organized by culture-specific categories and occurring at particular cultural sites.

After a hiatus of several decades, a series of foundational works ushered in the contemporary era of lesbian/gay studies. Sonenschein (1966, 1968) "broke the silence" as never before by arguing explicitly for the value of an ethnographic approach to the study of homosexuality. *Mother Camp* (1979), Newton's landmark study of female impersonators, was unparalleled in its day and has

recently experienced a revival among scholars interested in gendered ambiguity. Gayle Rubin's analysis (1975) of the part played by "obligatory heterosexuality" in the production of gender and sexuality is a classic in gender theory. The publication of Herdt's edited collection, *Ritualized Homosexuality in Melanesia* (1993a), and Walter L. Williams's *The Spirit and the Flesh* (1992a) inaugurated a proliferation of work on Melanesia and Native North America, respectively. Blackwood's *Anthropology and Homosexual Behavior* (1986a) (reprinted as *The Many Faces of Homosexuality*) remains among the most useful introductions to the variety of social arrangements studied under the rubric of homosexuality.

Ethnographic treatments of homosexual behavior and identity now range from erotic friendships in Lesotho (Gay 1986) to accounts of Nicaraguan *machistas* who have sex with other men but do not consider themselves homosexuals (Lancaster 1988, 1992). A reader with access to a reasonably well-stocked library can learn about same-sex relations among miners in Southern Africa (Moodie and Sibuyi 1989), Azande "boy marriage" (Evans-Pritchard 1970), butch/femme relationships among lesbians in the United States (Davis and Kennedy 1986, 1989; Faderman 1992; Kennedy and Davis 1993; G. Rubin 1992), marriage resistance by Chinese women (Sankar 1986; Topley 1975), or the formation of gay subcultures outside the West (Allyn 1992; Isaacs and McKendrick 1992). These works join analyses that interrogate the mutable (indeed, indistinguishable) character of anatomical sex and gender, including Bolin's (1987, 1988, 1992) studies of transsexuals and my theoretical discussion of the gendering of lesbian relationships (Weston 1993; see also Bower 1992; Bullough and Bullough 1993; Edgerton 1964; Nanda 1990; Newton 1984; Robertson 1989, 1991, 1992).

Generally less satisfying than these descriptively rich accounts are the transcultural surveys and comparative treatments. The distance between Westermarck's (1906) rudimentary review and Greenberg's massive 1988 compilation represents a leap in terms of material available for review, but merely a hop and a skip away from armchair anthropology in terms of form. In addition to the search for evidence of homosexuality in "other" societies (e.g., Bullough 1976; Opler 1965), several intellectual projects surface in

these studies: *(a)* assessments of the level of "tolerance" or "acceptance" for homosexuality across societies, *(b)* attempts to correlate specific practices or forms of social organization with the presence of transgendering or same-sex sexuality, and *(c)* the development of transcultural typologies of homosexuality. That researchers would pursue the first project is understandable, given the heterosexual presumption that pervades life in the Anglo-European societies into which most of them were born. Unfortunately, a good portion of the studies that fall into the first category rely heavily upon data from early ethnographies and the Human Relations Area Files (HRAF). Researchers have tended to use HRAF data uncritically to portray societies as coherent monoliths that either do or do not tolerate homosexual behavior (e.g., Werner 1979). Because references to homosexuality from both sources are often fragmentary and decontextualized, establishing criteria for assessing tolerance can be difficult and detecting conflicting views in different segments of a society virtually impossible.

Included in the search for correlations across cultures are Herdt's (1989a) attempt to relate the practice of "ritualized homosexuality" in New Guinea to the presence of a boy's father in sleeping arrangements and Whitehead's (1981) attempt to link "gender-crossing" in North American Indian societies with particular modes of generating prestige hierarchies (see also Shepherd 1987). Regardless of their geographic scope, many such studies run roughshod over historical context by grouping contemporary observations with details from earlier periods in order to make generalizations about "transvestism" or same-sex relations in a particular society (e.g., Gray and Ellington 1984; Heimann and Le 1975; Munroe 1980; Munroe, Whiting, and Hally 1969; Winkler 1990). Only the rare scholar, such as Knauft (1990, 1993) in his meticulous tracking of semen exchange and ritual in Melanesia, incorporates historical and comparative material in the reflective, judicious manner that leads to groundbreaking work.

Over the years, a great deal of effort has gone into the development of classificatory frameworks to order the data collected. Greenberg's (1988) sorting of homosexualities into transgenerational, transgenderal, and egalitarian is representative of this

trend. Transgenerational forms, characterized by an age differential between partners and a division of the sexual acts considered appropriate for each, have received renewed attention in recent years with the interdisciplinary expansion of work on Melanesia and ancient Greece. Forms such as American Indian "*berdache*," in which males adopt elements of the dress and activities usually assigned to females (or vice versa), occupy the transgenderal category.[1] With a few controversial exceptions, egalitarian relationships, supposed to feature reciprocity in sex acts and (for some authors) a lack of gendered distinctions between partners, cluster somewhat suspiciously in Anglo-European societies.

More is at stake here than an organizational exercise in the tradition of Linnaeus or a push to arrive at a set of Weberian ideal types. Putting "homosexuality" into the plural represented a breakthrough for Western societies that had consistently reduced homosexuality to a matter of personal preference or individual orientation (cf. Murray 1987b). Positing different forms of same-sex relations also allowed analysts to trace regional patterns and to pose diffusionist questions. For example, are the rare forms of "egalitarian" same-sex relationships described for some New Guinea societies "indigenous," or are they the product of the colonial encounter (Herdt 1993c; Murray 1992; Schneebaum 1988)? At the most general level, all these classificatory schemes assume "homosexuality" as a universal category with readily identifiable variants (Herdt 1991a, 1991b; Jacobs and Roberts 1989).

"Hearing Homosexual Voices"

The ethnocartography of homosexuality, if not homosexuals, in societies across the globe has not yet run its course, but it is beginning to run into the limits faced by any enterprise that seeks data first and asks theoretical questions later. Gayle Rubin's (1975) pioneering work would seem to have given the field an auspicious, theoretically sophisticated start. Yet the field as a whole is characterized still by the absence of theory Blackwood noted in the mid-1980s, despite the recent emergence of a new generation of studies drawing upon

the best of interdisciplinary scholarship. There are exceptions even in the older literature (Blackwood 1986a; Murray 1984), and many an author opens with an obligatory nod to Foucault before presenting research findings, but more commonly, the researcher's theoretical perspectives remain embedded in apparently straightforward reports from the field. In effect, the absence of theory becomes the submersion of theory. Lurking between the lines are functionalist explanations, ethnocentric assumptions, and *ad hoc* syntheses of philosophically incompatible schools of thought.

Nowhere are the effects of inattention to theory more poignantly outlined than in Bolton's discussions of AIDS research in anthropology (1991, 1992). As an ethnographer concerned with a quintessentially "applied" goal, preventing transmission of the Human Immunodeficiency Virus (HIV), Bolton found research questions on AIDS framed in ways that paradoxically hindered investigators from generating data useful for developing prevention strategies. By deconstructing the term "promiscuity" and identifying the potentially fatal drawbacks of its usage in education and research, he was able to reformulate the issues at stake in a manner that combines theoretical rigor with the practical significance inherent in any endeavor to save lives.

In the international arena, the "salvage anthropology" of indigenous homosexualities remains largely insulated from important new theoretical work on postcolonial relations. The story is a familiar one in the annals of the discipline: Well-meaning ethnographers rush out to record "traditional" practices and rituals before the latter change or disappear. At their worst, these efforts repackage colonialist discourse (e.g., "primitive" societies) for consumption by Anglo-European audiences (Bleibtreu-Ehrenberg 1990). At their best, they resurrect the vision of the Noble Savage living in a Noble Society that provides an honored place for at least some forms of transgendering or same-sex sexual activity. A few essays explore the politics of data gathering and document writing (Goldberg 1991; Roscoe 1991, 1991–92). Some apply techniques drawn from history and literary criticism to documents from the colonial period (Goldberg 1991; R. J. Morris 1990; Parker 1991). The majority, however, invoke a static conception of "traditional

cultures" that tends to assume the only "real" social change is the one produced by European interventions. Too often the result is an account unintentionally imbued with Orientalism, exoticism, romanticism.

My renewed call for theory is not intended to minimize the efforts of those who have written descriptive accounts of their experiences in the field or to deny the contribution of their observations. Indeed, there is a need for more fieldwork yet. Despite the accumulation of research sufficient to support the elaboration of typologies, knowledge of transgendering and same-sex sexuality remains fragmentary for many regions. Details are sometimes incidental to a larger study, as with Raymond Kelly's (1976) work on witchcraft or Nisa's remembrances of childhood sex play in her life history (Shostak 1981). Particularly lacking are data on homosexuality and homoeroticism among women outside the United States (Blackwood 1986b). There is still much to document, as long as ethnographers proceed with the understanding that theory is always and already implicit in their documentation.

Without the ethnocartographic moment, little would be known about the incredible variety of settings in which transgendering and same-sex sexuality occur. In a sense, ethnographers have begun to provide answers to the perennial question voiced by heterosexuals in the West: What *do* "they" do (whether in bed or in the bush)? Nevertheless, the incompleteness of this geographic coverage carries its own dangers. When only one or two investigators have studied homosexuality or transgendering in a particular region, it creates a situation in which the lone anthropologist becomes responsible for describing "his/her people." Thus Parker (1987, 1989, 1991, 1992) becomes identified with Brazil, Carrier (1976a, 1976b, 1985, 1989) with Mexico, Herdt (1981, 1982, 1986, 1987a, 1987b, 1989a, 1990b, 1993a, 1993b, 1993c) with the Sambia, and Robertson (1989, 1991, 1992) with Japan. The circumstantial pairing of one or two ethnographers with a particular society has meant that most of the data is configured by the analytic approach the anthropologist in question adopts. If you go to the literature seeking information on the Yellamma cult in India, you will likely come up with a structuralist (as opposed to a historical,

materialist, or postmodernist) account (Bradford 1983). Only in Native North America, Melanesia, and the United States have anthropologists conducted sufficient research to formulate competing interpretations that apply different analytic frameworks to similar phenomena.

Lesbian/gay studies in anthropology is currently going through a transition reminiscent of the shift from the anthropology of women to the anthropology of gender. As the anthropology of women began to come into its own, researchers broke through the confines of a scholarly project focused on the collection of data that would give women a voice previously denied them in ethnographic writing. The move to an anthropology of gender broadened the enterprise from data-gathering to theorizing and from an exclusive focus on women to the study of femininities, masculinities, and male-female relations. Eventually writers began to question the fundamental categories that grounded gender studies. Contemporary feminist debates about whether "woman" constitutes a valid analytic category find their parallel in critiques of the alleged universality of concepts such as homosexual and heterosexual, lesbian and gay, feminine and masculine, and even sexuality itself (cf. Oldenburg 1990).

This ferment has complicated irretrievably the task of gathering data on homosexuality. Making "gay people" visible in the ethnographic literature becomes impossible once one substitutes the theory that gay identity is a Western invention for the belief that "you'll know one when you see one." Breaking the silence about homosexuality becomes equally problematic after scholars begin asking what counts as homosexuality in a transcultural context.

Coming to Terms

"How are you going to define homosexuality? (Glad it's not me!)" These were the sentiments of many a colleague upon learning that I had been commissioned to write a review article on "lesbian and gay ethnography." From the beginning, topics associated with lesbian/gay studies in anthropology have been vexed by vague

and inconsistent usage of terminology. Whether the object of study is Zuni *lhamana* (*"berdache"*) or *hijras* in southern India, scholars must grapple with a plethora of terms historically applied to the phenomenon at hand: homosexual, hermaphrodite, sodomite, transvestite, transsexual, even transgenderite. When it comes to gender, many analysts continue to use "man" and "woman," like "masculine" and "feminine," as though the meanings of these categories were uncontested. For example, portraying male-to-female "crossdressing" as a form of "feminization" perpetuates Western assumptions about the unambiguously binary character of gender. Problems only multiply when a project involves transcultural comparisons.

Most of the terms thrown around so loosely in the past derive from sexology, a discipline that grew up with anthropology in the late nineteenth and early twentieth centuries. Of all the classifications of persons developed by sexology, "the homosexual" has proved among the most enduring. Early writers on homosexuality such as Benedict (1939, 1959), Mead (1949, 1963), and Kroeber (1940) presumed that certain people in any society would possess a presocial homosexual nature which might or might not find a socially acceptable outlet, depending upon the cultural options available (cf. Weinrich and Williams 1991).

Following Foucault's contention that the construction of homosexuality as an essential nature is the relatively recent product of Western history, Weeks (1987) argued for the utility of distinguishing between homosexual identity and homosexual behavior. "Who I am" and "what I do" then become analytically distinct. To say "I am a gay person" assumes the infusion of sexuality into total personhood in a way that might be incomprehensible to someone who touches the genitals of another man or woman in a society without a word for such an action. The experience of going to a gay bar (Achilles 1967; Read 1980) or engaging in lesbian-feminist politics (Dominy 1986; Krieger 1983; Lockard 1986; Wolf 1979) contrasts sharply with the organization of homoeroticism in societies that have not formed "communities" based on sexual identity. To complicate matters, the rise of queer politics in the United States destabilized the concept of a fixed identity (homosexual or

otherwise) even for the Western societies that had generated clas-
sifications such as lesbian and bisexual, bulldagger and sodomite
(Duggan 1992).

In his later writing, Herdt (1991a, 1991b) goes beyond the now
familiar caution against projecting the notion of homosexuality-
as-identity onto "other" societies. Granting homosexuality the sta-
tus of an "it entity" that transcends specific cultural contexts can
quickly become a methodologically problematic enterprise. By
setting out in advance to look for sexuality, the anthropologist
cannot help but reify the object of (ethnographic) desire. It is one
thing to speak of "ritualized homosexuality" in New Guinea; it is
quite another to recast this set of practices as "semen transac-
tions" (Herdt 1993b) or "boy-inseminating rites" (Herdt 1993c).
In the first case, the term "homosexuality" highlights eroticism
and same-sex genital contact. In the alternate phrasings, empha-
sis shifts to exchange relations or ingestion of a substance prized
for its life-inducing properties. Recourse to umbrella terms such
as homosexuality, heterosexuality, or crossdressing can obscure
more than it illuminates.

Writing about multiple genders or homosexualities does not
extricate researchers from this philosophical dilemma, because
these can be nothing more than varieties of something already
assumed to be known or recognizable. The $64,000 question
remains: What is to count as homosexuality, gender, and sexual
activity? Is the Kimam practice of rubbing sperm on young male
bodies for its growth-inducing properties best understood as a
form of "indirect homosexuality" (Gray 1986)? In whose eyes are
such interpretations salient?

One valuable outcome of such methodological critiques has
been a renewed emphasis on the importance of taking into account
context and meaning. Only by recognizing the insufficiency of
behaviorist definitions that rely upon formal properties (e.g., who
puts on what clothing) could investigators set aside the Anglo-
European assumption that sexuality comprises a domain unto itself.
Authors writing about a single society are now more likely to leave
key cultural categories untranslated, allowing meaning to emerge
from the text. In her studies of Oman, for example, Wikan (1977,

1991) employs the indigenous term *xanith* rather than transvestite or transsexual, earlier choices that ignited heated debate.

The abandonment of sexology-inspired universals in favor of local terms is but one instance of the ongoing tension in anthropology between the search for unified versus particular explanations (Herdt 1991a, 1991b; Jacobs and Roberts 1989). Yet the move to employ indigenous categories is no more neutral in its effects than the earlier, less reflective application of "homosexuality" to a multitude of occasions. Although intended as a corrective to ethnocentrism and overgeneralization, the use of "foreign" names constructs the subject of inquiry as always and already Other. Now seemingly without parallel, the *xanith* becomes implicated in a renewed form of Orientalism in which linguistic terms subtly reify differences and buttress ethnographic authority.

In the wake of the deconstruction of homosexuality as an analytic category, the field I have called "lesbian/gay studies in anthropology" looks much more like queer studies than gay studies as conventionally conceived. If lesbian and gay take a fixed sexual identity, or at least a "thing" called homosexuality, as their starting point, queer defines itself by its difference from hegemonic ideologies of gender and sexuality (Duggan 1992). In the West, "crossdressing," butch/femme, and sadomasochism all become queer through contrast with cultural representations that map masculinity and femininity onto genitalia and privilege heterosexual intercourse as "real sex." Like queer studies, ethnography in general takes the hegemonic ideologies of Anglo-European societies as an implicit point of comparison. It is not surprising that the same ethnographers who are reading about male-male sexuality in Brazilian religious sects (Fry 1986) are also reading about transvestism in the Pacific (Hart 1968; Mageo 1992), or that the emergent topics in this field focus on aspects of gendering and sexuality that would be transgressive in an Anglo-European context.

Each of the works reviewed here at least tacitly addresses the (Western) correspondence model of gender/sexuality that assigns anatomical sex a constant gender and a prescribed object of sexual desire. In many cases scholars engage with these issues only to conclude that an apparently transgressive practice is nor-

mative in its cultural context. Others raise the issue of sexuality only to deny its relevance, as Oboler (1980) does when she claims that partners in female-female marriage among the Nandi of Kenya have no sexual contact. I will continue to use the terms homosexuality and transgendering for convenience, but in effect the material covered remains the stuff of queer studies.

While terminological debates are not an end in themselves, the disputes discussed here have complicated lesbian/gay studies in some extremely productive ways. In an important essay, Adam (1986) argues that anthropologists cannot comprehend phenomena commonly glossed as homosexuality by viewing them along the single abstract axis of sexuality. In practice these phenomena are constituted in more complex ways that refract sexuality through classifications of age, kinship, etc. Parker (1991) avoids oversimplified dichotomies by exploring the nuances of an extensive range of Brazilian categories, including slang terms. In his provocative theorization of the relationship between sexuality and the state, Lancaster (1988, 1992) explains why the Nicaraguan *cochón* cannot be reduced to a variant of the North American homosexual, arguing that the division of male partners into subject and object of desire generates different possibilities for community formation and political organizing.

Povinelli (1992) finds that many Australian aborigines who regarded homosexuality negatively when a term such as lesbian, bisexual, or gay was applied to persons continued to accept homoerotic practices incorporated into women's rituals. In contrast, members of the younger generation who had learned to interpret homosexual behavior through the lens of identity tended to be more uncomfortable with the homoerotic elements of ritual. Robert Levy (1971, 1973) and Newton (1979, 1993a) are among the few who consistently distinguish identity from parody, exaggeration, and intensification. They remind readers that the realms of gendering and sexuality can incorporate humor as well as cultural critique (cf. Weston 1993).

Some of the most exciting work dealing with terminology examines the part that categorization plays in the negotiation of power. These analysts replace the positivist question that asks which term is most "accurate" with an interrogation of the contexts giving rise

to disputes about social classification, the effects of those conflicts, and the linguistic strategies adopted by the people involved. In a semiotic analysis of Chicago's gay and lesbian pride parade, Herrell (1992) examines the uses of symbols to create even as they signify community. Ellen Lewin (1990, 1993a) shows how lesbian parents facing the threat of custody litigation work to construct themselves not only as "good mothers," but as women who have successfully "achieved" motherhood. One of the narrators in Herdt's (1990b) discussion of hermaphroditism among the Sambia discusses the advantages of presenting oneself as a member of a third sex (as opposed to "really" male or female). In her analysis of a civil suit brought by a transsexual dismissed from her job as an airline pilot, Bower (1992) examines the ways court proceedings can transform as they attempt to reinstate a binary construction of sex and gender. Goldberg's (1991) insightful essay on Spanish representations of "the native body" following the European invasion of the Americas demonstrates how the ambiguity of a term such as sodomy allowed it to be mobilized for contradictory political ends (genocide, "mirror effects," resistance). Each reminds the reader that no one has a greater stake in the outcome of conflicts over terminology than the people who constitute themselves through and counter to available cultural categories.

Where the Boys Are

However discredited the concept of institutionalized homosexuality now that scholars have problematized the status of homosexuality as a master term, the concept did suggest that societies can routinize and normalize homosexual behavior. Under its auspices ethnographers began to accumulate a critical mass of material with twin regional foci on Melanesia and Native North America. Why these areas in particular have moved to the center of ethnographic attention is a question that merits investigation in its own right. For the present, rather than duplicate existing surveys of so-called ritualized homosexuality in Melanesia and "berdache" (itself no monolith) among North America Indians (Jacobs 1968;

Knauft 1987; Roscoe 1987), I review lines of inquiry in each area that have shaped the field as a whole. In both instances, anthropologists have focused on the process by which young males do or do not grow up to become men.

Over the last decade the literature on same-sex sexuality and masculinities in Melanesia has grown exponentially. Much of the work in this region has followed the psychodynamic and/or symbolic approach of Herdt's seminal research on the Sambia (Baldwin and Baldwin 1989; Gray 1986; R. Kelly 1976; Lidz and Lidz 1986; Schieffelin 1976, 1982). The scattered references in early ethnographies to same-sex genital contact during male initiations have now given way to an understanding of the significance of these rituals for the more general analysis of social relations in the region (Godelier 1986; Strathern 1988).

Many Melanesian groups have regarded semen as a healing and strengthening substance, essential for a young boy's growth yet subject to depletion over the course of a lifetime. Depending upon the particular society, male initiates may acquire this needed substance by going down on an older male (oral "sex"), by acting as the recipient in anal intercourse, and/or by rubbing semen on the surface of the body. According to Herdt (1981, 1987a, 1987b, 1993b), such practices set in motion a process of masculinization that speeds initiates along their way toward manhood.

Alternative interpretations of these rites have emerged, some through critiques of Herdt's work (Creed 1984; Elliston 1992), and others by shifting the focus of analysis from psychology to power relations (Godelier 1986) or biosocial factors (Schiefenhövel 1990). For example, Creed (1984) sees the "sex" integrated into initiations as a mechanism by which older men maintain their control over younger men. According to Lattas (1990), semen exchange in the Kaliai region of West New Britain provides the metaphor for gift-giving, "a poetic act of insemination" that feminizes men and is inseparable from the negotiation of local politics. Whitehead (1986a, 1986b) contends that many highland New Guinea groups elevate clan solidarity over manhood in fertility rituals. In these accounts what Elliston (1992) calls semen practices become as integral to marriage exchange, social solidarity, or securing the labor

involved in bride service as they are to the coming-of-age of individual initiates.

The Melanesian literature is notable for its attention to sexual subjectivities, albeit within the framework of developmental psychology rather than the exceptional work being done on this topic in queer theory. Outside the Melanesian context narratives of desire and discussions of eroticism are virtually nonexistent, with the important exception of Newton's reflexive essay (1993b) on the erotics of fieldwork in the United States and Kennedy and Davis's (1993) cultural history of lesbians in Buffalo, New York. Ethnographers who have carefully searched for evidence of "homosexual" activities may link behaviors to beliefs about gender, adulthood, or personhood, but seldom have they addressed the question of whether participants found those acts pleasurable. Do individuals seek out the opportunity to exchange semen, eventually come to enjoy the practice, or simply endure it because it is culturally prescribed?

Broaching these questions means grappling with the dilemmas of relating structure to agency, as well as reservations about applying the Anglo-European categories of pleasure and desire in Melanesian settings. Herdt and Stoller (1990) offer a rare book-length treatment of eroticism outside Anglo-European societies. Knauft's (1986) analysis of desire in a Gebusi text makes a strong case for attending to the excitement generated by transgression of the very rules and norms that have historically preoccupied ethnographers.

Because Sambian bachelors and initiates who do follow cultural expectations will end semen transactions with other males not long after marriage, the Sambian case argues eloquently against any absolute division of persons into heterosexual and homosexual. Put another way, the corpus of work on male-male relations in Melanesia has supplied scholars in gender studies with the material to challenge the reduction of sexuality to a presocial "fact of nature" (cf. Dover 1988; Trumbach 1977). To the extent that some Melanesian groups have considered semen practices an essential step toward manhood, the popularization of this research evokes a creative tension with the Anglo-European notion of male-male

genital contact as feminizing. It is now known that same-sex genital contact has been "accepted" in particular social contexts, but efforts to demonstrate its normative character walk a fine line between relativism and romanticism.

If the Melanesian material seduces readers by portraying societies in which homosexuality is a situational norm, research on American Indian "berdache" engages the fantasy of a society in which homosexuality can be at once normative and transgressive. *Berdache* is another catch-all term that ethnographers have used to describe males (or, less often, females) who take on at least some of the garments, occupations, and/or sexual partners culturally prescribed for what Anglo-Europeans might call the opposite sex. Systematic research on *berdache* predates the advent of lesbian/gay studies. The studies covered here begin with Angelino and Shedd's (1955) call for clarification of the concept.[2] As in Melanesia, these investigators have focused on males (but see Allen 1981; Blackwood 1984; Grahn 1986; Schaeffer 1965). Outside North America ethnographers have also drawn analogies between *berdache* and instances of transgendering such as the ones associated with Hawaiian *mahu* (R. Levy 1971, 1973) or *sarombavy* in the Malagasy Republic (Murray 1992).[3]

At the very moment *berdaches* contraverted expectations governing gendered organizations of labor, clothing, and sexual behavior, to some they seemed to have found a socially approved niche in which to practice "same-sex" sexuality (Kroeber 1940). This is not to imply that researchers have been in agreement on the degree to which "same-sex" sexuality has been a necessary or even integral part of becoming *berdache*. Many of these studies take the form of a search for one privileged feature of the institution, asking whether *berdache* in a given society was "really" about occupational preference, spirituality, sexuality, or dress. Certainly not every *berdache* took other males (or other females) as sexual partners.

The issue of whether *berdache* were accepted, even honored, members of their societies has been hotly debated. In a widely critiqued article on the historical development of the institution, Gutiérrez (1989) has argued that *berdache* originated as prisoners of war whose captors required them to wear women's clothing and engage in "homosexual acts" as a sign of subordination. In contrast,

Greenberg (1986) theorizes that the instances on record in which *berdache* became the target of teasing or censure had more to do with kinship than disdain. Because *berdache* relationships were integrated into kinship networks, *berdache* acquired joking partners and became subject to sanctions such as exile for disregarding incest taboos. Roscoe (1987, 1988b, 1990, 1991, 1991–92, 1992) and Walter L. Williams (1992a), who have published widely on the topic, both conclude that *berdache* were highly revered. At times their accounts verge on the sort of idealization Goldenweiser (1929) detected in Edward Carpenter's portrait of homosexuals as culture heroes who blaze new trails in the course of challenging established codes of conduct.

A second point of contention is whether *berdache* still exist in American Indian societies. Walter Williams (1992a) says "yes," though he believes the formal properties of the institution may be changing. "Crossdressing," for example, no longer seems to be central to the practices of those who might call themselves *berdache*. Herdt (1991a, 1991b) responds with an unconditional "no," blaming the Anglo-European conquest for their disappearance. Some of the gay- and lesbian-identified American Indians who have written on the topic locate themselves within an ongoing *berdache* or "Two-Spirit" tradition (Allen 1981; Kenny 1988; Midnight Sun 1988). Drawing upon his work with the group Gay American Indians, Roscoe offers a qualified "yes" as he notes the incessantly transforming character of what people call "tradition."

There are other ways to approach *berdache* than as a coherent institution (persisting or vanishing) or tradition (imagined or transmitted). The kinds of questions asked about *berdache* might sound different if brought into dialogue with recent theoretical developments in other disciplines. Imagine, for example, extending Silverman's (1992) concept of the double mimesis to a *berdache* such as We'wha, the famous Zuni *lhamana* who is the subject of Roscoe's (1991) ethnohistorical study. In an essay on Lawrence of Arabia, Silverman contends that the practice of ethnic crossdressing allowed Lawrence not simply to imitate the Arabs, or even to become Arab, but ultimately to "out-Arab" the Arabs. His sartorial presentation had more to do with the construction of "the

Arab" in the European imagination than with cultural adaptation or the transmission of social knowledge. By inspiring Arab followers to emulate his rendition of "Arabness," Lawrence hoped to augment his power.

In a double mimesis the *berdache*, recurrently described by anthropologists as better at "women's work" than women themselves, refracts twice through the ethnographic lens. Rebel and conformist both, positioned within rather than to the side of gendered hierarchies, We'wha's practice of *berdache* renegotiated power relations as it reconfigured his/her own subjectivity. In this view the *berdache* appears as a representation, more Woman than the women who surrounded him/her; in the eyes of many ethnographers, however, the *berdache* has become a separate gender altogether.

Beyond the Binary

Most ethnographic studies of transgendering have not availed themselves of this sort of cutting-edge work in gender theory. But if their overreliance on concepts such as "socialization" and "gender role" seems dated, their identification of multiple genders has generated interest across disciplines. Roscoe (1991) considers the Zuni *lhamana* a third gender; Wikan (1991) says the same about the *xanith* of Oman, males who wear a combination of women's and men's clothing and conduct themselves as women in some contexts, but who also do things that women ordinarily would not do, such as travel freely. In *Neither Man nor Woman*, Nanda (1986, 1990) argues that the *hijras* of India, male devotees of the goddess Bahuchara Mata who sometimes undergo a ritual of castration, should be regarded as a discrete gender because they consistently violate certain prescribed aspects of both women's and men's "roles." In each case, transgendering is at least occasionally associated with the practice of taking men as sexual partners.

Not long ago scholars spoke of cross-gendering rather than transgendering and alternative genders. To cross genders is to move from one to the other of two fixed positions; to engage in transgendering opens up as many possibilities as there are gender categories. The

two need not be mutually exclusive: Greenberg (1986) believes that both gender crossing and a third gender may have existed among some American Indian groups. In the case of hermaphroditism, Herdt (1990b) hypothesizes that the incidence must reach a critical mass in a population for a third gender category to emerge.

For scholars inclined toward essentialism, the third gender "role" offers an option to young people whose innate difference would have made them social misfits had they been born into a two-gender society. Other explanations look to the socially con-structed character of gender itself. Wikan (1977) describes Oman as a society in which the act of heterosexual intercourse (which *xanith* do not perform), rather than the possession of particular genitalia, becomes "fundamentally constitutive" of gender.

The high level of interest in the idea of societies with multiple genders is not particularly surprising, since the notion runs counter to the dualism of the Anglo-European two-gender system (W. L. Williams 1987). But there are problems with these analyses. Scholars remain unclear about what makes a particular classifica-tion qualify as a discrete gender. At what point does *berdache* stop being an instance of gendered ambiguity, or a variant of mas-culinity or femininity, and start becoming a gender in its own right? No satisfying explanations have been offered for why the number of genders posited seems to run in twos and threes rather than fives or sevens, or why so many of these categories lack female counterparts. Also left unexamined is the uncanny reso-nance between the anthropological "discovery" of multiple gen-ders and the nineteenth-century categorization of homosexuals as members of a third sex, midway between women and men.

While some ethnographers were investigating the possibility of multiple genders, others began to develop more nuanced read-ings of the dichotomy between Man and Woman. Newton (1979) discusses the complex layering of signifiers of masculinity and femininity in the orchestrated display of bodies, clothing, and movement known as stage drag. Gayle Rubin (1992) maintains that critics who reduce "butch" to "masculine" when writing about lesbians in the United States miss the intricate meanings attached to a term that differentiates members of the same sex along the

lines of gender. By distinguishing between primary and secondary genders, each socially assigned, Robertson (1989, 1991, 1992) is able to explore a range of types of "male" and "female" performed by members of an all-female musical revue in Japan.

In his important discussion of homosexuality and representations of masculinity among the ancient Greeks, Winkler examines how the poles "man" and "woman" were related and politicized in a society that recognized only two genders. Rather than present normative statements about manhood ("the Greeks believed"), he shows how members of the elite selectively invoked such norms to target political enemies. Surveillance became integral to the governance of a city-state in which ambitious opponents searched for evidence that a man had succumbed to "the reversibility of the male person, always in peril of slipping into the servile or the feminine" (1990: 50).

Other scholars have gone beyond the binary without making the nominalizing move that multiplies genders. Povinelli (1992), for example, describes the ritual moment at which senior aboriginal women in Australia become ceremonially both male and female. Gayle Rubin (1992) raises the issue of female-to-male transsexuals who blur the boundaries of sex by acquiring "intermediate" bodies rather than pursuing a complete sex change (cf. Bolin 1987, 1988, 1992). Working on the borderline of legal anthropology and political theory, Bower (1992) uses case law to shift the focus of discussion to the politics embedded in the process of adjudicating the classification of persons by sex, whether the classification be male, female, or transsexual. And in a brilliant theorization of how lesbians and gay men in the United States construct identity, Coombe (1992a, 1992b) examines the subversive uses of celebrity images (James Dean, Judy Garland, Greta Garbo or any of the classic movie ice queens) to create alternative representations of gender.

AIDS and the "American" Renaissance

Not to be underestimated as an influence on the current scholarly fascination with gendered ambiguity and the fragmentation of identity is the AIDS pandemic which, as no respecter of persons,

crosscuts the very identities that have provided the basis for the emergence of gay "subcultures." Because sexual activity provides one means of transmission of the human immunodeficiency virus (HIV), the pandemic has been instrumental in focusing anthropological attention on the topic of sexuality. While the number of AIDS studies has multiplied over the past decade, most confine themselves to epidemiological analysis and calls for research. Despite the persistent lack of funding for analyses based upon participant observation, a small but growing number of ethnographic studies have also emerged.

Although scholars working on AIDS have conducted research on sexual beliefs and practices among gay and bisexual men in the United States, to my knowledge no comparable studies exist for lesbians.[4] More specialized studies concentrate on phenomena such as the effects of representations of disease on young people coming out in the age of HIV (Feldman 1989; Herdt 1989b; Herdt and Boxer 1993). A few demonstrate the impact of the (re)medicalization of homosexuality, which historically has been inseparable from the constitution and oppression of gay subjects in Anglo-European societies (Bolton 1992; Martin 1992; Spencer 1983). Only the rare essay frames its discussion of AIDS with a category such as ethnicity that crosscuts sexual identity, yet remains inclusive of lesbian-, gay-, and bisexual-identified members of a population (Singer et al. 1990). All in all, when it comes to AIDS, there is still a world of anthropological research to be done.

Outside the United States, the drawbacks of applying conventional anthropological methodology to an epidemic that spans several geographic regions quickly become evident (Herdt and Boxer 1991; Parker and Carballo 1990; Parker, Herdt and Carballo 1991). Both Parker's (1987, 1989, 1992) research on Brazil and Carrier's (1985) on Mexico have challenged methodological approaches that treat "gay people" as members of bounded communities or subcultures (see also Carrier and Magaña 1992). The permeability of such communities even in the urban areas where they organize at least some aspects of same-sex sexuality demonstrates the relative ease with which HIV can cross imagined boundaries. In Mexico, for example, many men have sex with both women and

men without considering themselves gay. Identity then often becomes sexualized through categories of *activo* and *pasivo*, penetrator and penetrated, rather than object choice (cf. Lancaster 1988, 1992; Murray 1987a). In the United States as well, the high percentage of people who have had genital contact with someone of the same sex without adopting a lesbian or gay male identity has highlighted the need for changes in AIDS education (Singer et al. 1990). AIDS education programs developed in North America may turn out to have limited utility in societies that organize sexuality differently (Carrier and Bolton 1992).

Noting that the concentration on epidemiology has produced research that is practically useless for developing prevention programs, Bolton (1991) suggests that researchers give renewed emphasis to the participation component in participant observation. Must anthropologists who study sexuality content themselves with information gleaned from interviews and other forms of self-reporting? Bolton concludes that, in an era when many know they are supposed to be practicing safer sex, the only way to determine whether people practice what they preach is for at least some ethnographers to have sex as part of their research. Ethics and self-preservation require, he cautions, that the anthropologist practice safer sex or terminate the interaction if a partner is ready to engage in a high-risk activity without proper protection. To do any less when lives are at stake, Bolton argues, would be the truly irresponsible act. His call for a more participatory mode of research on sexuality is not without precedent: Compare the fieldwork for Humphreys's (1975) controversial *Tearoom Trade*, during which the ethnographer served as a lookout in restrooms where men had sexual encounters, or Murray's (1991) broader discussion of the topic, "Sleeping with the Natives as a Source of Data." The life and death issues associated with the transmission of HIV become intertwined with the dilemma of studying "sex" in societies that have privatized its practice.

Anthropological studies of AIDS are being conducted within the context of a new wave of research on the United States that has continued to gather momentum into the 1990s. The strength of recent lesbian/gay ethnography on the United States lies in its detailed treatment of historical context, class analysis, and material

relations. This literature also attends to the erotics and gendering of relations among women in a way that is lacking for other regions of the world.

Ethnographies of the United States from previous decades often presented "the gay world" as a monolith and treated their subjects as representative of lesbian- and gay-identified people everywhere (e.g., Ponse 1978; Warren 1974, 1977). In a radically oversimplified description of gay women in the Bay Area, for example, Wolf (1979) tends to mistake the lesbian-feminist part of the "community" she observed for the whole of the lesbian population. In contrast, three important new studies feature the careful scholarship and theoretical significance that should earn them a lasting place in the long tradition of community studies in the United States.

Newton's (1993a) cultural history of Cherry Grove, Fire Island, examines a resort town that developed the world's first "gay controlled geography." In Cherry Grove, lesbians and gay men for the first time could speak and act from the position of a numerical majority. Beginning with the 1930s, Newton chronicles the coalescence of a gay property-owning class with interests opposed to those of gay renters, workers, and day trippers. Though white ethnics and women were eventually able to gain admission to the Grove, the nationalist ideology of gay liberation in the 1960s did not prove strong enough to override class and racial divisions. Newton's detailed analysis of conflicts within a single gay "community" is welcome and unprecedented.

Like Newton, Kennedy and Davis (1993) capture the interplay between changes at the local level and the elaboration of a national "subculture" in the years following World War II. Their landmark history of lesbians in Buffalo, New York, is the first to demonstrate the contributions to the social movements of the 1950s–1970s made by women who participated in the working-class butch/femme culture of the bars. Kennedy and Davis's exploration of the semiotics of attraction and desire is also without parallel in ethnographies of lesbians and gay men.

In *Families We Choose* I also adopt a historical approach in my analysis of the way the cultural categories "biology" and "choice" figure in gay kinship ideologies (Weston 1991; cf. Nardi 1992a;

Riley 1988). This study links the emergence of a discourse on gay families in the 1980s to the enduring ramifications of the gay movement's call to disclose one's sexual identity to "blood" and adoptive relatives. To date this is the only lesbian/gay ethnography that examines how a range of racial, ethnic, and class identifications can become interpretively entailed in the transformation of practices such as kinship.

Outside the community studies tradition, Ellen Lewin's (1981, 1985, 1990, 1993a, 1993b) research on lesbian parents stands out for its analysis of strategies women have developed to manage the apparently conflicting identities of lesbian and mother. As the women elaborate these strategies in the context of custody disputes and demands from children, lovers, and fathers, Lewin finds them constantly negotiating their identities rather than policing the boundaries of sexual identity as though the latter were intrinsically most meaningful. In an absorbing account of living in the field with a partner of the same sex, Walters (1996) underlines the importance of not assuming a universal salience for the abstract categories of identity politics. Yemeni women took the author, who is African-American, and her white lover for mother and daughter. Walters believes that the emphasis on age as an organizing principle in Yemen superseded visible differences of skin color as well as any possible inference of a sexual relationship. Equally unique is Newton's essay (1993b) on the impact of erotic attraction on fieldwork, which extends discussions of reflexivity in an important new direction (see also Newton and Walton 1984).

More specialized studies range from an ethnography of a labor conflict at a lesbian auto repair shop (see Chapter 5, this volume) to works in progress on a gay theater company and the leather community (Joseph 1993; Perkins and Skipper 1981; G. Rubin 1991, 1993). Linguistic anthropology also makes a rare appearance in lesbian/gay studies in the "American" arena (Leap 1997; Lumby 1976; Murray 1979a, 1980, 1983; Sonenschein 1969). In Herdt's collection (1992) on gay men, Peterson and Carrier take a long overdue look at the relationship between racial/ethnic and sexual identities. Each of these essays adds depth and complexity to earlier work that includes Read's ethnography (1980) of "rituals of stigmatization" among patrons of a

gay tavern, Bolin's (1987, 1988, 1992) pioneering research on trans-
sexuals, and assorted studies of male cruising and sexual activity
(Corzine and Kirby 1977; Humphreys 1975; Troiden 1974). These
works also build upon research by a growing number of non-anthro-
pologists who use fieldwork and interview techniques to good effect
(e.g., Bérubé 1990; Faderman 1991, 1992; Plummer 1992; Sears 1991).

At its best, the new lesbian/gay ethnography on the United States
offers insights into topics of enduring anthropological interest: the
relationship between structure and agency (Herrell 1992; E. Lewin
1993a); space, migration, and cultural identities (Newton 1993a);
community formation (Kennedy and Davis 1993; Murray 1979b;
Newton 1993a); commodification (Coombe 1992a, 1992b; Weston
1993); ideological transformations (Weston 1991); contested hierar-
chies of "good" and "bad" sex (G. Rubin 1984); and the relation of
subordinate groups to a dominant culture. It seems fitting that much
of this research builds, however critically, upon the concepts of iden-
tity and community. For anthropologists who work in the United
States, the object of study remains the cultural crucible that gener-
ated lesbian and gay, bisexual and queer, heterosexual and homo-
sexual, as categories that continue to organize scholarship and lives.

Who's the Native Now?

Lesbian/gay studies in anthropology reached a turning point
when researchers moved beyond fact-finding missions, typologies,
and correlational studies to formulate questions about historical
change, material relations, and how "the natives" conceptualized
behaviors that observers glossed as transgendering and homosex-
uality. Ethnographers turned their attention to "what the natives
have to say for themselves," not only in blanket statements about
"traditional beliefs," but also in far more sophisticated interpretive
analyses (cf. E. Lewin 1991). One ironic outcome of the terminol-
ogy debates has been to cast doubt upon the division into Native
and Other (native to what?) that framed this shift. In many cases
ethnographers continue to favor holistic approaches that tie
homosexuality to place and locate "its" variants within bounded

cultures, subcultures, or sex/gender systems. Yet a move is also discernible to develop approaches to the study of gendering and sexuality that can deal with the diasporas and the fragmentation and reconfiguration of identities that have characterized the late twentieth century (e.g., Manalansan 1993).[5]

The significance of the participation of lesbian-, gay-, and bisexual-identified ethnographers in the development of transcultural studies of sexuality and gendering cannot be overestimated. But lesbian/gay studies in anthropology is no longer easily separable into the products of ethnographers and natives, or even ethnographers who double as informants. Though the change is incremental, research in other areas of anthropology has slowly become more inclusive. Studies of myth (Friedrich 1978; Nadelson 1981), life histories (W. L. Williams 1991), dance (Hanna 1988), political relations (Godelier 1986), gender (Strathern 1988), and sexuality in general (Moffatt 1989; Oldenburg 1990; Parker 1991) now occasionally integrate material on homosexuality, homosociality, and transgendering. Homophobia has become a topic for anthropological investigation (Arguelles and Rich 1984, 1985; Fitzgerald 1993; W. L. Williams 1992b). Scholars examine how "gay" practices such as camp are taken up and transformed by dominant ideologies (Coombe 1992a, 1992b; Newton 1979, 1993a). Politics as usual is disrupted when actors and fans of the all-female Takarazuka Revue in Japan create alternative gender constructs that resist state attempts to bend the theater to nationalist ends (Robertson 1991). Metaphors in medical texts encode sexualities at the cellular level in everyone's physiology, with ominous political implications (Martin 1992).

A quarter-century after the Stonewall Rebellion that marked the beginning of the gay movement, lesbians and gay men continue to wrestle with the limitations of a political strategy (coming out) that takes sexualized categories of personhood (lesbian, gay, bisexual) as givens. To the extent that these particular natives remain embedded in an economy of secrecy and disclosure, they encounter a paradox similar to the one facing their ethnographers: scholars in lesbian/gay studies who seek acceptance from a discipline which, until very recently, has marginalized them with

every new contribution to the field.

Rather than fostering a preoccupation with issues of visibility or patrolling the border between "insiders" and "outsiders," the best work in this field uses ethnographic material in classic relativist fashion to denaturalize Anglo-European conceptions of gender and sexuality. Anthropologists who have benefited from the theory explosion that has characterized queer studies in the humanities have begun to rework more conventional approaches to power, bodies, work, ritual, kinship, medicine, desire, performance, and ethnographic method. None of this would be possible without the constructivist current that has carried lesbian/gay studies in anthropology past the Scylla of breaking the silence and the Charybdis of bringing the previously closeted into the light.

requiem for
a street fighter

8

À mon Requiem, peut-être ai-je aussi, d'instinct, cherché à
sortier du convenu. Voilà si longtemps que j'accompagne à
l'orgue des services d'enterrements! J'en ai par-dessus la tête.
J'ai voulu faire autre chose.[1]

—Gabriel Fauré

Introït

"Who was Julie Cordell?" That's the question I encountered again
and again after the publication of my book on lesbians, gay men,
and kinship (Weston 1991). I had expected perhaps, "Are mothers
really easier to come out to than fathers?" or, "What do you think
of gay marriage?" Instead, "Who was Julie . . . Julie . . . Julie . . . ?"
echoed off the walls and wound its way through the telephone
lines to my home in Arizona. Behind that simple question lay the
difficult, unspoken ones: Was she your girlfriend? Your friend?
What happened to her? Why did she die so young?

It all started with a dedication. Not the kind required to make
it through the seven years it took to research and write the book.

No, this dedication was spartan in comparison, a mere three lines
sandwiched between the title page and the contents:

In memory of Julie Cordell
1960–1983
who came looking for community

Like many gay people of my generation, I had attended far too
many funerals by the time I reached my late twenties. For San
Francisco's "gay community," the 1980s was a decade that wit-
nessed the explosion of the AIDS pandemic, the exacerbation of
racial and class tensions, and worsening economic conditions for
people caught in the undertow of the wave of financial specula-
tion sweeping the city. As an ethnographer trained to read up on
my subject, I knew full well that topics such as class, death, and
sexuality would merit attention "in the field." As someone who
claimed membership in the community I studied, I knew too well
the subtle but no less debilitating effects of living in a society
where heterosexuality remains a pervasive assumption.

As long as I restricted my voice to that of the researcher, I could
not adequately communicate the experience of living under siege
in a subaltern population, regardless of how explicitly I brought
myself into the text. Claiming "insider" status by coming out in
print did not solve my dilemma. A single body cannot bridge that
mythical divide between insider and outsider, researcher and
researched. I am neither, in any simple way, and yet I am both.

When I write, I can call myself a gay anthropologist or an
anthropologist who is gay, a lesbian, queer, or a human being who
has foregrounded homoeroticism in her life for almost two
decades now. I can hold class relations constant by introducing
myself as a woman from a working-class background, or empha-
size the ways that professional employment has repositioned me
in the class hierarchy. I can highlight or downplay the contradic-
tions that face an Anglo writer who sets out to research a multi-
ethnic "gay community" that includes people of color who may or
may not call themselves gay. Because my subjectivity is neither
seamless nor fixed, the queering of my own identity has not always
translated into feelings of closeness or identification with the peo-

ple I study.[2] An ever-shifting self-as-subject has shaped my work in ways that can never be confined to field encounter or text.

In the charged context of analyzing as I live a stigmatized existence, composing a book has meant writing not only between the lines but also behind the lines. What follows does not fall neatly into any one of the established anthropological genres of ethnography, reflections on fieldwork, or literary critique of a monograph already produced. To address that deceptively straightforward question— "Who was Julie?"—I needed new ways to link observation to participation and context to contemplation. Only then would I begin to convey the effects of a kind of engagement with my research topic that cannot be neatly packaged into a field study of limited duration. Julie Cordell could have been—in some sense, was—my "best informant." Even though, by the time I taped my first interview, she was already dead.

Kyrie

As gay writers have experienced increasing success in having their work published, many have paused to take a closer look at the place of writing in queer lives. In recent years anthropologists, too, have scrutinized, in minute detail, what they write, how they write, and the political implications of both. This process of self-examination (some would say obsession) has raised a host of stylistic and ethical issues for the would-be writer. What should be done about the power inequities set up when a researcher adopts a tone of omniscience or writes in language inaccessible to readers in the places under study?

Many anthropologists have argued for the desirability of letting people encountered in the course of fieldwork "speak for themselves" by giving them voice in the texts that present research results. Others have called for ethnographers, through the narrative "I", to make an appearance in their own books and articles. No longer is it generally acceptable for anthropologists to conceal or deny the significance of their gender identity, age, class, or ethnicity. (Sexual identity represents a sort of final frontier in this

regard.) Instead, contemporary ethnographic writing tends to acknowledge these attributes as factors that shape an anthropologist's interpretations of what s/he observed in the field.[3]

In the midst of all this discussion, few have stopped to wonder how a writer arrives at the dedications that stand like sentinels at the gates to a book or a poem. When it comes to the front matter of books, there seem to be two kinds of readers: the ones who skip over the acknowledgments and dedication to "get to the good stuff," and the ones who consider the first few pages of a book part of the good stuff, a place to get the dirt on who's who and who knows who. With the passing years, I must confess that I find myself in the latter group. So I suppose I should not have been surprised when people started asking about Julie.

If a book is dedicated to someone who does not share the author's surname, speculation provides a handy tool for filling in the gaps. Perhaps the person mentioned is a spouse, child, or lover. Perhaps she represents the mythical woman-behind-the-woman, the one who stood by the author through the long hours of writing and revisions. The limited, almost stereotypical character of the images that come to mind suggests just how little an author customarily reveals regarding the events that led to a particular book's dedication.

More than a few writers dedicate their books to relatives. Who can forget *Lesbian Nation* (1973), which Jill Johnston claimed she wrote "for my mother, who should've been a lesbian, and for my daughter, in hopes she will be"? Like many authors, the anthropologist Lila Abu-Lughod (1986) dedicated one volume to her parents; Richard Handler presented *Nationalism and the Politics of Culture in Quebec* (1988) to "my father's sisters Gertrude, Esther, Mary, and Talie." Occasionally a lyric touch breathes life, along with mystery, into these concise formulations, as in the poet Audre Lorde's preface to *The Black Unicorn* (1978b), which reads, "For Linda Gertrude Belmar Lorde and Frederick Byron Lorde. The Face Has Many Seasons."

Some dedications embrace (as they construct) entire communities, like the one in Gloria Anzaldúa's *Borderlands/La Frontera* (1987), written "*a todos mexicanos* on both sides of the border," or

the one in the Gay American Indians anthology, *Living the Spirit* (Roscoe 1988a), which invokes "our ancestors and the memory of our fallen warriors." More obliquely, David Bergman, editor of *Camp Grounds: Style and Homosexuality* (1993), incorporates a quotation from a "gay" poet: "In Memory of Karl Keller: 'Do you think the friendship of me would be unalloy'd satisfaction?'—Walt Whitman."

The most common dedications are brief and cryptic: for "Wendy," "Yangitelig," "The 36 Sexual Rebels," even "Susan Louise and the Voice Dolls."[4] These allusions may or may not become decipherable once a reader has turned the pages. Sometimes they resonate with the book's topic or hint at some aspect of the fieldwork situation. In a twist on the ubiquitous invocation of kin, Robert Alvarez, Jr., offers *Familia* (1987), in part, "to the memory of my grandparents," who double as subjects of his study. More solemn, but no less restrained, are the inscriptions that open Vincent Crapanzano's *Waiting: The Whites of South Africa* (1985) ("For Tesgemariam Abebe and Rudolph Schmidt, Who Died") and Jonathan Boyarin's *Storm from Paradise: The Politics of Jewish Memory* (1992) ("For Aaron, the brother whom I never knew"). I suspect that behind many dedications are attachments laden with a feeling and a fierceness that seldom come across in the text that follows.

When it comes to my dedication of *Families We Choose* to Julie Cordell, there are many possible stories I could tell by way of explanation. Julie was not my inspiration for writing the book, although she had labored long hours on her own account of the women's music industry, a project I greatly respected. Julie was not my lover, although she was certainly my friend, and I would be lying to say we never stole a kiss in the back of the clubs where we went to hear salsa and jazz.

Because Julie met her death two years before my formal research project got underway, she technically was not a participant in the field study that provided material for the book. Her name appears at the beginning of *Families We Choose* due to a different sort of connection: an interpretive link between the narratives I constructed of Julie's life and the experiences of an entire

generation of lesbians and gay men, a link I made only in retro-spect, after the manuscript was drafted and ready to be sent off to the publisher. To understand this connection, you need to know something more about the way Julie Cordell lived and also about the way she died.

Offertoire

I first met Julie at a gathering of women who played conga drums. Alhough she was younger than I, she had moved to the Bay Area from New Mexico at about the same age I had been when I left the Midwest behind for an unseen city, eager to explore gay San Francisco. Like me, she had grown up white and working-class. At the time of her death, after three years on the West Coast, Julie was twenty-three.

Except for a stint working as a typesetter for local newspapers, Julie found only marginal, dead-end jobs waiting for her in the Bay Area. At times she worked in the underground economy to make ends meet. Julie was one of the few lesbians I've known who, as an adult, lived in a literal closet. The walk-in closet in the Oakland apartment she shared with roommates was just large enough to contain a full-size mattress; it was all she could afford. I remember that apartment well because it had a staircase leading up to the roof, where we would go with friends to enjoy the spec-tacular view of the bay and play drums until the sun dipped below the horizon.

In her struggles for survival, Julie was far from alone, although she felt alone with her "money troubles" much of the time. During those years, many young lesbians, gay men, and bisexuals had difficulty getting by on the modest income derived from ser-vice-sector jobs in an urban landscape being radically altered by gentrification. Twice roommates kicked Julie out for being late with her share of the rent. After one of these incidents, which left her homeless on the eve of her birthday, Julie camped out in my studio apartment for a month until she was able to locate work and move on. Her parents were Christian fundamentalists who

rejected her lesbian identification and called her up on the tele-
phone every so often to urge her to resist the devil's influence by
leaving San Francisco, that legendary city of vice and iniquity. In
any case, they were not wealthy people and could not have offered
much in the way of financial assistance even if Julie had been will-
ing to ask.

"The edge" is not a comfortable place to live. Tired of moving
from household to household and job to job, Julie found herself
locked into a serious depression. After months of battling the con-
dition on her own, she decided to check herself into a psychiatric
hospital. Like many queers, she had first encountered the mental
health system when she was coming out, grappling with desires
she didn't understand. This time she turned to psychiatry with a
sort of desperation, only to find herself further marginalized
among her gay friends and in society at large.

Libera Me

The last time I spoke with Julie, she told me she felt the gay com-
munity had let her down. In retrospect, her dream of finding a
harmonious community that had learned to cope with differences
of class, race, gender, age, ability, and sexuality seems naive. At the
time, however, many queer migrants to the Bay Area subscribed to
similarly utopian visions. As Julie had begun the research for her
own book, she had been dismayed to discover in women's music
not just a creative endeavor but a business, its stars no more than
human. The roommates who had kicked her out were both les-
bians. She had expected them to be more understanding, based
upon a shared sexual identity.

While Julie was hospitalized, yet another gay roommate
attempted to steal all her possessions and refused to return the
keys to her car until I leaned on the doorbell for a solid ten min-
utes. After Julie's release from the psychiatric facility, it took police
intervention and an escort from a few concerned friends to get
Julie back into her own apartment to gather up her few belong-
ings. As the police officer stood by looking bored and impatient,

Julie's former roommate began to taunt her, removing items from boxes as quickly as Julie could pack them, until the two eventually came to blows. Of the friends who offered their assistance on this occasion, I was the only one who identified as gay. This rueful observation was Julie's, not mine. In my preoccupation with keeping the interchange between Julie and her roommate from escalating into a full-scale brawl, I had set aside any inclination to operate as the note-taking anthropologist.

By the fall of 1983 Julie had made a decision to leave San Francisco for the southwestern city in which she had come of age. Her options were limited: She controlled little income, no savings, and no confidence that she could hold down a job in her depressed and medicated state. Although Julie had turned to friends in the past for help during emergencies, she did not feel she could rely upon them for the basic necessities of life. Instead, she turned to the only people she could name as family: relatives by blood and adoption. Her stepfather agreed to drive to California to pick her up from the hospital where she had undergone a second round of psychiatric treatment. She would be allowed back "home," provided she agreed to leave behind the corrupting influence of "homosexual companions" and return to her parents' version of faith in a Christian god.

The day before her stepfather was scheduled to arrive, Julie and I had planned to meet to say goodbye. When I called that morning to let her know I was running late, the receptionist told me that the hospital had released her to her stepfather's custody the previous afternoon. Disheartened at the lost opportunity to say our farewells, and suspicious of her stepfather's motives, I resolved to call Julie at her parents' house later in the month.

A few weeks later I did call, hoping to reconnect with Julie and to offer her support in what to me looked like extremely adverse circumstances in which to come to terms with her needs, her desires, her depression, and her future. After a long pause, her stepfather informed me, "Julie is no longer with us." I asked for her phone number, supposing she had found some way to gain a measure of independence with a room or an apartment of her own. "I mean she is no longer *with* us," he repeated. He went on:

"After I picked her up from the hospital, she suddenly leaped out of the car as we were driving through the city. We never made it out of San Francisco. The next thing I knew, they told me she had jumped off the Golden Gate Bridge."

What happened in the car that late autumn day only Julie's step-father knows. The report filed by the Coast Guard crew that picked her up off Baker's Beach said she was still alive when they hauled her aboard the boat. Even as she hit the water, her body fought to live, to draw in one more breath. It was to be her last battle.

In Paradisum

Why did I dedicate *Families We Choose* to Julie Cordell? One reason is thoroughly embedded in desires that spring from my own cultural context: a wish to restore to Julie her chosen name, coupled with a determination that her memory endure at least a few years beyond a life that was much too short. When all is said and done, I miss her deeply, and I still rage at the way she died. Read another way, the story behind my dedication bears a message and a moral. In what has often been characterized as a "post-AIDS" and "new gay" era, queers are still dying of some very old-fashioned causes. We still grapple with pervasive heterosexism in our encounters with employers, religious institutions, medical providers, and members of our straight families. Despite the visibility of gay organizations in urban areas, many of us still struggle to gain a modicum of self-acceptance. Suicide rates remain disproportionately high among gay and lesbian youth (B. J. Miller 1992; Remafedi 1994; Rofes 1983). Class conflict and racism cut a wide swath through "our" communities.

As the writing and rewriting of the manuscript for *Families We Choose* progressed, the prospect of opening the book with a reference to Julie acquired new significance for me. I began to rework my interpretations of what had happened to Julie in light of what I had learned while I was officially studying the gay community in the Bay Area. It was this back-and-forth movement between the stories of Julie I had told since her death and the stories of les-

bians and gay men who had never met my friend that finally convinced me to dedicate the work to her.

Families We Choose chronicles the historical emergence of the concept of gay families, a category that scarcely existed when Julie jumped from that bridge in 1983. Before the 1980s, "gay people" and "family" tended to appear as mutually exclusive categories in the United States. Lesbians and gay men were supposed to represent either an ominous threat to "the family" (in New Right rhetoric), or a group capable of creating exciting new alternatives to "the family" (in the rhetoric of many gay liberationists). Both formulations located queers somewhere outside kinship. To speak of gay families, lesbian families, chosen families, and families of friends was not the commonplace then that it has since become.

In the book I trace the appearance of gay families to two related developments of the 1970s and 1980s. The first was the unprecedented impact of the gay movement's call for all gay people to come out to heterosexuals, including relatives by "blood" and adoption. Within a matter of a decade it became customary for self-identified gay men and lesbians at least to consider disclosing their sexual identities to parents and other close kin. But did coming out necessarily imply membership in something called a gay community? Disillusionment set in as queers began to recognize what later seemed obvious: their different positioning within a population defined in terms of sexuality but crosscut by lines of race, ethnicity, gender, age, ability, religion, and class. More and more people dissociated themselves from the sanitized and masculinized gayness represented by the image of the "Castro clone." Some even questioned whether the concept of coming out applied in the same way to people of color and working-class whites.

Julie was not the only one in the early 1980s who had sought acceptance from parents, only to be told to fend for herself unless she was prepared to "go straight." And Julie was far from the only one who had failed to find, in the gay mecca that was supposed to be San Francisco, the vision of community that had originally brought her to the Bay Area. For Julie, as for many others, "community" turned out to be an entity too abstract, too encompass-

ing, and too homogenizing to provide the face-to-face relation-
ships, the tolerance for conflict, and the emotional sustenance
that could have seen her through a difficult life transition. In
Julie's eyes, neither the gay community nor the women's commu-
nity had ever come to terms with the class differences that had
contributed to her precarious financial condition, or with the stig-
matizing label of mental illness.

What would have happened if Julie had been born a few years
later, or held on until there was a cultural construct—a "family of
friends"—that might have allowed her to turn to her peers for the
validation and material support that her parents were never able
to provide? Sometimes I tell myself it's wishful thinking to believe
that a simple category like "family" could have carried the weight
of the problems and oppression that Julie faced at that point in
her life. Other times I tell myself to have more faith in the power
of human creativity. I remember all the days when Julie discovered
whatever intangible resources she needed to bounce back from
seemingly overwhelming chaos and despair.

Julie Cordell was not a working-class hero; neither was she a
passive victim of circumstances. She could be demanding. From
time to time, as she put it, she "got on people's nerves." Then
again, in a culture that values the trappings of self-sufficiency, it's
not easy to have to ask for the things you need to live. Sometimes
Julie tripped over her own stubbornness and insecurities only to
pick herself back up and try again. Sometimes she stayed down for
the count. More than once, friends stepped in to help. After a
while, some of them grew tired of helping and left her lying there
in the mess that she and society had made. No, Julie was nothing
like a working-class hero. There was a time when she fought, she
danced, she ate, she kissed, she breathed. She doesn't do those
things anymore.

Would a chosen family have given Julie the support she needed
to bounce back one more time? Would "once more" have been
enough in the absence of a meaningful job and adequate mental
health care services? I've often wondered, though I'll never know.
What I do know is that Julie's parents took her ravaged body back
to New Mexico without consulting her friends about the disposi-

tion of her remains or even informing us of her death. Under prevailing statutes, which grant great powers to relatives narrowly defined through marriage or "blood," they had every legal right to do so.

Today Julie's ashes lie in a vault under a surname that she rejected as a young adult. Julie chose for herself the name "Cordell," and this was the name under which her friends marked her passing when we gathered to beat drums and read poetry at the ocean's edge. It took me a long time after the ritual to feel anything but anger and pain and loss whenever I looked at the Golden Gate Bridge. It has taken even longer to remember the unparalleled beauty of that bridge against the setting sun the evening Julie and I played congas on a rooftop in Oakland.

the virtual
anthropologist

9

What walks like an ethnographer, talks like an ethnographer, packs a tape recorder, jots incessant notes, publishes, travels to conferences and applies for jobs just like an ethnographer, even begs and blunders and cajoles like an ethnographer, but is not and never can be a "real" ethnographer? Welcome to the netherworld of virtual anthropology, the state to which the field methodically consigns its "un-fit," a mode of inhabiting the discipline that substitutes ceaseless interrogation for all the comforts of home. How can you expect to teach based on this sort of fieldwork? Why didn't you study genuine families? Real women and real men? Authentic (pure, isolated, acceptable) natives? How can you have any perspective as an "insider"? Do you really call this anthropology?

The virtual anthropologist is the colleague produced as the Native Ethnographer.[1] Fixed as the one who sets out to study "her own," she attracts, disturbs, disorders. She may have acquitted herself with highest honors during her professional training. She may have spent long hours in the field, carefully researching a topic central to the intellectual history of the discipline. If she is lucky, she will carry with her a pedigree from an outstanding graduate program. (Being advantageously positioned in terms of class hierarchies helps.) If she is very smart and very, very lucky, she may

eventually secure a position at a top-ranked university, although precisely because she has been rendered virtual she is less likely to garner such accolades. In short, she may have gone through all the motions expected to bring about professional legitimacy, and, with it, access to what resources the profession has to offer (salary, students, coastal residence, travel, grants). Yet her work will remain suspect, subject to inspection on the grounds of authenticity rather than intellectual argument or acumen.

Too often described as a marginal figure, unfairly exiled to the periphery of the discipline, the virtual anthropologist actually moves through the professional landscape as a creature of another order. She is irredeemably Other, but not as the result of anything so blatant as an operation of exclusion based upon race, sex, class, ethnicity, nationality, or sexuality ("We don't hire/serve/need [epithet of choice] here"). Instead, oppression operates obliquely to incarcerate her within a hybrid category. It is as the Native Ethnographer that the virtual anthropologist finds her work judged less than legitimate, always one step removed from "the real stuff."

Curiouser and Curiouser
The Case of Queer Ethnography

Back in graduate school, when I first decided to study lesbians and gay men in the United States, the faculty members who mentored me pronounced the project "academic suicide." I found it hard to disagree. Before I could proceed, I had to reconcile myself to the possibility (probability?) that I would never get a job in "my field." (At least, I thought, I would get a book out of it: a way to present my research to a wider public.) One glance at the gloomy employment picture for ethnographers who had studied "homosexuality" reinforced this assessment. Almost none of them held appointments in anthropology, if they had jobs at all.

Is it simply that people were more likely to bow down before that spectral figure, homophobia, back in the early 1980s? I don't

think so. Graduate students still write to me, torn between the desire to run off with their first love, queer studies, and the advice of elders to accept the more sensible arranged marriage with "another culture" that would move them securely into "mainstream" anthropology. While job prospects may have improved ever so slightly, the structural circumstances that undercut the legitimacy of queer researchers who study queer topics remain. Anthropology's colonial heritage has formed a field that disciplines its natives in a society that nativizes its queers.

The points at which I have been and continue to be produced as a Native Ethnographer tend to be points of evaluation. These are the sites at which the discipline fields its ethnographers: not just job interviews, but conference presentations, book reviews, skewed readings of published research, and the many small interactions that mint that coin of the academic realm, national reputation (reputation as what?). Comments on such occasions range from the generic dismissal ("Fieldwork with gay people is not fieldwork") to the more refined art of the backhanded compliment ("When I saw the title for your talk, I thought it would be a really flaky topic, but you've just transformed my whole notion of kinship"). More often, those reactions remain unspoken, coiled back into the reception of essays like this. Which is your first inclination as a reader: to reduce the essay to a protest against the discrimination aimed at certain "kinds" of people or to read it for its theoretical contribution to debates on identity, subjectivity, and ethnographic writing?

Reactions to the threat posed by the hybridity of the Native Ethnographer may be couched as expressions of concern: "Some people (not me, of course, I'm your friend) think that if we were to offer you a job here, you would become an advocate." (Don't we all advocate for something?) Then there is the repetitive deployment of that thoroughly neutral category, "fit," as in, "We love your work, but you just wouldn't fit into this department." (Ever wondered why?)

For a change of pace, inventive sorts resort to the thinly veiled objection on methodological grounds: "Lesbians and gay men are too small a segment of society for your results to be meaningful."

(As opposed to research on that multitude, the Yanomami?)
"Well, there aren't many X left, but when you study the X you are
studying an entire social system." (Even Marx, who aspired to a
systems analysis, sought a point of entry—alienation, commodity
fetishism—that offered a unique line of sight into the whole.) "But
why bother with queer theory? It's just a passing fad." (Like the
Sapir-Whorf hypothesis? Or game theory? How about that one-
time razor's edge of anthropological analysis, structuralism?)
Every bit as disconcerting as the historical and political ignorance
embedded in such a litany is the utter lack of irony with which
otherwise astute colleagues pose these questions.

My dance with professional death would have been humorous
if it weren't so costly. Anyone who brings the wrong color or area
of competence to her work is familiar with the pressures of having
to do more and better than peers to get ahead. But it's difficult to
describe the unsettling experience of watching your job history
recast as a cautionary tale for the benefit of graduate students still
in training. Or the sense of moving through the world more ghost
than legend in one's own time. Or the slow and painful realization
that the portable inquisition is likely to follow you even if you
someday manage to secure a "good" position. Not that the
vagaries of the job market make it easy for most applicants to land
the job of their dreams (cf. Nelson 1995; Roseberry 1996). Still, in
my case, there was the telltale specificity of the grounds for
incredulity and dismissal: Explain why you call this anthropology.

Mistakenly concluding that my subjection to reality checks in an
interrogative key was the consequence of conducting research on a
stigmatized topic, mentors devised tactics to mitigate the effects of
a risky focus of study. Arranged in chronological order, their advice
went something like this: As long as you do theory, everything will
be okay. Write your way out. Just finish your dissertation. Just get
your degree. Once you sign a book contract, things will start to
change. Just wait until the book is in press. Wait until the book
comes out in print. Wait until people have time to read the book.
Maybe that second book manuscript will turn the tide. Perhaps if
you broadened your geographic area a bit (say, from lesbians and
gay men in the United States to Western Civilization)?

What these routinized strategies for establishing professional credentials failed to take into account are the processes that can render an anthropologist virtual. For that peculiar anthropological subject/object, the Native Ethnographer, career strategies that rely solely on meritocracy or a move to the disciplinary center necessarily prove inadequate.[2] To the degree that queerness is read not only through your research but through your body, hybridity becomes impossible to ignore.

Going Ethnographer

If one is not born an anthropologist, neither is one born a native. Natives are produced as the object of study that ethnographers make for themselves (Appadurai 1988; Fabian 1983). Coming of age "there" rather than "here" is generally enough to qualify you for this anthropological makeover. Expatriates, of course, need not apply: Suitable candidates must be able to lay claim to the ethnicities and nationalities assigned to their place of origin. In Europe and the United States (anthropology's "here"), attribution of native status becomes a bit more complicated. Assignees tend to occupy a sociohistorical location that makes them suitable for exoticization. Darker skin and deviance are always a plus.

With their self-absorption, sexual obsession, love of pageantry, celebration of the body, and party-going nature (please!), queers could have been sent over from central casting to play the savages within. Stereotypes all, but stereotypes that are remarkably continuous with the construction of the primitive in the annals of anthropology.[3] Much as accusations of idleness placed European beggars in a structurally analogous position to those certifiable savages, the "Hottentots" (Coetzee 1985), so the facile reduction of fieldwork among lesbians and gay men to "an extended vacation" evokes the frivolous, childlike behavior in which barbarians everywhere wallow.

Of course, lesbians and gay men do not offer the "best" natives for study. In representation, if not in action, they appear too modern, too urban, too here and now, too wealthy, too white.[4] Below

the perceptual horizon are queers with rural origins, immigrant status, empty pocketbooks, racial identities at variance with the Anglo. Ironically, the gay movement's problematic tendency to draw analogies between sexual and racial identity—as though all gays were white and people of color could not be gay—has encouraged even white queers who study queers to be taken as "insider" ethnographers in a way that heterosexual white anthropologists studying their "own" communities are not.[5]

Unlike "primitive" or "savage," the term *native* has made something of a comeback in recent years. This particular return of the repressed has occurred after a pluralist fashion that takes little notice of the power relations that produce different types of nativity. (I'm a native, you're a native, we're a native, too.) But each nativizing move can only be understood in its specificity. As the century turns the corner, queers are constructed not just as natives tethered to the symbolics of residence or birth, but as natives-cum-savages. Like primitives, who got such a bad rep after ethnologists decided they had not evolved to the point of practicing monogamous marriage, queers have been saddled with a sexuality that is popularly believed to evade the strictures of social control. For lesbians and gay men of color, these representations become overdetermined, given the racist legacy that primitivizes and hypersexualizes everyone but the Anglo.

As postmodern-day savages, queers have only a few, mostly unsavory, choices: They can be lazy or restless, noble, self-indulgent, or cruel. The articulate presence of these domestic but not domesticated natives is doubly disturbing because it disrupts the homogeneity of "home," that imagined space of sameness and security that shadows "the field."[6] To the degree that the queer who studies queers has been nativized, she joins a long line of African-American, American Indian, South Asian Indian, Mexican, and Brazilian anthropologists trained in "American" universities.[7] Like it or not, she is bound to incite professional insecurities about a changing world in which natives not only read the ethnographies that purport to explain them, but also threaten to show up in a graduate program near you.

So it is not surprising that the aspiring anthropologist who is

known to be "that way" finds herself reduced to her sexuality with the presumption that queer nativity is a prior attribute she brought with her into higher education. Forget for a moment the complexities of history and circumstance that undercut the utopian vision of a perfect native. Ignore the possibility that our anthropologist may not interpret her sexuality in terms of identity categories and identity politics. Table every theory you know that tells you identities do not produce transparent, shared experiences waiting to be expressed. Set aside the differences of race and religion and class and nationality that guarantee she will never be the consummate "insider" familiar with every nuance of a bounded community. Never mind that her own discipline is implicated in constructing the (queer) native as an internally homogeneous category. When she embarks upon a career in anthropology, she is likely to be seen as native first, ethnographer second.

Now bring the set-asides in the preceding paragraph back into focus. The complications they introduce into one-dimensional portraits of "the ethnographer" or "the native" describe precisely what is at stake when I characterize the Native Ethnographer as a hybrid.

Hybridity is a term that has lost in precision what it has gained in popularity as it has found its way into discussions of multiculturalism.[8] Although many writers have begun to use "hybrid" and "mixed" interchangeably, hybridity technically describes a process that compounds rather than mixes attributions of identity. If you want to understand the conflicts, suspicion, and general volatility of social relations that surround the lucky incumbent of the Native Ethnographer position, this distinction becomes indispensable.

Think back to that mystical moment in chemistry class when the instructor explained the difference between mixtures and compounds.[9] A mixture is something like a teaspoon of salt stirred together with a spoonful of pepper. Given lots of time, good eyes, and a slightly maniacal bent, a person can sort a mixture back into its original components, placing the pepper, grain by grain, in one pile, and the salt in another. A compound is another matter altogether. Compounds also combine disparate elements, but they

join those elements through a chemical reaction that transforms the whole into something different from its constituent parts. Water is a compound of oxygen and hydrogen. Put the two together in certain proportions under particular conditions and you will find a liquid where you might expect a gas. Trying to divide water into its elements mechanically, molecule by molecule, drop by drop, would be a fool's errand. Assuming that you understand the properties of water because you once inhaled "pure" oxygen could lead to early death by drowning.

So hybridity is not the sum of an additive relationship that "mixes" two intact terms (Native + Ethnographer). A person cannot understand what it means to be positioned as a Native Ethnographer by reading an essay or two on representations of savagery and then brushing up on the latest in interview techniques. Attempting to grasp each term in isolation is as fruitless as trying to spot the elements of hydrogen and oxygen in your morning cup of coffee. If you come up with anything at all, it is likely to be your own reflection.[10]

But if hybridity is not an additive relationship, neither is it the joining of two terms by a Lacanian slash (Native/Ethnographer). The slash is really nothing more than a variant of the mixture model that problematizes the relationship between the terms. A Native/Ethnographer would be someone who moves, more or less uneasily, between two fixed positions or "worlds" (professional by morning, queer by night). But no two identities attributed to the same body are that separable, that discrete. Nobody checks identities at the door. Whether or not the Native Ethnographer embraces the categories that define her, she is not a split subject, but a hybrid who collapses the Subject/Object distinction (more on this in a moment).

To continue the science analogy, if there is a chemical reaction that creates the Native Ethnographer as a particular sort of hybrid, it is the act of studying a "people" defined as one's own.[11] Or more accurately, it is the performance of this research activity in the context of the same set of social relations that produces inanities like the characterization of "insider" fieldwork as one long party. (I don't know what kind of parties you go to, but spin

the bottle looks pretty good next to 350 days of fieldnotes.) All of this is a social product. Studying "one's own" is no more a matter of natural affinity than nativity is the consequence of birth.

Whether someone becomes nativized—much less primitivized—depends upon matters of history and power that extend well beyond the academy. (To repeat: Darker skin and deviance are always a plus.) The mere act of surveying someone with an anthropological (or sociological, or historiographic) gaze is not enough to transform her into a native or credit her with membership in "a people." Veterans who study warfare are not nativized in the same way as queers who study sexuality, and the work of those veterans is much less likely to be read off their bodies.[12]

Because our youthful hero has been produced as a virtual anthropologist only in relationship to her object of study, her ethnography will be perpetually interpreted through her (now increasingly essentialized) nativity. "Evidence" of her sexuality pops up in her work in unexpected places, like Elvis at a road rally or Our Lady of Sorrows in Vegas. And this double-edged process does not require ignorance or ill will to wreak the havoc it does.

Through it all, the Native Ethnographer grapples with the instability of the terms that represent her. Colleagues who misrecognize hybridity as an additive relationship find themselves disturbed by the native's apparent ability to morph the anthropologist.[13] Imagining that the two parts coexist side by side within her, they ask questions that are the equivalent of trying to separate a compound by mechanical means. Their insistence on establishing a standard for "real" fieldwork and "real" anthropology attempts to ferret out the native in the anthropologist like the pepper in the salt. Surely somewhere there must be an advocate hiding behind the professional mask, the savage in ethnographer's clothing. Meanwhile, the anthropologist who finds herself mired in nativity in the eyes of colleagues can attempt to extricate herself by "going ethnographer": emphasizing observation over participation, or insisting on the authenticity of her research ("I did fieldwork, too, you know").

Although these offensive and defensive moves may seem opposed in the high-stakes game of authentication, they share an

insistence on the importance—indeed, the possibility—of separating the ethnographer from the native. But the two terms cannot be neatly distinguished once the discipline has brought them into a relationship of hybridity. As a compound state, hybridity represents something more complex than an "intersection" of separate axes of identity. The operations that transform the whole into something qualitatively different than the sum of its parts make it impossible to tease out the various ways in which research area and nativization combine to provide a basis for discrimination.

Was it studying the United States or the way you stood with your hands in your pockets (too butch) that led the interviewer to pose that hostile question about "real fieldwork"? Funny, another guy asked the same thing when the job specified a geographic focus on the United States, so maybe it's not geographic area after all. But if it wasn't area and it wasn't the hands in the pockets (still not sure about that one), maybe it was because you couldn't put to rest those lingering fears that, if appointed, you would become a crusader for "your people."

There are plenty of grounds these days for charging someone with a failure to perform "real anthropology." Studies of Europe or the United States, studies that traverse national borders, studies "up" instead of "down," studies of "one's own," studies that refuse to exoticize the stigmatized: All have been dismissed, at one time or another, as less than legit. But there is a pattern and a specificity to the occasions on which anthropologists have rallied to the real. In periods of disciplinary complacency, as well as the current era of budget cuts and postcolonial reflection, the anthropologist known as the Native Ethnographer has repeatedly been taken to task for passing herself off as the genuine article and falling short of authentic practice.

When Native Ethnographers attempt to prove themselves real in the face of the inevitable interrogation, they face the old duck dilemma: However convincingly they may walk and talk, quack and squawk, as they perform the time-honored rituals of professional legitimation, they will look *like* an ethnographer before they will be taken as (a real) one. As hybrids, they are continu-

ously produced in the cyberspace of the virtual. As hybrids, they compound subject with object. As hybrids, they become at once hypervisible and invisible, painfully obtrusive and just as readily overlooked.

In the course of professionalization, Native Ethnographers emerge from graduate programs that promise to transform the benighted Them (natives) into the all-knowing Us (anthropologists). On the job market, Native Ethnographers labor under the suspicion that greets shape-shifters, those unpredictable creatures who threaten to show up as Us today, Them tomorrow. The very presence in the discipline of queers who study queers could complicate this dichotomy between Us and Them in useful ways. But in the absence of the thoroughgoing reevaluation of the anthropological project that an understanding of hybridity entails, the irresolvable question that faces the virtual anthropologist remains: How are *these* ethnographers to make their Other?

I, Native

To be taken seriously as a scholar, it is not enough to author ethnographies: Our aspiring anthropologist must establish herself as an authority. But as a hybrid, she will find that she cannot authorize herself through recourse to the same time-tested rhetorical strategies that other anthropologists have employed to create professional credibility. The instability of hybridity and the discomfort it inspires make it well-nigh impossible to speak or write from the subject position of "I, Native Ethnographer." Social relations inside and outside the profession pull her toward the poles of her assigned identity, denying her the option of representing herself as a complex, integrated, compound figure. Instead of writing as "I, Native Ethnographer"—or some equally compound subject position—she ends up positioned as *either* "I, Native," *or* "I, Ethnographer." The nuance of the two as they are bound up together is lost.

"Why not try objectivity?" you ask. This distancing device served well enough to secure the reputations of anthropologists in days

gone by. Surveying her subjects with an omniscient gaze, the virtual anthropologist sometimes attempts to prove herself real by setting out to occupy the "I, Ethnographer" position with a vengeance. It's bad enough to study a fringe topic; why risk calling attention to an ethnicity shared with "informants" or committing a stigmatized sexual identity to print? Far better to play God. To remind the reader that society casts the Native Ethnographer as "one of them" would be to acknowledge that the author has helped create the universe she observes. Come to think of it, even gods have been known to spin a creation myth or two. Strictly empiricist anthropologists (good girls) don't.

Now this objectivist stance is not bad as a form of resistance to the ways that nativization reduces people to one-dimensional representatives of "their" putatively homogeneous society or community. But the author who writes as "I, Ethnographer" ignores at her peril the impact of her specific social positioning upon her research. And she pays a price when she bows to pressures to disembody herself in order to disavow nativity.

All right, then. Let's turn to the strategy of explicitly inserting oneself into the text, a gambit popularized by what has been dubbed the reflexive turn in anthropology. Writing under the ethnographic "I" means that the author must write *as* someone or something: a situated "self." What's in a pronoun? In reflexive writing, the narrator—as distinct from the author—generally situates herself in terms of identities that carry weight in Euro-American societies. Gender, ethnicity, class, nationality, and (once in a while) sexuality come to the fore.

Of course, reflexivity does not automatically confer credibility. (Witness a friend's reaction when she first leafed through my book on gay kinship ideologies, *Families We Choose* (1991): "There certainly are a lot of 'I's in your book! Is this supposed to be social science?") But reflexivity has the advantage of calling attention to differences that make a difference. If you set out to study a former colony from the former metropole, it just might affect how you are received. If your parents once numbered themselves among the colonized, your reception may shift accordingly. If people "in the field" code you as a woman with money to spend,

that assessment can affect your research in ways that bear examination. If you have never done drag but the person you're interviewing has, a "shared" gay identity may or may not affect the results you get on tape. But it is probably worth noting.

Reflexivity reminds the reader to view the circumstances of the anthropologist in relation to the circumstances of the people studied. It also highlights the ways in which the ethnographer's hand, however light, shapes the presentation of data from the field. Still, so much attention to identities can foster a dangerously reassuring belief in equality ("We're all 'I's' here") in situations where serious disparities prevail. All the pious calls for dialogue and mutual respect between the ethnographer and her subjects cannot change the fact that socially structured inequalities do not dissolve under the influence of acknowledgment and understanding. Reflexivity is not, in itself, an equalizing act.

Here lies the danger that reflexivity poses for the Native Ethnographer. To the extent that she uses identity categories to describe herself in her scholarship, she will most likely be read as speaking from the "I, Native" rather than the "I, Native Ethnographer" position. *Her* use of "I" splits the hybridity of the Native Ethnographer by giving nativity pride of place over professional standing. This nativization is the effect not of authorial intent but of power relations in the wider society. Even as I sit at my desk calling attention to the ways that nativization writes people out of the discipline, I am aware that the use of the first person in this chapter may end up reinforcing a tendency to view my work through the narrowing lens of an ascribed lesbian identity.[14] Why else would I be sent manuscripts for review on anything to do with queers (lesbians and ecology, anyone?), but so little material on the theoretical questions about ideology and identity that inform my research?

For the anthropologist who gets nativized as lesbian, gay, or bisexual, "coming out" when she writes up her data can create more problems than it resolves. By and large, the critique associated with reflexivity has addressed power relations between anthropologists and their "informants."[15] But what about the power differentials embedded in relationships with professional

"peers"? Which do you think would be harder: to reveal your positioning as a middle-class heterosexual white male, or as some deeper shade of queer? The price of methodological responsibility is higher for people positioned lower. Or, as Lady Macbeth might have said about much of the reflexive soul-searching to date, "What need we fear who knows it, when none can call our power to account?"

When the Native Ethnographer writes about how constructions of her gender or ethnicity or sexuality affected her research, she may provide insights that are crucial for interpreting her results, but she also subjects herself to an insidious sort of surveillance. Although sexualities need not be inscribed *on* bodies (no, Ethel, you can't always know one when you see one), the publications the virtual anthropologist produces will begin to be read *through* her body. Now thoroughly ensconced in nativity, she is likely to be credited with the "instant rapport" that is but one of the illusory attributes of the "insider": zap and cook, stir and eat, point and shoot, speak and be in accord, listen and understand. Culturally marked aspects of her identity flag "like" identities among her research subjects, while attributes that place her within the magic circle of domination encourage other aspects of her work to be overlooked.

Since the publication of *Families We Choose*, I have been intrigued by the patterned ways in which it is read and not read. As part of my research for the volume, I conducted a year of field-work in San Francisco, getting to know a wide range of gay men, lesbians, bisexuals, "don't-categorize-me's," and even the occasional heterosexual. The parameters of my field research are clearly laid out in the book, both in my words and in the voices of people I interviewed. Yet readers often transform *Families We Choose* into a lesbian text, turning me into a researcher who studies lesbians (what else?) and effectively erasing 50 percent of an interview sample composed of equal numbers of lesbians and gay men. Meanwhile, the racial diversity of the sample goes unremarked, despite its rarity amid the largely white social science studies of homosexuality. Each of these characterizations of the book filters my research through my placement in fields of iden-

tity and fields of power. *Families We Choose* is the product of a hybrid "I" who has been nativized in particular ways within and without the text: as a white (unmarked), lesbian (most certainly marked) scholar.

When the politics of reflexivity engage with the complex representation that is the Native Ethnographer, they end up looking more retro than radical. As though stigmatization and skewed readings were not enough, the forced retreat to an "I, Native" subject position embroils the writer in an inhospitable economy of disclosure and revelation. Leaving aside for the moment the associations of moral culpability attached to the confessional form, the concept of coming out of the closet implies the existence of a coherent, prefabricated identity waiting to be expressed for the pleasure of the viewing audience. Yet historical and cross-cultural research emphasizes the cultural specificity of the identity categories ("the" homosexual) that organize sexuality into a domain in Anglo-European societies (see Chapter 7 of this volume).

What is it, then, that can render even well-read scholars stupid in the face of identity politics? With a rudimentary knowledge of the literature on identity, how can they persist in asking such questions as "What was it like to work as an insider ethnographer?" (Inside what? An unbounded, heterogeneous population that can be neither counted nor defined?) Rhetorical questions, to be sure. The point is this: Coming out in print, however artfully executed, can too easily be misinterpreted as a public statement of the "truth" about a sexuality that is supposed to create automatic solidarity with at least some of the people encountered in the field.

Interestingly, the "coming out" passage in *Families We Choose* is barely that. I read it now as a failed attempt to resist nativization without obscuring my implication in identity categories that affected my field research:

> "Are you a lesbian? Are you gay?" Every other day one of these questions greets my efforts to set up interviews over the telephone. Halfway through my fieldwork, I remark on this concern with the researcher's identity while addressing a course in anthropological field methods. "Do you think you could have done this study if you weren't a lesbian?" asks a student from the

> back of the classroom. "No doubt," I reply, "but then again, it
> wouldn't have been the same study." (Weston 1991: 13)

While this passage recounts a "real life" incident, I strategically
selected that incident and crafted the passage with care. Students
and potential research subjects supply the categories (lesbian,
gay) that cast my sexuality in the mold of identity. No variant of
"homosexual" passes my lips, although it could be argued that I
tacitly assent to those categories with a response ("No doubt")
that leaves their terms intact. To round things off, the setting—a
methods class!—introduces an element of irony that beckons the
reader to reflection.

What else might a close reading of this passage suggest? My
departure from an identity politics that credentials certain people
as "insiders" and insists that only "authentic" members of a group
may speak.[16] My belief that power and positioning matter. My
impatience with identity-based constructions of sexuality that
cannot accommodate a range of intimacies and attractions.

Too subtle, perhaps? But what rhetorical devices besides the
ethnographic "I" are available to the hybrid who cannot reconcile
herself to the fate of having her professional persona endlessly
recycled through nativity? After she has exhausted the possibilities
of authorizing herself through strategies of objectivity and reflex-
ivity, what's a virtual anthropologist to do when it comes to the
thankless task of getting people to read her work through some-
thing besides persona and physique?

In a pinch, there's always reportage with an eyewitness twist.
Nothing like building the implicit claim "I was there" (Sorry, pal,
you weren't) into an ethnographic narrative to lay claim to special
insights inaccessible to the general reader (cf. Clifford 1988;
Geertz 1988). Of course, that claim depends upon maintaining a
clear separation between there and here, a separation usually
worked out by mapping categories of people onto place. Natives
are the ones who are always there, always embodied, always open
to scholarly inspection. Ethnographers are the ones who go there
("the field") to study natives with every intention of returning
here ("home"), whether "here" lies across the seas or in a co-op
apartment on the other side of town (Gupta and Ferguson 1997).

The odd anthropologist out has been known to jump disciplinary ship by "going native," but that hardly counts as an option for the ethnographer already located as a native. Because the virtual anthropologist's hybridity blurs the distinction between researcher and researched, she cannot create ethnographic authority by distancing herself in time or space from the people she studies. There is now, here is there, and we are them.[17]

Like an eagle caught far from its range, the Native Ethnographer's wings become tangled in the power lines that join two senses of "my people": the colonialist's "*my* people" and the activist's "my *people*." It's hard to say which formulation is more problematic: the first with its hierarchy of racial and labor relations left intact, or the second with all the limitations of the nationalist vision of an imagined community that undergirds identity politics.[18] The virtual anthropologist once again finds herself in an untenable position, unwilling or unable to produce "*my* people" (the Other of anthropological inquiry), and incapable of extricating herself from the grip of the professionally dangerous perception that she should "naturally" call some nativized group "my *people*." Understandably loathe to exoticize that which she cannot leave behind, she is less likely than most of her colleagues to build professional credibility on the backs of "informants" through an orientalizing move.

If all else fails, then, our ever-resourceful anthropologist can attempt to make the best of nativization by taking a stand on native authority.[19] Barely articulated notions of informant expertise have been embedded all along in the process of making ethnographic writing credible. Natives are the ones with a corner on the academic market for (genuine) experience, the kind worth documenting and transcribing and playing the voyeur to. Natives are well known to have bodies and practical knowledge, the better to filter their nativity through. For the real anthropologist, in contrast, experiential authority and embodiment end with the "return from the field."

No visible work discipline attaches to the visceral, concrete labor of "writing up." When books and essays make the ethnographer's body visible, they depict its toils and deprivations in the

field, seldom at the keyboard. Where, in experimental ethnography, are the endless cups of tea or coffee, sore muscles, aching head, and stiff hands from hours bent over a keyboard? When did the work of producing a monograph count as real experience, or for that matter, manual as well as mental labor? With the demise of armchair anthropology, who ever heard of an anthropologist, reflexive or otherwise, establishing credibility by proclaiming "I was there . . . for years . . . in my study"?[20]

If the labor of writing disappears for the ethnographer, the arduousness of research tends to fade from view for the native who "goes to the field." Working in a country or community portrayed as one's own becomes "not work," much as teaching a language is assumed to require no training for people labeled "native speakers." This ethnographic variant of natural rhythm (note the racialized and sexualized subtext) casts the virtual anthropologist once again as instant insider, accepted with open arms into the ethnographic utopia of a homogeneous community. Her experience as a native—the only experience about which she can speak authoritatively from the "I, Native" position—is taken to be familiar and complete, yielding knowledge acquired with little or no effort.[21]

Savaged again, and to what avail? Disappointingly, native authority doesn't get the virtual anthropologist very far. In a scholarly world that places a premium on explanation, the meaning of experience must remain opaque to the native in order to be revealed by that privileged interpreter, the social scientist. Being university trained, the virtual anthropologist can always pull the old hat trick (today native, tomorrow ethnographer; now you see the native, now you don't). But she will be hard put to write from the Native Ethnographer position, much less to work through its contradictions.

So the virtual anthropologist goes through her long- or short-lived career, constantly being pulled toward one or the other of the poles of her hybridity. Try as she might, she will not be able to produce a fully legitimized account of her field research. Why can't she authorize herself in the same way as the real anthropologist? Because most of the rhetorical strategies that establish

ethnographic authority are predicated upon a separation of object from subject. And the prescribed cure for this mind/body split—reflexivity—does not free the author from the trap. Even the most celebrated of experimental ethnographies end up reinstating a division between you and I, native and ethnographer, Other and Self, often at the very moment they "allow" people from the field to speak.[22]

There is, of course, one final (though limited) strategy familiar to informants everywhere who have exercised their perfect native authority with witty abandon. Whether ad-libbing "traditional" songs and stories, or making jokes at the anthropologist's expense that are received in all seriousness and duly recorded for publication, natives have always participated in an improvisatory construction of what is "empirically" available for study, including their own nativity (Limón 1991; Paredes 1978; Rosaldo 1989; Sarris 1991). Instead of letting parody pass as realism, the Native Ethnographer can be "true" to the hybridity forced upon her by creating parodies—rather like this essay—that are marked as such. Anthropologists may be nativized or virtualized, hybridized or realized. But camp is camp is camp.[23]

The problem with the Native Ethnographer, though, is that she won't stay put: The slippery rascal keeps sliding over from the object (Native) into the subject (Ethnographer) position. Hybridity is disconcerting precisely to the degree that it collapses the subject/object distinctions that work to insulate "us" from "them." Because the categories that nativize her combine with professional identity to yield a hybrid compound, she encounters a double bind when it comes time to write. To produce anthropology at all, she must treat the components of her hybridity as merely additive (Native + Ethnographer) or split (Native/Ethnographer) by writing from only one subject position at a time, unless hybridity itself becomes the focus of the piece. And each time her work submits to this double bind, as it must, it surrenders the intricate operations of hybridity to the oversimplifications of nativity or objectivity.

Just in case legions of readers inspired by the density of the last paragraph find themselves moved to set out on a quest for a better formula for ethnographic writing, let me add that this is a case

where rhetoric is not enough. In the end, ethnographic authority is more than "affected" by race or gender or sexuality or a host of other identities (cf. Deborah Gordon 1990). Those identities filter through both hybridity and a subject/object divide produced in social arenas apart from the text. Through it all, the legitimacy of the generic, unmarked anthropologist is read into reality by the very power relations that read the virtual anthropologist out.

Peripheral ReVision

Although being read out of "real" anthropology increases the chances that the Native Ethnographer will be marginalized within her discipline, the two processes are actually distinct. Not that there has been any noticeable expansion of appointments for queers who study queers in anthropology departments at top-ten universities. But virtuality does not assign the Native Ethnographer a particular position—be it center or margin—in the metaphorical space of the field. Instead, virtuality consigns her to the unnerving experience of moving through the professional landscape as something just short of genuine, regardless of where she plants her professional feet. It's about becoming not-real, though not quite imitation either, in ways that make her unmappable.[24]

Marginality models import the geopolitics of empire into the cyberspace of academic politics. Bemidji State becomes to the University of Michigan what the imperial outpost is to the metropolis (cf. Ashcroft, Griffiths, and Tiffin 1989; hooks 1984; Spivak 1990). Prestigious departments occupy the symbolic center of the academic universe, and their centrality, far from insulating them behind ivory-tower walls, grants them a high degree of control over the resources necessary to do the kind of anthropology that confers professional credibility. Hierarchies of practice and place ensure that aspiring anthropologists who "don't make the grade" are shipped off to the colonies ("the margins"), where long hours, temporary status, lack of leave time, too many committees, too many classes, high student-teacher ratios, and research conducted

on the fly make a ticket to the center more improbable with each passing megawork day.

Yet the virtual is not the marginal. Why else would the Native Ethnographer remain virtual, regardless of whether she occupies the center or periphery of the academic world? She cannot make herself "real" by changing the theoretical topic she studies or the institution she serves. A time-tested focus like politics, the latest in transnationalism, Stanford or Podunk U—it's all the same when it comes to hybridity. The compound position from which the Native Ethnographer speaks leaves her somewhere between subject and object, Us and Them, pedestrian reality and "here comes trouble."

In this sense, the process of hybridization that renders someone virtual is not equivalent to growing up on the wrong side of the tracks or enrolling in a school on the wrong side of the Mississippi. The upwardly mobile scholar who migrates from the periphery to an elite institution may work hard to maintain her marginality by writing on behalf of "her people" or remembering what it was like to come of age on the wrong side of town (hooks 1990).[25] But the virtual anthropologist who comes into the intellectual's equivalent of an inheritance needs no reminder. She remains virtual at the very moment she wins the all-expense-paid trip to an institution at the heart of the discipline. Purveyors of digs and doubts will track her down, even in her endowed chair. The girl could be responding to questions at the press conference called to celebrate her receipt of a MacArthur award (dream on!), and she would be kidding herself if she believed it impossible for some joker to rise up out of the audience to say, "Your work's very interesting, very interesting indeed, but why do you call it anthropology?"

With a little luck, the virtual anthropologist *may* live to pursue her career as an "outsider within," in Patricia Hill Collins's (1990) sense of a person assigned to a subordinate position in the belly of the beast.[26] Surely you've run across her: the lone member of the faculty allotted a windowless office, the one "inadvertently" dropped from the invitation list to departmental functions, or the one relentlessly included on the invitation list to departmental functions (where she can expect to have the pleasure of being

shown off as the embodiment of her colleagues' liberality and goodwill). But the virtual anthropologist is just as likely to pass her days as the outsider without: jobless, piecing together academic appointments, crisscrossing the globe in her search for admission to the tenured elect, consigned to the academy's back of beyond, eventually giving up or giving out.

Excised or tokenized, the virtual anthropologist inherits much of the loneliness associated with the outsider-within position, but little of its fixity. Her problems do not stem from being a dyke out of (her) place in academe, but from those seemingly unpredictable shifts from Native to Ethnographer and back again. What makes her virtual is neither a fixed identity (the house queer) nor a fixed location (at center or margins), but a compounding of identity with research that sets her in motion as a Native Ethnographer. At issue is not who she "is" or where she stands, but whether onlookers see her as a Native rising up out of the community she studies. If they do, the game's up: She'll be rendered virtual, going under to that telltale hybridity, another casualty of the kind of Othering that sends its targets ricocheting between subject positions.

No surprise, then, that virtuality does not yield to protests against exclusion from the center or efforts to jockey for a better position. Strategies of inclusion attempt to better the lot of the marginalized professional by confronting the forces of discrimination that have pushed her to the periphery. Strategies of critique rely upon the keen insight and creativity that some scholars believe accompany the view from the edge (see hooks 1990). Both tactics keep in place a territorial model for conceptualizing power relations. Both keep the long-suffering aspirant oriented to the field's metaphorical center, whether she adopts the stance that says, "Let me in!" or the voice that admonishes, "Let me tell you what's problematic about being in!"

A virtual anthropologist cannot pin her hopes on the search for a level playing field or a place in the sun, because these spatial metaphors keep intact the process of nativization that is her bane.[27] Natives in, natives out: The same pieces are shuffled around the board with nothing to challenge their construction.

But the polymorphic character of the virtual anthropologist makes her a shape-shifter at center or margin. Our hero's heightened visibility *as* a Native Ethnographer is the very condition of her invisibility. Now you see her, now you don't, because when you do see her, you can view her only through the lens of hybridity.

Though the topic may be academic suicide, the implications of being rendered virtual do not stop at books left unwritten and derailed careers. Being read out of reality transports the nativized scholar who studies "her own" into a different dimension of meaning altogether. The Native Ethnographer, in the full glory of her hybridity, confronts the conventional definition of anthropology as the study of (the hu)man, or even the study of cultural differences, with the possibility that the field might be more appropriately conceptualized as a site for the *production* of difference. Unlike headhunters and firewalkers from days gone by, safely contained "over there" in "the field," the virtual anthropologist's location "within" the discipline threatens to expose her inquisitors' participation in the power relations that fuel the process of nativization.

In the libraries and in the halls, queers who study queers find themselves grouped with other Native Ethnographers whose bid for professional status entails being reduced to the categories (sexuality, ethnicity, what have you) that are supposed to organize their identities. It's easy to forget that these one-dimensional representations feed back into the communities ethnographers study. At a time when "natives" worldwide resort to quoting ethnographies to explain their "traditions" to the state and to themselves, the virtual anthropologist is the ghost in a disciplinary machine whose finest documentary efforts have doubled as exotica, intervention, and spectacle. If anybody can help anthropology retool, she's the one.

notes

introduction: the bubble, the burn, and the simmer

Acknowledgments: Rosemary Coombe and Geeta Patel generously agreed to read and comment upon an early draft of this introduction. Whatever insights the essays in this book contain owe a great deal to the discernment of colleagues and friends. In places where the analysis falters, the limitations remain, of course, my own.

1. For the articles in *Glamour* and *Redbook*, see Cunningham (1992) and Salter (1992), respectively. Despite these developments, research funding and job opportunities remained limited for scholars who named "sexuality" as their topic. Sociologists and anthropologists who have called for the social sciences to "open up" to the study of sexuality are well aware of the obstacles, both inside and outside academic institutions, that continue to block such research (see Lewin and Leap 1996; Namaste 1994; Newton 1993c). Relatively few social scientists, such as Rosalind Morris (1995), have attempted to bridge the disciplinary divide by acknowledging the impact of humanities scholarship (e.g., performance theory) on the study of sex and gender within the social sciences.

2. See Basu (1993); Bleys (1995); Chow (1995); J. Kelly (1991); Nandy (1983); Patel (1997b); Sarkar (1994); Sinha (1995).

3. The phrase "thinking sex" derives from Gayle Rubin's (1984) classic article by the same name.

4. Entries appear in the index for Mead's *Coming of Age in Samoa* (1961).

5. Gilbert Herdt (1991a, 1991b) refers to this phenomenon as the conceptualization of sexuality as an "it-entity."

6. Of course, one could argue that the bulk of social science research has always

referred back to a Euro-American "Us." In this sense, the most culturally rela-
tive account of erotic practices "over there" becomes an implicit comparison
with and commentary upon the situation "back here" (see Gupta and
Ferguson 1997). Ruth Benedict, for example, famously observed that Zuni
could effectively accomplish "divorce" by setting a husband's belongings "on
the doorsill" (see Stocking 1992: 299, who notes Benedict's emphasis on "the
ease of sexuality" that prevailed in matrilineal pueblos). Widespread quotation
of this particular observation by Benedict can be attributed, at least in part, to
the fact that she wrote during an era in which divorce remained notoriously
difficult to obtain under the jurisdiction of United States courts. By way of
contrast, David Damrosch's (1995) reading of Lévi-Strauss's *Tristes Tropiques*
notes the gap between Lévi-Strauss's positive description of Nambikwara male-
male sex and the pejorative language applied later in the book to the gay male
residents of Fire Island's Cherry Grove. In Cherry Grove, wrote Lévi-Strauss,
"sterile couples can be seen returning to their chalets pushing prams (the only
vehicles suitable for the narrow paths) containing little but weekend bottles of
milk that no baby will consume" (quoted in Damrosch 1995: 9).

7. In *The Rites of Passage*, Arnold van Gennep categorized "puberty rites" as
 rites of separation "whose sexual nature is not to be denied and which
 are said to make the individual a man or a woman, or fit to be one. . . .
 they are followed by rites of incorporation into the world of sexuality
 and, in all societies and all social groups, into a group confined to per-
 sons of one sex or the other" (1960: 67).

8. See Delaney (1991). Like Lévy-Bruhl (1923: 438–439), Malinowski (1927:
 19 *passim*) found himself preoccupied with the question of whether "sav-
 ages" understood the details of conception. He found it "extraordinary"
 (given his belief in an ordered evolutionary hierarchy) that Melanesians
 should share the Australian aborigines' reputed ignorance of "the natur-
 al connection between intercourse and birth." Malinowski's own igno-
 rance, willful or otherwise, of the complexities of colonial relations comes
 through in his choice of anecdotes to illustrate his argument. In one, a
 young Papuan who has been away for two years becomes angry when a
 white man intimates that the recent birth of a child to the Papuan's wife
 demonstrates her infidelity (recounted in Stocking 1992: 255). The young
 man's response speaks as much or more to the economy of race and
 indentured labor in which he found himself than it does to any timeless
 "cultural" unfamiliarity with the facts of conception. The plantation sys-
 tem placed numerous strictures on sexuality; moreover, a situation in
 which a representative of the colonial powers made such an innuendo at
 the expense of the colonized could easily double as provocation.

9. Malinowski (1966: 40) later revised his analysis, noting that he had taken
 this particular exchange out of context by overlooking its place in a
 longer chain of transactions.

10. On changes in the meaning of "culture," see Sapir (1963) and Wagner
 (1981). Freud was not the only writer who opposed culture (or "civilization")
 to instinct. Malinowski, following his lead, included an entire section on
 "Instinct and Culture" in *Sex and Repression in Savage Society*, where he argued
 that "between the human parent and child under conditions of culture there

must arise incestuous temptations which are not likely to occur in animal families governed by true instincts" (1927: 164). According to Jeffrey Weeks (1986: 47), "The Darwinian revolution in biology, which demonstrated that man was part of the animal world, encouraged the search for the animal in man, and found it in his sex." For a critique of the utility of the culture concept for the analysis of social relations in the late twentieth century, see Abu-Lughod (1991); Coombe (1997); Thomas (1991); and Wagner (1981).

11. European explorers kidnapped Native Americans, too, and brought them back to Europe for profit and display (Takaki 1993: 30–31).

12. See, for a start, Asad (1973), Behar (1996), Diamond (1992), and Wolf (1996) on the politics of alliances between the social sciences and governments, power elites, reformers, employers, and social movements.

13. A debt evident across the decades, from Richard Burton's and F. F. Arbuthnot's (1995) early translation of the *Kama Sutra* to Foucault's (1978: 57) attribution of a static *ars erotica* to "China, Japan, India, Rome, [and] the Arabo-Moslem societies." Foucault postulated the *ars erotica* as a counterpoint to the West's *scientia sexualis*, both mechanisms for producing "the truth of sex."

14. For the accounts that sparked the initial controversy over the impact of erotic attraction on a researcher's perceptions and agenda, see Malinowski (1989) and Rabinow (1977). For more recent discussion of the same topic, see Kulick and Willson (1995). On the question of whether sleeping with people "in the field" can constitute an ethical research practice, see Altork (1995); Bolton (1991, 1995); and Murray (1991, 1996).

15. Interesting, too, that Mead—unlike Malinowski or Evans-Pritchard, who also wrote explicitly about "sex"—is the one more likely to be remembered as a chronicler of sexuality. Although it is common to cite Mead's reputation as a "popularizer" for the disregard in which her work came to be held by colleagues, reading practices that eroticized her work by reading it back through her body may also have contributed to her loss of stature well before the onset of the Mead/Freeman controversy. See "The Virtual Anthropologist," Chapter 9 in this volume, for suggestions as to why readers may continue to approach Mead's work in this way.

16. The citational practices described here are so widespread that to hold up one or two examples for censure would unfairly single out their authors. Some historians have credited social scientists such as McIntosh (1981) or Gagnon and Simon (1973) with giving them a greater sense of the variability and constructedness of the erotic (see Bleys 1995: 6). For the most part, however, humanities scholarship on sexuality continues to turn to social science for ostensibly factual data and evidentiary support.

17. "Ethnonostalgia" is a term coined by Diane Nelson in association with Mario Loarca (1996: 289) to describe the lingering power of "the primitive-modern divide." Nelson studied Mayan activists in Guatemala who used their skills as computer hackers to further political organization. She credits ethnonostalgia for the chuckles elicited by the very notion of a "Maya hacker" from friends and colleagues back in the States.

18. The video in question appeared in the "WGBH Boston Video" catalogue for Summer 1997, p. 38.

1. get thee to a big city

Acknowledgments: An earlier version of this essay was presented in 1992 at the Rural Women and Feminist Issues Conference, sponsored as part of the Rockefeller Residency Program by the Women's Studies Program at the University of Iowa. I am grateful to the participants in that conference for their comments, and to Janaki Bakhle, Kristin Koptiuch, Radhika Mohanram, Geeta Patel, and Kara Tableman for a series of thought-provoking conversations on migration and subjectivities. The National Science Foundation and American Association of University Women generously provided funding for field research.

1. Individuals interviewed for this essay varied in their preference for the terms "lesbian," "gay," "queer," "homosexual," or (in two cases) "bisexual." Where historical or textual context requires an inclusive term, I have elected to use "gay."

2. Although many of the people interviewed consented to have their real names appear in print, I employ pseudonyms for the sake of consistency and to protect the identities of those who felt themselves subject to censure in a society where homosexuality remains highly stigmatized.

3. For historical accounts of the impact of urbanization on the formation of homosexual subcultures, see Bérubé (1990); D'Emilio, (1983a, 1983b); and Trumbach (1977, 1985). Twelve of the eighty women and men I interviewed from 1985 to 1986 came of age in a rural setting. Although I did not trace migration patterns from one locale to another, I did record the number of years each person interviewed had resided in the Bay Area.

4. Cf. Anderson (1983), who discusses the introduction of book publishing under capitalism as a factor that contributed to the development of national consciousness.

5. Trumbach (1977) identifies "the anonymity of the city" as a factor contributing to the emergence of a homosexual "subculture" in European societies. See also Newton, who found that drag performers in the United States of the 1960s viewed themselves as "sophisticated urbanites. Organized nightlife is found in cities, and impersonators need the anonymity of cities to exist. But, more than this, impersonators see themselves as 'unnatural,' and in our culture, the city can accommodate every unnatural thing. It is the country that represents to us 'nature' and, ultimately, what is real. Impersonators said they felt uncomfortable in the country" (1979: 125). I am grateful to an anonymous reviewer for calling this passage to my attention.

6. Cf. Murray (1989), who found that chain migration and "gay networks" played a significant part in the process that brought self-identified gay men to San Francisco.

7. On the history of gender inversion theories, which considered "cross-gender" behaviors and traits reliable indicators of homosexuality, see Chauncey (1994) and Newton (1984). Although, as Chauncey argues, homosexuality in the United States has become increasingly defined by the sex of a person's partners (object-choice), rather than how s/he walks or what s/he does for a living, the inversion model persists in popular representations of

the effeminate faggot and the motorcycle-riding diesel dyke.

8. Herrell's (1992) analysis of Chicago's lesbian/gay pride parade explores the multiple, changing, and sometimes contradictory nuances of "gay community." On the fragmentation of lesbian/gay identity and the emergence of queer politics and theory, see Berlant and Freeman (1992); Duggan (1992); and Solomon (1992).

9. For a limited but useful account of the historical emergence of gay neighborhoods and their part in reshaping urban space, see Castells (1983). On the relationship of events like the Christopher Street Promenade to the consolidation of gay identity in an urban location, see Kugelmass (1993).

10. To the extent that cultures and homelands are invented as such and lend themselves to romanticization, life on the rez is no exception. At other times Danny admitted that during his trips "back home," he often struggled with boredom and the low pay and hard routine of life on a ranch.

2. forever is a long time

Acknowledgments: My thanks to David Halperin, Marilyn Ivy, Ellen Lewin, Radhika Mohanram, Geeta Patel, David Schneider, and Sylvia Yanagisako for their thought-provoking comments on this essay. Linda Watts and Alison Stratton provided invaluable assistance in locating research materials. Grants from the American Association of University Women and the National Science Foundation funded field research for the study. An earlier version of the essay was presented at the 1992 Matrilineality and Patrilineality in Comparative and Historical Perspective conference, University of Minnesota.

1. Here and throughout, I have changed names and (in the vignettes) developed composite portraits to preserve the anonymity of individuals I worked with while in the field. In addition to participant observation in the San Francisco Bay Area from 1985 to 1987 (with a follow-up visit in 1990), this study draws upon a set of eighty interviews with self-identified lesbians and gay men. People of color made up approximately one-third of the interview sample. About half of the interviewees could be described as coming from a working-class background, with a similar percentage of the whole employed in working-class occupations at the time of the study. For further details on the composition of the interview sample, see Weston (1991: 215–221).

2. When I employ the term "gay" without qualification, I intend the category to embrace self-identified gay men and lesbians. At various points in the essay, I substitute the phrase "lesbians and gay men" to remind readers that gendered differences (as well as differences of age, class, language, nationality, racial identification, and so on) crosscut this population.

3. For a feminist critique of the liberal individualism that frames discussions of friendship as a voluntary relation, see Friedman (1989).

4. For classic elaborations of the contrast between "real" and "fictive" kin, see Eisenstadt (1956) and Pitt-Rivers (1968).

5. See also Rapp (1987) and Yanagisako and Collier (1987).

6. What I call "the critique of kinship approach" refers to a theoretical tendency within kinship studies rather than a single school of thought or

mode of analysis. Considerable variation exists in the research agendas of anthropologists who have built upon Schneider's work. Yanagisako and Collier (1987), for example, have argued that gender constructs permeate the symbolism of bodies, biology, and procreation in understandings of kinship in the United States. Elsewhere, Yanagisako (1985) has explored how the historical construction of ethnicities inflects the meanings carried by core symbols such as "love" that are ostensibly held in common by participants in "American culture."

7. See Handler (1988); M. Jones (1990); Orvell (1989); and Sedgwick (1990).

8. On the ways "biology" figures in discourse on lesbian and gay families, see E. Lewin (1993a) and Weston (1991).

9. E.g., African-American, Puerto Rican, and American Indian gay men and lesbians raised the topic of genocide in discussions of parenthood more often than whites, whose racial identification inserted them into the history of race relations in a different way.

10. In the United States, features of kinship that scholars sometimes treat as paradigmatic also tend to be already (if not always) raced and classed. But that is the subject of another essay. For an investigation of differences in the meanings carried by terms such as "love," especially in association with cultural constructions of ethnicity, see Yanagisako (1985).

11. Cf. Nardi (1992a: 118), who contends that illness in general, and AIDS in particular, heightens the importance of friendship in the lives of lesbians and gay men.

12. *Compadrazgo* institutionalizes the relationship between a child's godparents and parents. When people "go for sisters (brothers, etc.)," they formalize their relationship by applying kinship terminology to a "nonbiological" tie.

13. Urban gay male and lesbian populations in the United States have long celebrated the "strength" and centrality of friendship (Nardi 1994). On the historical developments associated with the successive institutionalization of nonerotic friendships among homosexuals, followed by the concept of "gay community" and finally "gay families," see D'Emilio (1983b); Nardi (1992a); and Weston (1991).

14. Friendship has not always been construed as a temporally contingent relationship in Anglo-European societies (cf. Cicero 1898; O'Hara 1991). For a speculative treatment that links the construction of homosexuality as an identity to the devaluation of friendship, see Foucault's comments in Gallagher and Wilson (1987).

15. In one study, gay people were the only respondents likely to turn to friends before "blood" or adoptive relatives when seeking emotional support (cited in Nardi 1992a: 110).

16. Lesbians and gay men applied kinship terms to one another well before the 1980s, but these older usages were not organized by the cultural category of "choice" (see Weston 1991: 127; 135–136). Contemporary discussions of gay families are marked by a relative absence of kinship terminology, with at least two important exceptions: (1) terms of address used by children for adults (Mama, Tío, Aunt, etc.), and (2) the house system that organizes the African-American drag balls documented in Goldsby (1989) and the video "Paris Is Burning." For more on lesbian/gay community formation in the

years leading up to the 1980s, see D'Emilio (1983b, 1989); Herdt (1991a, 1991b); Kennedy and Davis (1993); and Newton (1993a).

17. Also at issue is who counts as an ex-lover. See Nardi (1992a, 1992b), who found sex and sexual attraction to be common elements in "best friend" relationships among white, middle-class gay men. When friendships persisted, sexual involvement tended to diminish over time.

18. Though this practice was more common in the past, it has not disappeared from anthropological accounts of friendship and other "nonbiological" kinship relations. See, for example, Uhl, who distinguishes the female friendships she studied in Andalusia from "special friendships instituted through . . . fictive kinship" (1991: 90).

19. See Gilmore (1975), who argues in a very different context against the tendency to view friendship as a substitute for kinship or as a residual category used to describe meaningful ties in the absence of kinship organized through a procreative nexus.

20. "Common-law marriage," which grants legal status to heterosexual couples who have not formally registered their union with the state, relies upon a similar criterion of coresidence over a specified period of time. Despite this apparent continuity with domestic partnership, common-law marriage today takes effect by default, incorporating heterosexual couples into the institution of marriage with little effort on their part. In contrast, domestic-partnership policies have been hard won through political battles that have brought into play strategic depictions of long-term lesbian and gay relationships.

21. Significantly, this pattern seems to hold for coverage in both the gay and non-gay press.

22. On the distinction between metaphorical and historical time, as well as the importance of analyzing the historical processes associated with the transformation of cultural constructs, see Thomas (1989).

23. Anita Levy discusses anthropology's part in creating a model of kinship grounded in a biologized concept of sexuality and gender difference. This new formulation was "a class- and culture-specific model to be sure, but one that appeared universal and natural. . . . The formation of this new family model out of older historical materials lent the emergent middle classes an appearance of legitimacy and permanency it [sic] would not otherwise enjoy" (1991: 59). On the dehistoricizing impact of ideologies that naturalize social relations, see also Eagleton (1991: 59).

24. Kathleen Jones's (1991) concept of authority is more useful for understanding the claims for entitlement and open-ended definitions of family advanced by gay kinship ideologies than the more customary equation of authority with determinate meanings and social control. I am grateful to Ellen Lewin for drawing my attention to this source.

3. made to order

Acknowledgments: Many thanks to Geeta Patel for a series of conversations that helped me think through various dimensions of the rhetoric of choice as it bears on tranformations of kinship in the United States.

1. Perhaps the one area of agreement between Anthony Giddens and his crit-

ics. For a concise statement of Giddens' theory of structuration, see Giddens (1979). Critiques include Baber (1991); R. Collins (1992); and Sewell (1992). On questions of structure and agency more generally, see Callinocos (1988); Mouzelis (1993); Scheppele (1994); and Wharton (1991).

2. A reading that may be related to the persistence of keen academic interest in agency, rather than structure, as the debate on structure versus agency wanes (e.g., Povinelli [1993]).

3. An example taken from the documentary *They're Doing My Time*, produced and directed by Patricia Foulkrod (New York: Cinema Guild/West Glen Films, 1989).

4. On the raced and gendered character of the juridical subject, see Poovey (1992) and P. Williams (1991).

5. An allusion to Stacey (1991), who, of course, sees much more fundamental transformations occurring in the "postmodern" families she studied.

6. Attention to rhetorical strategies would complicate, for example, E. Lewin's (1993a) discussion of "same versus different" with respect to lesbian mothers.

4. production as means, production as metaphor

Acknowledgments: My thanks to Celeste Morin, Kathy Phillips, Lisa Rofel, and Sylvia Yanagisako for their suggestions and support.

1. Contrast, for example, the approach of Strober and Arnold (1987). This study of women's movement into bank telling treats competence as something related to intrinsic job requirements, without considering that requirements and notions of competence can themselves be questioned and meaningfully interpreted.

2. For discussions of a shift in composition from male to female in particular occupations, see Greenbaum (1979) and Strober (1984).

3. Davies (1975); Edwards (1979); Milkman (1982, 1988).

4. Hartmann (1976); see also Strober (1984).

5. Cf. Salaman (1980: 1). Salaman's call for more attention to the role of ideology in "mystifying and buttressing work hierarchies and inequalities" reflects the degree to which the view of ideology as an overlay obscuring more fundamental socioeconomic factors permeates the sociology of work.

6. To reduce discourse on gendered traits to a rationalization for paying women lower wages cannot account for persistent references to gendered traits when employers justify their use of *higher*-paid male labor in skilled trades (cf. Benería 1987).

7. On labor market segmentation theory, see Edwards (1979) and Gordon et al. (1982). Nichols (1980) correctly notes that scholars have studied management more through pronouncements of industry journals and business school texts than through observation of action and decision-making processes. To his list of neglected subjects, I would add the less codified ideologies that affect management practices.

8. See Bourdieu (1977); Comaroff (1981); and Sahlins (1976). I speak here of ideology in its widest sense, as the culturally constituted symbols, meanings, and everyday "common sense" understandings that allow us to reason and perceive, to persuade, implicate, and struggle.

9. On the uncelebrated success of such small local programs, see Reskin and Hartmann (1986). The same authors note that when the OFCCP (Office of Federal Contract Compliance Programs) targeted the mining industry in 1978, the number of women working as underground miners rose from 1 in 10,000 to 1 in 12 within two years.

10. See Marx (1967) and Storey (1983).

11. Less common objections include "men won't work with women around" and "we had one once but she didn't work out," both of which touch on employer concern with production. Also mentioned were "women aren't dependable," "women belong in the home," "women have children and quit," "women can't handle swearing," "we only have one bathroom," and "my wife won't let me hire a woman" (Weston 1982: 139-145).

12. In his labor theory of value, Marx pays relatively little attention to the mode of expending labor power, since it contributes nothing in and of itself to the exchange value of a product (see Walliman 1981).

13. Sometimes, of course, employers fail to issue required safety equipment to discourage workers from using it, often in the belief that its use will slow down production. This type of overt negligence should not be confused with subtler pressures that associate competence and productivity with displays intended to "show" gendered traits.

5. sexuality, class, and conflict in a lesbian workplace

Acknowledgments: Our thanks to the women of Amazon for their willingness to relive their experiences of the conflict with us; and to Jane Atkinson, Akhil Gupta, Nancy Hartsock, Rebecca Mark, Sabina Mayo-Smith, Kathy Phillips, Renato Rosaldo, the San Francisco Lesbian and Gay History Project, and Anna Tsing for their insights and support.

1. For examples of the interpretation of class as class background within the lesbian-feminist movement, see Bunch and Myron (1974) and Gibbs and Bennett (1980).

2. One woman had moved out of the area, and we were unable to contact the remaining mechanic.

3. Regardless of where one stands in the definitional debate on lesbian identity (see Ferguson et al. 1981), it is clear that competing usages of the term "lesbian" all rest on criteria such as friendship, sexuality, and feeling, which historically have been assigned to the realm of the personal.

4. See Kuhn and Wolpe (1978) and I. Young (1981).

5. Lesbian identity then becomes a defining element of a distinctive type of workplace culture, making Amazon something more than an aggregation of isolated employees who "happened" to be lesbians or a repository for the piecemeal importation of artifacts from lesbian feminism.

6. In our heterosexist society, "woman" and "feminist" often function as code words among lesbians for "lesbian" and "lesbian feminist," in much the same way as sexism encourages the substitution of "people" or "men" as generic terms for "women."

7. The bridging of the private/public split provides a mechanism to explain the high levels of commitment often noted as characteristic of lesbian

institutions (see Ponse 1978). Contrary to Ponse's findings, no signifi-
cant association between commitment and conformity appeared in the
Amazon case.

8. An assumption widely criticized in recent years in the discussion on race
and difference within the women's community (see Moraga and
Anzaldúa 1981).

9. Compare McCoy and Hicks (1979). Their exclusively personal conception
of power ignores the possibility that both power and needs may be shaped
by social relations like class that divide the lesbian community.

10. We do not mean to imply that the owners' fears for the survival of lesbian
businesses are groundless; we do question the allegation that the workers
acted as agents of reactionary forces.

11. On the links between the changing organization of production and class rela-
tions under industrial capitalism, see Braverman (1974) and Edwards (1979).

12. Following Ollman (1971), we take alienation to mean a separation of the
individual from her life activity, the products of her labor, and other
human beings within the labor process.

13. See Marx and Engels (1978: 51–52).

14. For cross-cultural discussions of relationally defined gender constructs, see
MacCormack and Strathern (1980) and Ortner and Whitehead (1981).

15. On the owners' side, this understanding reflected lesbian-feminist ideolo-
gy, but for most workers it developed through an appeal to notions of gen-
der and sexuality to explain differences in their work experiences at
Amazon and at other businesses.

16. On the concept of hegemony, see Gramsci (1980) and R. Williams (1977).
Introducing power as a variable challenges Krieger's (1985) static view of
lesbian communities as either supportive or coercive to individuals.

17. Clearly it would be impractical for every lesbian auto mechanic to open
her own repair shop. This admonition also avoids dealing with the
source of the divisions in the lesbian community by deprecating worker
struggles and initiatives.

18. Garnsey (1978) advances these categories in an attempt to correct the
androcentrism of such theories.

19. The isolated attempts to apply socialist-feminist analysis to lesbians
ignore class relations within the lesbian community, directing their
attention instead to the origins of women's oppression or to relations at
the gay/straight boundary. In addition to Riddiough (1981), see S.
Williams (1980).

20. Hartsock (1981) draws a useful distinction between power understood as
domination and power understood as energy, capacity, and initiative.

6. theory, theory, who's got the theory?

1. Unpublished handout distributed at the first plenary session,
InQueery/InTheory/InDeed: Sixth North American Lesbian, Gay, and
Bisexual Studies Conference, University of Iowa, November 1994.

7. lesbian/gay studies in the house of anthropology

Acknowledgments: The final form of this essay owes much to the efforts of two research assistants, Alison Stratton and Linda Watts, who worked on the project at various stages. Ellen Lewin and Michael Moffatt made valuable suggestions about how best to organize this sort of review. Kristin Koptiuch and Ellen Lewin gave new meaning to the term collegiality by commenting on an earlier draft with less than 48 hours' notice. Conversations with Lisa Bower, Thaïs Morgan, Esther Newton, and Geeta Patel helped clarify my thinking on several topics discussed here. Arizona State University West generously provided release time and other forms of material support. Thanks are also due to the colleagues and friends—too many to name—who contributed bibliographic references, contacts, support, and condolences once they discovered I had taken on the task.

1. Although the term *berdache* is widely used in the literature under review, it has acquired pejorative connotations. Since the original publication of this essay, *Two-Spirit* has replaced *berdache* as the preferred term.
2. See also Allen (1981); Blackwood (1984); Callender and Kochems (1983, 1985); Devereux (1937); Forgey (1975); Grahn (1986); Greenberg (1986); Gutiérrez (1989, 1991); Kenny (1988); Kroeber (1940); Midnight Sun (1988); J. Miller (1982); Pilling (1992); Roscoe (1988b, 1990, 1991, 1992); Schaeffer (1965); Thayer (1980); Whitehead (1981); W. L. Williams (1992a).
3. Compare Dickemann (1993).
4. See Feldman (1986, 1989); Gorman (1991); Herdt (1989b); Herdt and Boxer (1993); Singer, Flores, Davison, Burke, Castillo et al. (1990).
5. See also Winkler's argument (1990) that ancient Greek society had its own versions of sexual identities, though none equivalent to "homosexual."

8. requiem for a street fighter

Acknowledgments: Many thanks to Esther Newton and Geeta Patel for their insightful comments on an earlier draft of this chapter. Versions of the essay were presented at the 1992 annual meetings of the American Anthropological Association in San Francisco and the 1991 OutWrite: National Gay and Lesbian Writers Conference.

1. "As to my *Requiem,* perhaps I have also instinctively sought to escape from what is thought right and proper, after all the years of accompanying burial services on the organ! I know it all by heart. I wanted to write something different" (translated in Orledge [1979]: 113). On Fauré's attempt to develop a composition that could meld classical structure with artistic innovations, see Nectoux (1991). Subheadings in this essay derive from the expanded orchestral version of Fauré's *Requiem,* Opus 48.
2. On the lack of any necessary correspondence between "insider" status and nearness to the people who end up as the focus of a research study, see Limón (1991) and Sarris (1991). Kondo (1990) discusses her experience of a "collapse of identity" as a Japanese-American woman conduct-

ing research in Japan. For Behar, fieldwork precipitated a "personal crisis of representation" that entailed situating herself as (among other things) "another new mestiza who has infiltrated the academy" (1993: 339). On the ever-shifting category "self," see also Butler (1991).

3. The annual OutWrite conference for lesbian, gay, bisexual, and transgender writers is a case in point. For a range of contributions to this discussion within anthropology, see Clifford and Marcus (1986); Fox (1991); Geertz (1988); Mascia-Lees, Sharpe, and Cohen (1989); Rosaldo (1989); Sangren (1988); and Thomas (1991).

4. Taken from Butler (1990); Lutz (1988); Sears (1991); and Povinelli (1993), respectively.

9. the virtual anthropologist

Acknowledgments: An earlier version of this chapter was presented in 1995 at the colloquium series in the Department of Anthropology, Princeton University. The essay has benefited greatly from a series of conversations with Deb Amory, Jared Braiterman, Susan Cahn, Rebecca Etz, Kristin Koptiuch, Yasumi Kuriya, Thaïs Morgan, Geeta Patel, Suzanne Vaughan, participants in the 1994 Anthropology and "the Field" conference organized by Jim Ferguson and Akhil Gupta at Stanford University and the University of California, Santa Cruz, and participants in the 1994 Thinking, Writing, Teaching, and Creating Justice conference hosted by the Center for Advanced Feminist Studies at the University of Minnesota. Smadar Lavie read the manuscript and offered many thoughtful suggestions, not all of which could be incorporated here. Special thanks to VéVé Clark for the irreverent comments and heartfelt exchange that helped make this essay what it is today. Finally, my thanks to colleagues like Celia Alvarez, Jean Comaroff, John Comaroff, Tim Diamond, Smadar Lavie, Sylvia Yanagisako, and the late David Schneider, who have all challenged in productive ways the processes that can render someone virtual.

1. "Native" is a problematic term that keeps people in their place by essentializing their characters, bounding their communities, and otherwise subjecting them to the disciplinary legacies of racism that emerged from colonial rule (Bhabha 1994; Narayan 1993). In this chapter, I capitalize Native Ethnographer to underscore the category's status as representation rather than birthmark.

2. Whether the production of the scholar who studies "her own" as a particular sort of hybrid obtains for fields such as literature or sociology, I leave to colleagues from those disciplines to determine. In some respects, the Native Ethnographer is a subject position peculiar to anthropology, with its long history of participation in the colonial ventures that produced "the native" as an object of Euro-American subjugation. Yet the processes of nativization unleashed by colonialism proceed apace within the academy as well as the world at large. Scholars of color who work in "ethnic studies" have found themselves produced in analogous fashion for the viewing (dis)pleasure of colleagues. As a candidate for the top position on a university campus, Arturo Madrid (1992: 10) confronted the question, "Why does a one-dimensional person like

you think he can be the president of a multi-dimensional institution like ours?" Lisa Duggan (1995) fielded similar insults from colleagues who wondered aloud how she, a "gay historian" (note the collapse of subject researcher into object research), could possibly be qualified to teach "generic" topics in American history. With regard to anthropology, Ruth Behar (1993: 299) eloquently conveys the effects of an identity politics that filters scholarship back through bodies whenever the bodies in question are marked as Other: "You mainly read women anthropologists for their critiques of androcentrism, and you mainly read anthropology or cultural criticism by people of color for their particular accounts of local places, or at best, as grist for your already grinding theoretical mill. You don't read either for 'high theory,' the sort of understandings that are supposed to be of such translocal importance that they can serve as grids for work anywhere. The more neutralizing the translation of local accents, the better. Ironic, isn't it? Can this be the discipline whose legitimacy is so wrapped up in foreign languages and worlds?"

3. This nativization of gay men and lesbians across race is quite evident in "The Gay Agenda," a video produced by a right-wing group in California and widely distributed to libraries across the United States. The video intersperses footage from the annual San Francisco gay and lesbian pride parade with talking heads who are trotted on screen to present unfounded statistics about "cure" rates and sexual habits of homosexuals. Against a visual montage of gyrating bodies, naked body parts, and sexual innuendo, a narrator intones dire warnings about the out-of-control sexuality and insatiable hunger for political power lurking behind the mild-mannered façade of gay rights groups. These hypersexualized and hyperbiologized representations of queers draw upon a long and racist history of depicting imagined threats to civilization as "we" know it, from portrayals of African Americans during Reconstruction to characterizations of aliens in horror films (cf. Bukatman 1993: 262).

4. Anthropologists have tended to construct morally graded variants of the (ideal but vanishing) native along continua from good to bad, genuine to faux, traditional to modern, rural to urban, inner-city to suburban, living in pristine isolation to having been corrupted by the lures of Western civilization (see Gupta and Ferguson 1997). Because the ideal native is also the native considered most suitable for study, it is not so surprising that, despite the recent nativization of lesbians and gay men, there has been no rush of anthropologists to the gold fields of queer studies.

5. This is not to say that queers of color and white queers in the United States occupy the same position, even vis-à-vis queerness, as a result of nativization. Witness the anger and discomfort voiced by several members (most of them people of color) of the Society of Lesbian and Gay Anthropologists when the group sold T-shirts that read, "These natives can speak for themselves." In this instance the term *native* became a contested site, with distributors of the T-shirt arguing that they had *reappropriated* the term *native* and critics decrying what they regarded as an *appropriation* of ethnicity carried out by a predominantly white group (cf. Bustos-Aguilar 1995: 164–165). Bustos-Aguilar presents a thoughtful,

impassioned critique of the ways in which white gay ethnographers have colluded in (not-yet-post-)colonial relations. His remarks are particularly scathing on the subject of the colonialist presumptions that continue to infuse research projects on same-sex eroticism and on the tendency for fieldwork "abroad" to edge over into sex tourism or surveillance.

6. Patel (1997a) and Raiskin (1994) discuss how processes of nativization undercut the complexity of ambiguously sexed/raced/nationalized bodies by tethering people to fixed social locations. On the discomfort and ambivalence associated with the racialized and sexualized colonial stereotype that helps produce the native, see Bhabha (1994). For a feminist critique of home as a locus of safety and familiarity, see Martin and Mohanty (1986) and M. B. Pratt (1991).

7. "Joins," that is, if colleagues have not already located her in this lineage by virtue of ethnicity, religion, and/or nationality (cf. Ashcroft, Griffiths, and Tiffin 1989). For authors who write explicitly, though not always contentedly, from the position of "native anthropologist" or "insider ethnographer," see Abu-Lughod (1991); D. Jones (1970); Limón (1991); Narayan (1993); Sarris (1991, 1994); and Zavella (1993).

8. Gloria Anzaldúa (1987; "borderlands" and "*mestizaje*"), Homi Bhabha (1994; hybridity as a product of colonial encounters), and Gerald Vizenor (1990; "crossbloods") have laid much of the theoretical groundwork for discussions of identities that will neither stay pure nor stay put. For examples incorporating the concepts of hybridity and *mestizaje* into scholarly discussions of multiculturalism, see Lavie and Swedenburg (1996); Lowe (1991); Lugones (1994); and C. West (1993). Hale (1994: 18) explores the complex relationship between *mestizaje,* nationalist ideologies, and the state, as well as the contention that *mestizaje* represents a "new form of colonialism" for people who identify as *indígenas.* In the intellectual borderlands where academic and popular audiences meet and meld, Lisa Jones (1994) and Greg Tate (1992) have also challenged readers to grapple with the historical contingencies of raced categories. M. B. Pratt (1995) conveys the slipperiness of terms such as "woman," "man," and "lesbian sexuality." Asad (1993), Crenshaw (1995), and Weston (Chapter 1, this volume) explore some of the material consequences of an identity politics that depends upon bounded, mutually exclusive categories like "sex" and "race" for its (in)effectiveness.

9. Nancy Hewitt (1992) has also used the distinction between mixtures and compounds to clarify matters of difference and identity in the United States. I am grateful to Rebecca Etz for calling this reference to my attention.

10. Narayan (1993) uses the term "hybridity" in her thought-provoking essay on the so-called native anthropologist, but in the sense of an additive rather than a compound relationship. In Narayan's account, hybridity brings two static, given social locations into a relationship, producing what I describe here as a mixture. Her discussion of "enactments of hybridity," which turns everyone into a hybrid with respect to something, includes a valuable exploration of the ways in which identities are selected and highlighted contextually. Yet this emphasis carries with it the danger of glossing over the power relations that historically have marked

particular people as particular sorts of hybrids. I see hybridity as a process that, once contextually invoked, not only locates but also subordinates people by encouraging most things they do or say to be interpreted through the compound category taken to define their hybridity.

11. The operations of hybridity may also help explain the anecdotal evidence that people who simultaneously claim a queer identity and study queer communities have greater difficulty finding employment than individuals who do one or the other. See also Newton (1993c).

12. "Natives" may be construed as objects for study, but not all objects of study are construed as natives. Anderson's now classic work (1983) on nationalism and imagined communities explores the processes that affiliate certain identities (but not others) with membership in "a people." For more on the impact of the fantasy of primitivism on anthropological practice and popular imagination, see Kuper (1988).

13. In this sense, hybridity has the potential to disrupt processes of nativization that attempt to fix subjects and hold them steady. On morphing and shape-shifting, see Bukatman (1993) and Smith (1993). On hybridity as a "space" of productivity, see Muñoz (1995). But see also Robert Young (1995), who cautions that the concept of hybridity can subtly reinforce (neo)colonialist fears of miscegenation and lend credence to efforts to police the boundaries of ostensibly pure (often racialized) categories. Awkward (1995) insightfully explores tensions between the instability of categories of gender or race (or class or sexuality), and the tendency to treat these categories of difference as though they were set in stone. For some of the ways in which naturalizing identity works to naturalize power, see Yanagisako and Delaney (1995).

14. I am grateful to Susan Cahn, always up for a good paradox, for helping me articulate this point.

15. But see Newton (1993b), who has taken reflexive anthropology to task for its failure to acknowledge that sexuality can be another arena in which ethnographers wield power over people "in the field."

16. Coombe (1993) offers an excellent critique of simplistic mappings of "voice" onto identity, standpoint, authenticity, or authority to speak on behalf of a group.

17. For further discussion of these authorizing devices, see Fabian (1983) on temporal distancing; Clifford (1988), Geertz (1988), and M. L. Pratt (1986) on geographic distancing; and Appadurai (1988) on the rhetorical mapping of people onto place entailed in nativization. Lavie and Swedenburg (1996) discuss the breakdown of distinctions between "home" and "field," researcher and researched, in the wake of diasporas and resistance movements.

18. On the relationship between imagined communities and identity politics, see Anderson (1983); Berlant and Freeman (1993); and Bhabha (1990).

19. Here again, however, the virtual anthropologist's extremely high level of education limits the legitimacy achievable with this tactic by rendering her a less than ideal native.

20. On the topic of the manual work discipline attached to mental labor, I am indebted to a series of discussions with Thaïs Morgan.

21. The point is not that social positioning and experience make no differ-
 ence, but rather that they are not transparent and do not lead to effort-
 less understanding or instant rapport (Behar 1993; Sarris 1991, 1994;
 Scott 1992). Narayan (1993) offers an excellent critique of the mislead-
 ing implications of the term *insider anthropologist.*
22. In Behar's *Translated Woman* (1993), for example, the author's "I" frames
 Esperanza's first-person account, effectively transforming Esperanza's
 "I" into a "you" (similarly for Shostak [1981] with Nisa, Crapanzano
 [1980] with Tuhami, and a host of others). The framing devices of
 authorship, introductions, and moments of reflexivity that have the
 power to interrupt the flow of a narrative undermine the apparent egal-
 itarianism of first-person pronouns by smuggling in old dichotomies.
 The resulting accounts, however innovative, end up consolidating "I,
 Native" and "I, Ethnographer" as mutually exclusive positions from
 which to speak and write. It's Self and Other, Us and Them, anthropol-
 ogist and informant all over again. For the virtual anthropologist, in con-
 trast, recourse to the ethnographic "I" makes nativization, exoticization,
 and stigmatization that much more likely to ensue. I am grateful to
 Geeta Patel for clarifying and queering my thinking about the work of
 pronouns in a text.
23. See Newton (1979, 1993a) and Román (1993) for analyses of camp as a
 form of intervention and resistance. Ross (1993) is more cautious, not-
 ing the link between camp and capitalist forms of commodity fetishism.
24. On the distinction between the virtual, the simulated, and the imitative,
 see Rheingold (1991) and Woolley (1992).
25. But see Bhabha's (1990: 292) guarded response to revisionist interpreta-
 tions that treat marginality as a potential site for resistance as well as vic-
 timization. Perhaps, he comments, scholars have been too quick to cele-
 brate the virtues of exile.
26. Collins grounds her concept of "the outsider within" in African-
 American women's work as slaves and domestic servants. She argues that
 the conditions of oppression responsible for locating black women's
 labor squarely in the domestic space of white families afforded African-
 American women a distinctive (and potentially subversive) perspective
 on white elites. More infiltrator than member, the outsider within occu-
 pies a vantage point that allows her to see things veiled from the privi-
 leged themselves.
27. Hybridization as a Native Ethnographer is a more complex operation
 than the exile that results from "discrimination," because hybridization
 is not an unmediated consequence of bearing the stigmata of nativity (cf.
 D'Emilio 1992). Neither do center/periphery models, with their con-
 comitant strategies of inclusion and critique, disrupt the process of
 nativization. This is a case in which Lefebvre (1991) is right to reject the
 geometric bent in the scholarly imagination that turns everything into a
 "space."

references

Abelove, Henry, Michèle Aina Barale, and David M. Halperin, eds. 1993. *The Lesbian and Gay Studies Reader.* New York: Routledge.

Abu-Lughod, Lila. 1986. *Veiled Sentiments: Honor and Poetry in a Bedouin Society.* Berkeley: University of California Press.

——— 1991. "Writing Against Culture." In *Recapturing Anthropology,* ed. Richard G. Fox, pp. 137–162. Santa Fe, N.M.: School of American Research.

Achilles, Nancy. 1967. "The Development of the Homosexual Bar as an Institution." In *Sexual Deviance,* ed. John H. Gagnon and William Simon, pp. 228–244. New York: Harper & Row.

Adam, Barry D. 1986. "Age, Structure, and Sexuality: Reflections on the Anthropological Evidence on Homosexual Relations." In *Anthropology and Homosexual Behavior,* ed. Evelyn Blackwood, pp. 19–33. New York: Haworth.

Allan, Graham. 1989. *Friendship: Developing a Sociological Perspective.* New York: Harvester Wheatsheaf.

Allen, Paula Gunn. 1981. "Beloved Women: Lesbians in American Indian Cultures." *Conditions* 7: 67–87.

Allyn, E. 1992. *Trees in the Same Forest: Thailand's Culture and Gay Subculture.* Bangkok: Bua Luang.

Altork, Kate. 1995. "Walking the Fire Line: The Erotic Dimension of the Fieldwork Experience." In *Taboo: Sex, Identity, and Erotic Subjectivity in Anthropological Fieldwork,* ed. Don Kulick and Margaret Willson, pp. 107–139. New York: Routledge.

Alvarez, Robert R., Jr. 1987. *Familia: Migration and Adaptation in Baja and Alta California, 1800–1975.* Berkeley: University of California Press.

Anderson, Benedict. 1983. *Imagined Communities: Reflections on the Origin and Spread of Nationalism.* London: Verso.

Angelino, Henry and Charles L. Shedd. 1955. "A Note on Berdache." *American Anthropologist* 57: 121–125.

Anzaldúa, Gloria. 1987. *Borderlands/La Frontera: The New Mestiza.* San Francisco: Spinsters/Aunt Lute.

Appadurai, Arjun. 1988. "Putting Hierarchy in Its Place." *Cultural Anthropology* 3 (1): 36–49.

Arguelles, Lourdes and B. Ruby Rich. 1984. "Homosexuality, Homophobia, and Revolution: Notes Toward an Understanding of the Cuban Lesbian and Gay Male Experience, Part I." *Signs* 9 (4): 683–699.

———. 1985. "Homosexuality, Homophobia, and Revolution: Notes Toward an Understanding of the Cuban Lesbian and Gay Male Experience, Part II." *Signs* 11 (1): 120–136.

Aronowitz, Stanley. 1981. *The Crisis in Historical Materialism.* New York: Praeger.

Asad, Talal, ed. 1973. *Anthropology and the Colonial Encounter.* New York: Humanities Press.

———. 1993. *Genealogies of Religion: Discipline and Reasons of Power in Christianity and Islam.* Baltimore: Johns Hopkins Press.

Ashcroft, Bill, Gareth Griffiths, and Helen Tiffin. 1989. *The Empire Writes Back: Theory and Practice in Post-Colonial Literatures.* New York: Routledge.

Awkward, Michael. 1995. *Negotiating Difference: Race, Gender, and the Politics of Positionality.* Chicago: University of Chicago Press.

Baber, Zaheer. 1991. "Beyond the Structure/Agency Dualism: An Evaluation of Giddens' Theory of Structuration." *Sociological Inquiry* 61 (2): 219–230.

Baldwin, J. D. and J. L. Baldwin. 1989. "The Socialization of Homosexuality and Heterosexuality in a Non-Western Society." *Archives of Sexual Behavior* 18 (1): 13–29.

Barrett, Michèle. 1980. *Women's Oppression Today: Problems in Marxist-Feminist Analysis.* London: Verso.

Barrett, Martha Barron. 1989. *Invisible Lives.* New York: William Morrow.

Basu, Amrita, ed. 1993. "Women and Religious Nationalism in India." Special issue of the *Bulletin of Concerned Asian Scholars* 25 (4).

Becker, Carol S. 1988. *Unbroken Ties: Lesbian Ex-Lovers.* Boston: Alyson.

Behar, Ruth. 1993. *Translated Woman: Crossing the Border with Esperanza's Story.* Boston: Beacon Press.

———. 1996. *The Vulnerable Observer: Anthropology That Breaks Your Heart.* Boston: Beacon Press.

Benedict, Ruth. 1939. "Sex in Primitive Society." *American Journal of Orthopsychiatry* 9 (3): 570–573.

———. 1959. *Patterns of Culture.* Boston: Houghton Mifflin.

Benería, Lourdes. 1987. "Gender and the Dynamics of Subcontracting in Mexico City." In *Gender in the Workplace*, ed. Clair Brown and Joseph A. Pechman, pp. 159–188. Washington, D.C.: The Brookings Institution.

Bergman, David, ed. 1993. *Camp Grounds: Style and Homosexuality.* Amherst: University of Massachusetts Press.

Berlant, Lauren and Elizabeth Freeman. 1992. "Queer Nationality." *boundary 2* 19 (1): 149–180.

Berndt, Ronald M. and Catherine H. Berndt. 1951. *Sexual Behavior in Western*

Arnhem Land. New York: The Viking Fund.

Bérubé, Allan. 1990. *Coming Out Under Fire: The History of Gay Men and Women in World War Two.* New York: Free Press.

Bhabha, Homi K. 1990. "DissemiNation: Time, Narrative, and the Margins of the Modern Nation." In *Nation and Narration,* ed. Homi K. Bhabha, pp. 291–322. New York: Routledge.

———. 1994. *The Location of Culture.* New York: Routledge.

Blackwood, Evelyn. 1984. "Sexuality and Gender in Certain Native American Tribes: The Case of Cross-Gender Females." *Signs* 10 (1): 27–42.

———, ed. 1986a. *Anthropology and Homosexual Behavior.* New York: Haworth.

———. 1986b. "Breaking the Mirror: The Construction of Lesbianism and the Anthropological Discourse on Homosexuality." In *Anthropology and Homosexual Behavior,* ed. Evelyn Blackwood, pp. 1–17. New York: Haworth.

Bleibtreu-Ehrenberg, Gisela. 1990. "Pederasty Among Primitives: Institutionalized Initiation and Cultic Prostitution." *Journal of Homosexuality* 20: 13–30.

Bleys, Rudi C. 1995. *The Geography of Perversion: Male-to-Male Sexual Behavior Outside the West and the Ethnographic Imagination, 1750–1918.* New York: New York University Press.

Boas, Franz. 1940. *Race, Language, and Culture.* Chicago: University of Chicago Press.

Bolin, Anne. 1987. "Transsexualism and the Limits of Traditional Analysis." *American Behavioral Scientist* 31 (1): 41–65.

———. 1988. *In Search of Eve: Transsexual Rites of Passage.* South Hadley, Mass.: Bergin & Garvey.

———. 1992. "Coming of Age Among Transsexuals." In *Gender Constructs and Social Issues,* ed. Tony L. Whitehead and Barbara V. Reid, pp. 13–39. Chicago: University of Illinois Press.

Bolton, Ralph. 1991. "Mapping Terra Incognita: Sex Research for AIDS Prevention—An Urgent Agenda for the 1990s." In *The Time of AIDS: Social Analysis, Theory, and Method,* ed. Gilbert Herdt and Shirley Lindenbaum, pp. 124–158. Newbury Park, Calif.: Sage.

———. 1992. "AIDS and Promiscuity: Muddles in the Models of HIV Prevention." *Medical Anthropology* 14: 145–223.

———. 1995. "Tricks, Friends, and Lovers: Erotic Encounters in the Field." In *Taboo: Sex, Identity, and Erotic Subjectivity in Anthropological Fieldwork,* ed. Don Kulick and Margaret Willson, pp. 140–167. New York: Routledge.

Bourdieu, Pierre. 1977. *Outline of a Theory of Practice.* New York: Cambridge University Press.

———. 1990. "The Scholastic Point of View." *Cultural Anthropology* 5 (4): 380–391.

Bower, Lisa C. 1992. "'Transsexuals in the Cockpit': The 'Dangers' of Sexual Ambiguity." Paper read at the annual meetings of the Western Political Science Association, San Francisco.

Boyarin, Jonathan. 1992. *Storm from Paradise: The Politics of Jewish Memory.* Minneapolis: University of Minnesota Press.

Bradford, Nicholas J. 1983. "Transgenderism and the Cult of Yellamma: Heat, Sex, and Sickness in South Indian Ritual." *Journal of Anthropological Research*

39 (3): 307–322.

Braverman, Harry. 1974. *Labor and Monopoly Capital.* New York: Monthly Review Press.

Bukatman, Scott. 1993. *Terminal Identity: The Virtual Subject in Postmodern Science Fiction.* Durham, N.C.: Duke University Press.

Bullough, Vern L. 1976. *Sexual Variance in Society and History.* New York: Wiley & Sons.

Bullough, Vern L. and Bonnie Bullough. 1993. *Cross Dressing, Sex, and Gender.* Philadelphia: University of Pennsylvania Press.

Bunch, Charlotte and Nancy Myron, eds. 1974. *Class and Feminism.* Baltimore: Diana Press.

Burton, Richard and F. F. Arbuthnot, trans. 1995 (originally, published 1883). *The Kama Sutra of Vatsyayana.* Ware, Hertfordshire: Wordsworth Editions.

Bustos-Aguilar, Pedro. 1995. "Mister Don't Touch the Banana: Notes on the Popularity of the Ethnosexed Body South of the Border." *Critique of Anthropology* 15(2): 149–170.

Butler, Judith. 1990. *Gender Trouble: Feminism and the Subversion of Identity.* New York: Routledge.

———. 1991. "Imitation and Gender Insubordination." In *Inside/Out: Lesbian Theories, Gay Theories,* ed. Diana Fuss, pp. 13–31. New York: Routledge.

Callender, Charles and Lee M. Kochems. 1983. "The North American Berdache." *Current Anthropology* 24 (4): 443–470.

———. 1985. "Men and Not-Men: Male Gender-Mixing Statuses and Homosexuality." In *Anthropology and Homosexual Behavior,* ed. Evelyn Blackwood, pp. 165–178. New York: Haworth.

Callinocos, Alex. 1988. *Making History: Agency, Structure and Change in Social Theory.* Ithaca, N.Y.: Cornell University Press.

Carrier, Joseph M. 1976a. "Cultural Factors Affecting Urban Mexican Male Homosexual Behavior." *Archives of Sexual Behavior* 5 (2): 103–124.

———. 1976b. "Family Attitudes and Mexican Male Homosexuality." *Urban Life* 5 (3): 359–375.

———. 1980. "Homosexual Behavior in Cross-Cultural Perspective." In *Homosexual Behavior: A Modern Reappraisal,* ed. Judd Marmor, pp. 100–122. New York: Basic Books.

———. 1985. "Mexican Male Bisexuality." *Journal of Homosexuality* 11 (1/2): 75–85.

———. 1989. "Sexual Behavior and the Spread of AIDS in Mexico." In *The AIDS Pandemic,* ed. Ralph Bolton, pp. 37–50. New York: Gordon & Breach.

———. 1992. "Miguel: Sexual Life History of a Gay Mexican American." In *Gay Culture in America: Essays from the Field,* ed. Gilbert Herdt, pp. 202–224. Boston: Beacon Press.

Carrier, Joseph M. and Ralph Bolton. 1992. "Anthropological Perspectives on Sexuality and HIV Prevention." *Annual Review of Sex Research* 2: 49–75.

Carrier, Joseph M. and J. R. Magaña. 1992. "Use of Ethnosexual Data on Men of Mexican Origin for HIV/AIDS Prevention Programs." In *The Time of AIDS: Social Analysis, Theory, and Method,* ed. Gilbert Herdt and Shirley Lindenbaum, pp. 243–258. Newbury Park, Calif.: Sage.

Castells, Manuel. 1983. "Cultural Identity and Urban Structure: The Spatial

Organization of San Francisco's Urban Gay Community." In *Urban Policy Under Capitalism*, ed. Norman I. Fainstein and Susan S. Fainstein, pp. 237–259. Beverly Hills, CA: Sage.

Chauncey, George. 1994. *Gay New York: Gender, Urban Culture, and the Making of the Gay Male World, 1890–1940*. New York: Basic Books.

Chodorow, Nancy. 1978. *The Reproduction of Mothering: Psychoanalysis and the Sociology of Gender*. Berkeley: University of California Press.

Chow, Rey. 1995. *Primitive Passions: Visuality, Sexuality, Ethnography, and Contemporary Chinese Cinema*. New York: Columbia University Press.

Cicero, Marcus Tullius. 1898. *De Amicitia*. New York: Century.

Clifford, James. 1988. *The Predicament of Culture: Twentieth-Century Ethnography, Literature, and Art*. Cambridge: Harvard University Press.

Clifford, James and George E. Marcus, eds. 1986. *Writing Culture: The Poetics and Politics of Ethnography*. Berkeley: University of California Press.

Coetzee, John M. 1985. "Anthropology and the Hottentots." *Semiotica* 54 (1/2): 87–95.

Cohen, Ed. 1991. "Who Are 'We'?: Gay 'Identity' as Political (E)motion (A Theoretical Rumination)." In *Inside/Out: Lesbian Theories, Gay Theories*, ed. Diana Fuss, pp. 71–92. New York: Routledge.

Collins, Patricia Hill. 1990. *Black Feminist Thought: Knowledge, Consciousness, and the Politics of Empowerment*. New York: Routledge.

Collins, Randall. 1992. "The Romanticism of Agency/Structure Versus the Analysis of Micro/Macro." *Current Sociology* 40 (1): 77–97.

Comaroff, John L. 1981. *Rules and Processes: The Cultural Logic of Dispute in an African Context*. Chicago: University of Chicago Press.

Comaroff, Jean and John Comaroff. 1991. *Of Revelation and Revolution: Christianity, Colonialism, and Consciousness in South Africa*. Chicago: University of Chicago Press.

Comstock, Gary David. 1991. *Violence Against Lesbians and Gay Men*. New York: Columbia University Press.

Coombe, Rosemary J. 1992a. "Author/izing the Celebrity: Publicity Rights, Postmodern Politics, and Unauthorized Genders." *Cardozo Arts & Entertainment Law Journal* 10 (2): 365–395.

———. 1992b. "Publicity Rights and Political Aspiration: Mass Culture, Gender Identity, and Democracy." *New England Law Review* 26 (4): 1221–1280.

———. 1993. "The Properties of Culture and the Politics of Possessing Identity: Native Claims in the Cultural Appropriation Controversy." *Canadian Journal of Law and Jurisprudence* 6 (2): 249–285.

———. 1997. "Contingent Articulations: A Critical Cultural Studies of Law." In Austin Sarat and Thomas R. Kearns, eds., *Law in the Domains of Culture*. Ann Arbor: University of Michigan Press.

Cory, Donald W., ed. 1956. *Homosexuality: A Cross-Cultural Approach*. New York: Burton & Westermark.

Corzine, Jay and Richard Kirby. 1977. "Cruising the Truckers: Sexual Encounters in a Highway Rest Area." *Urban Life* 6 (2): 171–192.

Crapanzano, Vincent. 1980. *Tuhami: Portrait of a Moroccan*. Chicago: University of Chicago Press.

――――. 1985. *Waiting: The Whites of South Africa*. New York: Random House.

Creed, Gerald W. 1984. "Sexual Subordination: Institutionalized Homosexuality and Social Control in Melanesia." *Ethnology* 23 (3): 157–176.

Crenshaw, Kimberlé. 1995. "Mapping the Margins: Intersectionality, Identity Politics, and Violence Against Women of Color." In *After Identity: A Reader in Law and Culture*, ed. Dan Danielsen and Karen Engle, pp. 332–354. New York: Routledge.

Cunningham, Amy. 1992. "Not Just Another Prom Night." *Glamour*, June, 222–225, 259–262.

D'Augelli, Anthony R. and Mary M. Hart. 1987. "Gay Women, Men, and Families in Rural Settings: Toward the Development of Helping Communities." *American Journal of Community Psychology* 15 (1): 79–93.

D'Augelli, Anthony R., Cathy Collins, and Mary M. Hart. 1987. "Social Support Patterns of Lesbian Women in a Rural Helping Network." *Journal of Rural Community Psychology* 8 (1): 12–22.

D'Emilio, John. 1983a. "Capitalism and Gay Identity." In *Powers of Desire: The Politics of Sexuality*, ed. Ann Snitow, Christine Stansell, and Sharon Thompson, pp. 100–113. New York: Monthly Review Press.

――――. 1983b. *Sexual Politics, Sexual Communities: The Making of a Homosexual Minority in the United States, 1940–1970*. Chicago: University of Chicago Press.

――――. 1989. "Gay Politics and Community in San Francisco Since World War II." In *Hidden From History: Reclaiming the Gay and Lesbian Past*, ed. Martin Duberman, Martha Vicinus, and George Chauncey, Jr., pp. 456–473. New York: Meridian.

――――. 1992. *Making Trouble: Essays on Gay History, Politics, and the University*. New York: Routledge.

Damrosch, David. 1995. "The Ethnic Ethnographer: Judaism in *Tristes Tropiques*." *Representations* 50: 1–13.

Davies, Margery. 1975. "Woman's Place Is at the Typewriter: The Feminization of the Clerical Labor Force." In *Labor Market Segmentation*, ed. Richard Edwards et al., pp. 279–294. New York: D. C. Heath.

Davis, D. L. and R. G. Whitten. 1987. "The Cross-Cultural Study of Human Sexuality." *Annual Review of Anthropology* 16: 69–98.

Davis, Madeline and Elizabeth Lapovsky Kennedy. 1986. "Oral History and the Study of Sexuality in the Lesbian Community: Buffalo, NY, 1940–1960." *Feminist Studies* 12 (1): 7–26.

――――. 1989. "The Reproduction of Butch-Fem Roles: A Social Constructionist Approach." In *Passion and Power*, ed. Kathy Peiss and Christina Simmons, with Robert A. Padgug, pp. 241–256. Philadelphia: Temple University Press.

Deacon, A. Bernard. 1934. *Malekula: A Vanishing People in the New Hebrides*. London: George Routledge & Sons.

Delaney, Carol. 1991. *The Seed and the Soil: Gender and Cosmology in Turkish Village Society*. Berkeley: University of California Press.

Devereux, George. 1937. "Institutionalized Homosexuality of the Mohave Indians." *Human Biology* 9: 498–527.

Diamond, Timothy. 1992. *Making Gray Gold: Narratives of Nursing Home Care.* Chicago: University of Chicago Press.

Dickemann, Mildred. 1993. "Gender Crossing and Gender Mixing: Balkan 'Sworn Virgins' and Western Women Travelers." Unpublished ms.

Dominy, Michelle D. 1986. "Lesbian-Feminist Gender Conceptions: Separatism in Christchurch, New Zealand." *Signs* 11 (2): 274–289.

Dorrell, Beth. 1991. "Being There: A Support Network of Lesbian Women." *Journal of Homosexuality* 20 (3/4): 89–98.

Dover, K.J. 1988. *The Greeks and Their Legacy.* New York: Blackwell.

Duggan, Lisa. 1992. "Making It Perfectly Queer." *Socialist Review* 22 (1): 11–32.

———. 1995. "The Discipline Problem: Queer Theory Meets Lesbian and Gay History." *GLQ: A Journal of Lesbian and Gay Studies* 2 (3): 179–191.

Durkheim, Emile and Marcel Mauss. 1963. *Primitive Classification.* Trans. Rodney Needham. Chicago: University of Chicago Press.

Eagleton, Terry. 1991. *Ideology: An Introduction.* New York: Verso.

Edgerton, Robert B. 1964. "Pokot Intersexuality: An East African Example of the Resolution of Sexual Incongruity." *American Anthropologist* 66: 1288–1299.

Edwards, Richard. 1979. *Contested Terrain: The Transformation of the Workplace in the Twentieth Century.* New York: Basic Books.

Eisenstadt, S. N. 1956. "Ritualized Personal Relations." *Man* 96: 90–95.

Eisenstein, Zillah, ed. 1979. *Capitalist Patriarchy and the Case for Socialist Feminism..* New York: Monthly Review Press.

———. 1981. *The Radical Future of Liberal Feminism.* New York: Longman.

Ellison, Christopher G. 1990. "Family Ties, Friendships, and Subjective Well-being among Black Americans." *Journal of Marriage and the Family* 52: 298–310.

Elliston, Deborah A. 1992. "Ritualized Homosexuality." In *Anthropology: Critiquing a Concept, Re-Situating Practices.* M.A. thesis, New York University.

Engels, Frederick. 1970. *The Origin of the Family, Private Property and the State.* New York: International Publishers.

Epstein, Steven. 1987. "Gay Politics, Ethnic Identity: The Limits of Social Constructionism." *Socialist Review* 93/94: 9–54.

Evans-Pritchard, E. E. 1940. *The Nuer.* New York: Oxford University Press.

———. 1951. *Kinship and Marriage among the Nuer.* Oxford: Oxford University Press.

———. 1970. "Sexual Inversion among the Azande." *American Anthropologist* 72 (6): 1428–1434.

———. 1976. *Witchcraft, Oracles, and Magic among the Azande.* Oxford: Clarendon Press.

Fabian, Johannes. 1983. *Time and the Other: How Anthropology Makes Its Object.* New York: Columbia University Press.

Faderman, Lillian. 1991. *Odd Girls and Twilight Lovers: A History of Lesbian Life in Twentieth-Century America.* New York: Columbia University Press.

———. 1992. "The Return of Butch and Femme: A Phenomenon in Lesbian Sexuality of the 1980s and 1990s." *Journal of the History of Sexuality* 2 (4): 578–596.

Feldman, Douglas A. 1986. "AIDS Health Promotion and Clinically Applied

Anthropology." In *The Social Dimensions of AIDS: Method and Theory*, ed. Douglas A. Feldman and T. M. Johnson, pp. 145–159. New York: Praeger.

———. 1989. "Gay Youth and AIDS." *Journal of Homosexuality* 17 (1/2): 185–193.

Ferguson, Ann, et al. 1981. "On 'Compulsory Heterosexuality and Lesbian Existence': Defining the Issues." *Signs* 7 (1): 158–199.

Fernandez, James W. 1986. *Persuasions and Performances: The Play of Tropes in Culture*. Bloomington: Indiana University Press.

Fitzgerald, Thomas K. 1977. "A Critique of Anthropological Research on Homosexuality." *Journal of Homosexuality* 2 (4): 385–397.

———. 1993. *Metaphors of Identity: A Culture-Communication Dialogue*. Ithaca, N.Y.: State University of New York Press.

Ford, Clellan S. and Frank A. Beach. 1951. *Patterns of Sexual Behavior*. New York: Harper.

Forgey, Donald G. 1975. "The Institution of the Berdache among the North American Plains Indians." *Journal of Sex Research* 11 (1): 1–15.

Foucault, Michel. 1978. *The History of Sexuality*. Vol. 1. New York: Vintage.

Fox, Richard G. 1991. *Recapturing Anthropology*. Santa Fe: School of American Research.

Freedman, Estelle, Barbara C. Gelpi, Susan L. Johnson, and Kathleen M. Weston, eds. 1985. *The Lesbian Issue: Essays from SIGNS*. Chicago: University of Chicago Press.

Freud, Sigmund. 1918. *Totem and Taboo*. London: Hogarth Press.

———. 1962. *Three Essays on the Theory of Sexuality*. New York: Basic Books.

Friedman, Marilyn. 1989. "Feminism and Modern Friendship: Dislocating the Community." *Ethics* 99: 275–290.

Friedrich, Paul. 1978. *The Meaning of Aphrodite*. Chicago: University of Chicago Press.

Fry, P. 1986. "Male Homosexuality and Spirit Possession in Brazil." In *Anthropology and Homosexual Behavior*, ed. Evelyn Blackwood, pp. 137–153. New York: Haworth.

Fuss, Diana. 1989. *Essentially Speaking: Feminism, Nature, and Difference*. New York: Routledge.

Gagnon, John H. and William Simon. 1973. *Sexual Conduct: The Social Sources of Human Sexuality*. Chicago: Aldine.

Gallagher, Bob and Alexander Wilson. 1987. "Sex and the Politics of Identity: An Interview with Michel Foucault." In *Gay Spirit: Myth and Meaning*, ed. Mark Thompson, pp. 25–35. New York: St. Martin's Press.

Garnsey, Elizabeth. 1978. "Women's Work and Theories of Class and Stratification." *Sociology* 12 (2): 223–243.

Gay, J. 1986. "'Mummies and Babies' and Friends and Lovers in Lesotho." In *Anthropology and Homosexual Behavior*, ed. Evelyn Blackwood, pp. 97–116. New York: Haworth.

Geertz, Clifford. 1973. *The Interpretation of Cultures*. New York: Basic Books.

———. 1988. *Works and Lives: The Anthropologist as Author*. Stanford: Stanford University Press.

Gibbs, Joan and Sara Bennett, eds. 1980. *Top Ranking: A Collection of Articles on Racism and Classism in the Lesbian Community*. New York: Come!Unity Press.

Giddens, Anthony. 1979. *Central Problems in Social Theory: Action, Structure and Contradiction in Social Analysis.* Berkeley: University of California Press.

————. 1982. "Class Structuration and Class Consciousness." In *Classes, Power, and Conflict,* ed. Anthony Giddens and David Held, pp. 157–174. Berkeley: University of California Press.

Gilman, Sander L. 1985. "Black Bodies, White Bodies: Toward an Iconography of Female Sexuality in Late Nineteenth Century Art, Medicine and Literature." *Critical Inquiry* 12: 204–242.

Gilmore, David. 1975. "Friendship in Fuenmayor: Patterns of Integration in an Atomistic Society." *Ethnology* 14: 311–324.

Godelier, Maurice. 1986. *The Making of Great Men: Male Domination and Power among the New Guinea Baruya.* New York: Cambridge University Press.

Goldberg, Jonathan. 1991. "Sodomy in the New World: Anthropologies Old and New." *Social Text* 9 (4): 46–56.

Goldenweiser, Alexander. 1929. "Sex and Primitive Society." In *Sex in Civilization,* ed. V. F. Calverton and S. D. Schmalhausen, pp. 53–66. New York: Macauley.

Goldsby, Jackie. 1989. "All About Yves." *Out/Look* 2 (1): 34–35.

Gordon, David M., et al., eds. 1982. *Segmented Work, Divided Workers: The Historical Transformation of Labor in the United States.* New York: Cambridge University Press.

Gordon, Deborah. 1990. "The Politics of Ethnographic Authority: Race and Writing in the Ethnography of Margaret Mead and Zora Neale Hurston." In *Modernist Anthropology: From Fieldwork to Text,* ed. Marc Manganaro, pp. 146–162. Princeton: Princeton University Press.

Gorman, E. M. 1991. "Anthropological Reflections on the HIV Epidemic among Gay Men." *Journal of Sex Research* 28 (2): 263–273.

Gouldner, Helen and Mary Symons Strong. 1987. *Speaking of Friendship: Middle-Class Women and Their Friends.* New York: Greenwood.

Graham, Julie. 1990. "Lesbian Sues AT&T." *Gay Community News,* November 3–9.

Grahn, Judy. 1986. "Strange Country This: Lesbianism and North American Indian Tribes." *Journal of Homosexuality* 12 (3/4): 43–57.

Gramsci, Antonio. 1980. *Selections from the Prison Notebooks.* New York: International Publishers.

Gray, J. P. 1986. "Growing Yams and Men: An Interpretation of Kimam Male Ritualized Homosexual Behavior." In *Anthropology and Homosexual Behavior,* ed. Evelyn Blackwood, pp. 55–68. New York: Haworth.

Gray, J. P. and J. E. Ellington. 1984. "Institutionalized Male Transvestism, the Couvade, and Homosexual Behavior." *Ethos* 12: 54–63.

Greenbaum, Joan M. 1979. *In the Name of Efficiency: Management Theory and Shopfloor Practice in Data-Processing Work.* Philadelphia: Temple University Press.

Greenberg, David F. 1986. "Why Was the Berdache Ridiculed?" In *Anthropology and Homosexual Behavior,* ed. Evelyn Blackwood, pp. 179–189. New York: Haworth.

————. 1988. *The Construction of Homosexuality.* Chicago: University of Chicago Press.

Grube, John. 1991. "Natives and Settlers: An Ethnographic Note on Early Interaction of Older Homosexual Men with Younger Gay Liberationists." *Journal of Homosexuality* 20 (3/4): 119–135.

Gupta, Akhil and James Ferguson. 1997. *Anthropological Locations: Boundaries and Grounds of a Field Science.* Berkeley: University of California Press.

Gutiérrez, Ramón A. 1989. "Must We Deracinate Indians to Find Gay Roots?" *Out/Look* 1(4): 61–67.

————. 1991. *When Jesus Came, the Corn Mothers Went Away: Marriage, Sexuality, and Power in New Mexico, 1500–1846.* Stanford: Stanford University Press.

Gutis, Philip S. 1989. "How to Define a Family: Gay Tenant Fights Eviction." *New York Times,* April 27.

Hale, Charles R. 1994. "Between Che Guevara and the Pachamama: Mestizos, Indians, and Identity Politics in the Anti-Quincentenary Campaign." *Critique of Anthropology* 14(1): 9–39.

Handler, Richard. 1988. *Nationalism and the Politics of Culture in Quebec.* Madison: University of Wisconsin Press.

Hanna, Judith L. 1988. *Dance, Sex, and Gender: Signs of Identity, Dominance, Defiance, and Desire.* Chicago: University of Chicago Press.

Hart, D. V. 1968. "Homosexuality and Transvestism in the Philippines." *Behavioral Science Notes* 3 (4): 211–248.

Hartmann, Heidi. 1976. "Capitalism, Patriarchy, and Job Segregation by Sex." In *Women and the Workplace: The Implications of Occupational Segregation,* ed. Martha Blaxall and Barbara Reagan, pp. 137–169. Chicago: University of Chicago Press.

Hartsock, Nancy. 1981. "Political Change: Two Perspectives on Power." In *Building Feminist Theory,* ed. Quest Staff, pp. 3–19. New York: Longman.

Hays, Robert B., Sarah Chauncey, and Linda A. Tobey. 1990. "The Social Support Networks of Gay Men with AIDS." *Journal of Community Psychology* 18: 374–385.

Heimann, E. and C. V. Le. 1975. "Transsexualism in Vietnam." *Archives of Sexual Behavior* 4 (1): 89–95.

Heller, Agnes. 1976. *The Theory of Need in Marx.* London: Allison & Busby.

Herdt, Gilbert H. 1981. *Guardians of the Flutes: Idioms of Masculinity.* New York: McGraw-Hill.

————. 1982. "Fetish and Fantasy in Sambia Initiation." In *Rituals of Manhood,* ed. Gilbert H. Herdt, pp. 44–98. Berkeley: University of California Press.

————. 1986. "Madness and Sexuality in the New Guinea Highlands." *Social Research* 53 (2): 349–367.

————. 1987a. *The Sambia: Ritual and Gender in New Guinea.* New York: Holt, Rinehart & Winston.

————. 1987b. "Semen Depletion and the Sense of Maleness." In *Cultural Diversity and Homosexualities,* ed. Stephen O. Murray, pp. 339–451. New York: Irvington.

————. 1989a. "Father Presence and Ritual Homosexuality: Paternal Deprivation and Masculine Development in Melanesia Reconsidered." *Ethos* 17 (3): 326–370.

————, ed. 1989b. *Homosexuality and Adolescence.* New York: Haworth.

————. 1990a. "Developmental Discontinuities and Sexual Orientation

Across Cultures." In *Homosexuality/Heterosexuality: Concepts of Sexual Orientation*, ed. P. McWhirter, S. A. Sanders, and J. M. Reinisch, pp. 208–236. New York: Oxford University Press.

———. 1990b. "Mistaken Gender: 5-Alpha Reductase Hermaphroditism and Biological Reductionism in Sexual Identity Reconsidered." *American Anthropologist* 92 (2): 433–446.

———. 1991a. "Representations of Homosexuality: An Essay on Cultural Ontology and Historical Comparison, Part I." *Journal of the History of Sexuality* 1 (3): 481–504.

———. 1991b. "Representations of Homosexuality: An Essay on Cultural Ontology and Historical Comparison, Part II." *Journal of the History of Sexuality* 1 (4): 603–632.

———, ed. 1992. *Gay Culture in America: Essays from the Field.* Boston: Beacon Press.

———, ed. 1993a. *Ritualized Homosexuality in Melanesia.* 2nd ed. Berkeley: University of California Press.

———. 1993b. "Semen Transactions in Sambia Culture." In *Ritualized Homosexuality in Melanesia*, ed. G. H. Herdt, pp. 167–210. Berkeley: University of California Press.

———. 1993c. "Ten Years After Ritualized Homosexuality in Melanesia: Introduction to the New Edition." In *Ritualized Homosexuality in Melanesia*, ed. G. H. Herdt. Berkeley: University of California Press.

Herdt, Gilbert and A. M. Boxer. 1991. "Ethnographic Issues in the Study of AIDS." *Journal of Sex Research* 28 (2): 171–187.

———. 1993. *Children of Horizons: How Gay and Lesbian Teens Are Leading a New Way Out of the Closet.* Boston: Beacon Press.

Herdt, Gilbert H. and Robert J. Stoller. 1990. *Intimate Communications: Erotics and the Study of Culture.* New York: Columbia University Press.

Herrell, Richard. 1992. "The Symbolic Strategies of Chicago's Gay and Lesbian Pride Day Parade." In *Gay Culture in America*, ed. Gilbert Herdt, pp. 225–252. Boston: Beacon Press.

Herskovits, Melville J. 1938. *Dahomey: An Ancient West African Kingdom.* New York: J. J. Augustin.

Hewitt, Nancy A. 1992. "Compounding Differences." *Feminist Studies* 18 (2): 313–326.

Hogbin, H. Ian. 1946. "Puberty to Marriage: A Study of the Sexual Life of the Natives of Wogeo, New Guinea." *Oceania* 16 (3): 185–209.

Hooker, Evelyn. 1965. "Male Homosexuals and Their 'Worlds.'" In *Sexual Inversion*, ed. Judd Marmor, pp. 83–107. New York: Basic Books.

———. 1967. "The Homosexual Community." In *Sexual Deviance*, ed. John H. Gagnon and William Simon, pp. 167–184. New York: Harper & Row.

hooks, bell. 1984. *Feminist Theory: From Margin to Center.* Boston: South End Press.

———. 1990. "Choosing the Margin as a Space of Radical Openness." In *Yearning: Race, Gender, and Cultural Politics*, pp. 145–153. Boston: South End Press.

Humphreys, Laud. 1975. *Tearoom Trade: Impersonal Sex in Public Places.* Chicago: Aldine.

Isaacs, Gordon and Brian McKendrick. 1992. *Male Homosexuality in South Africa: Identity Formation, Culture, and Crisis*. New York: Oxford University Press.

Jacobs, Sue-Ellen. 1968. "Berdache: A Brief Overview of the Literature." *Colorado Anthropologist* 1: 25–40.

Jacobs, Sue-Ellen and C. Roberts. 1989. "Sex, Sexuality, Gender, and Gender Variance." In *Gender and Anthropology*, ed. Sandra Morgen, pp. 438–462. Washington, D.C.: American Anthropological Association.

Jerome, Dorothy. 1984. "Good Company: The Sociological Implications of Friendship." *Sociological Review* 32: 696–718.

Jhally, Sut. 1989. "The Political Economy of Culture." In *Cultural Politics in Contemporary America*, ed. Ian Angus and Sut Jhally, pp. 65–81. New York: Routledge.

Johnston, Jill. 1973. *Lesbian Nation*. New York: Simon and Schuster.

Jones, Delmos J. 1970. "Toward a Native Anthropology." *Human Organization* 29: 251–259.

Jones, James H. 1997. *Alfred C. Kinsey: A Public/Private Life*. New York: W. W. Norton.

Jones, Kathleen B. 1991. "Trouble with Authority." *differences* 3 (1): 104–127.

Jones, Lisa. 1994. *Bulletproof Diva: Tales of Race, Sex, and Hair*. New York: Doubleday.

Jones, Mark, ed. 1990. *Fake?: The Art of Deception*. Berkeley: University of California Press.

Joseph, Miranda. 1993. "Representing 'the Gay Community': An Ethnographic Study of Theatre Rhinocerous." Unpublished ms.

Kehoe, Alice B. 1970. "The Function of Ceremonial Sexual Intercourse Among the Northern Plains Indians." *Plains Anthropologist* 15: 99–103.

Kelly, John D. 1991. *A Politics of Virtue: Hinduism, Sexuality, and Countercolonial Discourse in Fiji*. Chicago: University of Chicago Press.

Kelly, Raymond C. 1976. "Witchcraft and Sexual Relations: An Exploration in the Social and Semantic Implications of the Structure of Belief." In *Man and Woman in the New Guinea Highlands*, ed. Paula Brown and Georgeda Buchbinder. Washington, D.C.: American Anthropological Association.

Kennedy, Elizabeth Lapovsky and Madeline D. Davis. 1993. *Boots of Leather, Slippers of Gold: The History of a Lesbian Community*. New York: Routledge.

Kenny, Maurice. 1988. "Tinselled Bucks: A Historical Study in Indian Homosexuality." In *Living the Spirit*, ed. Will Roscoe and Gay American Indians, pp. 15–31. New York: St. Martin's Press.

Kessler, Suzanne J. and Wendy McKenna. 1978. *Gender: An Ethnomethodological Approach*. Chicago: University of Chicago Press.

Knauft, Bruce M. 1986. "Text and Social Practice: Narrative 'Longing' and Bisexuality Among the Gebusi of New Guinea." *Ethos* 14: 252–281.

———. 1987. "Homosexuality in Melanesia: The Need for a Synthesis of Perspectives." *Journal of Psychoanalytic Anthropology* 10 (2): 155–191.

———. 1990. "The Question of Ritualised Homosexuality among the Kiwai of South New Guinea." *Journal of Pacific History* 25 (2): 188–210.

———. 1993. *South Coast New Guinea Cultures: History, Comparison, Dialectic*. Cambridge: Cambridge University Press.

Kondo, Dorinne. 1990. *Crafting Selves: Power, Gender, and Discourses of Identity in a Japanese Workplace.* Chicago: University of Chicago Press.

Krieger, Susan. 1985. "Lesbian Identity and Community: Recent Social Science Literature." In *The Lesbian Issue: Essays from SIGNS,* ed. Estelle B. Freedman, Barbara C. Gelpi, Susan L. Johnson, and Kathleen M. Weston, pp. 223–240. Chicago: University of Chicago Press.

———. 1983. *The Mirror Dance: Identity in a Women's Community.* Philadelphia: Temple University Press.

Kroeber, Alfred L. 1940. "Psychosis or Social Sanction?" *Character and Personality* 3 (3): 204–215.

Kugelmass, Jack. 1993. "'The Fun is in Dressing Up': The Greenwich Village Halloween Parade and the Reimagining of Urban Space." *Social Text* 36: 138–152.

Kuhn, Annette and AnnMarie Wolpe, eds. 1978. *Feminism and Materialism: Women and Modes of Production.* London: Routledge & Kegan Paul.

Kuklick, Henrika. 1991. *The Savage Within: The Social History of British Anthropology, 1885–1945.* Cambridge: Cambridge University Press.

———. 1997. "After Ishmael: The Fieldwork Tradition and Its Future." In *Anthropological Locations: Boundaries and Grounds of a Field Science,* ed. Akhil Gupta and James Ferguson. Berkeley: University of California Press.

Kulick, Don and Margaret Willson, eds. 1995. *Taboo: Sex, Identity, and Erotic Subjectivity in Anthropological Fieldwork.* New York: Routledge.

Kuper, Adam. 1988. *The Invention of Primitive Society: Transformations of an Illusion.* New York: Routledge.

Lancaster, Roger N. 1988. "Subject Honor and Object Shame: The Construction of Male Homosexuality and Stigma in Nicaragua." *Ethnology* 27 (2): 111–125.

———. 1992. *Life Is Hard: Machismo, Danger, and the Intimacy of Power.* Berkeley: University of California Press.

Landes, Ruth. 1937. *Ojibwa Society.* New York: Columbia University Press.

———. 1940. "A Cult Matriarchate and Male Homosexuality." *Journal of Abnormal and Social Psychology* (35): 386–397.

Landtman, Gunnar. 1927. *The Kiwai Papuans of British New Guinea: A Nature-Born Instance of Rousseau's Ideal Community.* London: Macmillan.

Lang, Sabine. 1996. "Traveling Women: Conducting a Fieldwork Project on Gender Variance and Homosexuality among North American Indians." In Ellen Lewin and William L. Leap, eds., *Out in the Field: Reflections of Lesbians and Gay Anthropologists,* pp. 86–107. Urbana: University of Illinois Press.

Lattas, A. 1990. "Poetics of Space and Sexual Economies of Power: Gender and the Politics of Male Identity in West New Britain." *Ethos* 18 (1): 71–100.

Lavie, Smadar and Ted Swedenburg. 1996. "Between and Among the Boundaries of Culture: Bridging Text and Lived Experience in the Third Timespace." *Cultural Studies* 10 (1): 154–179.

Leap, William L. 1997. *Word Is Out: Gay Men's English.* Minneapolis: University of Minnesota Press.

Lefebvre, Henri. 1991. *The Production of Space.* Oxford: Blackwell.

Levine, Carol. 1990. "AIDS and Changing Concepts of Family." *Milbank Quarterly* 68 (1): 33–58.

Levy, Anita. 1989. "Blood, Kinship, and Gender." *Genders* 5: 70–85.

———. 1991. *Other Women: The Writing of Class, Race, and Gender, 1832–1898.* Princeton: Princeton University Press.

Levy, Robert I. 1971. "The Community Function of Tahitian Male Transvestitism: A Hypothesis." *Anthropological Quarterly* 44 (1): 12–21.

———. 1973. *Tahitians: Mind and Experience in the Society Islands.* Chicago: University of Chicago Press.

Lévy-Bruhl, Lucien. 1923. *Primitive Mentality.* Boston: Beacon Press.

Lewin, Ellen. 1981. "Lesbianism and Motherhood: Implications for Child Custody." *Human Organization* 40 (1): 6–14.

———. 1985. "By Design: Reproductive Strategies and the Meaning of Motherhood." In *The Sexual Politics of Reproduction*, ed. Hilary Homans, pp. 123–138. London: Gower.

———. 1990. "Claims to Motherhood: Custody Disputes and Maternal Strategies." In *Uncertain Terms: Negotiating Gender in American Culture*, ed. Faye Ginsburg and Anna Lowenhaupt Tsing, pp. 199–214. Boston: Beacon Press.

———. 1991. "Writing Lesbian and Gay Culture: What the Natives Have to Say for Themselves." *American Ethnologist* 18 (4): 786–791.

———. 1993a. *Lesbian Mothers: Accounts of Gender in American Culture.* Ithaca, N.Y.: Cornell University Press.

———. 1993b. "On the Outside Looking In: The Politics of Lesbian Motherhood." In *Conceiving the New World Order*, ed. Faye Ginsburg and Rayna Rapp. Berkeley: University of California Press.

Lewin, Ellen and William L. Leap, eds. 1996. *Out in the Field: Reflections of Lesbian and Gay Anthropologists.* Urbana: University of Illinois Press.

Lewin, Tamar. 1990. "Suit Over Death Benefits Asks, What Is a Family?" *New York Times*, September 21.

Lewontin, Richard. 1995. "Sex, Lies, and Social Science." *New York Review of Books* (April 20): 24–29.

Lidz, T. and R. W. Lidz. 1986. "Turning Women Things into Men: Masculinization in Papua New Guinea." *Psychoanalytic Review* 73 (4): 521–539.

Limón, José. 1991. "Representation, Ethnicity, and the Precursory Ethnography: Notes of a Native Anthropologist." In *Recapturing Anthropology*, ed. Richard G. Fox, pp. 115–136. Santa Fe: School of American Research.

Lockard, D. 1986. "The Lesbian Community: An Anthropological Approach." In *Anthropology and Homosexual Behavior*, ed. Evelyn Blackwood, pp. 83–95. New York: Haworth.

Long, S. and J. Borneman. 1990. "Power, Objectivity, and the Other: The Creation of Sexual Species in Modernist Discourse." *Dialectical Anthropology* 15: 285–314.

Lorde, Audre. 1978a. *Uses of the Erotic: The Erotic as Power.* New York: Out & Out Books.

———. 1978b. *The Black Unicorn.* New York: W. W. Norton.

Lovejoy, Nancy C. 1990. "AIDS: Impact on the Gay Man's Homosexual and Heterosexual Families." *Marriage and Family Review* 14 (3/4): 285–316.

Lowe, Lisa. 1991. "Heterogeneity, Hybridity, Multiplicity: Marking Asian American Differences." *Diaspora* 1 (1): 24–44.

Lugones, Maria. 1994. "Purity, Impurity, and Separation." *Signs* 19 (2): 458–479.

Lumby, M. E. 1976. "Code Switching and Sexual Orientation: A Test of Bernstein's Sociolinguistic Theory." *Journal of Homosexuality* 1 (4): 383–399.

Lutz, Catherine. 1988. *Unnatural Emotions: Everyday Sentiments on a Micronesian Atoll and Their Challenge to Western Theory.* Chicago: University of Chicago Press.

MacCormack, Carol and Marilyn Strathern, eds. 1980. *Nature, Culture, and Gender.* London: Cambridge University Press.

Madrid, Arturo. 1992. "Missing People and Others: Joining Together to Expand the Circle." In *Race, Class, and Gender*, ed. Margaret L. Anderson and Patricia Hill Collins, pp. 6–11. Belmont, Calif.: Wadsworth.

Mageo, J. M. 1992. "Male Transvestism and Cultural Change in Samoa." *American Ethnologist* 19 (3): 443–459.

Malinowski, Bronislaw. 1927. *Sex and Repression in Savage Society.* New York: Meridian.

———. 1966. *Crime and Custom in Savage Society.* Totowa, N.J.: Littlefield, Adams & Co.

———. 1989. *A Diary in the Strict Sense of the Term.* Stanford: Stanford University Press.

Malkki, Liisa. 1992. "National Geographic: The Rooting of Peoples and the Territorialization of National Identity Among Scholars and Refugees." *Cultural Anthropology* 7 (1): 24–44.

Manalansan III, Martin. 1993. "(Re)locating the 'Gay' Filipino: Resistance, Postcolonialism, and Identity." Unpublished ms.

Margolick, David. 1990. "Lesbians' Custody Fights Test Family Law Frontier." *New York Times*, July 4.

Martin, Biddy and Chandra Talpade Mohanty. 1986. "Feminist Politics: What's Home Got to Do With It?" In *Feminist Studies/Critical Studies*, ed. Teresa de Lauretis, pp. 191–212. Bloomington: Indiana University Press.

Martin, Emily. 1992. "The End of the Body?" *American Ethnologist* 19 (1): 121–140.

Marx, Karl. 1967. *Capital.* New York: International Publishers.

Marx, Karl and Frederick Engels. 1978. *The German Ideology.* New York: International Publishers.

Mascia-Lees, Frances E., Patricia Sharpe, and Colleen Ballerino Cohen. 1989. "The Postmodernist Turn in Anthropology: Cautions from a Feminist Perspective." *Signs* 15 (1): 7–33.

Mason, Karen Oppenheim. 1984. "Commentary: Strober's Theory of Occupational Sex Segregation." In *Sex Segregation in the Workplace: Trends, Explanations, Remedies*, ed. Barbara F. Reskin, pp. 157–170. Washington, D.C.: National Academy Press.

Masters, William H. and Virginia E. Johnson. 1966. *Human Sexual Response.* Boston: Little, Brown and Company.

Mathews, R. H. 1900. "Native Tribes of Western Australia." *Proceedings of the American Philosophical Society* 39: 123–125.

Mauss, Marcel. 1967. *The Gift.* New York: W. W. Norton.

McCoy, Sherry and Maureen Hicks. 1979. "A Psychological Retrospective on Power in the Contemporary Lesbian-Feminist Community." *Frontiers* 4 (3): 65–69.

McIntosh, Mary. 1981. "The Homosexual Role." In *The Making of the Modern Homosexual,* ed. Ken Plummer, pp. 30–44. Totowa, N.J.: Barnes & Noble.

McLennan, John M. 1865. *Primitive Marriage: An Inquiry into the Origin of the Form of Capture in Marriage.* Edinburgh: Black.

Mead, Margaret. 1949. *Male and Female: A Study of the Sexes in a Changing World.* New York: Morrow.

———. 1961. *Coming of Age in Samoa: A Psychological Study of Primitive Youth for Western Civilization.* New York: Dell.

———. 1963. *Sex and Temperament in Three Primitive Societies.* New York: Morrow.

Midnight Sun. 1988. "Sex/Gender Systems in Native North America." In *Living the Spirit,* ed. Will Roscoe, with Gay American Indians, pp. 32–47. New York: St. Martin's Press.

Milkman, Ruth. 1982. "Redefining 'Women's Work': The Sexual Division of Labor in the Auto Industry During World War II." *Feminist Studies* 8: 337–372.

———. 1988. *Gender at Work: The Dynamics of Job Segregation by Sex during World War II.* Berkeley: University of California Press.

Miller, B. Jaye. 1992. "From Silence to Suicide: Measuring a Mother's Loss." In *Homophobia: How We All Pay the Price,* ed. Warren J. Blumenfeld, pp. 79–94. Boston: Beacon Press.

Miller, Jay. 1982. "People, Berdaches, and Left-Handed Bears: Human Variation in Native America." *Journal of Anthropological Research* 38: 274–287.

Miller, Neil. 1989. *In Search of Gay America: Women and Men in a Time of Change.* New York: Atlantic Monthly Press.

Moffatt, Michael. 1989. *Coming of Age in New Jersey: College and American Culture.* New Brunswick, N.J.: Rutgers University Press.

Moodie, T. Dunbar with Vivienne Ndatshe and British Sibuyi. 1989. "Migrancy and Male Sexuality on the South African Gold Mines." In *Hidden from History: Reclaiming the Gay and Lesbian Past,* ed. Martin Duberman, Martha Vicinus, and George Chauncey, Jr., pp. 411–425. New York: Meridian/Penguin.

Moraga, Cherríe and Gloria Anzaldúa, eds. 1981. *This Bridge Called My Back: Writings by Radical Women of Color.* Watertown, Mass.: Persephone Press.

Morris, Robert J. 1990. "Aikane: Accounts of Hawaiian Same-Sex Relationships in the Journals of Captain Cook's Third Voyage (1776–80)." *Journal of Homosexuality* 19 (4): 21–54.

Morris, Rosalind C. 1995. "All Made Up: Performance Theory and the New Anthropology of Sex and Gender." *Annual Review of Anthropology* 24: 567–592.

Mouzelis, Nicos. 1993. "The Poverty of Sociological Theory." *Sociology* 27 (4): 675–695.

Muñoz, José. 1995. "The Autoethnographic Performance: Reading Richard Fung's Queer Hybridity." *Screen* 36 (2): 83–99.

Munroe, Robert L. 1980. "Male Transvestism and the Couvade: A Psycho-Cultural Analysis." *Ethos* 8: 49–59.

Munroe, Robert L., John W. M. Whiting, and David J. Hally. 1969. "Institutionalized Male Transvestism and Sex Distinctions." *American Anthropologist* 71: 87–91.

Murray, Stephen O. 1979a. "The Art of Gay Insulting." *Anthropological Linguistics* 21: 211–223.

———. 1979b. "The Institution of a Quasi-Ethnic Community." *International Review of Modern Sociology* 9: 155–175.

———. 1980. "Lexical and Institutional Elaboration: The 'Species Homosexual' in Guatemala." *Anthropological Linguistics* 22: 177–185.

———. 1983. "Ritual and Personal Insults in Stigmatized Subcultures: Gay—Black—Jew." *Maledicta* 7: 189–211.

———. 1984. *Social Theory, Homosexual Realities.* New York: Gai Saber.

———, ed. 1987a. *Male Homosexuality in Central and South America.* New York: Gay Academic Union.

———, ed. 1987b. *Cultural Diversity and Homosexualities.* New York: Irvington.

———. 1989. "Ethnic and Temporal Patterns of Gay Male Self-Identification and Migration to San Francisco." Unpublished ms.

———. 1991. "Sleeping with the Natives as a Source of Data." *Society of Lesbian and Gay Anthropologists Newsletter* 13 (3): 49–51.

———, ed. 1992. *Oceanic Homosexualities.* New York: Garland.

———. 1996. "Male Homosexuality in Guatemala: Possible Insights and Certain Confusions from Sleeping with the Natives." In *Out in the Field: Reflections of Lesbian and Gay Anthropologists,* ed. Ellen Lewin and William L. Leap, pp. 236–260. Urbana: University of Illinois Press.

Nadelson, L. 1981. "Pigs, Women, and the Men's House in Amazonia: An Analysis of Six Mundurucú Myths." In *Sexual Meanings: The Cultural Construction of Gender and Sexuality,* ed. Sherry B. Ortner and Harriet Whitehead, pp. 240–272. Cambridge: Cambridge University Press.

Nahas, Rebecca and Myra Turley. 1979. *The New Couple: Women and Gay Men.* New York: Seaview Books.

Namaste, Ki. 1994. "The Politics of Inside/Out: Queer Theory, Poststructuralism, and a Sociological Approach to Sexuality." *Sociological Theory* 12 (2): 220–231.

Nanda, Serena. 1986. "The Hijras of India: Cultural and Individual Dimensions of an Institutionalized Third Gender Role." In *Anthropology and Homosexual Behavior,* ed. Evelyn Blackwood, pp. 35–54. New York: Haworth.

———. 1990. *Neither Man nor Woman: The Hijras of India.* Belmont, Calif.: Wadsworth.

Nandy, Ashis. 1983. *The Intimate Enemy: Loss and Recovery of Self Under Colonialism.* Delhi: Oxford University Press.

Narayan, Kirin. 1993. "How Native Is the 'Native' Anthropologist?" *American Anthropologist* 95 (3): 671–686.

Nardi, Peter M. 1992a. "That's What Friends Are For: Friends as Family in the Gay and Lesbian Community." In *Modern Homosexualities: Fragments of Lesbian and Gay Experience,* ed. Ken Plummer, pp. 108–120. New York: Routledge.

_____. 1992b. "Sex, Friendship, and Gender Roles Among Gay Men." In *Men's Friendships*, ed. Peter M. Nardi. Newbury Park, Calif.: Sage.

_____. 1994. "Friendship in the Lives of Gay Men and Lesbians." *Journal of Social and Personal Relationships* 11.

Nash, June. 1979. *We Eat the Mines and the Mines Eat Us*. New York: Columbia University Press.

Nealon, Chris. 1990. "Lesbian Seeks Visitation Rights in Custody Battle." *Gay Community News*, November 25–December 8.

Nectoux, Jean Michel. 1991. *Gabriel Fauré: A Musical Life*, trans. Roger Nichols. New York: Cambridge University Press.

Nelson, Cary. 1995. "Lessons from the Job Wars: Late Capitalism Arrives on Campus." *Social Text* 13 (3): 119–134.

Nelson, Diane M. 1996. "Maya Hackers and the Cyberspatialized Nation-State: Modernity, Ethnonostalgia, and a Lizard Queen in Guatemala." *Cultural Anthropology* 11 (3): 287–308.

Newton, Esther. 1979. *Mother Camp: Female Impersonators in America*. Chicago: University of Chicago Press.

————. 1984. "The Mythic Mannish Lesbian: Radclyffe Hall and the New Woman." Reprinted in *The Lesbian Issue: Essays from SIGNS*, ed. Barbara C. Gelpi, Estelle B. Freedman, Susan L. Johnson, and Kathleen M. Weston, pp. 7–25. Chicago: University of Chicago Press.

————. 1988. "Of Yams, Grinders and Gays: The Anthropology of Homosexuality." *Out/Look* 1 (1): 28–37.

————. 1993a. *Cherry Grove, Fire Island: Sixty Years in America's First Gay and Lesbian Town*. Boston: Beacon Press.

————. 1993b. "My Best Informant's Dress: The Erotic Equation in Fieldwork." *Cultural Anthropology* 8 (1): 3–23.

————. 1993c. "Lesbian and Gay Issues in Anthropology: Some Remarks to the Chairs of Anthropology Departments." Paper read at the annual meetings of the American Anthropological Association, Washington, D.C.

Newton, Esther and Shirley Walton. 1984. "The Misunderstanding." In *Pleasure and Danger*, ed. Carole S. Vance, pp. 242–250. New York: Routledge & Kegan Paul.

Nichols, Theo. 1980. "Management, Ideology and Practice." In *The Politics of Work and Occupations*, ed. Geoff Esland and Graeme Salaman, pp. 279–302. Milton Keynes, England: Open University Press.

Norman, Michael. 1989. *These Good Men: Friendships Forged from War*. New York: Crown.

O'Hara, Daniel T. 1991. "Michel Foucault and the Fate of Friendship." *boundary 2* 18 (1): 83–103.

Oboler, R. S. 1980. "Is the Female Husband a Man?: Woman/Woman Marriage among the Nandi of Kenya." *Ethnology* 19 (1): 69–88.

Oldenburg, Veena T. 1990. "Lifestyle as Resistance: The Case of the Courtesans of Lucknow, India." *Feminist Studies* 16 (2): 259–287.

Ollman, Bertell. 1971. *Alienation*. London: Cambridge University Press.

Opler, Marvin K. 1965. "Anthropological and Cross-Cultural Aspects of Homosexuality." In *Sexual Inversion*, ed. Judd Marmor, pp. 108–123. New York: Basic Books.

Orledge, Robert. 1979. *Gabriel Fauré*. London: Eulenburg Books.

Ortner, Sherry B. and Harriet Whitehead, eds. 1981. *Sexual Meanings: The Cultural Construction of Gender and Sexuality*. New York: Cambridge University Press.

Orvell, Miles. 1989. *The Real Thing: Imitation and Authenticity in American Culture, 1880–1940*. Chapel Hill: University of North Carolina Press.

Paine, Robert. 1969. "In Search of Friendship: An Exploratory Analysis in 'Middle-Class' Culture." *Man/The Compact* 4: 505–524.

Paredes, Américo. 1978. "On Ethnographic Work Among Minority Groups: A Folklorist's Perspective." In *New Directions in Chicano Scholarship*, ed. Ricardo Romo and Raymund Paredes. La Jolla, Calif.: Chicano Studies Monograph Series.

Parker, Richard. 1987. "Acquired Immunodeficiency Syndrome in Urban Brazil." *Medical Anthropology Quarterly* 1: 155–175.

———. 1989. "Youth, Identity, and Homosexuality: The Changing Shape of Sexual Life in Contemporary Brazil." *Journal of Homosexuality* 17 (3/4): 269–289.

———. 1991. *Bodies, Pleasures, and Passions: Sexual Culture in Contemporary Brazil*. Boston: Beacon Press.

———. 1992. "Sexual Diversity, Cultural Analysis, and AIDS Education in Brazil." In *The Time of AIDS: Social Analysis, Theory, and Method*, ed. Gilbert Herdt and Shirley Lindenbaum, pp. 225–242. Newbury Park, Calif.: Sage.

Parker, Richard G. and M. Carballo. 1990. "Qualitative Research on Homosexual and Bisexual Behavior Relevant to HIV/AIDS." *Journal of Sex Research* 27 (4): 497–525.

Parker, Richard G., Gilbert Herdt, and M. Carballo. 1991. "Sexual Culture, HIV Transmission, and AIDS Research." *Journal of Sex Research* 28 (1): 77–98.

Patel, Geeta. 1997a. "Home, Homo, Hybrid: Translating Gender." *College Literature* 24(1): 133–150.

———. 1997b. "Homely Housewives Run Amok." Unpublished ms.

Perkins, K. B. and J. K. Skipper, Jr. 1981. "Gay Pornographic and Sex Paraphernalia Shops: An Ethnography of Expressive Work Settings." *Deviant Behavior* 2 (2): 187–199.

Peterson, J. L. 1992. "Black Men and Their Same-Sex Desires and Behaviors." In *Gay Culture in America: Essays from the Field*, ed. Gilbert Herdt, pp. 147–164. Boston: Beacon Press.

Pilling, Arnold R. 1992. "Northwest California Indian Gender Classes: 'Those Who Could Not Marry,' 'Those Men Who Have Never Been Near a Woman,' and 'Women Who Do Men's Things.'" *Society of Lesbian and Gay Anthropologists Newsletter* 14 (2): 15–23.

Pitt-Rivers, Julian. 1968. "Pseudo-Kinship." In *International Encyclopedia of the Social Sciences*, pp. 408–413. New York: Macmillan/Free Press.

Plummer, Ken, ed. 1992. *Modern Homosexualities: Fragments of Lesbian and Gay Experience*. New York: Routledge.

Ponse, Barbara. 1978. *Identities in the Lesbian World: The Social Construction of Self*. Westport: Greenwood.

Poovey, Mary. 1992. "Feminism and Postmodernism—Another View." *boundary 2* 19 (2): 34–52.

Povinelli, Elizabeth A. 1992. "Blood, Sex, and Power: 'Pitjawagaitj'/ Menstruation Ceremonies and Land Politics in Aboriginal Northern Australia." Paper read at the annual meetings of the American Anthropological Association, San Francisco.

———. 1993. *Labor's Lot: The Power, History, and Culture of Aboriginal Action.* Chicago: University of Chicago Press.

Pratt, Mary Louise. 1986. "Fieldwork in Common Places." In *Writing Culture*, ed. James Clifford and George E. Marcus, pp. 27-50. Berkeley: University of California Press.

———. 1992. *Imperial Eyes: Travel Writings and Transculturation.* New York: Routledge.

Pratt, Minnie Bruce. 1991. *Rebellion: Essays 1980-1991.* Ithaca, N.Y.: Firebrand Books.

———. 1995. *S/he.* Ithaca, N.Y.: Firebrand Books.

Preston, John, ed. 1991. *Hometowns: Gay Men Write About Where They Belong.* New York: Dutton.

Rabinow, Paul. 1977. *Reflections on Fieldwork in Morocco.* Berkeley: University of California Press.

Raiskin, Judith. 1994. "Inverts and Hybrids: Lesbian Rewritings of Sexual and Racial Identities." In *The Lesbian Postmodern*, ed. Laura Doan, pp. 156-172. New York: Columbia University Press.

Rapp, Rayna. 1987. "Toward a Nuclear Freeze?: The Gender Politics of Euro-American Kinship Analysis." In *Gender and Kinship: Essays Toward a Unified Analysis*, ed. Jane Fishburne Collier and Sylvia Junko Yanagisako, pp. 119-131. Stanford: Stanford University Press.

Read, Kenneth E. 1980. *Other Voices: The Style of a Male Homosexual Tavern.* Novato, Calif.: Chandler & Sharp.

Remafedi, Gary, ed. 1994. *Death by Denial: Studies of Suicide in Gay and Lesbian Teenagers.* Boston: Alyson Publications.

Reskin, Barbara F. and Heidi I. Hartmann, ed. 1986. *Women's Work, Men's Work: Sex Segregation on the Job.* Washington, D.C.: National Academy Press.

Rheingold, Howard. 1991. *Virtual Reality.* New York: Summit Books.

Riddiough, Christine. 1981. "Socialism, Feminism, and Gay/Lesbian Liberation." In *Women and Revolution*, ed. Lydia Sargent. Boston: South End Press.

Riley, Claire. 1988. "American Kinship: A Lesbian Account." *Feminist Issues* 8 (2): 75-94.

Robertson, Jennifer. 1989. "Gender-Bending in Paradise: Doing 'Female' and 'Male' in Japan." Genders 5: 50-69.

———. 1991. "Theatrical Resistance, Theatres of Restraint: The Takarazuka Revue and the 'State Theatre' Movement in Japan." *Anthropological Quarterly* 64 (4): 165-177.

———. 1992. "The Politics of Androgyny in Japan: Sexuality and Subversion in the Theater and Beyond." *American Ethnologist* 19 (3): 1-24.

Robinson, Paul. 1989. *The Modernization of Sex: Havelock Ellis, Alfred Kinsey, William Masters and Virginia Johnson.* Ithaca, N.Y.: Cornell University Press.

Rofes, Eric E. 1983. *I Thought People Like That Killed Themselves: Lesbians, Gay Men, and Suicide.* San Francisco: Grey Fox Press.

Róheim, G. 1933. "Women and their Life in Central Australia." *Journal of the*

Royal Anthropological Institute of Great Britain and Ireland 63: 207–265.

Román, David. 1993. "'It's My Party and I'll Die If I Want To': Gay Men, AIDS, and the Circulation of Camp in U.S. Theater." In *Camp Grounds: Style and Homosexuality*, ed. David Bergman, pp. 206–233. Amherst: University of Massachusetts Press.

Rosaldo, Renato. 1989. *Culture and Truth: The Remaking of Social Analysis.* Boston: Beacon Press.

Roscoe, Will. 1987. "Bibliography of Berdache and Alternative Gender Roles among North American Indians." *Journal of Homosexuality* 14 (3/4): 81–171.

———, with Gay American Indians, eds. 1988a. *Living the Spirit.* New York: St. Martin's Press.

———. 1988b. "Strange Country This: Images of Berdaches and Warrior Women." In *Living the Spirit*, ed. Will Roscoe, with Gay American Indians, pp. 48–76. New York: St. Martin's Press.

———. 1990. "'That Is My Road': The Life and Times of a Crow Berdache." *Montana Magazine of Western History*, Winter, 46–55.

———. 1991. *The Zuni Man-Woman.* Albuquerque: University of New Mexico Press.

———. 1991–92. "Writing Lesbian and Gay Culture(s): An Impossible Possibility?" *Our Stories*, 1, 10–12.

———. 1992. "How to Become a Berdache: Toward a Unified Analysis of Gender Diversity." Paper read at the annual meetings of the American Anthropological Association, San Francisco.

Roseberry, William. 1996. "The Unbearable Lightness of Anthropology." *Radical History Review* 65: 5–25.

Ross, Andrew. 1993. "Uses of Camp." In *Camp Grounds: Style and Homosexuality*, ed. David Bergman, pp. 54–77. Amherst: University of Massachusetts Press.

Ross, Ellen and Rayna Rapp. 1983. "Sex and Society: A Research Note from Social History and Anthropology." In *Powers of Desire: The Politics of Sexuality*, ed. Ann Snitow, Christine Stansell, and Sharon Thompson, pp. 51–73. New York: Monthly Review Press.

Rubin, Gayle. 1975. "The Traffic in Women: Notes on the 'Political Economy' of Sex." In *Toward an Anthropology of Women*, ed. Rayna Reiter, pp. 157–210. New York: Monthly Review Press.

———. 1984. "Thinking Sex: Notes for a Radical Theory of the Politics of Sexuality." In *Pleasure and Danger*, ed. Carole S. Vance, pp. 267–319. New York: Routledge & Kegan Paul.

———. 1991. "The Catacombs: A Temple of the Butthole." In *Leatherfolk*, ed. Mark Thompson, pp. 119–141. Boston: Alyson Publications.

———. 1992. "Of Catamites and Kings: Reflections on Butch, Gender, and Boundaries." In *The Persistent Desire*, ed. Joan Nestle, pp. 466–482. Boston: Alyson Publications.

———. 1993. "The Valley of the Kings: Leathermen in San Francisco, 1960–1985." Unpublished ms.

Rubin, Lillian B. 1985. *Just Friends: The Role of Friendship in Our Lives.* New York: Harper & Row.

Sahlins, Marshall. 1976. *Culture and Practical Reason.* Chicago: University of Chicago Press.

Salaman, Graeme. 1980. "The Sociology of Work: Some Themes and Issues." In *The Politics of Work and Occupations*, ed. Geoff Esland and Graeme Salaman. Milton Keynes, England: Open University Press.

Salter, Stephanie. 1992. "My Two Moms: Ryan's Parents Want Only the Best for Him. Should It Make Any Difference That They're Lesbians?" *Redbook*, May, 64–66, 70.

Sangren, P. Steven. 1988. "Rhetoric and the Authority of Ethnography: 'Postmodernism' and the Social Reproduction of Texts." *Current Anthropology* 29(3): 405–435.

Sankar, A. 1986. "Sisters and Brothers, Lovers and Enemies: Marriage Resistance in Southern Kwangtung." In *Anthropology and Homosexual Behavior*, ed. Evelyn Blackwood, pp. 69–82. New York: Haworth.

Sapir, Edward. 1963. *Selected Writings of Edward Sapir in Language, Culture, and Personality*. Ed. D. G. Mandelbaum. Berkeley: University of California Press.

Sarkar, Tanika. 1994. "Bankimchandra and the Impossibility of a Political Agenda." *Oxford Literary Review* 16 (1/2): 177–204.

Sarris, Greg. 1991. "'What I'm Talking about When I'm Talking about My Baskets': Conversations with Mabel McKay." In *De/Colonizing the Subject: The Politics of Gender in Women's Autobiography*, ed. Sidonie Smith and Julia Watson, pp. 20–33. Minneapolis: University of Minnesota Press.

———. 1994. *Mabel McKay: Weaving the Dream*. Berkeley: University of California Press.

Schaeffer, Claude E. 1965. "The Kutenai Female Berdache: Courier, Guide, Prophetess, and Warrior." *Ethnohistory* 12 (3): 193–236.

Scheppele, Kim Lane. 1994. "Legal Theory and Social Theory." *Annual Review of Sociology* 20: 383–406.

Schiefenhövel, W. 1990. "Ritualized Adult-Male/Adolescent-Male Sexual Behavior in Melanesia." In *Pedophilia*, ed. J. R. Feierman, pp. 394–421. Berlin: Springer-Verlag.

Schieffelin, Edward L. 1976. *The Sorrow of the Lonely and the Burning of the Dancers*. New York: St. Martin's Press.

———. 1982. "The Bau Aa Ceremonial Hunting Lodge: An Alternative to Initiation." In *Rituals of Manhood*, ed. Gilbert H. Herdt, pp. 155–200. Berkeley: University of California Press.

Schneebaum, Tobias. 1988. *Where the Spirits Dwell: An Odyssey in the New Guinea Jungle*. New York: Grove.

Schneider, David M. 1968. *American Kinship: A Cultural Account*. Englewood Cliffs, N.J.: Prentice-Hall.

———. 1984. *A Critique of the Study of Kinship*. Ann Arbor: University of Michigan Press.

Schroedel, Jean Reith. 1985. *Alone in a Crowd: Women in the Trades Tell Their Stories*. Philadelphia: Temple University Press.

Scott, Joan W. 1992. "Experience." In *Feminists Theorize the Political*, ed. Judith Butler and Joan W. Scott, pp. 22–40. New York: Routledge.

Sears, James T. 1991. *Growing Up Gay in the South: Race, Gender, and Journeys of the Spirit*. New York: Haworth.

Sedgwick, Eve. 1990. *Epistemology of the Closet*. Berkeley: University of California Press.

Seidman, Steven. 1991. *Romantic Longings: Love in America, 1830–1980*. New York: Routledge.

———. 1994. "Symposium: Queer Theory/Sociology: A Dialogue." *Sociological Theory* 12 (2): 166–177.

Sewell, William H., Jr. 1992. "A Theory of Structure: Duality, Agency, and Transformation." *American Journal of Sociology* 98 (1): 1–29.

Shepherd, Gill. 1987. "Rank, Gender, and Homosexuality: Mombasa as a Key to Understanding Sexual Options." In *The Cultural Construction of Sexuality*, ed. Pat Caplan, pp. 240–270. New York: Tavistock.

Shortt, John. 1873. "The Kojahs of Southern India." *Journal of the Anthropological Institute of Great Britain and Ireland* 2: 402–407.

Shostak, Marjorie. 1981. *Nisa: The Life and Words of a !Kung Woman*. Cambridge: Harvard University Press.

Silverman, Kaja. 1992. *Male Subjectivity at the Margins*. New York: Routledge.

Simpson, David. 1993. *Romanticism, Nationalism, and the Revolt Against Theory*. Chicago: University of Chicago Press.

Singer, M., C. Flores, L. Davison, G. Burke, Z. Castillo et al. 1990. "SIDA: The Economic, Social, and Cultural Context of AIDS among Latinos." *Medical Anthropology Quarterly* 4 (1): 72–114.

Sinha, Mrinalini. 1995. "Nationalism and Respectable Sexuality in India." *Genders* 21: 30–57.

Smith, Stephanie A. 1993. "Morphing, Materialism, and the Marketing of Xenogenesis." *Genders* 18: 67–86.

Solomon, Alisa. 1992. "Identity Crisis: Queer Politics in the Age of Possibilities." *Village Voice*, 27–33, 39.

Sonenschein, David. 1966. "Homosexuality as a Subject of Anthropological Inquiry." *Anthropological Quarterly* 39 (2): 73–82.

———. 1968. "The Ethnography of Male Homosexual Relationships." *Journal of Sex Research* 4: 69–83.

———. 1969. "The Homosexual's Language." *Journal of Sex Research* 5: 281–291.

Spencer, N. 1983. "Medical Anthropology and the AIDS Epidemic: A Case Study in San Francisco." *Urban Anthropology* 12 (2): 141–159.

Spivak, Gayatri Chakravorty. 1990. *The Post-Colonial Critic*. New York: Routledge.

Stacey, Judith. 1991. *Brave New Families: Stories of Domestic Upheaval in Late Twentieth Century America*. New York: Basic Books.

Stack, Carol B. 1974. *All Our Kin: Strategies for Survival in a Black Community*. New York: Harper & Row.

Stein, Arlene and Ken Plummer. 1994. "I Can't Even Think Straight: Queer Theory and the Missing Sexual Revolution in Sociology." *Sociological Theory* 12 (2): 178–187.

Steward, Julian H. and Louis C. Faron. 1959. *Native Peoples of South America*. New York: McGraw-Hill.

Stocking, George W., Jr. 1968. *Race, Culture, and Evolution: Essays in the History of Anthropology*. New York: Free Press.

———. 1992. *The Ethnographer's Magic and Other Essays in the History of Anthropology*. Madison: University of Wisconsin Press.

Stoler, Ann Laura. 1995. *Race and the Education of Desire: Foucault's History of Sexuality and the Colonial Order of Things.* Durham, N.C.: Duke University Press.

Storey, John. 1983. *Managerial Prerogative and the Question of Control.* Boston: Routledge & Kegan Paul.

Strathern, Marilyn. 1988. *The Gender of the Gift.* Berkeley: University of California Press.

Strober, Myra H. 1984. "Toward a General Theory of Occupational Sex Segregation: The Case of Public School Teaching." In *Sex Segregation in the Workplace: Trends, Explanations, Remedies,* ed. Barbara F. Reskin, pp. 144–156. Washington, D.C.: National Academy Press.

Strober, Myra H. and Carolyn L. Arnold. 1987. "The Dynamics of Occupational Segregation among Bank Tellers." In *Gender in the Workplace,* ed. Clair Brown and Joseph A. Pechman, pp. 107–157. Washington, D.C.: The Brookings Institution.

Suggs, Robert C. 1966. *Marquesan Sexual Behavior.* New York: Harcourt, Brace & World.

Takaki, Ronald. 1993. *A Different Mirror: A History of Multicultural America.* Boston: Little, Brown.

Tate, Greg. 1992. *Flyboy in the Buttermilk: Essays on Contemporary America: An Eye-Opening Look at Race, Politics, Literature, and Music.* New York: Simon & Schuster.

Thayer, James Steel. 1980. "The Berdache of the Northern Plains: A Socioreligious Perspective." *Journal of Anthropological Research* 36: 287–293.

Thomas, Nicholas. 1989. *Out of Time: History and Evolution in Anthropological Discourse.* Cambridge: Cambridge University Press.

———. 1991. "Against Ethnography." *Cultural Anthropology* 6 (3): 306–322.

Topley, Marjorie. 1975. "Marriage Resistance in Rural Kwangtung." In *Women in Chinese Society,* ed. Margery Wolf and Roxane Witke, pp. 67–88. Stanford: Stanford University Press.

Trexler, Richard C. 1995. *Sex and Conquest: Gendered Violence, Political Order, and the European Conquest of the Americas.* Ithaca, N.Y.: Cornell University Press.

Troiden, R. R. 1974. "Homosexual Encounters in a Highway Rest Stop." In *Sexual Deviance and Sexual Deviants,* ed. E. Goode and R. R. Troiden, pp. 211–228. New York: Morrow.

Trumbach, Randolph. 1977. "London's Sodomites: Homosexual Behavior and Western Culture in the 18th Century." *Journal of Social History* 11: 1–33.

———. 1985. "Sodomitical Subcultures, Sodomitical Roles, and the Gender Revolution of the Eighteenth Century: The Recent Historiography." *Eighteenth-Century Life* 9: 109–121.

Uhl, Sarah. 1991. "Forbidden Friends: Cultural Veils of Female Friendship in Andalusia." *American Ethnologist* 18 (1): 90–105.

van Gennep, Arnold. 1960. *The Rites of Passage.* Trans. Monika B. Vizedom and Gabrielle L. Caffee. Chicago: University of Chicago Press.

Vance, Carole S. 1989. "Social Construction Theory: Problems in the History of Sexuality." In *Homosexuality, Which Homosexuality?,* ed. Dennis Altman, Carole Vance, Martha Vicinus, Jeffrey Weeks et al., pp. 13–34. London: GMP.

―――. 1991. "Anthropology Rediscovers Sexuality: A Theoretical Comment." *Social Science and Medicine* 33 (8): 875–884.

Vázquez, Carmen. 1992. "Appearances." In *Homophobia: How We All Pay the Price*, ed. Warren J. Blumenfeld, pp. 157–166. Boston: Beacon Press.

Vizenor, Gerald. 1990. *Crossbloods: Bone Courts, Bingo, and Other Reports*. Minneapolis: University of Minnesota Press.

Wagner, Roy. 1981. *The Invention of Culture*. Chicago: University of Chicago Press.

Walliman, Isidor. 1981. *Estrangement: Marx's Conception of Human Nature and the Division of Labor*. Westport, Conn.: Greenwood Press.

Walters, Delores M. 1996. "Caste among Outcastes: Interpreting Sexual Orientation, Racial, and Gender Identity in the Yemen Arab Republic." In *Out in the Field: Reflections of Lesbian and Gay Anthropologists*, ed. Ellen Lewin and William L. Leap, pp. 58–69. Urbana: University of Illinois Press.

Warren, Carol A. B. 1974. *Identity and Community in the Gay World*. New York: Wiley.

―――. 1977. "Fieldwork in the Gay World: Issues in Phenomenological Research." *Journal of Social Issues* 33 (4): 93–107.

Weber, Max. 1958. *The Protestant Ethic and the Spirit of Capitalism*. New York: Charles Scribner's Sons.

Weeks, Jeffrey. 1986. *Sexuality*. New York: Tavistock Publications.

―――. 1987. "Questions of Identity." In *The Cultural Construction of Sexuality*, ed. Pat Caplan, pp. 30–51. New York: Tavistock.

Weinrich, James D. and Walter L. Williams. 1991. "Strange Customs, Familiar Lives: Homosexualities in Other Cultures." In *Homosexuality: Research Findings for Public Policy*, ed. John C. Gonsiorek and James D. Weinrich, pp. 44–59. Newbury Park, Calif.: Sage.

Werner, D. 1979. "A Cross-Cultural Perspective on Theory and Research on Male Homosexuality." *Journal of Homosexuality* 4 (4): 345–362.

West, Cornel. 1993. *Race Matters*. Boston: Beacon Press.

West, Jackie. 1978. "Women, Sex, and Class." In *Feminism and Materialism: Women and Modes of Production*, ed. Annette Kuhn and AnnMarie Wolpe, pp. 220–253. London: Routledge & Kegan Paul.

Westermarck, Edward. 1906. *The Origin and Development of the Moral Ideas*. London: Macmillan.

Weston, Kath. 1982. *The Apprenticeship and Blue Collar System: Putting Women on the Right Track*. Sacramento: California State Department of Education.

―――. 1991. [Second ed. 1997] *Families We Choose: Lesbians, Gays, Kinship*. New York: Columbia University Press.

―――. 1993. "Do Clothes Make the Woman?: Gender, Performance Theory, and Lesbian Eroticism." *Genders* 17: 1–21.

Wharton, Amy. 1991. "Structure and Agency in Socialist-Feminist Theory." *Gender & Society* 5 (3): 373–389.

Whitam, Frederick L. 1987. "A Cross-Cultural Perspective on Homosexuality, Transvestism and Trans-Sexualism." In *Variant Sexuality*, ed. Glenn D. Wilson, pp. 176–201. London: Croom Helm.

Whitam, Frederick L. and M. J. Dizon. 1979. "Occupational Choice and Sexual Orientation in Cross-Cultural Perspective." *International Review of Modern Sociology* 9: 137–149.

Whitam, Frederick L. and R. Mathy. 1986. *Male Homosexuality in Four Societies.* New York: Praeger.

White, Edmund. 1980. *States of Desire: Travels in Gay America.* New York: Dutton.

Whitehead, Harriet. 1981. "The Bow and the Burden Strap: A New Look at Institutionalized Homosexuality in Native North America." In *Sexual Meanings,* ed. Sherry B. Ortner and Harriet Whitehead, pp. 80–115. Cambridge: Cambridge University Press.

————. 1986a. "The Varieties of Fertility Cultism in New Guinea, Part I." *American Ethnologist* 13 (2): 271–289.

————. 1986b. "The Varieties of Fertility Cultism in New Guinea, Part II." *American Ethnologist* 13 (1): 80–99.

Wieringa, Saskia. 1989. "An Anthropological Critique of Constructionism: Berdaches and Butches." In *Homosexuality, Which Homosexuality?,* ed. Dennis Altman, Carole Vance, Martha Vicinus, Jeffrey Weeks et al., pp. 215–238. London: GMP.

Wikan, Unni. 1977. "Man Becomes Woman: Transsexualism in Oman as a Key to Gender Roles." *Man* 12: 304–319.

————. 1991. *Behind the Veil in Arabia: Women in Oman.* Chicago: University of Chicago Press.

Williams, F. E. 1936. *Papuans of the Trans-Fly.* Oxford: Clarendon Press.

Williams, Patricia. 1991. *The Alchemy of Race and Rights.* Cambridge: Harvard University Press.

Williams, Raymond. 1973. *The Country and the City.* London: Chatto & Windus.

————. 1977. *Marxism and Literature.* New York: Oxford University Press.

Williams, Susan. 1980. "Lesbianism: A Socialist Feminist Perspective." In *Pink Triangles: Radical Perspectives on Gay Liberation,* ed. Pam Mitchell, pp. 107–116. Boston: Alyson Publications.

Williams, Walter L. 1987. "Women, Men, and Others: Beyond Ethnocentrism in Gender Theory." *American Behavioral Scientist* 31 (1): 135–141.

————. 1991. *Javanese Lives: Women and Men in Modern Indonesian Society.* New Brunswick, N.J.: Rutgers University Press.

————. 1992a. *The Spirit and the Flesh: Sexual Diversity in American Indian Culture.* 2nd ed. Boston: Beacon Press.

————. 1992b. "Benefits for Non-Homophobic Societies: An Anthropological Perspective." In *Homophobia: How We All Pay the Price,* ed. Warren J. Blumenfeld, pp. 258–274. Boston: Beacon Press.

Wilson, Monica. 1963. *Good Company: A Study of Nyakyusa Age-Villages.* Boston: Beacon Press.

Winkler, John J. 1990. *The Constraints of Desire: The Anthropology of Sex and Gender in Ancient Greece.* New York: Routledge.

Wiseman, Jacqueline P. 1986. "Friendship: Bonds and Binds in a Voluntary Relationship." *Journal of Social and Personal Relationships* 3: 191–211.

Wolf, Arthur P. 1995. *Sexual Attraction and Childhood Association: A Chinese Brief for Edward Westermarck.* Stanford: Stanford University Press.

Wolf, Deborah G. 1979. *The Lesbian Community.* Berkeley: University of California Press.

Wolf, Diane L., ed. 1996. *Feminist Dilemmas in Fieldwork*. Boulder, CO: Westview Press.

Woolley, Benjamin. 1992. *Virtual Worlds: A Journey in Hype and Hyperreality*. Oxford: Blackwell.

Yanagisako, Sylvia Junko. 1985. *Transforming the Past: Tradition and Kinship among Japanese Americans*. Stanford: Stanford University Press.

Yanagisako, Sylvia Junko and Jane Fishburne Collier. 1987. "Toward a Unified Analysis of Gender and Kinship." In *Gender and Kinship: Essays Toward a Unified Analysis*, ed. Jane Fishburne Collier and Sylvia Junko Yanagisako, pp. 14–50. Stanford: Stanford University Press.

Yanagisako, Sylvia and Carol Delaney, eds. 1995. *Naturalizing Power: Essays in Feminist Cultural Analysis*. New York: Routledge.

Young, Iris. 1981. "Beyond the Unhappy Marriage: A Critique of Dual Systems Theory." In *Women and Revolution*, ed. Lydia Sargent, pp. 43–69. Boston: South End Press.

Young, Robert J. C. 1995. *Colonial Desire: Hybridity in Theory, Culture and Race*. New York: Routledge.

Yukins, Elizabeth. 1991. "Lesbian/Gay Parents Dealt Legal Setback." *Gay Community News*, May 12–28.

Zavella, Patricia. 1993. "Feminist Insider Dilemmas: Contructing Ethnic Identity with 'Chicana' Informants." *Frontiers* 13 (3): 53–76.

permissions

"Get Thee to a Big City" is reprinted from *GLQ: A Journal of Lesbian and Gay Studies*, volume 2 (1995).

"Forever Is a Long Time" is reprinted from *Naturalizing Power: Essays in Feminist Cultural Analysis*, edited by Sylvia Yanagisako and Carol Delaney (Routledge, 1995).

"Theory, Theory, Who's Got the Theory?" is reprinted from *GLQ: A Journal of Lesbian and Gay Studies*, volume 2 (1995).

"Requiem for a Street Fighter" is reprinted from *Out in the Field: Reflections of Lesbian and Gay Anthropologists*, edited by Ellen Lewin and William L. Leap (University of Illinois Press, 1996).

"The Virtual Anthropologist" is reprinted from *Anthropological Locations: Boundaries and Grounds of a Field Science*, edited by Akhil Gupta and James Ferguson (University of California Press, 1997).

The author and publisher would like to thank the following for permission to reproduce copyrighted material:

"Production as Means, Production as Metaphor" is reprinted from *Uncertain Terms: Negotiating Gender in American Culture*, edited by Faye Ginsburg and Anna Lowenhaupt Tsing (1990) with the kind permission of Beacon Press.

"Sexuality, Class, and Conflict in a Lesbian Workplace" is reprinted from *Signs*, volume 9 (1984) with the kind permission of The University of Chicago Press.

index

ability 97, 106–108, 111, 114, 139, 144, 183, 186, 197; capability as 99, 103–104, 106

Activo/Pasivo 170

Adam, Barry 160

adoption 73, 84, 184, 186

adultery 4, 7, 9, 14

age relations 7, 29, 51, 92, 112, 152–153, 172

agency 85, 89, 93. *See also* agency/structure debate

agency/structure debate 85, 163, 173, 221n.1, 2

AIDS 65, 87, 178, 185, 219n.11; representations of 35, 40, 50, 88; research on 154, 169–171

alienation 118, 120–122, 126, 140–141, 192, 223n.12

Anderson, Benedict 34, 229n.12

Angelino, Henry 164

Aronowitz, Stanley 136

authenticity 57, 62, 73, 75, 78–81, 189, 197–198; ideologies of 62, 77–78

authority 79–80, 123–124, 220n.24; ethnographic 159, 199, 204, 206, 208; "native" 205–207

bars, gay and lesbian 50–51, 53, 96, 171

Beach, Frank A. 149

Benedict, Ruth 10, 150, 157, 214n.6

berdache; see Two-Spirits

Berndt, Catherine 10

Berndt, Ronald 10

biology 9, 16, 61, 62–63, 73, 77–78, 81, 104, 172. *See also* science

Blackwood, Evelyn 151, 153

Boas, Franz 14

bodies 3, 6, 78, 81, 161, 167–168, 175, 178, 187, 193, 196; work discipline and 96–97, 101, 105, 110, 193, 197, 202, 205–206

Bolin, Anne 151, 173

Bolton, Ralph 154, 170

Bourdieu, Pierre 78, 144

Bower, Lisa 161, 168

Bowers v. Hardwick 90

butch/femme 45, 97, 145, 151, 159, 168, 171, 198

camp 89, 174, 207, 230n.23

capitalism 41–42, 99, 103, 118, 128, 136, 139, 216–217n.4, 223n.11, 230n.23

Carpenter, Edward 165

Carrier, Joseph 155, 169
choice: consumer 26, 87; family forma-
tion and 81, 83, 85–93; friendship
and 67; ideologies of 65, 113, 115
chosen families. *See* families
class 26, 51, 87, 97, 104, 115, 118,
135–139, 143–144, 187; relations
of 4, 21, 29, 62, 112, 125–126, 133,
135, 146, 171, 186, 189. *See also*
class background, class conflict
class background 98, 115, 136–137,
178, 182–183
class conflict 9, 116–118, 123, 129,
178, 185
classification 4, 7, 15, 31–33, 69, 77,
79, 152, 156–157, 160, 166–167
Collins, Patricia Hill 209
colonialism 8–9, 11, 18–19, 27, 62,
153–155, 191, 205, 214n.8, 226n.1,
226n.2, 227n.5, 228n.8. *See also*
home rule, social movements
coming out 20, 29, 38–40, 44, 119,
146, 183; HIV as impetus to 65,
169, 186; narratives of 31–35, 57,
90; political strategy of 172,
174–175; publication as form of
178, 202–204; relatives and
65–66, 81
commodification 103, 173, 192,
230n.23
community 30, 32, 38, 45, 49, 52,
160, 173, 195; divisions within
51–55, 141, 171, 186; imagined
34–35, 40, 46, 48–49, 178, 186,
196, 205; lesbian and gay 40, 44,
47, 64, 120, 135; women's 31, 139
Compadrazgo 66, 219n.12
contract, politics of 131–133, 135, 141
Coombe, Rosemary 168, 229n.16
Cordell, Julie 177–179, 181–188
Cory, Donald W. 148
court cases 60, 73–74, 84, 87–88, 90,
91, 161
Creed, Gerald 162
cross-dressing. *See* transgender
cultural relativism 9, 12, 174–175
cultural studies 22, 23, 144
culture concept 16, 215n.10

custody and visitation rights 19, 60,
73–74, 79, 84, 88, 90, 161, 172, 184

Darwin, Charles 4, 16–18, 78
Davis, Madeline 163, 171
Deacon, A. Bernard 6
Degérando, Joseph Marie 17
D'Emilio, John 149
Derrida, Jacques 144
deviancy models 12, 15, 150, 193
diaspora 5, 25, 48, 56
diffusion 14, 153
disciplinary formation 144, 189–190,
195, 210–211; sexuality in 1–5,
12–13, 20–21, 23–25, 157
division of labor 13, 17, 26, 115, 123,
128, 133, 139, 141; class and
124–125, 135, 137; gendered
("sexual") 100–101, 103, 140;
mental/ manual 112, 206
domestic partnership 74, 84, 220n.20
double mimesis 165
Durkheim, Emile 4, 15, 16

Ellison, Christopher 67
Elliston, Deborah 163
employment 42, 47, 96, 187; "alterna-
tive" workplaces and 118–119,
140–142; anthropology and 178,
190–191, 198–199, 213n.1, 228n.11;
discrimination in 95, 147, 161, 192,
209–210, 230n.27; strategies for
obtaining 101, 105–107; working-
class 96–97, 104. *See also* class rela-
tions, division of labor, workplace
relations
Engels, Frederick 16, 17
entrepreneurship 119, 126, 131, 136,
139–140
eroticism 3, 8, 13, 15, 17, 21–24, 27,
157, 163, 171. *See also* sexuality
ethnic studies 25, 226n.2
ethnocartography 149, 153, 155
ethnography 5, 8–11, 16, 159, 179,
205–206; lesbian/gay 156,
171–173, 190, 197
Evans-Pritchard, E. E. 10, 13–14, 22,
215n.15

ex-lovers 63, 65, 71–72. *See also* lovers
exoticism 11, 15, 25, 27, 155, 193, 198, 205, 211

families 4, 13, 17, 20–21, 92, 119, 180–181; "alternative" 61, 65, 73, 88; "chosen" 57, 62, 65, 72, 83–85, 87–88; contested definitions of 59–62, 81–82; friends in 65–66, 74–75, 91, 187; lesbian and gay 57, 64–66, 73, 81, 91, 172, 186; nuclear 59, 73, 83, 86, 92. *See also* choice, ideologies of; kinship; legitimation
family values debate 88, 91
Faron, Louis 6
Fauré, Gabriel 177, 225n.1
femininities 52, 96–97, 159, 167–168; study of 156–157
feminism 30, 99, 113, 116, 122, 128, 138, 156; lesbian- 96, 115, 120, 126, 131, 136–139, 141, 157, 171; socialist- 113, 115, 140–141, 223–224n.19
fieldwork 26, 31, 58, 155, 170, 172, 178–181, 189, 191, 193, 196–198
"flora-and-fauna" studies 6, 11–12, 21, 23–24
Ford, Clellan S. 149
Foucault, Michel 24, 149, 154, 157, 215n.13
Freud, Sigmund 4, 16, 21, 215n.10
friendship 8, 24, 91, 151, 218n.3; kinship and 58, 62–64, 66–68, 71–72, 74–75, 80, 87; work relations and 119, 121, 134

Gagnon, William 2, 215n.16
gay identity. *See* sexual identity; subjectivities, lesbian/gay
gay families. *See* families, lesbian and gay; kinship, ideologies of
gay kinship ideologies. *See* kinship
gay "subcultures" 32, 151, 169, 171, 174, 216n.3
Geertz, Clifford 10
gender 13, 20, 62, 144–145, 151, 157, 159; relations of 51, 87, 98, 105, 171;

representations of 45, 51–53, 92, 167–168, 174, 202, 208; studies of 70, 156, 163, 174, 213n.1; work and 104–110, 112–114, 130–131, 140. *See also* division of labor; gender-bending; gender inversion theories; gendering; occupational sex segregation; third gender; transgender
gender-bending 97, 147
gender inversion theories 97
gendering. *See* butch/femme; femininities; gender; masculinities; transgender
genealogical reckoning 57–59, 61, 78
gift exchange 13, 15, 117, 123, 130, 162
Goffman, Erving 9
Goldberg, Jonathan 161
Goldenweiser, Alexander 147, 165
Great Gay Migration 32, 34, 44, 49, 55
Greenberg, David 151, 152, 165, 167
Gutiérrez, Ramón 164

Herdt, Gilbert 151–152, 155, 158, 161–163, 165, 167, 214n.5
hermaphroditism. *See* intersexuality
heroes: culture 165; working–class 187
Herrell, Richard 161, 217n.8
Herskovits, Melville 6
heterosexuality 5, 7, 18, 70, 73, 82, 89, 158, 159, 167, 194, 202; presumption of 68, 151, 152; theory and 137; work and 97, 131. *See also* sexual behavior; sexuality
hiring practices. *See* employment
Hogbin, Ian 10
home: concept of 194, 227n.6, 229n.17; departure from and return to 31, 33, 44, 54, 110, 204; privatized sphere of 36–37, 90; social location and 11–12, 222n.11
home rule 8, 18
homelands 26, 49, 56, 217n.10
homelessness 47, 49, 182
homophobia 40, 53, 174, 190

homosociality 147, 174
Hooker, Evelyn 2, 150
"Hottentot Venus" 18
Human Relations Area Files
 (HRAF) 148, 152
Humphreys, Laud 170
hybridity 19, 26, 190, 193, 195-198,
 203-207, 210, 228n.10-11,
 229n.13, 230n.27

identity 31, 50, 119-120, 157, 168,
 169, 173, 178, 191, 195, 198,
 202-203, 207, 210; politics of 26,
 49, 54, 56, 172, 195, 203. *See also*
 sexual identity
incest 8, 13, 15-16, 47, 165, 215n.10
ideology 26, 31, 61, 73, 76, 100-101,
 108, 112, 120, 122, 159, 201;
 changes in 81-82, 174. *See also*
 authenticity, ideologies of; choice,
 ideologies of; kinship, ideologies
 of; self-reliance, ideologies of
insider/outsider distinction 175,
 178, 189, 194-196, 202-204, 206,
 225n.2
intersexuality 157, 161, 167

Johnson, Virginia 2, 12

Kehoe, Alice 10
Kelly, Raymond 7, 155
Kennedy, Elizabeth 163, 171
Kinsey, Alfred 2, 12
kinship 13, 26, 30, 57-59, 77-79,
 85-87, 160, 165, 186, 191; critique
 of 59-61, 218n.6; "fictive" 58,
 66-67, 72-73, 82; ideologies of
 60-61,63-68, 73, 76-81, 119, 172
kinship studies 59-60, 77, 81, 218n.6
Knauft, Bruce 152, 163

labor 27, 97, 105, 120, 126, 141-142;
 academic 23, 205-206; bride ser-
 vice 163; concrete 103, 107, 114,
 206; indentured 214n.8; markets
 for 42, 99; products of 111. *See also*
 division of labor; labor conflict;
 labor movement; labor power;

labor relations; production
labor conflict 26, 116-118, 127, 134,
 135, 140, 172. *See also* class conflict
labor movement 95, 102, 118, 133, 135
labor power 96, 103-105, 107
labor relations 103, 123, 128, 131,
 132, 140, 205
Lancaster, Roger 160
Landes, Ruth 150
legitimation 70, 73, 81; professional
 148, 149, 190-191, 198-199,
 206-207; rhetoric of 64, 75-76,
 79, 89, 92; struggle for 61, 76, 80
lesbian identity. *See* subjectivities, les-
 bian/gay; sexual identity
lesbian-feminism. *See* feminism
lesbian/gay studies 1-2, 5, 11, 25,
 145-146, 150, 156, 159, 164,
 173-175, 191, 227n.4. *See also* sexual-
 ity studies
LGBT (Lesbian/Gay/Bisexual/Trans-
 gender) movement 1, 3, 24, 32-33,
 35, 37, 50, 147, 149, 171, 194; coming
 out and 68, 81, 172, 174, 186
Levy, Robert 160
Lewin, Ellen 161, 172
love 17, 18, 34, 58, 61, 84, 90, 124,
 218n.6
lovers 6, 34, 57, 65, 68, 70-71, 119,
 140, 164, 166, 172; differentiation
 between 152-153; finding 33-34,
 39

Maine, Henry 16, 18
Malinowski, Bronislaw 2, 9-10, 15,
 21-22, 214n.8-10, 14-15
marginality 22, 61, 175, 183, 208-211,
 230n.25
marriage, 2, 8, 15-16, 66, 68, 73, 81,
 151, 160, 163, 188, 194, 220n.20;
 "classes" of 4, 15; heterosexual
 70, 83, 89, 92; lesbian/gay 67, 76,
 177; resistance to 151
Marx, Karl 100, 103, 115, 136, 192
masculinities 51, 55, 108-109,
 112-113, 159, 162, 167-168, 186;
 study of 156-157
Masters, William 2, 12

masturbation 5-6, 11, 143
Mathews, R. H. 5
Mauss, Marcel 4, 15
McIntosh, Mary 149
McLennan, John 16-17
Mead, Margaret 8, 22, 150, 157. *See also* Mead/Freeman controversy
Mead/Freeman controversy 19, 215n.15
media 60, 74, 135; formation of gay community and 35-36; representations of sexuality in 38, 91
methodology 3, 11-12, 19-20, 158, 169-170, 175, 191, 202, 204; empirical 5, 11, 21-22, 27, 34, 149, 200, 207. *See also* theory
migration 4, 26, 173, 216n.3; chain 217n.6; circular 42, 54; gay identity and 29-30, 42, 47, 55; narratives of 43-45; reasons for 42; race/ethnicity and 42; rural to urban 33, 41, 45, 48, 55. *See also* Great Gay Migration
Morgan, Lewis Henry 17
Murray, Stephen 170

Nanda, Serena 166
Nash, June 7
nationalism 18, 26, 49, 77, 171, 174, 191, 193, 195. *See also* home rule; social movements
Native Ethnographer, the 189-190, 196
nativization 31, 173-174, 191, 193-195, 197-198, 200-203, 205, 207, 210-211, 227n.5
needs, creation of 9, 123, 125, 128, 223n.9
neighborhoods, gay 32, 50-52, 55, 217n.9
Newton, Esther 143, 150, 160, 163, 167, 171-172
norm, concept of 8, 12-13, 15, 19-20, 100

objectivism 111, 199-200, 207
Oboler, Regina 160
occupational sex segregation 99, 113-114

orientalism 25, 155, 159, 205
othering 15, 62, 159, 174, 190, 199, 205, 207, 210

Parker, Richard 155, 160, 169
partners. *See* lovers
performance 10, 174, 213n.1; job 98, 107-108, 111, 196
Povinelli, Elizabeth 160, 168
power 20, 62, 87, 113, 115, 124, 141, 160, 187. *See also* agency; class; labor power; race
primitive promiscuity debate 13, 16-18
primitivization. *See* nativization
private/public split 118-122, 123, 125, 131-132, 134, 140-141
privatization 36, 84, 90-92, 170; property and 17
procreation 59-61, 66, 73, 77-79, 81, 218n.6
production 99, 103; gendering of 99, 101, 107-108, 114; organization of 108, 120, 125; scholarship as 12, 27, 148, 211; social relations of 115, 125, 137, 151. *See also* division of labor

queer, concept of 159
queer studies. *See* lesbian/gay studies
queer theory 1, 5, 143-146, 163, 175, 192, 217n.8

race 7, 18, 87, 104, 136, 190, 195, 208; sexuality and 4, 20, 27, 54-55. *See also* race relations; racialization; racism
race relations 14, 42, 52-55, 146, 183, 186, 214n.8
racialization 51, 54-55, 172, 206, 227n.6, 229n.13; categories of 7, 120
racism 18, 52-54, 97, 136, 185, 193, 226n.1
reflexivity 84, 109. *See also* subject position; writing, reflexive
ritual 9, 13, 14, 21, 154, 160, 162-163, 166, 168, 173, 175, 188, 198

"ritualized homosexuality" 152, 158, 162
Rivers, W. H. R. 2
Robertson, Jennifer 155, 168
Róheim, G. 6
Roscoe, Will 165
Rubin, Gayle 151, 153, 167, 168

sadomasochism 159
Schneider, David M. 58–59, 218n.6
science, conceptions of 11, 24, 78–79, 195–196
Seidman, Steven 24
self-reliance, ideologies of 139–140, 187
sexology 12, 157, 159
sexual behavior 2, 11, 33, 143, 155, 164; homo- 147, 150–152, 157, 160–161. See also heterosexuality; masturbation; sadomasochism; sodomy
sexual identity 32, 46, 76, 96, 119, 130–131, 160, 157–159, 183, 195, 204. See also coming out; sexuality; spatial relations
sexual imaginary 32, 34–35, 38–40, 42, 48–50, 52, 53–55
sexuality 32, 40, 42, 50, 54, 96, 163; categories of 148, 156–158, 160; commercialization of 42; domain of 3–5, 24–25, 148, 158, 203; intellectual lineage for 1–5, 27, 147–148, 159, 169; state influence on 160; stigmatization of 37–38, 47, 50, 62, 69, 147, 150, 179, 192, 200. See also heterosexuality; sexual identity; sexualization; transgender
sexuality studies 1, 23–25. See also lesbian/gay studies
sexualization 8, 12, 31, 87, 145, 170, 175, 206; economy and 98; hyper- 18, 194, 227n.3. See also sexual identity; sexuality
Shedd, Charles 164
Shortt, John 7
Silverman, Kaja 165
Simon, John 2, 215n.16
Simpson, David 143
social constructivism 9, 149–150

social evolution 4, 13, 15, 16–18, 20, 214n.8
social movements 2, 8, 136, 215n.12, 229n.17. See also labor movement; LGBT movement; women's movement
sodomy 5, 9, 161
Sonenschein, David 150
spatial relations 54, 204; lesbian/gay identity and 31–32, 35, 40–41, 44–48, 53, 173; metaphorical 83, 91, 194, 199, 208, 210, 230n.27; territorial 40, 208–209. See also migration; urban-rural relations
spectacle 22, 211
Stack, Carol 67
state, the 17, 19, 84, 87, 90–91, 95, 139, 160, 174, 211
Steward, Julian 6
Stoller, Robert 163
subject position 199–200, 202–203, 207, 210, 226n.2. See also reflexivity
subjectivities 163, 166, 178, 191; lesbian/gay 32–33, 38, 54–55, 62; racialization of 54–55; representations of 40–41; 51
subject/object distinction 193, 196–197, 199, 207–208
Suggs, Robert 140
suicide 26, 184–185; academic 4, 190, 211
surveillance 41, 44, 47–48, 55, 168, 202, 227n.5

temporality 26, 64, 71, 78, 229n.17; friendship and 67–68, 71; kinship and 57–58, 62, 67–68, 74–77, 78–80
theory 13, 21, 24, 26–27, 100, 136, 143–146, 148, 153–154, 192, 226n.2; straight versus street 145
third gender 158, 166–167
transgender 3, 148, 152–155, 159, 164, 166, 173. See also LGBT movement
transnationalism 25, 198, 209
transsexuality. See transgender
trust, politics of 122–125, 128, 130–131, 133–135, 141

Two-Spirits (*berdache*) 10, 54, 152, 157, 162, 164–166, 167, 242n.1

urban/rural relations 31–32, 43; sexual identity and 29, 31, 40–42, 44–45, 54–55, 193. *See also* Great Gay Migration; migration; spatial relations

Vance, Carole 150
Vaughan, Suzanne 144
virtuality 26, 189, 192, 197, 199–200, 206, 208–211
visibility 30–31, 172, 175, 185, 205; gay subjects and 45, 47, 51; hyper– 199; Native Ethnographer and 211; rhetoric of 90–91, 156, 174–175

Weber, Max 4, 13, 153
Weeks, Jeffrey 149, 157
Westermarck, Edward 10, 148, 151

White, Hayden 144
Whitehead, Harriet 152, 162
Wikan, Unni 159, 166–167
Williams, F. E. 150
Williams, Raymond 100
Williams, Walter L. 151, 165
Wilson, Monica 7
Winkler, John 168, 224n.5
women's movement 136, 240n.1. *See also* feminism
workplace relations 100, 107–111, 114, 117, 122–123, 197. *See also* class relations; division of labor; employment; nativization; race
writing 23, 33, 64, 95, 130–131, 144, 178–182, 185; employment strategy of 192; ethnographic 12, 18, 154–155, 191, 205, 207–208; labor and 205–206; reflexive 4, 26, 172, 178, 199–205, 207